THE ETHICS OF COLLECTING
CULTURAL PROPERTY

D0752499

The Ethics of Collecting

WHOSE CULTURE?

Cultural Property:

WHOSE PROPERTY?

Second Edition, Updated and Enlarged

———

Edited by
Phyllis Mauch Messenger

Foreword by
Brian Fagan

UNIVERSITY OF NEW MEXICO PRESS
ALBUQUERQUE

Library of Congress Cataloging-in-Publication Data

The ethics of collecting cultural property : whose culture?
 whose property? / edited by Phyllis Mauch Messenger.—2nd ed.,
 updated and enl.
 p. cm.
 Includes bibliographical references and index.
 ISBN 0-8263-2125-9 (paper : alk. paper)
 1. Cultural property, Protection of—Moral and ethical aspects
 2. Antiquities—Collection and preservation—Moral and ethical aspects.
 I. Messenger, Phyllis Mauch, 1950 – .
 CC135.E84 1999
 363.6'9—dc21 99-31907
 CIP
Design by Susan Gutnik.

© 1989, 1999 by the University of New Mexico Press.
All rights reserved. First edition 1989. Second edition 1999.
Second printing, second edition 2003.

Dedication

To Clemency Chase Coggins, who lit the torch and passed it on.

To the *campesinos* of Mexico and Central America who have shared so generously. May our discussions of cultural stewardship not exclude them.

Phyllis Mauch Messenger
December 20, 1988
Deephaven, Minnesota

CONTENTS

CONTENTS

CONTENTS

CONTRIBUTORS

ROGER ANYON is an archaeologist with Heritage Resources Management Consultants in Tucson, Arizona and the former director of the Pueblo of Zuni Archaeology Program in Zuni, New Mexico. He has done archaeological fieldwork in England, Italy, and the American Southwest, particularly the Mimbres and Zuni areas.

ANN M. EARLY has been a survey archeologist with the Arkansas Archeological Survey since 1972. She is an associate professor of Anthropology at the University of Arkansas—Fayetteville, and teaches part-time at Henderson State University. She focuses on issues related to public archaeology and late prehistoric cultures of the Southeast.

DOUGLAS C. EWING is an art dealer, specializing in American Indian art and Master paintings. He is past President of the American Association of Dealers in Ancient, Oriental and Primitive Art in New York.

ELIZABETH GRAHAM is a professor of anthropology at York University and a research associate in the Department of New World Archaeology of the Royal Ontario Museum, Toronto, Ontario. She is the former archaeological commissioner of Belize, where she continues to do archaeological fieldwork.

GILLETT G. GRIFFIN is curator of Pre-Columbian art for The Museum at Princeton University, Princeton, New Jersey. He has taught and written widely on Pre-Columbian art.

ANN GUTHRIE HINGSTON is the former executive director of the Cultural Property Advisory Committee, located at the United States Information Agency in Washington, D.C. She has held writing and administrative positions at the West Virginia Arts and Humanities Council, the National Endowment for the Arts, and The White House.

LEO J. HARRIS, a practicing attorney for over thirty years, has recently been the art law chairman of the Minnesota State Bar Association. With his wife, Molly, he has furthered his interest in the arts by establishing a small press which specializes in publishing books on the arts and popular culture.

ELLEN HERSCHER was director of the International Council of Museums Committee for the American Association of Museums from 1984 to 1990. She has served as chair of the Committee on Professional Responsibilities for the Archaeological Institute of America, Washington, D.C. From 1983 to 1989 she edited "The Antiquities Market" in the *Journal of Field Archaeology* and is a contributing editor of *Archaeology* magazine. She has carried out archaeological work in Cyprus, Lebanon, and Turkey.

CHRISTY HOHMAN-CAINE has been the Minnesota state archaeologist and a forest archaeologist for the Chippewa National Forest. Currently she is an adjunct professor of Anthropology at Hamline University, St. Paul, Minnesota. She has worked extensively with Native American constituencies in Minnesota in initiating tribal-based cultural heritage programs, and in protecting cemeteries and sacred sites.

ANTHONY L. KLESERT is director of the Navajo Nation Archaeology Department and its Cultural Resource Management Program. Since 1975 he has worked in the Four Corners region of the American Southwest, dealing with issues of public archaeology, historic preservation and tribal sovereignty.

CHARLES S. KOCZKA retired in 1987 as a senior special agent in the U.S. Customs Service, New York. For fourteen of his twenty years with U.S. Customs he specialized in the recovery of stolen art. He now lectures on art crime and serves as an advisor to attorneys, art dealers, and others who deal with the international art market.

JAIME LITVAK KING is a researcher in the Institute of Anthropological Research at the National Autonomous University of Mexico (UNAM), and former director of the Institute. He has

written many books and articles on archaeology and cultural patrimony, including *Arqueología y derecho en México,* which he edited.

SHEILA MCNALLY is a professor of art history in the Department of Classical and Near Eastern Studies at the University of Minnesota—Twin Cities. She has served as president of the Twin Cities chapter of the Archaeological Institute of America, and is active in Middle Eastern archaeology.

PHYLLIS MAUCH MESSENGER is director of CACHE—the Center for Anthropology and Cultural Heritage Education at Hamline University, where she coordinates public archaeology programs and a teacher certificate program in anthropology and cultural heritage education. She was a founding member of the Society for American Archaeology's Public Education Committee and for six years served as its vice chair and co-editor of *Archaeology and Public Education,* SAA's education newsletter. In addition to editing *The Ethics of Collecting Cultural Property,* she has co-authored a book and written numerous scholarly articles on archaeology and stewardship of the past.

DEBORAH NICHOLS is a professor of anthropology at Dartmouth College in Hanover, New Hampshire. She has done archaeological fieldwork in the American Southwest, Mexico, the northeastern United States, and American Samoa, and was formerly Assistant Director of the Black Mesa Archaeology Project.

DAVID M. PENDERGAST is vice president for collections and research and former curator-in-charge in the Department of New World Archaeology at the Royal Ontario Museum, Toronto, Ontario. His archaeological fieldwork has focused on the Maya in Belize and, most recently, in Cuba.

ERIC POEHLER is a graduate of Bemidji State University where he studied international affairs. His senior research paper on the international antiquities market was inspired by *The Ethics of Collecting Cultural Property.* He is carrying out graduate studies in anthropology at the University of Chicago.

DAVID SASSOON lived and worked in Kathmandu, Nepal, from 1980 to 1984. He has been managing editor of *Action for Children,* a quarterly tabloid published by the Non-Governmental Organizations Committee on UNICEF in New York.

THOMAS K. SELIGMAN was deputy director for public programs and planning at The Fine Arts Museums of San Francisco during the decade of complex negotiations with Mexico concerning the Teotihuacán murals. A scholar of African art, he has a special interest in the ethical issues concerning cultural property and was a member of the Cultural Property Advisory Committee to the President of the United States.

ORRIN C. SHANE, III is curator for archaeology in the Research and Collections Division at The Science Museum of Minnesota in St. Paul. His archaeological work focuses on the midwestern United States, especially Minnesota and Ohio, and the Middle East, including the site of Çatalhöyük in Turkey.

ALAN SHESTACK is associate director of the National Gallery of Art in Washington, D.C. and was former Director of the Museum of Fine Arts Boston and the Minneapolis Institute of Arts. He is a former president of the Committee on Ethics for the Association of Art Museum Directors.

GEORGE STUART is staff archaeologist for the National Geographic Society in Washington, D.C. He has carried out extensive fieldwork in Mexico, Central America, and the southeastern United States. He has written numerous books and articles on archaeology for the public.

KAREN J. WARREN is a professor in the Department of Philosophy at Macalester College, St. Paul, Minnesota. She specializes in ethics and social philosophy, environmental ethics, and feminism.

In Brian Fagan's 1988 forward to the first edition a decade ago, he noted the crisis proportions of archaeological site destruction and looting worldwide and the surprisingly little attention being paid to the situation and related ethical issues, even among archaeologists. Site destruction and the theft of objects of cultural heritage certainly continue, with changing political and economic situations bringing new regions into the limelight, notably Eastern Europe, China, Southeast Asia, and Africa. However, the issues are being discussed and addressed by a greater number of individuals and constituencies, at many levels, and the legal grounds for addressing the problem have been strengthened.

In the United States, the past decade has seen increased prosecution of the looters of archaeological sites and the purchasers of their booty. Federal agencies and professional societies have worked together to promote public education as the only long-term solution to the problem of site looting and vandalism. These public education efforts in archaeology are seeing wide-ranging ripple effects as public understanding of the value of saving the past for the future increases. Children who are excited about what they can learn from the past grow up to be citizens and taxpayers who are more likely to support preservation laws, both domestic and international.

Certainly the passage of the Native American Graves Protection and Repatriation Act (NAGPRA), resulting in greatly increased consultations among museums, archaeologists, Native American tribes, and government

Phyllis Mauch Messenger

agencies, has been a major factor in increasing important dialogue about the question of who owns the past. Other countries are watching our experience with NAGPRA with great interest as they wrestle with their own issues of repatriation.

Balancing these hopeful developments, regional warfare, poverty, and political instability continue to fuel the destruction of cultural property and the continuation of the international antiquities market. The Gulf War brought horror stories of the destruction of ancient sites in Iraq; the rise and fall of various African states saw the wholesale looting of museums; and the opening of Eastern Europe brought a flow of goods, both legal and illegal. One need only to surf the internet to find readily available antiquities ripped off the facades of national treasures in Southeast Asia.

The first edition of *The Ethics of Collecting Cultural Property* introduced a range of perspectives on the ownership and preservation of cultural property. It sought to allow multiple voices to tell their stories directly to the reader both in individual essays and in the reporting of a round table discussion held during the original 1986 *Ethics of Collecting* conference. The volume was sent round the world by the U.S. Information Agency to close to 200 U.S. consular offices. The subsequent paperback edition has become a sourcebook for college classes on archaeology, ethics, and museum studies, as well as a blueprint for discussions among groups ranging from American museum curators to archaeologists and indigenous peoples in New Zealand.

The revised edition keeps the original essays intact while adding new information and resources. Chapter 14 has been revised to include updates on the case studies included in it. An epilogue, chapter 16 discusses NAGPRA and other new U.S. laws, public education initiatives, revisions of professional codes of ethics, and the development of bilateral agreements related to the 1970 UNESCO Convention. This chapter also includes numerous references for further reading. Information in Appendix I has been expanded and two new appendices have been added. Appendix II includes two new codes of ethics. Appendix III lists organizations and resources with significant interest in cultural heritage issues, and provides their contact information, including websites which have become a major source of information on this topic (while acknowledging the ephemeral nature of web-site addresses).

Some comments on language and spelling choices in the revised edition are appropriate. Discussions of American archaeology and federal agency work invariably lead to a mixing of spellings of *archaeology*, since most federal agencies, and a few other institutions, drop the second *a*. Quotes and titles follow original spellings. Regarding the use of *provenance* versus *provenience*, I have chosen to use the second spelling in the epilogue, to reflect the English version which refers to an object's *original* context. *Provenance,*

on the other hand, often refers only to an object's history as cultural property. This differentiation, I believe, is important to maintain, as it reflects the value we place on an object as a source of information or a piece of property. Similarly I have chosen to replace *cultural property* with *objects of cultural heritage* or other similar terms. Chapter 16 includes a discussion of these issues.

Of course, these revisions and additions barely scratch the surface of addressing possible issues, when we consider the context in which these discussions and developments are taking place: with renewed indigenous and First Nations rights, the globalization of culture juxtaposed with persistent ethnic warfare, and the incessant destruction of archaeological sites by development, highway construction and mechanized agriculture, as well as the unabated desire to own objects of beauty from the past. And the instant flow of information offers us a steady diet of sad stories about clues from the past disappearing before we can record or study them.

Should we be hopeful about the future of the past? I choose to say yes. I believe that when *The Ethics of Collecting Cultural Property* first appeared in 1989, it was among a wave of significant new developments that have changed the nature of the discussion about archaeological ethics and priorities. I believe there is a future for the past, one that is based on shared knowledge, inclusivity, and stewardship, rather than on domination, elitism, and ownership. Are we there yet? Of course not. But we have turned the corner and we are on the right path. I see it in the faces of children and in the ongoing work of many individuals and organizations with more than a passing interest in understanding and preserving our cultural heritage. Just as with protection of the environment, it will take a generation or more of persistent effort to change cultural norms. And there will continue to be setbacks as well as successes. And, just as environmental protection policies often grow out of negotiations among contesting parties, stewardship of cultural heritage must be based on consultation, creativity, and often, compromise.

If *Ethics of Collecting* continues to spark thoughtful discussion, greater understanding of the issues, and perhaps some changes of opinion, it will have served its purpose.

FOREWORD

The discovery of the prehistoric past by archaeologists ranks as one of the major scientific achievements of the past two centuries, an achievement as momentous as Charles Darwin's *evolution* and *natural selection* or the *theory of relativity*. Archaeology itself, began, of course, as little more than a glorified treasure hunt, but a treasure hunt that enthralled the world. The discovery of the earliest civilizations was a glorious adventure story, worthy of Indiana Jones at his best. Kings visited digs in Greece and Egypt, banner headlines announced the latest finds, and thousands flocked to see exotic artifacts from distant millennia in London, Berlin, and Paris. These were the pioneer days of archaeology, when excavators like Hormuzd Rassam and Heinrich Schliemann used battering rams, brute force, and hundreds of workmen in a frenzied search for ancient cities and spectacular artifacts. From these excavations was born the science of archaeology. They also spawned a terrible legacy—concerted efforts to loot and rob the past.

We may laugh and shudder at the antics of the Layards, Stephenses, and Schliemanns, but their researches were the foundations of the modern, scientific archaeology we know today. Their immediate successors were the redoubtable General Pitt Rivers, Ernst Curtius, A. V. Kidder, Mortimer Wheeler, and many other men and women who advocated much more precise excavation methods and taught that excavation was destruction of a finite resource—the archaeological record. Not that

Brian Fagan
University of California at Santa Barbara

their warnings were heeded, for wanton destruction accelerated as the pace of industrial development quickened after World War II.

With the advent of radiocarbon dating, spectrographic analysis, pollen analysis, remote sensing, we have come a long way since Kidder and Wheeler. We live in a world of high technology archaeology, gazing back over a landscape of more than 2.5 million years of human experience, of ever proliferating complexity in human culture and society. Only one thing has not changed since the days of Layard, Schliemann, and Wheeler—the inexorable destruction of the archaeological record. In truth, we have lived with the ravaging of the past so long that we tend often to forget about it, mentally to put the problem aside.

The damage in many parts of the world is so serious today that it is no exaggeration to predict that there will be no undisturbed archaeological sites in many places within a generation. This crisis of the past has received surprisingly little attention from American archaeologists, let alone the general public. The tragic litany of destruction has been much publicized in Europe, where many conservation organizations like Britain's RESCUE are very active. Even there, the decimation of the past continues, albeit with considerably enhanced public awareness. The saga of destruction is much worse in the Americas and many parts of the Third World, where the archives of the past are vanishing with increasing speed in the face of unprecedented rural and urban industrial expansion—and at the hands of looters and collectors, some operating on an international scale. As long ago as 1970, Hester Davis of the Arkansas Archaeological Survey wondered publically whether there was a future for the past. Few people heeded her perceptive but doleful forecast. We ask the question with even more pressing urgency today.

Fortunately, a few archaeologists and concerned citizens have waged a tireless campaign on behalf of the past, lobbying for federal and state legislation, working for the adoption of the UNESCO Convention on Cultural Property, and encouraging an ethical dialogue between archaeologists and other interested parties—developers and business interests, American Indian groups, and even looters and collectors. Their efforts have had some important results and initiated a timely dialogue about the ethics of the past.

The Ethics of Collecting Cultural Property is an important book, for it focuses on ethical dilemmas that confront not only archaeologists but everyone in society. Judging from the literature, these dilemmas, while familiar ones, are little explored. Astonishing although it may seem, few archaeologists have ever debated the ethics of archaeology, let alone made efforts to communicate them to a wider audience. As *The Ethics of Collecting Cultural Property* tactfully points out, it is time we did, for the days of intellectual myopia and comfortable specialization are long gone.

The essays in this volume pose fundamental, and sometimes uncomfortable, questions about the past. The questions are myriad, the answers often tough and uncomfortable ones. Who, for example, owns the archaeological record? An individual landowner, the descendants of those who created it, the nation, or does it form part of the common cultural heritage of all humankind? Do people have the right to collect artifacts, even from privately owned land, and to excavate for personal profit and gratification? Or should all artifacts be deposited in museums for the common enjoyment of everyone? What about the export of artifacts from one country to another? Should all archaeological finds remain in their country of origin, even if there are inadequate museum facilities available there? The proper answers to these, and many other, questions will determine the future of the past. As the essays in this book point out, we are a long way from even slightly definitive solutions to our ethical problems.

I urge every archaeologist young or old, specialist or nonspecialist, professional, amateur, or those just casually interested, to read this book. It offers some critical blueprints and ample food for thought for the urgent task that lies ahead. Perhaps the most important lesson it teaches us is that the future of the past lies not only in archaeologists', but everyones', hands. If *The Ethics of Collecting Cultural Property* sparks a widespread debate about archaeological ethics and priorities, and some concerted action by us all, then our grandchildren will have a past to enjoy. One thing is certain. If we continue, intellectually ostrich-like, on our present course, there is no future for the past.

The purpose of this volume is to present a range of perspectives on issues relating to the ownership and preservation of the artifacts of past cultures. This project evolved out of a growing need felt by many individuals to know and understand why they should or should not collect antiquities, particularly Pre-Columbian pieces from Mexico and Central America. The resulting collection of essays reaches far beyond the initial questions, revealing the complexity and scope of these international issues.

The following essays present a number of thought-provoking perspectives. The reader will no doubt conclude that the issues are not clearcut, nor does the global labyrinth of legislative measures intended to regulate imports and exports of art provide any easy solutions. It is hoped that thoughtful readers will develop their own ethical perspective and act accordingly.

The contributions in this volume originated in several ways. The core of papers developed out of a 1986 conference on the ethics of collecting held in Minneapolis, Minnesota. Two additional papers were first presented at the 1987 Society for American Archaeology Conference in Toronto, Ontario. Several other authors were invited to contribute specific topics as the volume took shape.

The idea for the conference began in 1983 with the modest proposal within the Maya Society of Minnesota that one of its monthly lecture meetings be a round table discussion of the pros and cons of collecting. The Maya

Phyllis Mauch Messenger

Society, a loosely-knit organization of people interested in Maya archaeology and ethnography—and art and Latin American culture in general—included individuals who collect art objects in the course of their well-planned travels and, on the other end of the spectrum, archaeologists whose training and experience in Mexico and Central America led them to be suspicious of any kind of collecting. George Stuart, staff archaeologist with the National Geographic Society, agreed to participate in the panel, offering the observations of one who, in a very public position, must have the cooperation of many individuals and often must search for compromises.

It soon became evident that the topic deserved substantial discussion, so a planning committee representing eleven community organizations, museums, and college and university units was formed. With the support of the sponsoring organizations and a grant from the Minnesota Humanities Commission, a conference to include speakers from around the United States and from Mexico took shape. The intention was to create an atmosphere of cooperation and dialogue in which many perspectives could be presented and discussed. Speakers would include an attorney, a philosopher of ethics, museum directors, art historians, a collector, a dealer, and archaeologists.

On May 23–24, 1986 the conference, "The Ethics of Collecting Cultural Property: Whose Culture? Whose Property?" took place. The presentations and the ensuing round table discussion and informal conversations during the day-and-a-half conference succeeded both in bringing nominal enemies together to explore solutions and compromises and in helping audience members develop their own position on the issues. The conference also raised other questions that could not be addressed in the time available.

Conference organizers decided to continue the dialogue and expand it in the form of a publication. With additional funding from the Minnesota Humanities Commission and with encouragement from the University of New Mexico Press and many individuals, they invited all conference speakers and several additional authors to contribute their perspectives to the volume. These included a journalist, a United States Customs agent, the Director of the President's Commission on Cultural Property, and archaeologists who work with American Indian groups.

Meanwhile, the Society for American Archaeology held its fifty-second annual meeting in Toronto May 7–10, 1987. One of the scholarly symposia was titled, "Plunderers, Profiteers, and Public Archaeology: Practical Approaches to Preventing the Looting of Archaeological Sites and the Traffic of Antiquities." From that well-attended session came a sense that the public discussion of site destruction for the sake of the international art market had come of age. It had taken nearly two decades, brought on in part by the dogged persistence of one art historian, Clemency Coggins, whose listings of

Maya site destruction and artifact theft in 1969 and 1970 sent shock waves through the museum and art world.

From that SAA session came two additional papers describing the destruction of archaeological sites by looting in Central America and the American Southeast.

In order to maintain and promote the sense of cooperation and discussion to search for points of agreement and compromise that was evident in the 1986 conference in Minneapolis, individuals who deal with these issues in their professions were asked to provide commentary on the papers. A summary of the round table discussion appears at the end of the papers and commentaries, followed by a conclusion by George Stuart.

In the course of considering the following essays, the reader may find it useful to note several events and terms that are mentioned repeatedly.

The term "cultural property" generally is considered to include archaeological or ethnological objects of cultural or historic significance. The archaeological material is usually considered to be over 250 years old. "Cultural patrimony," perhaps more appropriately called cultural heritage, is the mass of these objects, which as a whole are considered to be of importance to the identity of a nation or a cultural group.

The Convention on the Means of Prohibiting and Preventing the Illicit Import, Export and Transfer of Ownership of Cultural Property—usually referred to as the UNESCO Convention—was adopted in 1970 by the United Nations Educational, Scientific and Cultural Organization (UNESCO). Sixty-four countries, including the United States, are parties to the Convention, which encourages countries to protect their archaeological and ethnographic treasures and calls for international cooperation in controlling international commerce in endangered materials. (The UNESCO Convention and related terms are discussed in detail by Ann Guthrie in Chapter 9).

A source often referred to for an overview of issues of law and ethics in the international art market is *The International Trade in Art* by Harvard law professor Paul Bator. He discusses existing legal structures, values, and goals related to this trade, as well as methods of regulating and deregulating the import and export of art to successfully conserve sites and monuments. He argues that total embargos are not only impossible to enforce, but actually encourage the illicit market rather than remove it. Bator also presents a thorough discussion of *United States v. McClain,* a 1977 case involving artifacts that, according to Mexican law, had been illegally exported from Mexico to the United States for sale. At issue in the *McClain* case was whether 1897 and 1972 Mexican statutes vesting ownership of Pre-Columbian antiquities in the Mexican government would make illegal export an act of theft under the U.S. National Stolen Property Act. While convictions were reversed

on technicalities, the *McClain* case seemed to set a precedent for allowing foreign statutes to govern interpretation of American law.

An excellent source of information on the McClain case, the UNESCO Convention, the U.S.-Mexico Treaty of Cooperation, and other laws and cases related to the art market is the newly revised two-volume *Law, Ethics, and the Visual Arts* by Stanford University Law Professor John Henry Merryman and Art History Professor Albert E. Elsen (1987). They provide clear summaries, case studies, commentaries, and thought-provoking questions.

Much debate of these cases and related issues has taken place, as the following essays will testify. The debate is far from over.

ACKNOWLEDGMENTS

Many individuals and organizations deserve thanks and recognition for the part they played in bringing this volume to fruition. The idea for the conference that led to this publication arose out of discussions among members of the Maya Society of Minnesota. In 1984 Lewis C. "Skip" Messenger Jr. presented the idea to George Stuart of the National Geographic Society, who was enthusiastic about the need for such a conference and expressed his willingness to participate. His periodic words of encouragement were crucial to the project's success.

Thanks to the planning committee who fleshed out conference themes, came up with names of participants, and critiqued the grant proposal. These included Maya Society members John Harris, Elizabeth West, Skip Messenger, and Ann Pineda; Science Museum of Minnesota Archaeologist Orrin Shane; Minneapolis Institute of Arts Curator Louise Lincoln; and University of Minnesota personnel: Joan Carothers of the Center for Ancient Studies, Lynn Sikkink, anthropology graduate student, and Tom Trow, College of Liberal Arts Cultural Affairs Liaison. Special thanks to Tom for teaching Skip and me grantsmanship and for helping the committee build on ideas generated in 1983 by another committee proposing a similar conference (which did not take place). That committee, headed by Ann Gunter of the Department of Art History at the University of Minnesota, proposed to discuss the then-pending enabling legislation for the UNESCO Convention on Cultural Property. This independent genesis of ideas by two essentially distinct groups—which anthropologists might call a case of cultural convergence—reinforced that this was an idea whose time had come.

Ten local sponsoring institutions gave support in many

ways, from mailing lists and volunteers to financial and logistical support. These groups include the Archaeological Institute of America (Twin Cities Chapter), Hamline University (which served as fiscal agent for the project), the Minnesota Archaeological Society, the Minnesota Historical Society, the Minneapolis Institute of Arts (which housed the conference and provided support through its volunteer group, the Arts Resource and Information Center), the Science Museum of Minnesota (which coordinated brochure production), and at the University of Minnesota, the Departments of Art History and Classical Studies, the Center for Ancient Studies, and the Institute of International Studies. The Institute under Director Brian Job has been particularly generous throughout the conference, writing, and editing stages in contributing staff time, supplies, and moral support. The College of Liberal Arts Scholarly Conferences Committee supported the conference and the prospectus-writing stage of the publication. In addition, many individual volunteers, coordinated by Elizabeth West, contributed their time and expertise.

The Minnesota Humanities Commission (MHC) supported the conference with a grant made in cooperation with the National Endowment for the Humanities and the Minnesota State Legislature. The MHC staff, particularly Tim Glines, offered valuable suggestions, including the addition of a philosopher of ethics to the panel. The Commission made a second generous grant to encourage publication of the conference proceedings. I am especially grateful for their faith in this project and their willingness to accept this as their first funded publication.

Many thanks are due the conference speakers, whose revised and augmented papers form the core of this volume. Speakers included Douglas Ewing, Gillett Griffin, Leo J. Harris, Ellen Herscher (thanks to Katie Vitelli for guiding me to her), Jaime Litvak King, Tom Seligman, Alan Shestack, George Stuart (who presented the keynote address and concluding remarks), and Karen Warren. Thanks also to moderators Skip Messenger, Karen Warren, Frederick Asher, Orrin Shane, and Sheila McNally. Orrin Shane and Karen Warren were especially helpful in their later role as manuscript commentators. Minnesota State Archaeologist Christy Hohman-Caine generously agreed to step in as a commentator when others were unable to continue with the second phase of the project. Thanks also to Paul Perrot of the Virginia Museum of Fine Arts for reviewing one of the chapters.

The Office of International Education at the University of Minnesota contributed toward travel funds which allowed me to attend the 1987 Society for American Archaeology conference in Toronto. Thanks to all the participants of the symposium on "Plunderers, Profiteers, and Public Archaeology," who provided encouragement and corroboration that the issues being discussed were important and timely. Elizabeth Graham and David Pendergast of the

ACKNOWLEDGMENTS

Royal Ontario Museum and Ann Early of the Arkansas Archeological Survey
contributed revisions of their presentations to this volume.

I am grateful to journalist David Sassoon and U.S. Customs Agent Charles
Koczka, who attended the 1986 conference, and agreed to write chapters for
the book. Ann Guthrie Hingston, director of the Advisory Committee on Cul-
tural Property, contributed an up-to-the minute summary of the Committee's
actions. When the University of New Mexico Press encouraged me to seek
a North American Indian perspective on cultural property issues, Michael
Dorris guided me to Deborah Nichols, who worked with Tony Klesert and
Roger Anyon on a much-needed chapter.

This project has been helped by a number of individuals and institutions
who have assisted by providing photographs and information. These include
Elizabeth Boone and Patricia Raynor of Dumbarton Oaks, Dorie Reents-
Budet of Duke University Museum of Art, Hester Davis of the Arkansas Ar-
cheological Survey, Lawrence G. Desmond of the California Academy of Sci-
ences, Mikael Engebretson of the ADAPA Institute, Edith Waldron of the
Philosophical Research Society, Carolyn Tate and Carol Robbins of the Dallas
Museum of Art, Irene Harakal and Patricia O'Connell of the Art Institute of
Chicago, John Henry Merryman of Stanford University, and Prince Subhadra-
dis Diskul of Thailand. Thanks to Peter Wells of the Center for Ancient Studies
and others involved in the conference "Presenting the Past" for providing
such stimulating discussion. Individuals include Brian Fagan, UC Santa
Barbara; Arthur Spiess, Maine Historic Preservation Commission; Harvey
Shields, U.S. Travel and Tourism Administration; Marion Davison, Milwaukee
Public Museum; Christopher Chippendale, Cambridge University; and Lynell
Schalk, Bureau of Land Management, Portland, Oregon, who also provided
additional materials. The editor gratefully thanks Mexico's National Museum
of Anthropology for permission to publish photographs of the mask from Pa-
lenque and the Olmec offering.

The University of New Mexico Press, particularly Director Beth Hadas and
Editor Claire Sanderson, have provided vital encouragement and guidance
since I first proposed the idea of this volume to them before the 1986 confer-
ence. Their suggestions and support were crucial in seeking MHC funding,
and their confidence apparently was unwavering as they waited patiently for
all the pieces of this manuscript to come together.

A more generalized sort of thanks are due some individuals and groups.
Clemency Chase Coggins and Ian Graham unknowingly served as role mod-
els and sources of inspiration for many years. The archaeologists, site guards,
and local workers with whom I have worked in Mexico and Honduras im-
parted the unshakable idea that preserving cultural heritage was an impor-
tant goal toward which to strive. They instilled a perspective that is some-

times at odds with a purely North American viewpoint; yet it would be impossible to abandon that perspective after studying and working there.

Lewis C. Messenger Jr. deserves much credit for helping me guide this project to completion. From the genesis of the idea, through grant writing, presiding over the conference (and the Maya Society as president the last several years), transcribing lectures, and juggling computer time and child care, he has been generous and supportive.

Putting together this volume was not without its difficulties, a situation which mirrors the complex reality of the topic. Some individuals were hesitant to present their views in public, especially in print. Several collectors and dealers declined the invitation to participate, fearing they were being set up as the straw man. A self-proclaimed *huaquero,* or looter, from a South American country, also declined. Several archaeologists who rely on state funding feared reprisals channeled through their legislatures if they wrote candidly about specific events and people involved in looting in their state. An additional chapter, representing the perspective of the Instituto Nacional de Antropología e Historia (INAH) of Mexico, was to be included, but it was not available for publication due to last-minute unforeseen circumstances.

A special thanks to those who have contributed to revisions for the revised edition of this book. Thanks to Eric Poehler for his thorough research and valuable insights; to Ed Friedman and colleagues in the SAA Public Education Committee; to Ellen Herscher, Clemency Coggins, Frank McManamon, Dan Haas, Tim McKeown, Dick Waldberg, Marilyn Nichols, Ricardo Elia, Mark Lynott, Alison Wylie, Tom Trow, Jim Jones, KD Vitelli, Anne Pyburn, Skip Messenger, and many others. A special thanks to the University of New Mexico Press and editor Durwood Ball for their patience, understanding, and encouragement.

Almost no one whose work appears in this volume will agree with all viewpoints expressed. In fact, at times there were individual concerns over appearing in the same publication with some of the other authors. For everyone's willingness to stick with the project, I am grateful. Every possible effort was made to present a variety of viewpoints and to make those positions accessible to a broad audience. Any failure to accomplish these goals should not be attributed to individual authors. If this volume succeeds in engendering continued debate and thoughtful discussion, then it will have succeeded.

Perspectives of the "Victims": Case Studies

A Philosophical Perspective on the Ethics and Resolution of Cultural Properties Issues

INTRODUCTION

Who, if anyone, owns the past? Who has the right or responsibility to preserve cultural remains of the past? When, if ever, should preservational or educational considerations override national sovereignty in determining the disposition of cultural materials? What should be declared illegal or illicit trade in cultural properties? What values are at stake in conflicts over cultural properties, and how should these conflicts be resolved?

Questions such as these are at the heart of the debate over so-called "cultural properties." These questions raise important philosophical issues about the past (e.g., what constitutes the past; who, if anyone, may be said to own the past; who may have access to the past and to the information derived from it; what controls may be exercised over remains of the past). They also bring to the fore both the diversity of values associated with the preservation of cultural properties (e.g., aesthetic, educational, scholarly, cultural, and economic values) and the conflicts of interests of the various parties to the dispute (e.g., governments or nations, private citizens, collectors, art and antiquities dealers, museums and museum curators, suppliers or sellers, customs agents, indigenous peoples, present and future generations of humans).

Karen J. Warren

It is easy to get lost in this cacophony of voices over cultural properties. These voices raise very different, often competing, perspectives on the nature and resolution of cultural properties issues. What is needed to help guide one through the morass is a philosophical framework for understanding and assessing the variety of claims and perspectives in the debate over cultural properties.

The primary purpose of this essay is to provide such a framework. I begin by presenting an overview of what I take to be the main arguments and issues in the debate over cultural properties. This section is intended to be reportive of what I understand to be the central arguments in the debate and suggestive of some of the key philosophical issues raised by that debate. I then suggest that what is at stake philosophically in the debate over cultural properties is much deeper and richer than a critique of any particular argument would show; what is at stake is the very way in which one conceives the dispute, and, hence, the way in which one attempts to resolve that dispute. I do this by showing how the current debate over cultural properties reflects what I call "the dominant perspective" in the Western philosophical tradition, and by suggesting some respects in which that perspective is itself problematic as a conceptual framework for identifying and resolving so-called cultural properties issues. I conclude by suggesting that what is needed is a rethinking of the debate in terms which preserve the strengths of a dominant perspective while making a central place for considerations often overlooked or undervalued from that perspective. This is the promise of "an integrative perspective" on cultural heritage issues.

PHILOSOPHICAL OVERVIEW: THE 3 Rs

One way to organize the various claims which surface in the dispute over cultural properties is in terms of what I call "The 3 R's." The 3 R's are claims concerning the restitution of cultural properties to their countries of origin, the restriction of imports and exports of cultural properties, and the rights (e.g., rights of ownership, rights of access, rights of inheritance) retained by relevant parties.

Claims to the 3 R's are offered by the various parties to the disputes and represent a wide range of relevant values. Typically, these claims conceive the debate over "cultural properties" as a debate over ownership of the past, where "the past" is understood not only as the physical remains of the past (e.g., artifacts, places, monuments, archaeological sites) but also the "perceptions of the past itself" (e.g., information, myths, and stories used in reconstructing and transmitting the past).[1]

Some of the arguments in support of the claims concerning the 3 R's are mutually compatible; others are not. Many of these arguments turn on how one answers the question "Who owns the past?" Three sorts of alternative and competing answers are given: (1) "Everyone owns the past," since the past is the common heritage of all; it is "humanity's past;" (2) "Some specific group (e.g., indigenous peoples, scholars, collectors, museums, nations) owns the past," since that group speaks for or represents the important values that are at stake in the debate over cultural properties; and (3) "No one owns the past," since the past is not really the sort of thing that is ownable. As will be shown, these three sorts of answers reflect competing philosophical positions about the ownership of "cultural property," understood here in the widest sense to include both physical remains of the past and "perceptions of the past itself."

In this section I identify what I take to be the main sorts of arguments for, and the main sorts of arguments against, claims to the 3 R's by countries of origin,[2] and the basic philosophical issues raised by each. I treat each argument like the basic plot line of a story: The argument's plot line is the basic focus or issue addressed. While a change in cast of characters and circumstantial details provides different, often more complex, versions of the story, the plot line of the story remains basically unchanged by these variations on a theme.

Six Arguments Against Claims to the 3 R's by Countries of Origin

1. The Rescue Argument Many of the sorts of cultural properties at issue would have been destroyed (e.g., by natural elements, war, looters) if they had not been rescued by those foreigners or foreign countries with the skills and resources to preserve them. Those who rescued them now have a valid claim (right, interest, entitlement) to them, whether or not they had such a claim prior to their rescue and preservation by foreigners. Hence, the rescue of these cultural properties by foreigners and foreign countries justifies their retention by foreign parties or countries. Any efforts toward repatriation of these properties by countries of origin, on whatever basis, is unjustified.

The Rescue Argument raises two basic, interrelated issues about the practice of rescuing or saving cultural properties. The first issue is whether that practice is justified; the second is, if justified, whether that practice gives foreign countries (including individual foreigners) a valid claim to the rescued properties.

Three grounds for justification of the rescue of cultural properties are

typically offered: first, the values preserved and interests served justify the rescue as a practice, whatever the costs or benefits of the rescue in a particular case; second, the benefits gained in a particular case justify the rescue in that case; and, third, those who rescue cultural properties have a right (e.g., right of ownership) to those properties, which right is passed on to genuine beneficiaries.[3]

Notice that, taken together, these three different grounds offered for the justification of rescuing cultural properties draw upon the whole range of issues about values, rights, and utility (e.g., cost-benefit) considerations which are addressed by the remaining five arguments given below. As such, whether or not the Rescue Argument is sound will turn, in part, on the strengths and weaknesses of these other arguments.

2. The Foreign Ownership Argument The removal of many cultural properties by foreign countries (or foreigners) was undertaken legally (e.g., by permit); they were neither stolen nor illegally imported.[4] Since they were legally removed, those who removed them (or their genuine beneficiaries), and not the countries of origin, own them and are legally entitled to keep them. Therefore, no claims to restitution, restriction, or rights of ownership of countries of origin against such foreign countries or foreigners are valid.

The main issue raised by the Foreign Ownership Argument is what constitutes "legality" with regard to the removal of cultural properties. How one answers that question will affect how one answers the secondary question of the legality of claims to the 3 R's—restitution, restriction, and rights—by countries of origin.

Considerations of legality are not, as they might first appear, straightforward questions of fact. To determine legality one must ask a host of other questions as well: According to whom was the cultural property legally removed? According to which laws was the removal deemed legal? What is illicit or illegal under the existing law of the country of origin? Was the country of origin under foreign rule at the time the property was removed? What are taken to be the relevant facts bearing on the issue of legality? Are the facts intersubjectively and interculturally verifiable and agreed upon as facts?

Such questions make visible important issues about what counts as a fact and whether agreement about facts is sufficient to ensure agreement about the legality of the removal of cultural properties. For even when alleged questions of fact are resolved, there may still be important ethical disagreement about how to value the facts, for example, about what valuational attitude to take toward the facts. This ethical disagreement in attitude may persist even when agreement in belief is reached about the facts or about the legality of the removal of cultural properties. Until agreement in attitude on the relevant ethical issues is also reached (e.g., agreement on how to value

the facts, or whether what is legal ought to be legal), disagreement on whether such practices should be declared illicit or illegal will persist.

Attempts to answer these definitional, empirical, and valuational questions reveal the respects in which the resolution of many legal issues presupposes the resolution of many nonlegal issues (e.g., about what one takes as fact and how to value the facts). Determining the soundness of the Foreign Ownership Argument, then, will involve determining the correctness of a whole range of other commitments (explicit or implicit) on other-than-strictly legal issues; in fact, it will turn on just such issues as are raised by the other five arguments against claims to the 3 R's by countries of origin.

3. The Humanity Ownership Argument Many cultural properties have artistic, scholarly, and educational value which constitutes the cultural heritage of human society. But the cultural heritage of human society belongs to a common humanity. Hence, these cultural properties belong to a common humanity: they are not and cannot be owned by any one country, and no one country has a right to them. Since countries of origin do not own or have a right to them, blanket declarations of ownership by countries of origin are not binding and ought not be upheld by foreign courts.

The general issue raised by the Humanity Ownership Argument is whether one can speak meaningfully of the past being owned by "everyone, and no one in particular." If so, then any claims to ownership by any specific group (whether a foreign country or country of origin, whether a collector, art dealer, or museum curator) are moot.

Certainly there is precedent in law and ethics to speak of rights which hold against "the world at large"—so called *in rem* rights, in contrast with *in personam* rights. "No trespassing rights" are frequently cited as examples of in rem rights. But whether any such rights talk, including talk of a "common humanity" as rightful owner of cultural properties, is properly construed as talk of ownership is a controversial issue. That issue would have to be resolved in the affirmative in order for the Humanity Ownership Argument to be plausible. Furthermore, there would need to be agreement that there is a relevant common humanity. Marxists or feminists might challenge just such a claim as presupposing a mistaken, ahistorical notion of what it is to be human. For traditional Marxists, humans are always historically and materially located; "human nature" is always a response to the prevailing mode of economic production in a society or culture. On this view, there is no such thing as a "human nature" or "common humanity," if by that, one means a transcendental ahistorical, asocial "essence" which all humans have, independent of their particular concrete and historical location. Similarly, many feminists have argued that in contemporary culture, thoroughly structured by such factors as sex/gender, race, and class, there is no such thing as a

human simpliciter: all humans are humans of some sex/gender, race/ethnicity, class, affectional preference, marital status, etc.[5] Such feminists argue against "abstract individualism," that is, the view that humans can meaningfully be said to exist independent of and abstracted from any social, historical circumstances. If the "common humanity" referred to by the Humanity Ownership Argument refers to some notion of an ahistorical essence or abstract individualism, the argument will be rejected by these classical Marxists and feminists.

4. The Means-End Argument The practice of selling or exporting cultural properties has materially aided the promotion of many important values: the preservation of priceless artifacts; the enrichment of aesthetic sensibilities; the advancement of education and scholarship; the breakdown of parochialism; the encouragement of cultural pluralism; the role of art as a good will ambassador. Not only is the promotion of these values both desirable and justified; its continuance requires the "free flow" of at least some cultural properties. Hence, the practice of selling or exporting cultural properties is both desirable and justified, and restrictions on such practices are undesirable and unjustified.

The Means-End Argument is a utilitarian argument against regulations of imports and exports in terms of the multifarious benefits of import/export practices. The philosophically interesting issues it raises are many: When do such utilitarian considerations outweigh nonconsequentialist (deontological) considerations[6]—such as ones based on alleged claims of rights, claims to restitution, or claims to compensatory justice (e.g., by repatriation of stolen or taken cultural properties) by countries of origin? What is the scope of such utilitarian claims? Are only some practices of selling or exporting some cultural properties undesirable and unjustified, and hence only some restrictions desirable and justified on utilitarian grounds? Or is the scope wider than this? And even if the utilitarian benefits of (some) unrestricted export/import practices is established, where should the cultural properties stay? Claims to restitution by countries of origin are not automatically ruled out by the Means-End Argument.

The Means-End Argument is a very popular kind of argument against claims to the 3 R's by countries of origin. This is because the Means-End Argument makes a fundamental place not only for the full range of values at issue in the debate over cultural properties, but also for those parties to the debate who support the export/import of cultural properties on the basis of the benefits and advantages gained by such practices for themselves and others. However, the Means-End Argument leaves totally open the question about *how* to control the international trade in cultural properties in order both to prevent theft and looting and to ensure the protection and preserva-

tion of those properties. Should one do so through physical protection, economic incentives and sanctions, embargos, screening and licensing systems, or import/export regulation?[7] If the use of export-import regulations is desirable and justified, one must state exactly which ones are, which cultural properties are/should be regulated by them, and how appeal to them preserves the relevant values at stake. It is on just these points of substance and detail that advocates of the Means-End Argument differ drastically. To resolve those issues, more is needed than the Means-End Argument itself (as given here) provides.

5. The Scholarly Access Argument In order to preserve cultural properties, those whose primary responsibility or role is to promote and transmit cultural information and knowledge (e.g., scholars, educators, museum curators) must have scholarly access to cultural properties. Restitution to or retention by countries of origin of cultural properties will prevent such persons from having scholarly access to cultural properties. Hence, such restitution and retention is unjustified.

If scholarly access to cultural properties is viewed primarily as a necessary means to a desired end (viz. the preservation of cultural properties), then the Scholarly Access Argument is a version of the Means-End Argument and can be treated as such. If, however, scholarly access to cultural properties is viewed as a right or responsibility of persons properly authorized to preserve cultural properties, then the Scholarly Access Argument is a separate argument in its own right. Understood as the latter, it is grounded on the assumptions that there is a responsibility to preserve cultural properties, and that fulfillment of that responsibility is the right or duty of properly authorized persons—typically authorized because of the official powers, roles (offices, positions), or institutions (e.g., museums) such persons have, occupy, or represent.

On either interpretation of the Scholarly Access Argument, then, the main issues raised are the same: What is the nature and ground of a responsibility to preserve cultural properties, and whose responsibility, or even right, is it to do so? If it is the right or responsibility of some specific group (e.g., scholars, collectors, museum officials), then those arguments which locate that right elsewhere (e.g., in "everyone" or in "no one"), or which do not see the preservation of cultural properties as an issue of rights at all (e.g., the Means-End Argument), are seriously problematic, if not simply unsound.

6. The Encouragement of Illegality Argument The practice of restricting the selling or export of cultural properties encourages illegal activity (e.g., the looting of archaeological sites, black market trade). Since such illegal activity ought not be encouraged, such practices are unjustified.

The Encouragement of Illegality Argument raises an important issue about the practice of restricting the "free flow of art": Is such restriction part of the problem or part of the solution (or both)? A variation on the argument is expressed by such sentiments as "If I don't buy (sell) it, someone else will" and "It's no good for one country to stop buying or trading cultural properties if everyone else continues to do so."[8] This is more than just a worry about the consequences of export/import regulation; it is a worry about the justification of the practices themselves, and whether those practices serve the ends they are intended by design (and not simply by consequences) to serve. As such, the Encouragement of Illegality Argument raises just the sort and range of philosophical issues that the traditional utilitarian-deontological controversy in ethics raises: Do the net costs of the consequences of the practices render the practices themselves unjustified? Or are there other, nonutilitarian considerations (e.g., rights of courts, customs offices, bona fide owners) which justifiably trumps utilitarian considerations in cases of illegal practices? Resolving this question will call into play the same sorts of complex and controversial considerations that surface in traditional utilitarian-deontological disputes.

To summarize, the six arguments (or, properly speaking, argument-types) discussed here are a rendering of what I understand to be the main sorts of arguments given against claims to the 3 R's by countries of origin, and some of the main philosophical issues raised by each. Consider now the sorts of arguments given in support of claims to the 3 R's by countries of origin.[9]

Three Arguments For Claims to the 3 R's by Countries of Origin

1. The Cultural Heritage Argument All peoples have a right to those cultural properties which form an integral part of their cultural heritage and identity (i.e., their "national patrimony"). The practices of permitting foreign countries to import cultural properties and to retain those currently housed on foreign soil deprive indigenous peoples and countries of origin of their right to their cultural heritage. Hence, such practices are unjustified. These practices should be stopped and cultural properties presently displaced in foreign countries should be returned to their countries of origin.

The Cultural Heritage Argument raises the vital issue of the relevance and legitimacy of claims to cultural property based on considerations of national patrimony, that is, those aspects of a country which are of special historical, ethnic, religious, or other cultural significance and which are unique in exemplifying and transmitting a country's culture. The Cultural Heritage Argument assumes that countries have a legitimate claim to preserve, foster, and enrich those aspects of their culture that represent their national identity. What it leaves open is which cultural properties those are, which im-

port/export practices must be stopped, how many cultural properties must be returned, and whether "cultural patrimony" must stay permanently in the country of origin.

It is what is left open, and not the main assumption about a country's right or claim to its cultural patrimony, which makes the Cultural Heritage Argument especially controversial. Unless it is clear which cultural properties constitute a country's national patrimony and which regulations are supported by claims to a country's cultural heritage, the argument loses its critical bite. Foreign countries could use the same sort of argument to defend claims to the retention of cultural property that has been in the country so long that it now constitutes part of *their* cultural heritage. Foreign countries also could reject the argument by rejecting the remedies proposed (e.g., import/export restrictions), without rejecting the main assumption on which the argument is based, viz. that countries of origin have a legitimate claim to protect and preserve their cultural heritage. Since both uses of the Cultural Heritage Argument by foreign countries would be unacceptable to its advocates, the Cultural Heritage Argument must provide answers which rule out such usurpations of the argument.

2. The Country of Origin Ownership Argument The past, as expressed in cultural property, is owned by the property's country of origin. Since the countries of origin own them, they have a right to have their cultural property returned to them or, if already located in the country, to keep it there.

This argument repudiates claims to ownership of cultural property that locate that ownership elsewhere than in countries of origin. Hence, it constitutes a rejection of both the Foreign Ownership and the Humanity Ownership Arguments. Nonetheless, like those arguments, it construes the main issue concerning cultural properties as one of ownership: It assumes that the question "Who owns the past?" is legitimate; it simply provides a different answer. Whether any of these arguments is plausible, then, will depend on the strength of the position that the past—both the material remains and the "perceptions of the past"—is properly described in terms of ownership and property.

3. The Scholarly and Aesthetic Integrity Argument The practices of collecting and importing cultural properties contribute to the breakdown in the scholarly value of those properties and their aesthetic integrity as an artistic complex (e.g., by mutilating large monuments, disrupting a series of interconnected panels, "thinning" intricately carved stelae, destroying the complex system of hieroglyphic inscriptions necessary for identifying artifacts).[10] Since it is important to preserve the educational value and aesthetic integrity of cultural properties, such practices are unjustified. Restriction

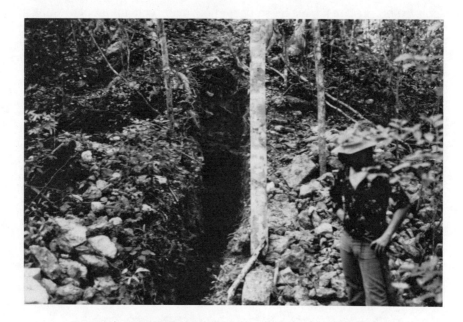

A worker from a government-sanctioned excavation inspects a looter's trench cut through a structure at the site of El Mirador, a large Late Preclassic Maya site in the Guatemalan Peten. Looters look for slumps that indicate doorways, then dig straight one-meter wide trenches until they find a burial or cache. Ironically the looters probably acquired their excavating skills while working on controlled scientific excavations at the site, including those sponsored by the National Geographic Society and the New World Archaeological Foundation. Such situations illustrate the complexity of issues of ownership, access, and preservation. *Photo by Mikael Engebretson.*

on the import/export of such cultural properties is therefore required and justified.

There are two main issues here, one which is relatively uncontroversial and a related one which is quite controversial. The relatively uncontroversial issue is whether the practices which destroy or jeopardize the scholarly or aesthetic integrity are wrong. Nearly everyone agrees that they are, even though there is disagreement about just what constitutes the practice, whether an individual activity genuinely "falls under this (rather than some other) practice," and whether the practice may be justified in a particular (though not all) case. The main question, then, is whether restrictions on the im-

port/export of particular cultural properties falling under those practices, or of restitution to countries of origin of other cultural properties (i.e., those collected or imported without jeopardizing their scholarly or aesthetic integrity), should be permitted or required. This question remains even if the practices which violate the scholarly or aesthetic integrity of cultural properties are wrong and ought to be restricted.

RETHINKING THE DEBATE

The preceeding overview of the debate over cultural properties has been organized in terms of nine main kinds of arguments concerning claims to the 3 R's by countries of origin, noting the key philosophical issues raised by each. In the remainder of this chapter I take a different approach. I look at the debate taken as a whole, and offer reasons for supposing that the traditional categories and concepts used in the debate, as given by these arguments concerning the 3 R's, are inadequate as is to provide a theoretical framework for addressing and resolving conflicts concerning the disposition of cultural remains of the past. To do that, I discuss four issues: the nature and importance of conceptual frameworks; the language used to discuss cultural properties; ways of correcting bias in a theory or perspective; and alternative models of conflict resolution. Taken together, I show how acknowledgment of the importance of these four issues can help in the attempts to resolve the debate over cultural properties.

The Nature and Importance of Conceptual Frameworks

Whether we know it or not, each of us operates out of a socially constructed world view or conceptual framework. A conceptual framework is a set of basic beliefs, values, attitudes, and assumptions that shapes, reflects, and explains our view (perception, description, appraisal) of ourselves and our world.[11] It is the lens through which "we" (whoever we are) conceive ourselves and our world. As a social construction, a conceptual framework is affected by such factors as sex—sex/gender, race/ethnicity, class, age, affectional preference, religion, and national background.

Some conceptual frameworks are oppressive.[12] An oppressive conceptual framework is one which functions to justify or maintain dominant-subordinate relations, or subordination of one group by another. As I use the term, an oppressive conceptual framework is characterized by three features: (1) Value, hierarchical or "Up-Down" thinking—an organization of diversity by a spatial metaphor ("Up-Down") that attributes greater value, prestige, or status to that which is "Up" or higher than to what is "Down" or lower.[13] (2) Value dualisms—disjunctive pairs in which the disjuncts are

presented as exclusive (rather than inclusive) and oppositional (rather than complementary), and where greater value, prestige, or status is attributed to one disjunct than the other. (3) A logic of domination—a structure of argumentation or reasoning which justified subordination, typically on the grounds that whatever is "Up" has some property that whatever is "Down" lacks and in virtue of which what is "Up" is superior to that which is "Down." The unstated assumption is that the superiority of what is "Up" justifies the subordination or unequal treatment of what is "Down."

When an oppressive conceptual framework is Western and patriarchal, traditionally Western male-identified beliefs, values, attitudes, and assumptions are taken as the only, or the standard, or the more highly valued ones. In a Western and patriarchal conceptual framework, inappropriate or harmful Up-Down thinking is/has been used to justify the inferior treatment of women and Third World peoples on the grounds that the claims (beliefs, values, attitudes, assumptions) of these groups are less significant, less cultivated, or otherwise inferior to those of the dominant Up-group and its claims. In a Western patriarchal conceptual framework, inappropriate value dualisms conceptually separate as opposites aspects of reality that are in fact inseparable or complementary, for example, treating as ontologically or metaphysically separate and opposed what is human to what is nonhuman, mind to body, reason to emotion.

Current conceptions of the debate over cultural properties in terms of arguments for and against claims to the 3 R's by countries of origin in many important ways reflects a Western and patriarchal conceptual framework. It also (and not incidentally or accidentally) reflects a familiar perspective—what I call the "dominant perspective" in the Western philosophical tradition. What I want to show now is one way this tradition and the sort of Western and patriarchal conceptual framework which houses it contribute to a particular and not altogether satisfying way of construing the so-called debate over cultural properties. I do so by discussing a favored approach, what I call a "rights/rules approach," to talking about humans, ethics, and ethical conflict resolution in what I refer to as the "dominant tradition" in Western philosophy.

A rights/rules approach to discussions of humans, ethics, and ethical conflict resolution is an ethical framework for assessing what is morally right, wrong, or obligatory in terms of either alleged rights or duties (legal or moral) of relevant parties (e.g., individuals, groups of individuals, nations) or governing legal or moral rules which warrant as justified or morally permissible the action or practice in question. Typically these rules are utility-based or duty-conferring rules; that is, they specify the net utility of performing or not performing a given act or kind of act, or of acting in accordance with a given rule, or the duties persons have in virtue of the governing rules

(respectively). A rights/rules ethical framework views moral conflict as essentially a conflict among rights and duties of individuals or groups of individuals, and/or a conflict of relevant rules. Typically, a rights-rules approach adjudicates moral conflicts by appeal to the most basic right, duty, or rule in a value-hierarchical way, for example, where the "authority" of a right, duty, or rule is given from the top of a hierarchy and is appealed to in order to settle the conflicts or dispute.

In the dominant tradition, the inappropriate or harmful use of a rights-rules ethic occurs when all moral situations are mistakenly or misleadingly construed as adequately captured by talk either of who has what rights or duties, or which rules prevail. In the dominant tradition, rights are assumed to be *prima facie rights* which hold "other things being equal," and the relevant moral rules are assumed to be objective, universal, impartial, and cross-culturally binding.

In recent discussion of ethics, feminists have begun to challenge this hierarchical rights/rules approach to ethics in the Western philosophical tradition. For example, in her book *In A Different Voice,* psychologist Carol Gilligan contrasts this Western philosophical highly individualistic, hierarchical, rights/rules ethic with an essentially contextual, holistic, and web-like ethic of care and responsibility in relationships.[14] Gilligan argues that these two ethical orientations have thematic and gender significance: they reflect important differences in moral reasoning between men and women on such basic issues as how one conceives the self, morality, and conflict resolution.[15] According to Gilligan, the moral imperative in the rights/rules ethic tradition is an injunction to protect the rights of others against interference, to do what is fair, and to do one's duty. In the ethic of care, the moral imperative is an injunction to care and avoid hurt, to discern and relieve the "real and recognizable suffering" of this world, to express compassion.[16] The contrasting images of hierarchy and web convey different ways both of structuring relationships and of viewing the self, morality, and conflict resolution.[17] According to Gilligan, the image of a hierarchy emphasizes an exclusive realm of individual rights, a morality of noninterference, and a conception of the self in separation or isolation, while the image of a web provides a nonhierarchical vision of human connection, an inclusive morality of care and responsibility, and a contextual conception of the self in community or in relationships.[18]

Philosopher Kathryn Pyne Addelson makes a related point in her article, "Moral Revolution." Addelson argues that there is a bias in the dominant world view which results from the near exclusion of women from the domain of intellectual pursuits. That bias conceives of ethical problems "from the top of the hierarchy," and assumes that the authority of that position rep-

resents the "official" or "correct" or "legitimate" point of view.[19] Addelson offers as her paradigmatic example of such bias the rights/rules ethic of the Western philosophical tradition.[20] According to Addelson, the dominant tradition perpetuates the sort of dominant-subordinate structures which create inequality, in part by not noticing that the point of view at the top of the hierarchy is not, as the tradition assumes, a value-neutral objective, universal, and impartial point of view. According to Addelson, the perceptions and power of subordinate groups (e.g., women, Third World peoples) are necessary to create new social structures and world views which do not have such a bias.[21]

This is not the place to discuss the strengths and weaknesses of the Gilligan and Addelson accounts. They are offered merely to show the respects in which "the dominant tradition" has come under attack recently by feminists who view it as biased in key respects (e.g., by sex/gender, by race/ethnicity, by class/privilege). Consider, now, how an understanding of this sort of criticism of the dominant perspective applies to the "debate over cultural properties."

Language and Conceptual Frameworks

The language we use and the questions we ask reflect our conceptual framework or world view. In the debate over cultural properties, the language we use reflects our conception of the main issues in that debate and sets into place the sorts of remedies that are taken to be relevant to resolving that debate. To illustrate this, consider the title of this book, *The Ethics of Collecting Cultural Property: Whose Culture? Whose Property?*

First, the language used in the title reflects the by now familiar conception of the debate as essentially a debate about property. As such, the language grows out of and reflects a conceptual framework which takes as fundamental and most important (most highly valued) considerations of property and ownership. But such talk is unpacked in terms of the rights and duties of relevant parties. The debate therefore presupposes the legitimacy and efficacy of construing the debate over cultural properties in terms of both properties which properly can be said to be owned, and a rights/rules framework for stating and resolving what are taken to be the most important ethical issues addressed in the debate: Who owns what cultural properties? To which cultures (countries) does the cultural property properly belong? Who has a right to collect or own cultural properties? Who has what duties with regard to cultural properties? Which rules prevail in the disposition of cultural properties—ones expressing utilitarian considerations, or ones expressing deontological, nonutilitarian considerations?

The nine specific sorts of arguments for/against claims to the 3 R's—res-

titution, restriction (or regulation), and rights—are couched in the same sort of language. The assumption underlying them is not simply that the question "Who owns the past?" is a meaningful and important question; it is typically the main or focus question. Several arguments are explicitly so construed (i.e., the Rescue, Foreign Ownership, Humanity Ownership, Cultural Heritage, and Country of Origin Ownership Arguments). The other arguments (i.e., the Means-End, Scholarly Access, Encouragement of Illegality, and Scholarly and Aesthetic Integrity Arguments) implicitly or covertly appeal to a rules ethical framework for justifying serious consideration of values and interests not explicitly unpacked in terms of property and rights. Thus, all of the specific sorts of arguments given are presented within some sort of rights/rules framework.

Second, the language used to conduct the debate over cultural properties is often male gender-biased. Interchangeable talk of cultural properties and national patrimony goes unnoticed as a gender-biased category of analysis. Since "one way a tradition conceals data is through the concepts and categories it uses,"[22] use of the concept or category national patrimony to discuss an entire society's cultural heritage is at least misleading. Surely it is at least an open question whether the concept national patrimony, like the concepts of property, ownership, utility, and rights, properly captures the relevant information about the relationship of all people to their cultural history. For persons in a cultural context where "the past" is not viewed as property, perhaps not even as "past" (e.g., some Native American cultures), or where talk of property, ownership, utility, and rights do not capture important conceptions of the past (e.g., communal kinship with the "living past") or where one's cultural heritage and relationship to that heritage is not captured in the male-biased language of patrimony, what one takes to be the relevant issues—in fact, what one takes to be the debate itself—will not be captured by the current conception of the debate in terms of the dominant perspective on cultural properties. These concerns about the adequacy of the very language in which the debate is couched affect many of those cultures/countries from which the relevant cultural properties originate. Parties to the debate must take enormous care not to see as inferior, irrelevant, or of less significance the sorts of concerns that indigenous peoples, for example, may raise about both how their cultural heritage is talked about and how it is treated if they are to avoid conducting the debate over cultural artifacts from within an oppressive, Western, and patriarchal conceptual framework.

What all of this suggests is that it is important to recognize and appreciate the nature and power of conceptual frameworks and of the language by which they are given concrete expression. By conceiving the dispute over

cultural heritage issues as a dispute over properties, and by focusing the debate over cultural properties on the question of rights and rules governing ownership of or access to the past, the dominant perspective keeps in place a value-hierarchical, dualistic, rights/rules ethical framework for identifying what counts as a worthwhile value or claim, for assessing competing claims, and for resolving the conflicts among competing claims. Where such a framework is problematic or inadequate, what can be done to remedy the inadequacy?

Correcting Bias in the Dominant Tradition

If there is a bias in a theory, it may be that reforming the theory by making internal changes—redefining key terms, changing assumptions, extending its application in a new or different way—will remedy the bias. But if the bias is within the theory itself, rather than with its application, then that bias will not be remedied simply by reforming the application of the theory, altering a few of its assumptions, or revising the arguments given within the theory.[23] In such a case, more radical ways of construing and resolving the debate will be needed.

Is there a kind of bias in the debate over cultural properties, one which has been introduced by the near exclusive reliance on a value-hierarchical, value-dualistic, and rights/rules ethic, which subordinates the interests or claims of those in subordinate positions relevant to the dispute? If so, is it a bias that reforming from within that conceptual framework will remedy, or is it the sort of bias that requires reconceiving the very terms of the debate itself?

I already have suggested that there is such a bias, and that it enters into the debate in two ways.[24] The first way bias is introduced is by construing the dispute as basically a dispute about ownership, property, and rights. Since several of the main arguments concerning the 3 R's are explicitly couched in such terms (viz. the Rescue, Foreign Ownership, Humanity Ownership, Cultural Heritage, and Country of Origin Ownership Arguments), they overtly contribute to that bias. To the extent that at least some cultural properties issues really are issues of property, and to the extent that others are not, tinkering from within will be appropriate in some cases and not in others.

The second way bias is introduced relates to the first: Casting the dispute as a dispute about ownership, property, rights and rules at least encourages a resolution of conflicts over cultural properties from a value-hierarchical, win-lose perspective. Such a strategy of conflict resolution will be appropriate to the extent that the issues of the controversy genuinely fit a hierarchical model of conflict resolution (discussed below); to the extent that they do

not, it biases the issues to treat the resolution of all cultural heritage issues from the perspective of a hierarchical model. Since all of the arguments given concerning the 3 R's are presented from within a hierarchical rights-rules model, the question of bias arises for each of them.[25]

In order to eliminate whatever bias there is in the conception of the debate over cultural properties from within the dominant tradition, it is necessary to identify those issues which can, and those issues which cannot, be adequately addressed and resolved from within that perspective. While it is outside the scope of this essay to do that critical work here, what I have said so far suffices to show how the issue of the adequacy of the dominant conceptual framework arises, why it is such an important issue, and what would need to be shown to decide the issue one way or the other.

Any workable remedy to bias probably lies somewhere in between the extremes of reform and revolution. Some of the biases are correctible by reform; others are not. In order to know which sorts of remedies apply in which sorts of cases, it is important to recognize alternative models of conflict resolution. It is to that issue that I now turn.

Models of Conflict Resolution: 3 Alternatives

Three alternative models of conflict resolution are what I refer to as the hierarchical, compromise, and consensus models. On the hierarchical model, one chooses between competing rights, claims, interests, and values by selecting the most basic, most important, or otherwise most stringent one. This model presupposes a pyramidal or hierarchical, Up-Down organization of the relevant variables, and appeals to some basic rule (principle, standard, criterion), value, or right to justify selection of the relevant variable as most stringent. If, for example, a claim to right of ownership of a foreign country conflicts with a claim to right of ownership of a country of origin, on a hierarchical model one would decide which right is more stringent or valid by appeal to some governing rule (principle, standard). The hierarchical model is particularly useful in a litigious approach to conflict resolution.

The hierarchical model is an adversarial, win-lose model which presupposes that one not only can organize diverse claims in terms of hierarchies, but that one can provide some way of rank ordering them. First, conflicting rights, claims, interests, and values do not always neatly form hierarchies, especially when the variables are of different types. For example, how should one hierarchically order the scholarly value of collecting cultural artifacts with the right of a country of origin to restrict their distribution? Second, there are problems with providing objective rankings or weightings for selecting among these competing considerations: What is the appropriate

weighting and ranking of rights vis-à-vis scholarly values? Furthermore, underlying the hierarchical model is the assumption that it is possible and appropriate to resolve (all) conflicts by providing a value-hierarchical ranking. But this assumption is controversial. As has been suggested, value-hierarchical rankings often maintain inequalities or misdescribe reality by perceiving diversity in terms of value dualisms and Up-Down orderings (e.g., of dominate-subordinate relationships). And those values which do not neatly fit into a value-hierarchical ranking (e.g., web-like values of care, friendship, or kinship) or do not translate neatly into a rights/rules framework without misdescribing the situation (e.g., as a situation of rights rather than as one of compassion and care), seem to get lost in the model.[26] Lastly, the model dictates a winner and loser in the resolution of the conflict. But not all conflict must have a winner and a loser. That is a limitation of the model, not necessarily a limitation of the controversy, the values or claims at issue, or the parties to the dispute. To see that this is so, consider two alternative models.

A compromise model is designed to provide something, though not everything, for all parties to the dispute, or to provide some of each of the relevant values, rather than realizing any one value to the exclusion of others. Some claims or values are traded-off in order to realize others. Underlying this model is the presumption that values can be realized in degrees. Its successful use requires that parties to a dispute are willing to compromise.

A third model is the consensus model: all parties voluntarily engage in a process of reaching mutually agreed upon goals, typically with the help of a third party facilitator or mediator perceived to be a neutral party to the dispute. Consensus-building is process oriented. Typically it begins with people putting their values and attitudes on the table, and uses empowerment strategies and techniques to have people collectively, voluntarily, and cooperatively decide what the problem is, how they will resolve it, and what will count as a resolution of the conflict. Since this model involves voluntary cooperation in a non-binding decision making process, it takes time, good will, and cooperation. It fails when mutually acceptable agreement is not reached.

There may be some situations in which the hierarchical model is the most, or the only, appropriate model. For example, in the context of cultural properties, it may be useful to litigate conflicting legal claims by parties to the dispute. Nonetheless, exclusive reliance on this model contributes to the problem, not the solution, by promoting an adversarial, value-hierarchical, win-lose approach to the resolution of all conflicts over "cultural properties." It is particularly inappropriate and inapplicable if one reconceives at least part of the debate in terms other than those of property or rights. To

illustrate this, consider a tenth, different sort of argument than the nine we have already considered concerning the 3 R's.

"The Non-Renewable Resource Argument" So-called cultural properties are like environmentally endangered species. First, they are non-renewable resources; once exhausted or destroyed, they cannot be replenished or replaced. Second, they are not anyone's property and no one can properly be said to own them. Our relationship to them is more like that of a steward, custodian, guardian, conservator, or trustee than that of a property owner. Since these cultural properties ought to be preserved yet are no one's property, no one has a right to them. Hence, no one has a claim to their restitution or restriction based on an alleged right (e.g., right of ownership) to them. Their protection and preservation is a collective responsibility of all of us as stewards: it must acknowledge our important connection with the past, be conducted with care and a sense of responsibility for peoples and their cultural heritages, and respect for the context in which cultural remains are found.

There are at least four related main issues raised by the Non-renewable Resource Argument: (1) How much are at least some cultural properties like environmentally endangered species? (2) To what extent are humans like stewards, custodians, guardians, conservators, or trustees of cultural heritages? (3) Exactly whose responsibility is it to preserve cultural heritages? And, (4) Is a responsibility to preserve cultural heritages based on or grounded in a web-like ethic of care? If the analogy between environmentally endangered species and cultural heritages is strong, then at least some talk of cultural property is a misnomer. We should speak instead of endangered cultural heritages, endangered cultural pasts, or even, more simply, endangered cultures. If those who have responsibility to preserve cultural heritages are conceived as stewards of that heritage, then talk of property rights and ownership of that heritage is inappropriate and misguided. If this responsibility is grounded in web-like considerations of care and contextual appropriateness, then the dominant tradition's rights/rules ethic also is either inappropriate, limited, or seriously inadequate as a framework for capturing all or perhaps even the most important relevant ethical considerations.

The linguistic changes in how one speaks about cultural heritage issues which are suggested by the Non-Renewable Resource Argument are significant: they challenge not only how one conceives the debate over so-called "cultural properties" but also how one solves that debate. If at least some aspects of a culture's heritage or past are not the sort of thing that properly can be talked about in terms of property, ownership, and rights, then, the construal of the debate in such terms is inappropriate.

Furthermore, a hierarchical model of conflict resolution simply is the

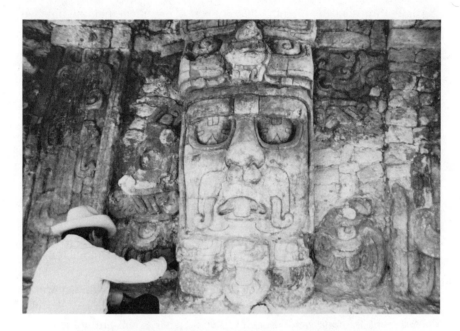

An excavated structure at the site of Kohunlich in Quintana Roo, Mexico is known for the huge painted stucco masks on its facade. The three rows of masks which have been excavated must be treated by INAH technicians to slow decay of delicate stucco and paint which is deteriorating with exposure to the elements. The bottom rank of masks has been left unexcavated for future generations and better technology. Viewing archaeological sites as nonrenewable resources may contribute to an integrative process in which various agencies can work together to develop responsible plans for study and conservation of sites. *Photo by Phyllis Messenger.*

wrong tool for the job if what one is trying to do is resolve competing claims about who has what communal responsibilities of care regarding the preservation of cultural heritages. That issue is complex, not simple, and requires that we complexify both our thinking about and our remedies to the issue of endangered cultures in ways that resist simple constructions of the debate in terms of rights or rules.

In summary, by construing the debate over cultural heritages as a debate over cultural properties, and by viewing conflicts in that debate as conflicts among competing claims concerning restitution, restriction, and rights (i.e.,

the 3 R's), the debate is conceived from a perspective characterized by value-hierarchical, normatively dualistic, rights/rules thinking and a model of conflict resolution that is a win-lose model. Given that there are alternative ways to conceive the debate and to resolve the conflicts over cultural heritage issues, the dominant perspective seems inadequate by itself as a theoretical framework for understanding and resolving so-called cultural properties issues.

RETHINKING THE DEBATE:
AN INTEGRATIVE PERSPECTIVE

In this chapter I have attempted both to provide an overview of the main arguments and issues involved in the current debate over cultural properties and to suggest why it is important to rethink the terms of that dispute from a nonhierarchical, nonadversarial (win-lose) perspective. I have also attempted to suggest why an adequate solution to the dispute will involve more than simply refining arguments from within the dominant perspective on cultural properties. It will require what I call an integrative perspective to the understanding and resolution of cultural heritage issues.

An integrative perspective is intended to preserve the strengths and overcome the limitations of the dominant perspective's approach to cultural heritage issues. It does so by making a central place for considerations typically lost or overlooked in that approach: (1) It takes seriously cultural heritage issues which are not properly viewed as concerns about property, ownership, and rights (e.g., concerns of indigenous peoples who do not see land or cultural artifacts as possessions one owns); (2) It emphasizes preservation as a primary value and recognizes the respects in which cultural heritages are like endangered species; (3) It encourages talk of stewardship, custodianship, guardianship, or trusteeship of the past, especially for those aspects of the past—both the physical remains of the past (artifacts, places, sites, monuments) and the perceptions of the past (information, stories, myths)—which are not owned or ownable; (4) It acknowledges and preserves the importance of the diversity of values and perspectives involved in the resolution of cultural heritage issues. This means it is flexible in when and how it is appropriate to apply considerations of rights, property and ownership, and when it is not, and it recognizes the variety of available strategies and solutions for resolving conflicts over cultural heritage issues; (5) It involves the meaningful use of compromise and consensus models for resolving disputes over cultural heritage claims. One way it does this is by encouraging nonlitigious, voluntary, reciprocal, and mediated solutions to

conflicts and the sharing of cultural artifacts (e.g., through museum collection sharing programs; loans; jointly undertaken studies, restorations, publications, and exhibitions); (6) It involves the restitution of legitimate "cultural heritage" to countries of origin and the use of restrictions to eliminate illicit traffic in cultural artifacts.

The first step to implementing an integrative perspective to cultural heritage issues is to make visible the conceptual framework in which the debate over cultural properties is currently conducted. This will require abandoning language which biases the terms of the dispute in favor of the dominant perspective (e.g., replacing inappropriate talk of cultural properties and cultural patrimony with talk of cultural heritage issues or endangered cultural heritages). It also will require recognition of nonhierarchical models of conflict resolution. By making visible the nature and function of the dominant conceptual framework, one is in a position to envision alternatives for how one conceives and resolves the debate over cultural heritages.

The second step to implementing an integrative perspective is to make context central to how one understands cultural heritage issues. Most of the physical remains of the past are at best fragments. All cultural properties, like the cultural heritage that constitutes the past, come with a context. Objects without a context (i.e., without provenance) are dispossessed of the very sorts of information that are essential to their constituting a cultural heritage. An integrative perspective to cultural heritage issues would make context central to any adequate account or resolution of cultural heritage issues. Once the twin goals of making visible the conceptual framework of the dominant perspective and incorporating contextual considerations into the discussion of cultural heritage issues are realized, an integrative perspective can begin to implement specific changes in the way the debate over "cultural properties" is conceived and conducted (e.g., changes suggested at 1–6 directly above).

An integrative perspective on cultural heritage issues encourages all of us to rethink the dispute as one of preservation (not, or not simply, one of ownership) of the past, and to rethink the resolution of the cultural properties conflict from a compromise or consensus model of conflict resolution, rather than from a value-hierarchical, normatively dualistic, win-lose model. An adequate resolution of cultural heritage issues—that is, one which uses appropriate language, concepts, and categories, captures the diversity of values, claims, and interests of various parties to the dispute, and provides flexibility in the resolution of conflicts—requires that we rethink the terms of the dispute. That is what an integrative perspective on cultural heritage issues promises.

NOTES

1. For a discussion of these two different foci of ownership of the past, see Isabel McBryde's "Introduction" in *Who Owns the Past?*, ed. by Isabel McBryde (London: Oxford University Press, 1985) and Cha. 5, "Whose Past?" in Karl E. Meyer's *The Plundered Past* (New York: Atheneum Press, 1977).

2. I treat these as arguments for and against claims to the 3 R's which are advanced by countries of origin, rather than as claims organized around a typology of relevant values (e.g., aesthetic, educational, religious or economic values) or as claims advanced by other groups (e.g., specific individuals, such as curators, collectors, scholars); foreign countries (i.e., countries which have or would like to have cultural property but are not the country of origin of that property); humanity as a whole. The rationale for identifying the arguments in terms of claims to the 3 R's by countries of origin is that this provides an organizational schema which accommodates all the values and parties to the dispute, while accurately highlighting how issues concerning cultural properties arise (viz. because the traffic in cultural property is basically traffic from countries of origin outward; whatever values and interests are at stake are so ultimately because of this traffic outward). Hence, this typology appropriately leaves open the question whether foreigners or foreign countries do or might support some of the claims to the 3 R's by countries of origin (e.g., by arguing on behalf of the relevant values and interests of indigenous peoples to their cultural heritage).

3. In the case of what is owed, a "genuine beneficiary" is one who has a legitimate or valid claim (i.e., a right) to what is owed, while a "mere beneficiary" is one who stands to benefit from the performance of an owed act but does not have a legitimate or valid claim (i.e., a right) to what is owed. This distinction is particularly important in the case of inheritances, e.g., the inheritance of possessions or properties owned by benefactors. If those who rescued cultural properties have a right to them, and their descendants (whether individuals or countries) are acknowledged as "genuine beneficiaries," then those descendants also have a right to them.

4. In his book *The International Trade in Art* (Chicago: The University of Chicago Press, 1982), Paul M. Bator discusses what counts as "illegality" in the international art trade under existing law. Since not all illegal export is theft (or some other form of illegal taking) and not all illegal exports are cases of illegal import, the structure of illegal trade consists of four factors: export regulations, theft, importing illegally exported cultural properties, and importing stolen cultural properties (pp. 9–13). According to Bator, in the United States, the only case of illegal export that constitutes illegal import is the 1972 statute "Importation of Pre-Columbian Monumental or Architectural Sculptor or Murals," which bars the import of illegally exported "pre-Columbian monumental or architectural sculpture or mural" (cited in Bator, p. 11, n. 32).

5. See, e.g., the position of Alison Jaggar, *Feminist Politics and Human Nature* (Totowa, N.J.: Rowman and Allanheld, 1983); Naomi Scheman, "Individualism and

The Objects of Psychology," in *Discovering Reality: Feminist Perspectives on Epistemology, Metaphysics, Methodology, and The Philosophy of Science,* eds. Sandra Harding and Merrill B. Hintikka (Netherlands: D. Reidel Publishing Company, 1983): 225–244.

6. Utilitarian and deontological theories of ethics are both normative theories of moral obligation. They provide theoretical answers to the question "What acts, or kinds of acts, or human conduct is right, wrong, or obligatory?" Utilitarian theories are "consequentialist theories," i.e., they assess the rightness, wrongness, or obligatoriness of human conduct solely in terms of the consequences of such conduct. Specifically, according to utilitarianism, performing a given act (or kind of act), or following a certain rule, is justified if and only if no alternative act (kind of act, rule) provides a higher net balance of good over evil (typically understood in terms of pleasure over pain). Jeremy Bentham and John Stuart Mill are the historical figures most frequently associated with utilitarianism. Deontological theories are nonconsequentialist, i.e., they assess the rightness, wrongness, or obligatoriness of human conduct in terms other than the consequences of such conduct. Aristotle and Immanuel Kant are among the prominent historical figures identified with deontological ethical theories.

7. For a clear and thorough survey of the options available for controlling the international trade in art (including cultural properties), and the author's view of which ones are desirable and why, see Paul M. Bator, ibid., Cha. III.

8. See Karl E. Meyer, ibid., pp. 190–191.

9. These three argument are not simply rebuttals of the six arguments already given. They involve additional claims about the claims of countries of origin against foreign countries and others.

10. See Paul M. Bator, ibid., Chas. I and II.

11. Recent feminist theory in all academic disciplines has focused attention on describing and critiquing what I call here a "world view" or "conceptual framework." This is especially so in philosophy and ethics. See, e.g., Kathryn Addelson's "Moral Revolution" and Joyce Trebilcot's "Conceiving Women: Notes on the Logic of Feminism," in *Women and Values: Readings in Recent Feminist Philosophy,* ed. by Marilyn Pearsall (Belmont, Ca.: Wadsworth Publishing Co., 1986: 291–309 and 358–363, respectively; Elizabeth Dodson Gray's *Patriarchy As A Conceptual Trap* (Wellesley, Mass.: Rountable Press, 1982); Alison Jaggar, ibid.

12. For a discussion of oppressive, especially patriarchal, conceptual frameworks, see my "Feminism and Ecology: Making Connections," *Environmental Ethics* (Spring, 1986): 3–20.

13. For a discussion of value-hierarchical thinking in what she calls "patriarchal conceptual frameworks," see Elizabeth Dodson Gray. *Green Paradise Lost* (Wellesley, Mass.: Rountable Press, 1981), p. 20. See also my discussion of patriarchal conceptual frameworks in "Feminism and Ecology: Making Connections," *Environmental Ethics* (Winter, 1987).

14. Carol Gilligan. *In A Different Voice* (Cambridge, Mass.: Harvard University Press, 1982).

15. Gilligan writes that "the different voice" she describes is "characterized not by gender but by theme. Its association with women is an empirical observation, and it is primarily through women's voices that I trace its development. But this association is not absolute . . ." (ibid., p. 2.) Gilligan uses "the male voice" and "the female voice" to highlight a distinction between two modes of thought and two different ways of conceiving the self, morality, and conflict resolution. It is this aspect of what Gilligan says that I am interested in conveying here.

16. E.g., ibid., pp. 73, 90, 100, 164–165.

17. Ibid., p. 62.

18. Ibid. Note that Gilligan does not argue for the superiority of one view over the other. Rather, she argues for a convergence of the two perspectives (i.e., an "ethic of justice" or a rights/rule ethic and an "ethic of care"). See pp. 151–174.

19. Ibid., p. 307.

20. Addelson calls this dominant tradition in ethics "the Thomson tradition," named after Judith Jarvis Thomson's approach to doing ethics, and contrasts it with a minority tradition, what she calls "the Jane tradition," named after a group of politically active women in Chicago who formed an organization called Jane.

21. Ibid., p. 306.

22. Addelsen, ibid., p. 305.

23. This is the main point expressed by Kathryn Addelson in her article, "Moral Revolution," ibid.

24. While I do not explicitly argue for the claim that there is a bias in the dominant tradition's construal of the debate over cultural properties, what I have said about world views, the dominant tradition and its associated "patriarchal world view" is sufficient to show what such a defense would involve.

25. Notice that those arguments which focus either on the values or the practices associated with collecting "cultural properties" and are presented in connection with utilitarian considerations (e.g., the Means-End, Scholarly Access, Encouragement of Illegality, and Scholarly and Aesthetic Integrity Arguments) implicitly introduce the first sort of bias by relying on an objective and universalizable "rules" approach to resolving cultural property issues. They also encourage the second sort of bias, since they presuppose a resolution of cultural properties conflicts from within a value-hierarchical win-lose model.

26. Although I do not argue explicitly for these claims here, the arguments given earlier by Gilligan and Addelson are among the sorts of arguments which have been given in support of these claims.

Ancestral Sites, Shrines, and Graves: Native American Perspectives on the Ethics of Collecting Cultural Properties

The colonization of North America by Europeans beginning in the sixteenth century caused fundamental changes for the aboriginal American societies whose ancestors had occupied the continent since the last ice age. Their populations were devastated by epidemics of European diseases (to which they had no natural immunity), by wars, and by dislocations that resulted in the loss of control over traditional homelands and the cultural and natural resources contained within them. Today the issue of who controls Native American cultural properties in the United States is still controversial. After a brief review of the history of conflicting interests over these resources, we examine how three Native American societies—the Navajo, Zuni, and Abenaki—are dealing with this issue. None of us is Native American; rather, the perspective we present derives from our experiences as archaeologists working for and with Native Americans.

CONFLICTING VALUES

Euro-American interest in collecting relics—objects of value in and of themselves—from Native American

Deborah L. Nichols,
Anthony L. Klesert,
Roger Anyon

sites goes back to the time of initial contact: the Pilgrims dug up an Indian grave soon after landing on Cape Cod in 1620 (Cronon 1983:84). Subsequent territorial expansion was accompanied by widespread denial of a connection between living Native Americans and archaeological remains best exemplified by the "myth of the Moundbuilders", which attributed the prehistoric burial mounds and earthworks found in the eastern United States to virtually anyone (lost tribes of Israel, Phoenicians, etc.) except the ancestors of living Native Americans, who were seen as too barbaric to have created such works. This ideology justified the "right" of Euro-Americans to collect relics, destroy sites, and develop the land in the interest of "God, Progress, Manifest Destiny, Mammon, or all of the above" (Fowler 1986:137). Although it has been irrefutably shown that the mounds and earthworks were created by prehistoric Native Americans, new versions of this myth have since emerged: Celts and astronauts from other planets are often cited nowadays as the creators of prehistoric sites.

The moundbuilder controversy played an important role in the late nineteenth century in the development of two other groups interested in Native American cultural remains—museums and archaeologists—although initially their methods differed little from those of the relic collectors. The growth of archaeology as a profession and the knowledge that archaeological sites could provide information about past cultures led to increasing concern about the destruction of aboriginal American sites by looting and development. Early preservation efforts, however, were directed toward sites important in Euro-American history and large prehistoric ruins of greatest interest to archaeologists and the museums who sponsored their work.

As a result of the environmental movement of the 1960s, greatly expanded legislation was enacted to deal with the conservation of archaeological sites (both historic and prehistoric), which came to be seen as nonrenewable cultural resources. Current laws are extremely complex, but basically they require management and protection of aboriginal American sites on federal land (including all trust territories), Indian reservations, and most state-owned land. Construction projects that would adversely impact sites are also subject to such legislation if federal (and often state) funding is involved. The development of cultural resource management in the United States coincided with increasing activism on the part of Native Americans for self-determination and concern for the protection of archaeological sites, repatriation of sacred objects, and reinterment of burials.

This activism reflected the fact that prehistoric and historic cultural properties often have a religious and cultural significance to Native Americans that has usually been ignored by the dominant Euro-American culture. Native American values were explicitly recognized for the first time in the defi-

nition of cultural resources by passage of the 1978 American Indian Religious Freedom Act, which guaranteed access to the sites and sacred objects necessary to practice traditional religions, though it is still unclear just how broadly this act will be applied. Native American tribes have enacted regulations to protect ancestral sites, shrines, and other sacred places on reservations and are developing their own museums and cultural resource management programs; however, not all Native American groups have tribal lands and, more importantly, most sites are on private lands, where the rights of the present landowner are paramount. In contrast to the situation in many other countries, aboriginal American sites and artifacts in the United States have never been viewed as a national patrimony because of a strong private-property ethic and because they are not associated with the dominant Euro-American culture (Knudson 1986; Fowler 1986).

The threat to Native American sites posed by looters has never been greater than it is in the United States today because of a tremendous rise in the commercial value of antiquities, especially "Indian" artifacts, over the past fifteen years. Probably no area in the world has experienced greater plundering of archaeological sites than the Mimbres Valley of New Mexico, where entire prehistoric pueblos have been leveled with bulldozers to acquire the famous Mimbres pottery from prehistoric burials, and the problem is not restricted to the Southwest (Goodwin 1986). Looting is sacrilegious to many Native Americans as well as destructive of the sole source of information about their unwritten past. In the next sections we look at the effects of looting on three Native American societies and the efforts of those societies to gain greater control over their cultural resources.

NAVAJO

The Navajo Indian reservation encompasses about 16,500,000 acres in the Four Corners region of the American Southwest. At first glance, the region appears inhospitable and barren of life, but people have in fact lived here for at least the last 10,000 years. It is one of the richest sources of prehistoric remains in the entire United States, and it suffers accordingly at the hands of looters.

The population on the reservation today numbers about 160,000 persons, who live for the most part in scattered, single-family ranches and small communities that serve as centers for supplies, mail, and other services. Navajos have inhabited the Four Corners region since perhaps as early as the 1300s, and consider it their sacred place of origin. Although most recognize that prehistoric puebloan (Anasazi) ruins are the remnants of nonancestral people, Navajos consider the sites sacred and respect them as places of the

dead (in the Southwest prehistoric peoples buried their dead, along with grave goods, in their settlements.) Thus it is an affront to Navajo religious beliefs for outsiders to search for pots and disturb the bones of "ancient enemies" or their own ancestors (Holt 1983).

In an effort to protect ruins and other cultural and natural resources owned by the Navajo, the Navajo Nation Resources Enforcement Agency (the "Tribal Rangers") attempts to patrol this immense region. The Rangers work closely with the Navajo Nation Historic Preservation and Archaeology Departments, and all three depend greatly on the support of local residents. In fact, most reports of looting and vandalism are made by local people. Tribal staff coordinate formal investigations with the Federal Bureau of Investigation (FBI) and agents of the Bureau of Indian Affairs (BIA).

Unauthorized collecting of materials is of greatest concern to the Navajo at prehistoric sites, historic sites, and sacred places. Sites important to the Navajo in all three categories, especially the last two, occur on and off the currently defined reservation, but concern is as great for sites outside the arbitrary boundary line as for those within. Prehistoric sites, particularly Anasazi puebloan ruins, are those most severely and regularly damaged by pothunters. The pattern of looting mirrors that of development and encroachment by non-Navajos on the reservation: sites along the periphery of the reservation, near major roads, and around settlements are most susceptible. Most looters apparently come from border towns and larger communities on the reservation, where non-Indians reside. Protected cliff ruins are favorite targets because of the excellent preservation of remains; however, they are relatively scarce. Larger "open" sites are also commonly damaged. Although looting is usually limited to hand excavations, many sites have been systematically cratered by holes dug in search of valuable artifacts. This has caused undercutting of walls in cliff ruins and extensive erosion at other sites, which leads to collapsed or exposed rooms and destruction of other features.

Prosecution of plunderers is difficult for they are rarely caught in the act. With the cooperation of local residents, tribal officials, the BIA, and the FBI, two pot hunters were recently convicted in federal court for causing extensive damage to a late Anasazi site on the reservation north of Holbrook, Arizona. The defendants were found guilty of felony charges, fined, and sentenced to prison terms and public service. Unfortunately, the punishment does not compensate for the value (in cultural and scientific terms) of the disturbed site or the stolen artifacts, and it has not deterred others, since pothunting continues throughout the area.

Historic sites are also the target of looters, particularly the early defensive "pueblitos" occupied by Navajos and pueblo peoples during the Pueblo

Revolt of the 1680s and the sites occupied by their children during wars with Utes and Comanches. The *Dinetah* (the heart of the Navajo origin) contains many such sites and is an area of significant religious importance to Navajos (Johnson and Powers 1987). The lands belong to the Forest Service, the Bureau of Land Management, the state of New Mexico, and other tribes, however, and are not in the currently defined Navajo reservation. Thus the Navajo must depend on other parties to protect their sacred sites, and this has resulted in some unfortunate occurrences. Several of the more spectacular ruins fall within state jurisdiction, but the policies concerning the sites vary from one agency to another: thus the State Historic Preservation Office sponsored studies of these ruins and protective measures for them while other state offices permitted drilling of exploratory oil and gas wells at the base of the buttes on which the sites rest, which has opened them to looting and vandalism.

Sacred Navajo places have also been invaded and damaged. Caches of religious paraphernalia (e.g., prayer bundles, figurines, ritual arrangements of feathers and reeds) are commonly found in out-of-the-way places, including Anasazi sites. Removing these objects is a violation of Navajo traditional religious beliefs equivalent to robbing a church. Collectors often unintentionally intrude upon sacred places in their search for materials, as is the case with a large petrified forest near the reservation town of Chinle, which is constantly being pillaged by people who can no longer steal specimens from the better-known (and better-protected) Petrified Forest National Park. Since petrified wood from Chinle is used by Navajo medicine men and other religious practitioners in curing and other sacred observances, the whole area is sacred. Every time people collect paleontological specimens for their gardens or for sale, they intrude on the beliefs and traditions of a Native American religion. The fact that this is done in ignorance makes it no less a violation of tribal ordinances against the collection of paleontological remains.

ZUNI

The present-day Zuni Indian Reservation covers almost 410,000 acres in west central New Mexico plus an additional 11,000 acres north of Saint Johns, Arizona. The area is much smaller than the approximately 15,500,000 acres that fell under Zuni sovereignty in 1846 (Ferguson and Hart 1985). The Zuni, descendants of prehistoric pueblo populations, have lived in large aggregated settlements since before Europeans arrived in the sixteenth century, although it was not until after the Indian pueblos revolted against the Spanish in the 1680s that the entire tribe congregated into a single community at present-day Zuni Pueblo. Today the rapidly expanding population

lives in the communities of Zuni and nearby Blackrock. Outlying farming villages, once occupied only from the late spring planting through the fall harvest, are now used on a daily basis by farmers commuting from Zuni in pickup trucks along paved or gravel roads.

The Zunis believe that their prehistoric ancestors once inhabited the thousands of abandoned Anasazi and Mogollon pueblos scattered over northwest and north-central New Mexico and northeast and north-central Arizona. Myths tracing the travels of the tribe through the Southwest and its eventual settlement of the Zuni area are the source of their strong emotional bond to these ruins as ancestral places. Thus it is not only the ruins of the Zuni Reservation but also the thousands of ruins on federal, state, and private lands which should be left undisturbed as the final resting places of previous generations. These ruins house burials that are being plundered on an unprecedented scale by the relatively recent European migrants to the Southwest. The disturbance of grave sites is abhorrent to the Zuni, and the perpetrators are regarded as criminals.

Looting on the Zuni Reservation is strictly prohibited. Even so, pothunting does occur in remote areas at night or in bad weather, when it is difficult for the few rangers of the Zuni Fish and Wildlife Program to patrol the area. Sheepherders and other Zunis monitor the land and report recent potholes at sites or suspicious activities of non-Zuni visitors. Law enforcement officials respond quickly, and prosecution of pothunters involves officials from the Zuni Fish and Wildlife Program, the Zuni Police Department, and the Zuni Archaeology Program, as well as the BIA and the FBI. Violating laws is not the only issue involved in looting archaeological sites, however, since most of the collectable pots stolen from graves and sold on the antiquities market come from sites on private lands.

The Zuni (along with most Native Americans) have a radically different notion of land use and ownership than Euro-Americans. Modern boundaries that arbitrarily divide land along straight lines into Euro-American divisions of townships, ranges, and sections disregard previous Indian land ownership, and this has created some absurd situations. The Box S site in New Mexico, a 473-room pueblo dating to the mid and late thirteenth century A.D. (Kintigh 1985), is situated partly on the Zuni Reservation and partly on private land. Known to the Zuni as *Heshoda Imk'osk'wa*, it is regarded as an ancestral site. In 1982, the private portion of the land was sold to developers, who moved in with backhoes in the belief that they owned the entire pueblo. The Zunis, outraged by this wholesale destruction of ancestral graves and tribal heritage, sought a remedy by establishing the exact reservation boundary. A cadastral survey in the fall of 1982 determined that less than one-

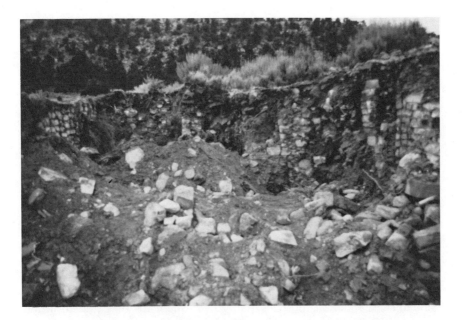

Results of looting at the Box S site in New Mexico. The ancestral Zuni site "Heshoda Imk'osk'wa" was desecrated by pothunters, who uncovered burials and left remains of walls and other objects strewn about. *Photo by Roger Anyon.*

quarter of the site fell within the present reservation boundary, but it had already been looted. After a fence line was established and clearly marked, the developers proceeded with impunity on the privately owned land; the Zunis could only watch as their ancestors' graves and tribal heritage were destroyed. Many burials were desecrated at Box S, the bones smashed and scattered over and the grave goods sold for profit on the antiquities market. Such desecration of modern cemeteries is illegal as well as morally repugnant; it should be no less so for ancient burial sites.

Historic and present-day shrines are also looted for saleable artifacts— Zuni prayer sticks, for example, or *Ahayu:da* (War Gods). These sacred objects are placed at chosen locations at specified times for ritual purposes. To the Zuni they are part of a vital, on-going religion, the very core of their culture, a significance which is unknown or ignored by non-Zuni collectors. Removing sacred objects is not only theft of property but, in the eyes of the Zuni, it also robs them of their power.

ABENAKI

The notion of cultural properties in New England usually brings to mind Colonial churches, stone fences, farmhouses, and Revolutionary War forts and battlefields. Remains of the lesser-known Native American occupation are not prominent features of the landscape (as they are in the Southwest), since most have been decayed by dampness and covered over by centuries of deposition and Euro-American development. Yet they have not been overlooked by collectors, as the earlier example of Pilgrims looting an Indian grave shows. Plowed fields are combed for projectile points and stone axes, stream banks are inspected for exposed archaeological remains, and burials, although rare, are especially valued because of their associated objects—pipes, beads, and pottery vessels. While excavating a prehistoric cemetery threatened by the construction of a house, Vermont archaeologists were forced to camp at the site around the clock to keep collectors from looting the graves at night.

The presence of prehistoric artifacts in New Hampshire and Vermont contradicts a widely held belief that Native Americans only hunted in the area but never actually lived there. Vermont and the interior of New Hampshire were in fact inhabited by Western Abenaki speakers at the time of European contact and probably since at least late Woodland times (c.a. A.D. 1000). The Abenaki consisted of independent bands who occasionally formed alliances with one another. Each band was associated with a palisaded village, usually on a bluff overlooking a navigable stream, as their economy was based on a combination of fishing, hunting, and farming. During the sixteenth and seventeenth centuries, the Abenaki population was reduced more than ninety percent by epidemics and wars, and they gradually abandoned (or were dislocated from) the southern portion of their territory, eventually congregating at settlements in Quebec, Canada, and northern Vermont (Day 1978). Today there are approximately four thousand people in New Hampshire and Vermont who identify themselves as Native American (the numbers evenly divided between the two states), but New Hampshire Abenaki are dispersed and comprise only a small percentage of the state's Native population; in Vermont they represent nearly eighty percent of Native Americans and are an organized group.

The Abenaki, like most Native American groups in the East, lack federal government recognition as a tribe. By 1775, their numbers had been decimated and "Indian" affairs in the original thirteen states were left largely to the discretion of those states (Haviland and Power 1981:257). Consequently, there are no reservations in either New Hampshire or Vermont, and the amount of federally controlled land is quite small. Both states, however,

have enacted legislation to protect archaeological sites on state lands, and Native Americans, who traditionally avoided public exposure in these states, have become increasingly active about the disposition of archaeological remains.

In 1985 the Native American Mother Earth Church[1] petitioned the governor of New Hampshire for legislation to require reburial of prehistoric skeletal remains and associated artifacts. The church is a pan-Native American organization composed of people from very diverse backgrounds, some longtime residents of the region and others affiliated with tribes and groups distant from New Hampshire. The pastor of the Native American Mother Earth Church describes herself as an Apache medicine woman of Mohawk descent. The church's petition reflected a national movement and was motivated by its belief that skeletal remains of native people should be returned to the earth that nourished them; any importance the remains held for private collectors, museums, or scientific inquiry was outweighed by the fact that they were ancestral remains. While existing state law protected cemeteries, it did not cover prehistoric and early historic burials except in the case of state lands and contract projects, where they were treated as archaeological resources.

Efforts to develop protective legislation in New Hampshire were tortuous: testimony in public hearings was polemical and often highly emotional. Archaeologists and Native Americans conflicted over mandated reburial of all skeletal remains without regard to their antiquity, their historical and/or scientific value, and their relationship to modern ethnic groups. Archaeologists found themselves in a quandary: while sympathetic to the concerns of Native Americans, they were also strongly committed to data collection and preservation—and prehistoric skeletal remains are very rare in New Hampshire's wet acidic soil (the total number of known prehistoric skeletons is only thirty-five). Native Americans, in the absence of established, organized communities, disagreed about who should represent them in the state and who should have rights to rebury skeletal remains. State legislators' lack of knowledge made it difficult for them to deal with the issue.

Beyond the rhetoric of the hearing rooms, there were many areas of agreement between Native Americans and archaeologists, including the

[1] The Native American Mother Earth Indian Church is a pan-Indian organization located in New Hampshire. It was founded by Reverend Beverly Bolding in 1980 who identifies herself as Mohawk-Abenaki and as an Apache medicine woman (Brian Robinson, personal communication, 1985). Size of the church's membership is unknown but probably numbers less than 100 persons in terms of active participants in New Hampshire.

need for legal protection of all burials because of increasing incidents of vandalism. In New Hampshire it is Colonial graves that presently are most threatened by looting (a recent manifestation of the problem is especially bizarre: occultists seeking skulls). Ultimately, the state legislature adopted regulations to protect all burials, recognizing different levels of relationship in determining disposition rights over human skeletal remains. The problem of how the diverse Native American population in New Hampshire should be represented and who has affinity to prehistoric remains is yet to be resolved. Additionally, enforcement of the new provisions to prohibit looting of grave sites will be difficult in rural areas, regardless of whether they are on public land or private.

Vermont has avoided such a controversy, partly because the native population is less diverse and partly because archaeologists and Abenaki have developed a working relationship that allows them to discuss issues of mutual concern. Abenaki have participated in field investigations with archaeologists, and they have recently worked out an agreement with archaeologists whereby skeletal remains from a prehistoric cemetery in an area sacred to the Abenaki will be turned over for reburial after studies are completed. The archaeologists, in turn, are helping the Abenaki, who have no tribal land in Vermont, to find a reburial ground that can be protected from looting and are supporting their efforts to gain federal recognition. Differences between scientific values and traditional belief systems do not necessarily preclude cooperation between Native Americans and archaeologists, especially when the knowledge gained through the study of archaeological remains benefits Native peoples as well.

Greater public involvement in protecting archaeological remains is critical in New England because most sites are on private land, which is increasingly subject to development. One successful effort in this direction is New Hampshire's public archaeology program, which trains avocationals in field and laboratory techniques, enabling them to work directly with professional archaeologists. Without these contributions, much recent work in the state would not have been possible. Such programs are essential if sites in northern New England—both prehistoric and historic—are to be protected from the kind of looting that is so destructive in the Southwest.

CONCLUSIONS

In the preceding sections we have attempted to present Native American perspectives on the ethics of collecting cultural properties. Our examples do not cover all aspects of this issue; however, they should make clear that looting Native American sites to obtain artifacts for personal ownership or for

sale to collectors is not solely a legal matter. To many Native Americans, looting is a crime far beyond that of breaking a federal, state or tribal law: it is an act of desecration that violates deeply held religious beliefs that are essential to the spiritual well-being of Native Americans. Ignorance plays a role in the persistence of looting, as does prejudice, but financial gain is an increasingly important factor.

Desecration of ancestral sites and the pillaging of sacred objects is part of a very vicious cycle involving looters, dealers, and galleries, which is fueled by the desire of collectors to possess "Indian" artifacts. They may be motivated by the exotic or aesthetic quality of the objects, an interest in the culture that produced them, or the future profits to be made, but regardless of motive, the effects are destruction and desecration, and collectors must be made aware of this. It is ironic that people who profess their cultural awareness by collecting Native American artifacts are in fact demonstrating contempt of traditional and religious Native American beliefs.

The most effective way to reduce looting is to end the practice of collecting artifacts obtained in this manner. Museums have begun to require pedigrees for Native American objects before accepting them for their collections. Legal sanctions with sufficiently strong penalties and enforcement resources have a role to play, as well. One approach that is being used in some countries is to prohibit the inheritance of antiquities.

But most important is the need for a change in attitudes. Archaeologists and museums have a special responsibility to broaden public awareness and knowledge of Native Americans, which includes a responsibility to respect Native American values. Although differences still exist between Native Americans and archaeologists, they can be surmounted with cooperation and with better communication of the results of archaeological investigations. We share a commitment to conserve the remains of the past, not for the private use of a few individuals but for current and future generations. In this regard, we suggest that the Native American ethic—one that respects the power and authority of these remains and eschews the possibility of "ownership" by anyone—is the only defensible position to take towards the heritage of the past.

REFERENCES

Cronon, William
 1983 *Changes in the Land: Indians, Colonists, and the Ecology of New England.*
 New York: Hill and Wang.

Day, Gordon M.
 1978 Western Abenaki. *Handbook of North American Indians: Northeast,* vol. 15, edited by Bruce G. Trigger, pp. 148–159. Washington D.C.: Smithsonian Institution Press.
Ferguson, T. J. and E. Richard Hart
 1985 *A Zuni Atlas.* Norman: University of Oklahoma Press.
Fowler, Don D.
 1986 Conserving American Archaeological Resources. *American Archaeology, Past and Future,* edited by David J. Meltzer, Don D. Fowler, and Jeremy Sabloff, pp. 135–172. Washington D.C.: Smithsonian Institution Press.
Goodwin, Derek V.
 1986 Raiders of the Sacred Sites. *The New York Times Magazine,* December 7:65–74.
Haviland, William and Marjory W. Power
 1981 *The Original Vermonters.* Hanover, NH: University Press of New England.
Holt, H. Barry
 1983 A Cultural Resource Management Dilemma: Anasazi Ruins and the Navajo. *American Antiquity* 48:594–599.
Johnson, Byron P. and Margaret A. Powers
 1987 Defensive Sites of the Dinetah. *Division of Conservation Archaeology Studies* No. 5. Navajo Nation, Window Rock.
Kintigh, Keith W.
 1985 Settlement, Subsistence, and Society in Late Zuni Prehistory. *University of Arizona Anthropological Paper* No. 44. Tucson: University of Arizona Press.
Knudson, Ruthann
 1986 Contemporary Cultural Resource Management. *American Archaeology, Past and Future,* edited by David J. Meltzer, Don D. Fowler, and Jeremy A. Sabloff, pp. 395–414. Washington D.C.: Smithsonian Institution Press.

Profiteers and Public Archaeology: Antiquities Trafficking in Arkansas

The destruction of archaeological sites for pleasure and profit in Arkansas is a century-old phenomenon that is characteristic of site destruction elsewhere in the southeastern and southwestern United States. Rich sites, most on private land in the South, fuel the digging fever and contribute to an interstate antiquities market. If the archaeological profession is going to deal with this problem, it is essential to understand who the persons involved are, what explanations they give for their activities, and what strategies they employ. Without this information, it is difficult to develop a program to effectively counteract this continuing loss of the region's archaeological heritage.

In this paper I will look at the people involved in site destruction in Arkansas, and describe some of the strategies we use to try to deal with the problem. My observations come from almost fifteen years of contact with diggers and collectors, and I have also drawn on the observations of my colleagues in the state who have had experiences similar to mine. I am excluding from this study surface collecting 'arrowhead hunters' and legitimate amateur archaeologists whose interest is in contributing to archaeological research. Moreover, amateur archaeologists have made significant contributions to

Ann M. Early

archaeological research in Arkansas for several decades. While the cumulative activities of arrowhead hunters may remove some information from the archaeological record, and the research of amateurs may not always meet professional standards, the loss of the cultural resource data base through their actions is insignificant compared to the destructive effects of grave robbing and the antiquities trade in the region.

The group of people responsible for much of this destruction has many of the characteristics of a distinct subculture, with its own division of labor, oral traditions, folklore, and world view. It lies outside the sphere of the state amateur archaeological organizations. Some members, particularly the large collectors, are active participants in the larger society. Membership in this group comes gradually, as newcomers are invited along on digging expeditions, are shown private collections, and are introduced to a network of practitioners around the state.

There are three principal groups within this subculture. The first to consider is the gravediggers. They may operate part time, seasonally, or full time, and are a diverse mix of unemployed laborers, farm workers, blue collar workers, and entrepreneurs. Some dig alone, but more commonly they work in groups that have a prominent digger/dealer as leader. The groups seem to change composition frequently, often because of distrust among the members.

Some dig because of a professed fascination with Indian culture. Others seem to be compulsive collectors, and they continue digging even though their houses are bulging with artifacts, and bags of broken pottery fill all available storage spaces. For many, the adventurism of the activity itself is a major stimulus for digging. This is reinforced by a shared oral tradition with tales of outsmarting landowners and competing diggers (and archaeologists), of finding relics in sites that were thought to be 'dug out', and of hitting that really deep grave after others had given up the search. And for some the lure of treasure is the driving force. The enticement of mythical riches is reinforced by tales of spectacular $20,000 and $30,000 sales made at grave sites or out of the backs of pickup trucks. The folklore of treasure is as important as actual monetary gain, and many seem to continue digging with the hope of making that one spectacular find.

Although some gravediggers claim to have no interest in the monetary value of their collections, they almost invariably seem to end up trading and selling objects to each other, to dealers, or to collectors. Most objects are left unmarked seemingly to conceal their provenance, unless their value can be enhanced by attribution to a well-known site or previous collector.

Strategies employed by diggers to find sites are similar to those used by

professional archaeologists: use of informants, perusal of the literature, and fieldwork. Landowners and people who work outdoors are often canvassed systematically for information on site locations. These requests for information do not always reveal the purpose of the inquiry. Landowners and arrowhead hunters have learned to their dismay that after revealing the location of a site it was subsequently looted.

Gravediggers search the professional literature for site locations and occasionally they use records kept by amateurs as well. They also rely on fieldwork. This may range from searching through clearcuts, agricultural fields, and other areas disturbed by modern activity, to extrapolating the distribution pattern of sites from previous excavations and targeting particular landforms for intensive searching.

Methods for gaining access to archaeological sites vary, and reflect a wide range of attitudes regarding landowners, the concept of private property, and the justification for digging. Some individuals or groups try to lease sites outright in order to dig, or offer landowners varying amounts of cash for access to sites. In northeast Arkansas a current rate is reported to be half the value of the objects recovered. These offers are often hard to decline. The owner of a Caddoan ceremonial center in the Red River valley was recently reportedly offered $20,000 for a lease.

Others try to gain access to sites without paying for the privilege. Diggers may ask to 'go look' at a site, or to do an unspecified amount of digging. Landowners may be unaware of the real purpose of the request until the visitors are gone and all the holes are discovered. Diggers also offer to share what they find with the landowner, or with people who know site locations. Since these people are rarely present when discoveries are made, the equitability of this division of spoils is in the hands of the diggers. Reports surface occasionally of a landowner who decides he is being cheated, and terminates a digging arrangement. As a result, some sites suffer periodic digging episodes as one group gains access to a site, and then is thrown off to be replaced by another.

Another common method of gaining access can be termed 'permission by default' by which diggers will work wherever they please until they are specifically and personally told to leave. When caught by a landowner or property manager, response ranges from truculence (as in 'no #$@#% person is going to tell me where I can dig') through evasiveness ('well, this is timber company land, and they don't care if we dig') to downright creative ('I know I shouldn't be digging here, but I just couldn't help myself'). On occasion, when a visitor is not seen as a direct threat, diggers will simply ignore him and continue their activity. Without a challenge, these operations may

go on indefinitely until new excavations are merely turning over already disturbed earth, trees on the site are dying or being cut down, and significant local environmental degradation occurs.

Finally, there is illegal digging, sometimes reportedly done at night with flashlights or lanterns or inside tents. This and the preceding method seem to fuel the folklore and provide much of the high excitement for participants and observers. Stories of such exploits, and tales of people trying to thwart them, circulate endlessly.

Digging requests are occasionally accompanied by varying forms of intimidation suggesting that the sites will be dug with or without permission.

Excavation techniques vary from probing and digging individual burials to using soil cores, ditch witches (mechanical diggers that excavate a narrow trench, turning over the soil in the process), and other heavy machinery. The resulting destruction is often enormous in comparison to the amount of objects recovered. One archaeologist observed a truckload of diggers drive onto a site. As soon as they disembarked they began shoveling randomly in search of artifacts. After about an hour they jumped back in their truck and left as rapidly as they had arrived, leaving about ten large holes behind them.

Diggers justify their activities in a number of ways. Their major argument is that they are saving relics from destruction by natural forces, by agricultural activity, or by other diggers. Some may actually start out with this belief. Invariably, they end up destroying sites under no threat except from diggers themselves. Another justification is that digging expresses an appreciation of Indian culture. One man explained to me at length that by keeping records, and studying topics like what foods Indians ate, professional archaeologists were actually projecting a degraded image of prehistoric people while he and his associates, because they made no such records and dug up beautiful objects, were the only ones who truly appreciated these people.

Basic to this justification is the view that all one needs to appreciate Indian culture is the objects they made, that the artifacts, in a sense, speak for themselves. Hypotheses, research plans, and contextual records are unnecessary. Most diggers have never been exposed to the basic concepts of science. They know archaeologists say they are destroying the scientific value of archaeological sites. They do not know how to go about 'real' science, so, they espouse a 'science' of their own that requires only the objects they obtain and a fertile imagination to reconstruct Indian lifeways.

Finally, there are diggers whose primary goal is money. Few people are outspoken about this stance. It is also clear that when talking about each other, one digger will express his or her disdain for the activities of another by commenting that 'he's only in it for the money'.

The second group in this subculture is dealers who buy and sell artifacts on both the wholesale and retail level. Some also finance excavation themselves, but it is unclear how often they employ their own digging crews full time, and how frequently they depend on independent diggers to supply them with artifacts. Indirect evidence indicates that in northeastern Arkansas at least, these organized groups do not have much permanence. One recent example comes from southwest Arkansas where a dealer leased a mound group, and over the course of a few years used heavy machinery to trench through the mounds on the site. Visitors were kept away from the excavations, and information about discoveries was tightly controlled. Dealers are clearly an important information node in a network of diggers and financiers, all of whom are in more or less continuous interaction. The largest dealer in southwest Arkansas also appraises collections, operates a roadside exhibit featuring open burials and an arrowhead hunting field, and has an interstate mail-order business in artifacts and archaeological publications. He has a wide range of opportunities to hear about discoveries, learn the location of sites, and solicit business. Recently he has taken an idea from fieldschools, and advertised a 'dig it yourself' operation where, for fifty dollars a day, participants get relics and a certificate of attendance. His mail-order flyers recommend buyers contact him privately with special requests, because he has access to artifacts that are not publicly advertised for sale.

Once artifacts enter the commercial market system, questions of authenticity and provenance become significant. An important sideline in this activity is the reconstruction and restoration of broken objects. The goal is to create an object that looks like what the collector envisions it was in its original state. This often involves extensive remodeling, creating new surfaces or rebuilding missing parts. Collectors often complain that archaeologists should take a greater interest in studying their relics, that their collections are repositories of scientific knowledge that we disdain using for our own selfish reasons. In reality, the effort involved in deducing the original physical attributes of these objects far outweighs whatever data we may gain. And, such cooperation invariably enhances the value of the object and the prestige of the collector. It is also clear that as objects move from diggers to dealers to collectors, the opportunity for passing off outright fakes and heavily modified originals as authentic artifacts increases. This activity too, seems to be part of the game for some participants. Because of the increase in illicit digging, any site provenance information is questionable, and I see a trend for the use of secondary provenance, such as displays, well-known private collections, or exhibit catalogs.

The third subgroup in antiquities trafficking in Arkansas, and the group

that seems most responsible for the surge in interest, is the financiers. These are wealthy collectors with an attachment to Indian things and a desire to find a tax shelter, and leaders of digging groups. Collectors are in contact with dealers, diggers, and presumably with collectors in other states. Although they reject the values and practices of academic archaeology regarding unrecorded digging, and some view buying and selling artifacts as an important financial enterprise, they characteristically seek support for their activities in a number of ways.

Collectors purchase individual artifacts and complete collections. At a recent legislative hearing, one described purchasing relics from newly opened graves at an excavation site. The direct role of collectors in excavations is uncertain, but some are active in finding sites, and it is possible they may arrange for excavations as well. Profits come from the sale of artifacts and tax deductible contributions of unwanted relics to museums.

Some collectors are deeply concerned with establishing the legitimacy of their activities. Their explanations are so similar to those offered by diggers, that there must be a uniform oral tradition about these activities that members of this group share. They emphasize they are saving beautiful objects that celebrate the achievements of prehistoric Indian cultures, and that otherwise would not be seen or appreciated by the general public. They say archaeologists ignore these achievements, or hide the evidence in museum storerooms. They describe themselves as legitimate educators of the public. Linked to this argument is their role, at least in Arkansas, of mounting their own exhibits and contributing to privately prepared artifact catalogs.

Because they deny that contextual information is necessary for conducting research, these people produce information on past cultures that is questionable and highly idiosyncratic. For example, a few years ago collectors mounted an artifact display in a museum. It was comprised mainly of pottery vessels with the type names attached to them. One vessel, a gourd effigy, had been placed on its side, and the accompanying tag said simply 'effigy breast'. Collectors reject the accusation that they contribute to the destruction of the cultural data base. They say they are helping to save what otherwise would be destroyed. They say they are keeping objects in Arkansas that once would have been sold out of state. And they claim that some data archaeologists collect are irrelevant or unnecessary. "It's through art that you can look into the minds and hearts and souls of other people," one collector said in a recent magazine article. "If you look at the Mona Lisa, what other information do you need?"

Over the last decade, digging in Arkansas seems to have accelerated. Reports of site destruction on federal as well as private land in neighboring states indicate that the problem is regional in scope. While it appears that

This midden site in Arkansas was heavily damaged by pothunters using bulldozers and shovels. They cut down trees, tore up brush, and abandoned a large table screen which they had used to find small artifacts in the dirt. When such destruction is discovered, archaeologists and volunteers from local archaeological societies often work together to record what little remains and pick up pieces of artifacts discarded by the looters. *Photo courtesy of the Arkansas Archeological Survey.*

the presence of a resident group of dealers and large collectors is one cause of this surge of activity, finding an appropriate means of dealing with the problem is far more difficult than simply documenting its occurrence. At a meeting of archaeologists at the Caddoan Archaeological Conference in the spring of 1987, a comparison of site destruction in the four state area that makes up this archaeological region indicated that unless we can turn this situation around, a large part of the prehistoric data base will shortly be lost. Selective looting of late prehistoric sites is likely to produce a similar result in East Arkansas. What has not been lost to looters may go to land levellers, leaving no intact sites in parts of the state by the end of the century.

As grim as the preceding discussion is, there are some encouraging signs that at least some opportunity to counteract this situation is available.

The Arkansas Archeological Survey publicly advocates site preservation and appropriate study. It does not have a statewide program for dealing with site destruction, but individual regional archaeologists have developed approaches that have been effective in a number of situations. Because the regional archaeologists live 'close to the source' and have long-standing ties with citizens, landowners, and amateur archaeologists, they are better able to deal with situations than if they were secluded in academic departments far from their data base. More than anything else, it is the personal relationships survey archaeologists have developed with these groups that mark our individual successes. In addition, recent events indicate that the mood of the general populace regarding gravedigging is not as complacent as it was a generation ago. The following observations and recommendations are mine, but I believe my colleagues share my perception of the situation.

Two things must happen to effectively deal with antiquities trafficking. The opportunity to destroy sites must be limited, and the public atmosphere that sanctions grave robbing must be changed. We have used a number of strategies to protect remaining sites. First is teaching landowners about the scientific value of the cultural resources they own, and about the destructive effects of unrestrained digging. This takes time and sustained personal contact between archaeologists and landowners. It also takes archaeologists willing to support their arguments by repairing mounds and other sites damaged by looters, by putting important sites on the National Register, by mediating between conservation groups like the Archaeological Conservancy and owners of important sites, and by teaching landowners what constitutes a significant archaeological site. This has meant at times delaying personal research interests for a day, or a week, or longer, walking with landowners over their property and showing them exactly what a site is and what grave robber trenches have done, identifying artifacts in their personal collections, and in effect proving that you have a genuine interest in preserving every single site you are concerned about on their land. We are often helped inadvertently in this activity by gravediggers themselves, who often wear out their credibility with landowners by damaging property, deceiving their hosts or worse, challenging landowners' rights to protect their own property. There is an information network among landowners, too, and tales of troubles with diggers are widespread. Once landowners learn we are not the ogres we are sometimes portrayed to be, they are often pleased to talk with us.

As a result of these activities we have seen some of the major mound groups in the Red and Ouachita River valleys put off limits to diggers. Working with privately owned timber companies we have seen their owners institute blanket no digging policies that are enforced by their field personnel as well as can be expected in the remote bottomland hardwood forests of cen-

Pothunters at work on a Mississippian site in northeast Arkansas. Some pothunters dig with permission of the landowner. While this activity is legal in the United States, there are ethical concerns over loss of data about past cultures and about desecration of burials and cultural remains. *Photo courtesy of the Arkansas Archeological Survey.*

tral and southern Arkansas. Similar work with other private landowners in encouraging preservation seems to be successful on a site-by-site basis.

Unfortunately, as one digger told me, "There are a whole lot more of us than there are of you." This is obviously true, but we look for help from the 600 members of the Arkansas Archeological Society, and other interested citizens to communicate their interest in site preservation to their site owning neighbors and friends. A stewardship program in which individual amateurs keep a close watch on important sites has been proposed. It has not been formally implemented, but many Society members are performing this activity informally around the state. They watch for the start of digging activity at key sites, encourage landowners to adopt preservation policies, report new site locations to us, and in one instance, have even called the sheriff to arrest illicit diggers working at a site under their care.

This help does not come without cost, usually measured in the time sur-

vey archaeologists spend giving public lectures, visiting sites and looking at collections, welcoming society members into their offices or onto their field projects, teaching them about archaeology and archaeological research, and generally treating them as colleagues instead of impediments or second class citizens. To recruit new Society members, and teach them the distinction between gravedigging and archaeology, the Survey has expended great efforts over the last twenty years to conduct a training program during which amateurs can contribute to research and learn the ethics and practices of academic archaeology. This experience includes not only fieldwork, but seminars and close interaction between amateurs and up to a dozen professional archaeologists over the course of a two-week period.

One afternoon spent in the hot sun cleaning up a mess left by gravediggers is a powerfully sensitizing experience. Each person who has had this experience can be a more effective spokesperson for site protection and legitimate research. Because we are able to keep track of a great many of the people who participate in this program, we are also certain that they are not the ones who go on to the ranks of commercial grave robbing.

Influencing public opinion about the destruction caused by the unscientific collection of beautiful relics, and in general making the digging of human graves for profit a distasteful enterprise is more difficult. Many people are truly unaware that pottery vessels and other fancy relics come out of human graves, that they are obtained at the cost of great destruction, and that the destruction is going on today. Others, who do not own land or know landowners with sites that are being plundered, are unaware of the extent of illegal digging that goes on as well. Revealing the destructive consequences of relic collecting is one of the more powerful means of getting public attention and sympathy for a preservation ethic. Diggers know this, and often deny or obscure this aspect of their activities. I have been told repeatedly by people who are vaguely aware of relic collecting how one or another digger would never sell his artifacts, or would never dig without permission, or knows how to dig without destroying anything, when I know just the opposite is true.

Survey archaeologists spend a considerable amount of their time giving presentations to schools, civic organizations, museum groups, historical societies, and clubs of all sorts, communicating information about legitimate archaeological research in the state and whenever possible about the destruction of sites as well. We design exhibits, distribute leaflets, and for several years have shared an information booth at the Arkansas State Fair with the amateur Society. Numerous Society members contribute to this effort by giving presentations and making up their own county fair booths. One Sur-

vey archaeologist regularly loans out slides and artifact kits to amateurs for school talks. Survey archeologists also provide a continuous source of presentations for the monthly meetings of regional chapters of the Arkansas Archeological Society. We share talks, visit each other's amateur contacts, and most of us rarely turn down a request for a presentation. The Survey, through the Arkansas Endowment for the Humanities, will be using an NEH grant to create a large traveling exhibit on prehistoric cultures in Arkansas for future public education.

There are many things that we should try. We need to develop a curriculum unit for the public schools on Arkansas prehistory, similar to some introduced in Louisiana and Arizona, that would not only tell children about the state's Indian heritage, but also introduce them to the ideas of site preservation and archaeology. We need to educate law enforcement people about the antiquity laws and the extent of illegal digging. We need to reach out to agricultural support organizations like the Farm Bureau and Agricultural Extension Service to reach more landowners more efficiently. We need to implement these measures across the state through a coordinated program from our central office, because individual regional archaeologists cannot be effective through local and district offices alone.

Occasionally suggestions have been made to strengthen antiquities laws. Just how controversial an enterprise this may be was well illustrated in the winter of 1986–7. In November, a collector auctioned off his artifacts. The notice of the sale, appearing on a Sunday, listed the objects and included an Indian skull for sale. By Monday morning, simmering feelings among members of Arkansas' Indian population had boiled over. This precipitated days of newspaper articles and phone calls to the auctioneer. The skull was removed from the sale, and its whereabouts is unknown, but there was a demonstration at the auction with the print and television press present. Public sentiment, as reflected in the press and radio, strongly backed the Indians. In December, a bill was prefiled in the Arkansas Legislature that would have effectively outlawed the deliberate disturbance of any human burials in the state by any person or activity, the commercial display of human remains, and the sale or barter of bones or artifacts from graves.

The director of the Arkansas Archeological Survey and the state archaeologist worked with the sponsor of the bill and with members of the urban Indian community to rework some provisions, and an amended version was first presented at a public hearing in one legislative committee. Meanwhile, opposition was being mounted that included sending a copy of the original bill and an anonymous flyer to amateurs and collectors all over the state. The flyer read in part, "This liberal, socialistic bill drafted by a radical minor-

ity group would require registration of your collection, stops digging and collecting on private land . . . stops farming on sites, and makes crooks out of good tax-paying citizens who happen to love Indian culture and artifacts."

At the public hearing, diggers, dealers, and collectors focused on a few major arguments: that no-one would be able to identify grave goods in an adequate legal sense and separate them from relics found elsewhere, that farmers would have to stop their operations when burials were encountered, that archaeologists would not be able to salvage all the burials endangered by farming activity, and that collectors loved Indian culture so their activities did not desecrate Indian graves. Extensive discussion, occasionally including some bizarre debates over whether one would want one's grandmother dug up, produced considerable sentiment for the bill and against the diggers, but the measure went to an *ad hoc* subcommittee to work out a compromise. This committee, made up of Indians, archaeologists, legislators, diggers, dealers and collectors revised the bill several times, but predictably failed to come up with an acceptable compromise over the essential point of digging up Indian graves and taking out artifacts for sale. Nevertheless, the subcommittee returned the bill with a recommendation to pass. At the final legislative hearing the revised bill was recommended for introduction to the full House, and several legislators spoke forcefully against the practice of grave robbing for profit.

When the bill was introduced, opponents had leafletted members of the House, warning that the bill would interfere with farming operations and would require registration of private collections. This last argument no doubt touched a nerve in a society which views any kind of registration as a significant abridgement of personal freedom. Changes "that would allow the legislature to reaffirm the dignity of all people," but still allow commercial relic hunters to dig graves on private land and keep or sell whatever they found were added as amendments with an overwhelming vote and the sponsor thereupon pulled the bill before it could be passed in this altered condition. No further action took place in the 1987 legislative session, but efforts to draft an acceptable bill continue.

While the legislative limbo continues, the level of digging seems to be escalating. Out-of-state collectors have contacted local diggers attempting to buy their collections. This activity may be short lived, however, because legislation affecting human burials also is under consideration in neighboring states. In 1987, Oklahoma enacted a burial protection law similar to the one proposed in Arkansas. This is a hopeful sign that legislative action aimed at protecting some sites is possible. These efforts may result in a significant curtailment of both legal and illegal digging throughout the region.

The Battle for the Maya Past: The Effects of International Looting and Collecting in Belize

When the list of countries that had ratified the UNESCO Convention on illicit trade in antiquities grew to include some of the major consumer nations, it appeared to many that real headway had been made in bringing archaeological looting to a stop. In some respects, the UNESCO-linked legislation seemed to embody the qualities of the laws that had long existed in countries such as Belize. At the very least, it appeared to provide a means of embarrassing collectors and pressuring dealers so that the international trade in antiquities could be slowed, if not stopped. To date, however, the potential of the legislation has largely gone unrealized. Some aspects of the antiquities trade have indeed diminished, but due in large part to law-enforcement activity unrelated to the UNESCO ratification; at the same time, the overall scale of looting has, at least in the area we know best, risen dramatically.

In Belize, as in many Third World countries, the problem is the reverse of that faced in North American archaeology; it is not the collecting avarice of the local population, but rather the acquisitiveness of foreigners, that fuels the engine of archaeological destruction. At least in the United States and Canada the looting is most

David M. Pendergast
Elizabeth Graham

likely to begin and end with locals, whose punishment under local law can, in many instances, put an effective stop to the activity. In Belize, locals or recent immigrants from El Salvador or Guatemala will probably be found digging clandestinely far more often than Americans, and they can be punished fairly severely for their actions. However, they are simply the field end of an operation that may span several countries, and usually involves several levels of illegal activity. Whatever the punishment meted out locally, it is not to be expected that its effects will be felt by those elsewhere whose pockets the plundering truly lines.

In times past the foreign market lay largely in the United States, as indeed a major part of it still does; today, however, Maya artifacts have hit the big time, with a market that extends from North America to places as geographically and culturally remote from Belize as Japan and Australia. With an expanding, rather than a contracting market, the normal law of supply and demand can be expected to operate, and all evidence indicates that it is doing just that. The perception of anyone at work in the field is that no legislation, or any enforcement thereof, has had appreciable effects in North America; elsewhere, the legislation has yet to be thought of, and hence the market remains wide open.

The effect of looting in the Maya area is exceedingly difficult to assess because we are nowhere near having a master list of significant sites, and are faced with jungle terrain in which clandestine activities of many sorts can be carried on with near-absolute impunity. The jungle may even, on occasion, cloak an attack by looters on a well-known site that is a government archaeological reserve, and is assumed by everyone to be safe from assault (Pendergast and Graham 1979, 1981). For some years there have been a good many parts of the Maya lowlands outside Belize in which, guerrilla activities aside, no archaeologist would set foot on an unchecked site unless he or she had a strong death wish. Today this is also true of Belize, and it prevents archaeological assessment of looting activity as effectively as it prevents the survey that would tell us what sites are there to be looted.

Because contacts between archaeologists and looters are rare, we have no way of knowing the true scale of clandestine excavation in Belize. There are, however, bases for rough calculation, in addition to the listing by Gutchen (1983) of sites where destruction is known to have taken place. To begin with, we have a limited amount of data on the size of looting crews; we have seen one camp, and a friend has seen another, sufficient to house seventy to eighty people, and in the latter case the tracks of a bulldozer-like vehicle with trailer were also in evidence, as was the fact that at least some of the looters were well armed. Though much looting is unquestionably less grand in scale, these two operations, which are surely not unique in the his-

tory of Belize looting, involved crews larger than any ever mustered by archaeologists at work in the country.

Apart from the question of relative crew sizes in legal and illegal operations, there are several factors we can introduce to the calculation of the overall scale of looting. In the simplest terms it is obvious that archaeologists are heavily outnumbered, but the scales are tipped further in the looters' favor by the fact that illegal diggers can work year round, can dig unimpeded by thoughts of recording or of preservation of fragile architectural features, and need only search those parts of structures that are most likely to yield saleable artifacts. In addition, most excavation crew members require the near-constant supervision of an archaeologist in order to proceed with their work, whereas in most cases the clandestine digger chops away with nothing but his own knowledge to guide him. The final addition to this already staggering list of looters' advantages is the fact that the profit to be made from illegal operations guarantees far better funding than any archaeologist can ever hope to have.

Though it is clear that not all looters enjoy the whole series of advantages enumerated above, the list probably presents a fair average picture of the difference between controlled and clandestine excavation. It can therefore be taken as the basis for calculating the effective degree to which archaeologists in Belize are outnumbered by their lawbreaking counterparts. When all the factors are taken into account, we estimate there are effectively 200 working illegally, and some of our Belize-experienced colleagues feel that this figure is quite a bit too low.

If we wished to take a further step in this somewhat haphazard numerical exercise, we could take the maximum number of archaeological workers likely to be excavating in Belize at any time in a normal field season and multiply it by the factor derived above, to get at the effective overall sizes of the legal and illegal forces. Archaeologists and excavators rarely if ever exceed 70, and a fair average for a season is probably near 50, so that the product of the multiplication is approximately 10,000. This does not mean, of course, that at any given moment there are 10,000 looters busy hacking away at Belize's Maya ruins, but rather that the annual effect of looters' efforts may well be about what one could expect if 10,000 legal excavators were at work for a normal (three-month) season. Whether the figures have any real meaning is obviously open to debate, but their import is clear: Belize's archaeological heritage is under heavy siege.

An examination of Belize's record in the area of protective legislation would suggest to the uninformed that the defenses raised against the looters' siege are, and have long been, virtually impregnable. Opponents of antiquities legislation in developed nations argue that the inability or unwill-

ingness of Third World countries to protect their archaeological heritage confers respectability, in fact almost a kind of academic sanctity, on the preservation of artifacts by collectors; this self-serving and groundless argument seems particularly ridiculous when applied to Belize, which has a far better record on this score than any of the nations that now consume its heritage. The earliest attempt at protection of archaeological sites dates from the 1890s, and since 1924 Belize has had very stringent laws, coupled with governmental ownership of almost all archaeological sites. In 1972 the laws were very considerably strengthened, and all sites were brought under government control; at present, Belize's ring of protection around its archaeological heritage surely ranks among the strongest in the world. But the ring cannot be drawn tighter than enforcement conditions permit, and it is here that Belize, like many Third World countries and indeed, in some senses, every country, faces an almost insurmountable problem.

It is in the denseness and extent of the tropical forest that one major element of Belize's archaeological difficulties lies. The jungle erects truly formidable barriers in the path of archaeological survey, so that there are a good many vast tracts of land in which there are very few recorded sites. When there is no knowledge of what there is to protect, not even the best tactical situation will permit control of looting; in fact, a fair portion of the knowledge regarding sites in many areas of the country is collected during mop-up work after looting has been reported by mahogany hunters, chicle gatherers, or others whose work takes them through the remote parts of the forest. The jungle serves also to conceal looting activity; it is only the rare, and generally the incompetent, looters whose activities are carried out near centers of population or in other places without heavy concealment.

Though the jungle is a formidable obstacle to the apprehension of looters, there are times when illegal diggers are apprehended and brought to court, where the government faces another kind of battle in prosecuting them. Ironically, the looter in Belize finds himself protected by a democratic court system based in British jurisprudence; operating on the assumption of innocence until guilt is proved, the law erects formidable defenses around anyone caught in the act of tearing an ancient Maya site to pieces. The array of evidence against the accused must be airtight, for though looters may appear impecunious, they often have access to seemingly unlimited funds with which to hire the best lawyers. Most cases against looters are heard in magistrate's courts where, in the British system of law in force in Belize, members of the police force must act as prosecutors. The officers are often outmatched by lawyers whose keen eye for loopholes quite frequently allows an unquestionably guilty looter to escape punishment, and may even result in a magistrate's order that confiscated artifacts be returned to the accused.

Whatever the good will of the police and the magistrate himself, the path to justice in looting cases generally proves a rocky one indeed.

As in North American court proceedings, the barriers thrown up in the prosecutor's way can be almost endless. Cases can be dismissed because only one witness can confirm artifact possession, whereas two are required by law. If, because of his involvement in archaeological administration, the Archaeological Commissioner cannot appear as an expert witness, there may be no such person available in the country, and if a professional archaeologist can be found to testify, his qualifications may be challenged interminably by the defense. Questions can be posed again and again as to the proof that the objects submitted in evidence are artifacts, and equally numerous challenges can be raised against an expert witness' statement that archaeological mounds are not simply natural phenomena. This sort of obfuscation can so cloud the issues as to make a reasoned verdict well-nigh impossible. Thus every case begins from square one, and no precedents exist on which successful prosecution can be guaranteed. Even when the government succeeds in obtaining a verdict of guilty, the persons actually charged are only the local bottom echelon of the looting structure, and those from abroad, whose guilt is far greater, go scot free.

At best, the laws of Belize, like those of most other countries with a focus on protection of their heritage, provide an argument to the remainder of the world that artifacts illegally excavated and illegally exported should be repatriated. They document the country's concern with the problem more than they aid in prosecution of the guilty—simply because prosecution has apprehension as its necessary prerequisite, and apprehension is difficult in the best of circumstances. In Belize, a tightly restricted budget combines with the environmental factors cited above to produce a situation in which probably less than five percent, and possibly less than one percent, of archaeological material looted from the country's sites is identified and recovered within the country's borders. The record is, sadly, no better for material that has made its way to to North American or other markets; here, only chance discovery by Customs or other agencies is likely to make possible the specification of country of origin, and perhaps the eventual return of the artifacts, shorn of all the insights they might have provided into Maya prehistory, to their source.

Frustrated by a force of looters that is larger, and almost certainly better funded, than the country's entire military and paramilitary establishment, the Belize government and North American archaeologists who work in the country have long sought some means, whether internal or a combination of local and international effort, of controlling the traffic in antiquities. Suggestions have ranged from not entirely frivolous plans for placement of antiper-

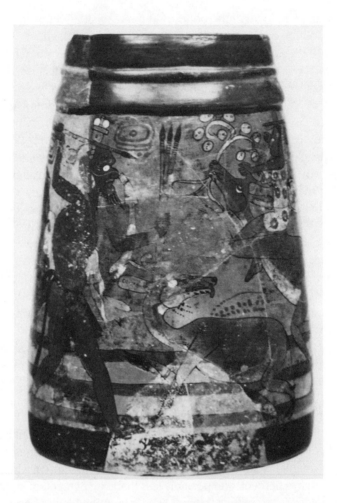

This unique piece, called the Actun Balam Vase, lay in more than fifty pieces in the Actun Balam cave. Surface fragments discovered by mahogany hunters in 1964 were carried away. Three pieces ultimately were turned over to the Cayo District administrator. Archaeologists excavated additional sherds in the cave and found some at the mahogany hunters' campsite. Other pieces were retrieved from the mahogany hunters and from a backyard garbage dump. Others remained in the possession of men in San Antonio Cayo, who feared trouble with the government if they came forward. As a result, one of the great masterpieces of Maya vessel painting remains restored, but in incomplete condition. Because the scene is not repetitive, and is laden with symbolism, the absence of more than one quarter of the vase is painfully significant. *Photo courtesy of the Royal Ontario Museum.*

sonnel mines throughout sites and development of fake jades that would explode long after their insertion into the marketplace, to emplacement of United Nations troops as site guardians and other foreign-presence steps that might indeed have some beneficial effects if they were possible. Massive foreign investment in archaeological work has also been posed as a solution to the looting problem; this step may be more likely to occur than is the stationing of foreign troops in Belize, but the achievement of a real solution or anything that approximates one is, we fear, not a probable outcome of either of these efforts. The simple fact is that, no matter what human or financial resources may be mobilized within the country, the looting problem is not capable of solution within Belize itself.

The external solution seems already to have been put in place, or at least to have had its mechanism lubricated and set in motion, through legislation in many countries that ratifies the UNESCO Convention. Unhappily, this appearance is very far from the truth, and indeed may even have led to some degree of complacency on the part of those who are so ill-informed as to assume that the taking of legislative action constitutes resolution of difficulties. Those who know better recognize that the law is no stronger than the will and the wherewithal required for its enforcement. In the United States and Canada, among other countries, the wherewithal clearly exists, and in Canada, at least, the will has thus far shown itself to be strong; however, prosecutions have been very few, and convictions even fewer. Surely the message to looters, transporters, and collectors of stolen archaeological material is clear: continue with impunity, for the risks are next to nonexistent.

If this message is to be changed, a number of steps—none of them easy—will be required. More consistent, and more meaningful, checking of large shipments from Belize (and many other countries) will be required at all ports of entry, so that artifacts do not pass as machinery. This will, however, touch only a tiny portion of the problem, for most artifact-running into the United States and elsewhere does not involve passage through any port, or by any government eyes. A major hole could be blown in the artifact transport system by even more vigilant surveillance of the aerial drug traffic out of Belize, which would make the trafficking connection between marijuana growing and looting less easy. The volume of such traffic is suspected to be very high at present; if the growers ever find their huge profits destroyed, there is a very great likelihood that they will turn en masse to one of their current auxiliary money-making activities, and convert looting and clandestine artifact transport into one of the main hard-currency industries in Belize.

The traffic in antiquities may be reduced somewhat by a variety of border controls, but it cannot rest on such measures alone. Raiding and seizure throughout the dealers' world and the auction houses will have to become

commonplace, and the consequences to those caught with illicit material will have to be as severe as the law allows—which is, unfortunately, not very severe at all. These steps will also help curtail traffic in antiquities from Belize, as from any country—but neither they nor the border controls are very likely to take place, at least not at the level required, and none approaches a real solution to the problem.

One of the relatively new, and relatively severe, difficulties in applying the steps outlined above is that the market for Maya antiquities, once limited largely to Hollywood, portions of Texas, and the New York zone, has not only spread across the United States but has also extended to countries never previously seen as consumers, such as Japan and Australia. Japan zealously protects its own heritage, but appears to place little or no value on that of other peoples; Australia, long a "laundering" area for archaeological material, seems now to provide an open field for artifact trafficking in all forms. The absence in these and other countries of concern for the preservation of the world's archaeological heritage, coupled with the presence of copious quantities of disposable income, makes the likelihood of enactment of legislation very low, and the likelihood of enforcement of any international sanctions lower still.

Is there, then, any effective method of stopping the looting in a country such as Belize, and the international traffic in its heritage? If we seek to put a real plug into the pipeline, the answer is probably no. One step, which as far as we know has yet to be taken in any developed country with UNESCO-related legislation in place, is the extension of raiding and seizure to individual collectors, attended by the greatest possible amount of publicity. It is surely true that collectors in the United States, Canada, and many other countries continue their activities today in full knowledge that they are flouting not only widely accepted codes of morality (see Levine and Pendergast 1982) and the laws of source nations, but also the laws of their own countries. The amount of media coverage given to the looting problem, both at home and abroad, destroys the defense of ignorance, if such defense was ever admissible, and yet collection goes on apace. The only action that will dull most collectors' appetites for further Maya—or other—archaeological material is one that will bring their violation of the law into the full glare of day.

Embarrassment is the only penalty that would have meaning to those whose incomes permit the collecting, and hence are more than sufficient to make loss of objects, or even stiff fines, if they existed, no more than trifling inconveniences. Most of North America's wealthy, whether public figures or shadowy corporate magnates, would do almost anything to avoid adverse publicity, especially if lawbreaking is the accusation. We see this sort of ac-

Two Classic Maya vessels of a style commonly found at Altun Ha, Belize and rarely found elsewhere. Altun Ha was probably the center of manufacture of this particular type of polychrome, though some unprovenanced pieces are said to have been found at other sites. Properly documented, they might have revealed information on trade connections between sites. The Altun Ha specimen on the left, like all others excavated at the site, has full provenance data. From its context, much can be learned about its age, manufacture, ownership, and use. The vessel on the right was acquired by the Duke University Museum of Art at a time when it was an accepted practice for museums to purchase or accept unprovenanced objects. Now the Classic Maya pottery in the Duke University museum's collection has been chemically sampled for neutron activation studies as a part of the Maya Polychrome Ceramics Project housed at the Conservation Analytical Laboratory of the Smithsonian Institution. Through this sampling, the museum seeks to move beyond these vessels as isolated objects of aesthetic value to actively supporting research to retrieve as much cultural information as possible in the face of the vessels' lack of provenance. *Photo on left courtesy of the Royal Ontario Museum; photo on right by Dorie Reents-Budet.*

cusation as a step that would deter many—though surely not all—from purchase of illicitly excavated material offered for sale in North America. Sadly, no solution to the problem exists elsewhere, and none is very likely to emerge in the foreseeable future. Those of us who are at work excavating sites in Belize cannot quite hear the looters' shovels, but the illusion of their audibility is very strong, and growing stronger as the number of shovels increases. Until the acquisition of looted artifacts is made distasteful, if not dangerous, worldwide, that sound, and the knowledge of what it means in loss of irreplaceable data, will always be with us.

REFERENCES

Gutchen, Mark A.
 1983 The Destruction of Archaeological Resources in Belize, Central America. *Journal of Field Archaeology* 10: 217–227.
Levine, Louis D., and David M. Pendergast
 1982 The Immoral Minority. *Canadian Collector* 17: 4, 72–73.
Pendergast, David M., and Elizabeth Graham
 1979 The Ruin of a Ruin: Picking up the Pieces at Xunantunich. *Brukdown* 11: 11–13, 35. Belize City.
 1981 Fighting a Looting Battle: Xunantunich, Belize. *Archaeology* 34: 4, 12–19.

Considering the Perspective the Victim: The Antiquities of Nepal

It is not seemly nor of good report
That thieves at home must hang, but he that puts
Into his overgorged and bloated purse
The wealth of Indian nations, escapes.
　　　　　　　　　　　　　—William Cowper

AN APPEAL TO COMMON SENSE

To consider the ethics of collecting cultural property is to consider what is good and bad or right and wrong, what is the moral duty and the obligation of the collector, or of the society which functions as collector. Moreover, the formulation of any such ethics requires that we not be influenced by the biases of any specific profession; any ethical system should not be conveniently structured to preserve the privileges enjoyed only by those who, through their rationalized acquisitiveness, have made it necessary to consider the ethics of collecting cultural property in the first place.

Since the passage of the UNESCO "Convention on the Means of Prohibiting and Preventing the Illicit Import, Export and Transfer of Ownership of Cultural Property" in 1970, there have been various legal maneuverings and an ongoing debate in the United States—the world's biggest art importing market. We have witnessed the quirky McClain decision of 1977, which centered

David Sassoon

around the attempted sale in the United States of Pre-Columbian artifacts illegally exported from Mexico (see discussion in Chapter 11), and various attempts to have it overturned. We saw the passage of the Cultural Property Act of 1983 which has done close to nothing to stem the tide of illicit trade. Yet throughout the past seventeen years of testimony and argument, lobbying and deliberation, what has been conspicuously missing from national debate has been consideration of the perspective of the victim.

These following few pages will, then, substantiate the case of one particularly aggrieved nation, add a bit of evidence into the pool of information we weigh as we speculate on ethical conduct, and appeal to common sense as we struggle toward interpretations. The particular victim of which I shall speak is the Kingdom of Nepal, in whose capital city I had the good fortune to reside from 1980 to 1984. I lived there first as a United Nations Volunteer in the employ of UNICEF, and subsequently on my own as a photographer, writer, and researcher. It was there, sadly, that I encountered first hand the theft of antiquities and first began to question and investigate this undeniable form of injustice. Now, several years since my departure from that most hospitable country, I find myself in a position in which all I can do is state what should be ethically obvious: Nepalese culture belongs to the Nepalese first and foremost, and so do their antiquities.

Yet there are those who would dispute these assertions, or at least those who behave as if they do—not only for Nepal but for all the cultures of the world—and therefore we debate the ethical issues involved in collecting cultural property.

From a cynical perspective, considering the ethics of any activity is just so much wasted effort. Men and women will never live up to abstract standards of any sort, no matter how noble or apparently true, no matter how much lip-service is paid. Furthermore, cynics will say, it is unrealistic to think that anyone can formulate an ethics to govern the disposition of cultural property. Such an ethics must encompass and satisfy the values and rights of every culture in the world, given that the international art trade has invaded every conceivable "source."

Yet an effort is necessary, and plausible. It is necessary because what is at stake is far more than objects of monetary, aesthetic, or scholarly value. What is truly at stake is the very soul of humankind—past, present and future. The highest hopes and aspirations, the loftiest ideas, the most valuable notions ever conceived have been enshrined in wondrous works of art.

But over these last few decades as never before, we, merchants of culture, we, self-appointed custodians of humanity's greatest heritage, have caused irreparable damage to so many of these wonders and have betrayed

the very notions of conduct and value that they symbolize. In denigrating the past, we denigrate ourselves and our posterity.

There is another reason why the formulation of a proper ethics is necessary. Without a standard of conduct to which we can commonly aspire as equal citizens of this earth our global village, we will never have a chance to mutually solve the conflicts of interests that plague this messy business of the international trade in antiquities. An ethical basis upon which to determine conduct is likely to offer a more enduring model of consensus than those which are presently determined by international might—political and economic.

If the necessity of establishing an ethics of collecting cultural property is accepted, its plausibility becomes a moot question. Necessity is, after all, the mother of invention. We could simply begin by laying down some ethical axioms or principles inspired by religious tradition. "Thou shalt not steal" seems an appropriate commandment to consider; the Seven Deadly Sins (Pride, Gluttony, Sloth, Lechery, Avarice, Envy, and Wrath) would no doubt also provide ample food for thought in this context.

Because we live in a rational age that is uncomfortable with the maxims of revealed Truth, however, the determination of what is ethical can be left to common sense, that universal faculty whose source is the incorruptible kernel of truth to be found at the core of every human being. If we rely on common sense, we will not need specialists to carry an excessive burden in the debate. Common sense, too, has the added virtue of recognizing the obvious truth with childlike simplicity. Without too much fuss or complication, it can determine what is truly in the interest of art and humanity and separate it from what is in the interest of a particular institution, a specific collection, an individual pretension, or a bank account.

Lest the reader mistrust the exercise of relying on common sense, it should be pointed out that it is a faculty long recognized by epistemologists. Cartesian thinkers have seen it as something evident by the natural light of reason and hence common to all people. More prosaically, *Webster's Third International Dictionary* defines it as "good sound ordinary sense: good judgment or prudence in estimating or managing affairs esp. as free from emotional bias or intellectual subtlety or as not dependant on special or technical knowledge."

Armed with common sense, let us see what it can do. Take the term "cultural property". By attaching an adjective (cultural) to a commonly understood noun (property), we have created a stratum of materiality that somehow is beyond the reach of ordinary notions of ownership, theft, and restitution. If you are caught with *property* that does not belong to you, then

you are a thief. If you are caught with *cultural property* that does not belong to you, however, no-one is quite sure what you are. Does this make sense? Common sense?

This terminology distances us from the victims of this somehow special class of dishonest acquisition; the language we are using shields us from the odious fact that the people whose antiquities are being stolen are the victims of a crime we most certainly allow, and often even condone.

Over the years, we have listened to the perspective of the nation's art dealers, and we have listened to the perspective of the nation's scholars. But there has been nobody who has given voice to the perspective of the villagers who wake up one morning to find their God missing from the temple. They never before had to consider their community's possessions as objects of international consumption, and they are scarcely in a position to hop a plane and explain the sorrow of their loss. Because of the omission, it was almost as if the debate between aesthetes and scholars was a debate that was trying to determine which of the two parties had a greater right to be the keepers of the world's cultures.

We can perhaps excuse the omission because the debate was not being carried out for the purpose of arriving at a standard of purely ethical conduct, but rather to balance and protect in legal terms the conflicting rights and privileges of the players of an abusive international competition. Here, however, we are pondering the right and wrong of these matters, and it is imperative to consider the perspective of the victim as we deliberate, with common sense as our guide, an ethics of collecting antiquities.

A CASE STUDY:
THE KINGDOM OF NEPAL

Presented here is evidence concerning the fate of antiquities in Nepal, evidence that was gathered, at least initially, wholly by accident. Nevertheless, this tiny Himalayan kingdom—geopolitically defenseless, geographically remote and economically impoverished—presents us with a case study almost perfect in its proportions and invaluably instructive. By examining what has happened there over the course of less than forty years—the period of time it has been open to outsiders—we are presented with a microcosm of the social devastation that can result from the foreign imperative to study, catalogue, and collect.

Nepal is a small landlocked country wedged between India to the south and China to the north. One wise Nepalese prime minister once likened its position to a yam stuck between two boulders. While from a political perspective Nepal may indeed be seen as a tuber in a precarious position, from

a cultural perspective, on the contrary, it has held immense importance. For centuries, Nepal, and most significantly the Kathmandu valley, functioned as a cultural crossroads, a centerpoint for the great caravan routes that stretched between India and Tibet. Together with the loads of salt and grain that traversed its territory came and went goods of a different and perhaps more important sort: religious ideas and cultural influences that have shaped the development of the whole region. Nepal in a sense was a great switching station for the spiritual and intellectual impulses that traveled up and down this chain of human exchange.

The caravan route brought in its path great surplus wealth. Monies were poured into impressive public works—temples, fountain complexes, monasteries and palaces—and both the Hindu and Buddhist religious traditions which developed symbiotically were articulated in complicated and unique forms. Today, Nepal is the home of a form of Mahayana Buddhism found nowhere else in the world, a complex of belief and practice that holds clues to older forms that have since been wiped out.

For the greater glory of these esoteric ideas, generations of artisans developed a tradition of craftsmanship that became renowned throughout Asia. Working with wood, stone, metal and hand-ground pigments, these artisans, of an ethnic group known as Newar, came to be in great demand in the courts of neighboring kingdoms, and today, their handiwork is in evidence in every city and village of the Kathmandu valley. Miraculous works of art enshrined in and decorating temples, at crossroads and points of religious epiphany can be seen at every turn of the head. Almost anyone who visits Kathmandu refers to it as a "living museum," and no amount of repetition is likely to turn the epithet into a cliche.

Yet Nepal is a living museum in a far more profound way as well. The treasures of its many temples are in the hands of select groups whose job it is to safeguard and display it on appropriate religious occasions. Annually, each temple, for example, will play out the mythological drama of its resident divinity through a festival. The temple's images, adorned with ornaments, are proudly displayed. Similarly, wealthy families who possess their own images, or community institutions endowed with an image commissioned through donations of poorer individuals, engage in this custom.

The festival calendar punctuated by frequent displays and processions functions as a museum system in its own right. The masses of people who go on pilgrimage to see the sacred objects, or who partake in a procession, are annually reminded of their common heritage and are bound together into a solid social network of shared beliefs and responsibilities. Because these images are so rarely seen, they remain sacred, and these displays of art are crucial in keeping religious meaning and cultural traditions alive.

Until the 1950s, few foreigners had ever visited Nepal. The Ranas, a family of autocratic oligarchs which ruled the country for over a century, had successfully kept the country independent of colonial domination and in isolation. Following a revolution that restored the monarchy to power, Nepal embarked on a program of development, aided by the richer nations of the world, and threw its doors open to the international community. By 1975, more than 100,000 tourists were flocking to the "Himalayan paradise" annually, and more and more foreigners were becoming residents as development projects and embassy representations expanded. Today, there are direct flights from Kathmandu to Bangkok, Hong Kong, Karachi, Rangoon, Dacca, Dubai, Colombo, New Delhi, Calcutta and various other cities in India.

Nepal is naturally and culturally fascinating, and aside from the tourists, it has drawn an ever-increasing number of scholars and researchers of every stripe. Over the course of just a few short decades, they have accumulated vast quantities of knowledge for the benefit of humanity. Yet this knowledge, too, has been put to a more pernicious use, for it allows us to name and number, appreciate rarity and finally, assign value. When it comes to antiquities, this is dangerous knowledge indeed, for it allows a market to be defined and for people to smuggle and deal. Now, there exists a professional group of Westerners who reside in Kathmandu a significant portion of the year and whose primary vocation is the smuggling of antiquities.

Yet this is not a new phenomenon. These smugglers have simply taken over the job from less single-minded predecessors, others who have done the same job under the guise of being scholars or embassy or foreign mission employees from just about every major Western country. That the antiquities of Nepal have been steadily disappearing is simply proven by looking at the number of museum and private collections of this loot, or even by simply paging through art magazines and noting the advertisements for galleries specializing in Nepalese art. These galleries in Albuquerque, Los Angeles, Miami, Seattle, and New York like to do business "by appointment only."

Several years ago, I entered a gallery on Madison Avenue in New York and came face to face with a seventeenth century *torana* from Nepal. *Toranas*, beaten in metal or carved in wood, sit above the doorways to the inner sanctums of all major temples in Nepal. An integral feature of temple architecture, they function as a kind of iconographic blueprint, portraying on their surfaces the deities a devotee can expect to encounter inside the temple. On this particular torana was an incarnation of Siva, one among the triumvirate of great Hindu gods, sitting in meditation. At the back of the gallery, however, behind a desk in the inner sanctum as it were, sat not Siva but an art dealer named Krishna.

**This brass *Torana*, which rests above one of the door-
ways to the sanctum of white Machendranath in Kath-
mandu, has had its tutelary images stolen. The temple
today is enclosed by bars installed by residents fearful
of further theft. *Photo by D. Sassoon.***

Seeing the torana on Madison Avenue struck me as wholly unnatural, if
not sacrilegious, and I couldn't help inquiring how the hell this object had
come to be where it was. I was promptly escorted out the door. Since then I
have become more adept at masking the intent of my curiosity, and in a sub-
sequent conversation with a well-respected and venerable old dealer of ori-
ental art, I was candidly informed that Nepalese antiquities are really periph-
eral luxuries of our culture. If we possessed none of them, we would hardly
be impoverished.

"There are collectors who are serious and genuine, but most are—let's
say 'extroverts'. They want to show off. It's an ego trip. A collector will want
Nepalese art because it is different. Not many people are collecting it. It's
exotic," this dealer explained. "And anyway, Nepalese art is not really suit-
able for the modern mind. It has so many curlicues. It might look good with
French furniture, but that's about it. Don't you agree?"

This dealer was a rather endearing fellow. I wish I could say the same
about another dealer I happened to meet recently who had the demeanor of

a smug parasite. He had just returned from Nepal with five exquisite (by his account) pieces and had already found his buyers. He was well aware of what I thought about what he was doing, and he made the claim that never has he "smuggled" anything out of Nepal. After some circumlocuitous conversation, I established that every piece he has exported has had an appropriate stamp from the department of archaeology, easily acquired by paying a large enough sum of money to the man in charge of the wax and the official government seal.

I also established that this dealer had little concern for the country that provided the bounty upon which he lived. He had more to say about the opening of a new restaurant than about the events of the year (1986) that were socially, economically, and politically significant: the advent of television; the installation of a new government under a new prime minister; the attempted assassination of a prominent journalist at home in bed in the dead of night; the opening of the border with Tibet to tourists; a crackdown on heroine smuggling that implicated former government ministers. Surely these events must have left a trace that could be tasted in a place other than a new restaurant. I could not help feeling that I was conversing with a human sponge that had found a rather comfortable niche, affordable, balmy, and exotic.

If I heap what appears to be an inordinate amount of opprobrium upon this poor man, it is only because in the context of this discussion of ethical behavior, such contempt seems deserved. It is true that he is freely and honestly fulfilling his desires and engaging in free enterprise which we encourage and hold so dear. A bit of common sense, however, makes it clear that this sort of behavior is presently detrimental to the cultural integrity of many Nepalese, and also in the long run harmful to our very own quest for knowledge and understanding. The price we pay for allowing this business is of a far more costly sort than the sums paid for an ancient masterpiece.

Anthropologists will testify to the breakdown of tradition that comes in the wake of disappearance of art works. The indigenous museum system that has evolved over centuries is being threatened by the appetite of a more powerful and foreign one. Many wealthy families have stopped displaying their images, while many temples are now obscured by fences and iron grillwork which not only are aesthetically offensive, but which also prevent devotees from giving offerings and receiving blessings in a traditional manner.

At the same time, Nepal's own scholars have grown resentful of the rape of their country. One professor at Tribhuvan University in Kathmandu had the following to say in a letter on this matter:

> "I have a friend who is an archaeologist who has all but given
> up his profession, because according to him, every time there

is an illustrated lecture on the art history of Nepal delivered by [names deleted] it is almost 100 percent sure that the art objects discussed have vanished from Kathmandu. The United States' art historians have academically guided the art pillage of Kathmandu." (K.P. Malla, letter, 1984).

This is a rather damning and exceedingly straightforward statement from the pen of a man who speaks with some authority from the perspective of the victim. He did not mention, however, another reason why his friend may be giving up his profession. Aside from a few exceptional cases, the policy of the government of Nepal prohibits archaeologists from digging within the country, and this policy is likely to continue given what is happening to the antiquities that lie on the surface.

The Rising Nepal, the government's English language daily newspaper, lent support to this policy in an editorial published on November 17 of 1984:

> The need to provide security is clearly called for to ensure that our relics and artifacts from our past are not allowed to slip through our fingers and end up decorating a lovely—but foreign—museum or art gallery. If we cannot provide such security, it might be a good idea not to encourage such excavation work: our treasures may be safest under twenty feet of earth.

This is a shame, and we have only ourselves to blame. Indications from the few excavations that have been permitted point to an unimaginable wealth of secrets that lay buried in the rich soil of the Kathmandu valley. In addition, if the speculations of Gautam Vajracharya, one of Nepal's foremost art historians, are true, there are literally treasure houses of wealth buried under the ground. In a brief article which at first seems like a footnote to an arcane bit of architectural history, Vajracharya described the practice of burying treasure as common throughout many centuries that witnessed repeated invasions of the Kathmandu valley. He gave evidence of the existence of hitherto ignored underground caches of wealth beneath the back yards of medieval palace compounds. (Vajracharya 1984).

The invaders who threaten the Kathmandu valley at the present time are of a different sort than previously, but their actions encourage the continuation of a drama of hide-and-seek. Unless the developed nations of the world, and the scholars, dealers, and collectors who live there, adopt a more responsible policy to safeguard the treasures of the world, Nepal's contemporary culture as well as its heritage will continue to be impoverished through theft, avarice, and neglect. The last and only resort for Nepal and similarly victimized nations may be to restrict cultural exchange and the honest search for historical understanding.

A FEW GENERAL RECOMMENDATIONS

The case of Nepal presents an instructive example of the abusive and destructive nature of the present avenues along which the collection of antiquities gain ground. Most attempts to correct this situation have focused on various formulas to regulate and control this trade through legal mechanisms that have proven too complicated, ambiguous, and virtually impossible to enforce. The basic problem with all these treaties and laws enacted by nations individually as well as internationally is that they proceed from a negative point of departure: that is, they seek to prevent lucrative activity without any real authority, and capture malefactors without the ability to punish. While the efforts to initiate such mechanisms are necessary, they should go hand-in-hand with exploring ways of encouraging behavior in a positive direction.

One notion that we have clearly lost sight of is patronage, with the patron as the defender, protector and advocate of a cause, in our case Art. The idea of patronage has degenerated over the course of time to such an extent that today we bestow on the collector the nobility of the patron. By no stretch of the imagination can today's collectors be seen as defending, protecting, and advocating the cause of Art.

After having seen the great artistic achievements of the Nepalese *in situ,* I cannot avoid the sensation of witnessing a great crime when I stand before those same antiquities wrenched from their living context and forever relegated as a curiosity in a well-humidified but hermetically sealed plexiglass cabinet. Exhibitions are instructive and entertaining, thus valuable, and the general public cannot be expected to travel halfway around the world to see the great works of other cultures. Yet we probably possess enough artifacts in our basements to mount unique exhibitions continuously for another century, and we can easily offer newly studied or freshly discovered masterpieces to the public through the channel of international exchange rather than theft, if only we would be willing.

There are those who argue that collectors are saving much of humankind's heritage from certain doom by extricating it from inimical surroundings of decay, neglect, instability, and poverty. Senator Daniel Patrick Moynihan has been for more than a decade the champion in Congress of art dealers and collectors, and has used his influence to maintain the *status quo* in this country's laws. "Nothing has been more striking than the respect which Western countries have shown for the artifacts of other countries," he once argued in Congress. While he and others are to a certain extent correct, this attitude betrays a paternalism that may show a respect for artifacts but a lack of consideration for the very countries in question.

This is where a revived notion of patronage comes into play. Instead of removing antiquities from their place of origin, could we not contribute to preserving them *in situ?* Could we not share our expertise and wealth to build museums large and small, and of still unimagined originality, all over the world? Could we not support the creation of new works of art, could we not make sure that the age-old knowledge preserved by today's threatened craftsmen be kept inviolate into the future?

These efforts until now have been primarily advocated by organizations such as UNESCO, which has had a bad name of late. There is no doubt that such efforts could also be championed privately. It has been estimated that the trade in antiquities reaches nearly a billion dollars per annum. Surely people with vast riches could exercise a bit of common sense and make a more visionary effort.

There is another positive direction in which efforts can be made that would benefit the public, enhance international understanding, and show respect for other cultures: we can refine our ideas of what is worth collecting and include the creative products of contemporary culture. By limiting our interest to valuable antiquities, we exhibit our avarice and declare to its victims that only their forebears ever produced anything of a standard of quality such as to merit our attention.

A few years ago I was in Puri in India, the holy city that is the home of the Lord Jagannath. There, on the broad boulevard, animated by the sound of the bare feet of countless pilgrims walking on the sandy street toward the grand temple, I found a stall in which icons enshrined in light bulbs were offered for sale. You could purchase for a few rupees a painted clay statuette of your favorite god of the Hindu pantheon, or even one of Christ, set on a simple wooden base and covered by the shapely dome of a discarded Phillips bulb. They were the most charming constructions, and they spoke volumes about the spirit of devotion, about ingenuity, resourcefulness, and about a wholly different notion of value in a setting of humble poverty. Surely such things as these, or the clay figurines and colorful paintings made by devotees on festival days in Nepal, belong in our museums.

If such a notion seems far-fetched, we need only look at the same impulse in our own country, at the Vietnam Memorial in Washington, D.C., where our own pilgrims are leaving momentoes of every sort that are being collected and stored by the Park Service for posterity. I can imagine an exhibition of these a hundred years from now that would be far more instructive to our descendants about the heart and soul of our times—like so many gods in light bulbs—than any of the grand abstractions now being produced in the ateliers of Greenwich Village.

Finally, there is another more complicated and difficult step we can take

in a positive direction, and that involves lifting the veil of secrecy which surrounds the international trade in antiquities. If this business is indeed to be conducted on an ethical basis, then we certainly should not have anything to hide. Yet, the assumption that transactions are entitled to be kept private pervades the antiquities market.

Paul Bator, a lawyer and member of the United States' negotiating delegation at the drafting of the UNESCO Convention, made the following trenchant observation in an article he published in the *Stanford Law Review* of January 1982:

> It is assumed that buyers and the public have no business knowing where and when and for how much an object was acquired. It is the propriety of secrecy which is assumed; and it is secrecy which enables persons, otherwise aspiring to the highest standards of personal probity, to become accomplices in the acquisition of looted masterpieces.

The public must be informed constantly about the issues involved in the continuous pillage of our heritage. We must ask questions, and the public must be encouraged to ask questions. We must replace the reflexive awe with which we are taught to regard anything connected with the world of Art with a more realistic appraisal of the function and mission of this possibly exalted and exalting activity. Because we live in a society that values so highly the right to know, with enough clamor and properly directed outrage, we have a chance of lifting this veil of secrecy, and expose to public disgrace—a most powerful and effective instrument of correction—those who would destroy the soul of humankind, those who would denigrate our past, present, and future.

REFERENCES

Bator, Paul
 1982 An Essay on the International Trade in Art. *Stanford Law Review* 34(2): 275–384.
The Rising Nepal, 1984 Editorial. [English-language daily newspaper of the Nepalese government.] November 17.
Vajracharya, Gautam
 1984 *The Treasure Garden: A Survival of Nepalese Landscape Architecture.* Paper delivered at the University of Wisconsin, Madison, Wisconsin, Asian Studies Conference.

The Murals of Teotihuacán: A Case Study of Negotiated Restitution

The legal and ethical issues concerning the repatriation or restitution of cultural property has been a topic of discussion among nations for centuries. Art and artifacts have been traded, stolen, or taken as the booty of military victory, sometimes being returned years later to the country of origin, but more often, being kept in a "foreign" country in a national treasury or museum.

In recent years the tempo and tone of the demands for restitution, particularly from so-called Third World countries (often referred to as supplier nations) has increased dramatically as the entire archaeological record of past civilizations is being destroyed by thieves who supply a voracious international market for art. International bodies like the United Nations Educational Scientific and Cultural Organization (UNESCO) have debated the issues and developed guidelines and policies which are hoped to help remedy this intolerable situation. The United States is one of a few wealthy industrial "consumer" states that has been slow to heed the cry and its museums, collectors, and art market have been criticized for decades as being the most villainous. Perhaps this kind of blanket criticism makes it especially important to describe the efforts of over more than a decade to negotiate the ownership of a group of Pre-Columbian Mexican wall paintings left in a bequest to

Thomas K. Seligman

73

The Fine ArtsMuseums of San Francisco.[1] The situation began in the summer of 1976 when Crocker Bank of San Francisco called my office at The Fine Arts Museums and said that we were one of the beneficiaries of the estate of Harold Wagner. First I requested the bank send a copy of the will to me and to our city attorney so that we could understand the entire context of this bequest.

I went to Harold Wagner's house in downtown San Francisco in August 1976. It was an incredible experience. Laid out over the entire living room floor and a good part of the dining room and basement were wall paintings which I was sure were from Teotihuacán, an important and famous Pre-Columbian city just north of Mexico City which flourished a thousand years before the Spanish conquest (100 BC–AD 800).

Some of the mural fragments were framed and mounted with decorative cork borders. Some were just in boxes on the floor. I had never confronted a situation like this before, although I was aware of the kinds of issues that might be involved—questions of illegal importation, repatriation, and international treaties, let alone the issue of stabilizing and preserving the delicate murals.

As curator-in-charge of Africa, Oceania, and the Americas for the museums, I was responsible for the care and ultimate deposition of these artifacts. The first concern, from the point of view of any museum professional, has to be for the safety of the objects. These priceless murals were scattered around Wagner's house, which was being shown to the other legatees, and Crocker Bank wanted to sell the house as quickly as possible to settle the estate so they could deal with the distribution of the assets. We pointed out to the bank that the murals were on a fragile four-inch-thick adobe backing, having been sliced out of ancient walls in fragments of varying sizes, including a fourteen-foot-long serpent. They were obviously very delicate and should not be left around the house. Crocker Bank and the museum worked out a temporary solution where the museums stored the objects until the will was probated and the assets, including the murals, were distributed.

Wagner's handwritten will was very unusual in that it stated that the deceased "hoped" the museums would pay for all costs of administering the estate in return for receiving its bequest of the murals. Our lawyer advised us that was impossible according to local laws and it could be alleged that we

[1] The Fine Arts Museums of San Francisco was created in 1972 by the merger of two separate city-owned museums—the M. H. deYoung Memorial Museum and the California Palace of the Legion of Honor.

Mural fragments from Teotihuacán before and after
conservation. Photo on top shows the torso and head
of a processional figure wearing a tassel headdress.
The fragments are boxed as they were transported
from the bequest of Harold J. Wagner to the Fine Arts
Museums of San Francisco. Photo on bottom shows the
same fragment after conservation, positioned within
a larger portion of the mural. This piece was among
those returned to the Instituto Nacional de Antropo-
logía e Historia (INAH) in Mexico City. *Photos by James
Medley, Jr.*

were buying the murals if we followed such a course. Thus we had a complex dilemma of conflicting legal and ethical issues.

My ethical position and my institution's ethical positions may or may not have been the same. I had only tested this area once before when in 1975 we were contemplating buying a stone object from Nigeria. In that instance after some research I had reason to believe the object might have been taken illegally from Nigeria. So before proceeding I wrote to the Nigerian Department of Antiquities and obtained their permission to acquire the object.

We could have tried a similar approach with Mexico, although this was not the same kind of situation, as we were not willing buyers, only a legatee to Wagner's will. Our institution's position was contained in our acquisitions and collections management policy, which had recently been revised following Clemency Coggins' 1969 article focusing on the despoliation of Maya sites. After her revelation of the terrible looting of sites in Mexico and Central America for the antiquities market, a number of museums formulated what were known as "self-limiting acquisitions policies" under which we would try to police ourselves. Our policy was broad and theoretical and this situation became its first test case.

At the time of Wagner's death, the 1970 UNESCO "Convention on the Means of Prohibiting and Preventing the Illicit Import, Export, and Transfer of Ownership of Cultural Property" had been passed, although it had not been signed by the United States. The Art Museum Directors Association had touched on the issue of cultural patrimony and what one could or should do in this regard in their 1971 manual *Professional Practices in Art Museums.* And there was the 1971 "Treaty of Cooperation Providing for the Recovery and Return of Stolen Archaeological, Historical and Cultural Properties between the United States of America and the United Mexican States" which specifically refers to wall art, and there was no question that these murals were wall art within the definitions of the treaty.

We had no firsthand knowledge of what Mexico's position might be as no one on our staff was professionally involved with Mexico. We did some research with our attorneys and talked to people in the Department of State concerning what the Mexican laws and attitudes might be. It became clear to us that Mexican law and U.S. law were definitely opposed on the issue of ownership. The most fundamental question to me was how to best start dealing with Mexico and with whom should we deal. If the will was probated and the murals came to us, they would be ours by U.S. law, yet we would want to recognize Mexico's moral position and possibly negotiate some sort of shared ownership or partial repatriation.

All of these questions led to a great deal of research. We consulted

widely with other art historians, museums, professional organizations, and lawyers. We had lengthy discussions with objects conservators in this country and from the International Conservation Center in Rome, because the objects were clearly fragile. Even though Crocker Bank had used an art packer to move them to the museums, the first time we opened them, two of the objects were broken, thus amplifying our concern about their condition. We were surprised to learn that there was very little precedent that could enlighten our situation. One related precedent was the well-publicized case of Norton Simon's acquisition of an Indian bronze sculpture depicting Shiva as Lord of Dance, known as Shivapuram Nataraja. Simon acquired the Shiva in 1972 from a New York dealer for $900,000. The dealer had somehow acquired it from a well-known collection in Bombay which in turn had somehow acquired it from a restorer who was treating it for bronze disease after it had been removed from its temple in South India. The government of India sued Simon for the object's return and in April 1976 the government and Simon agreed that Simon would give up title and rights to the Shiva in favor of India and India would agree to loan it to the Simon Foundation for ten years, after which it would be returned to India. A side agreement allowed the Simon Foundation to freely acquire any Indian art treasures located out of India for a one-year period with full immunity from India. This was for the stated purpose of exhibiting other great works "along with the Shivapuram Nataraja as a help to better understanding between people of differing cultures."[2] Thus there was at least one recent precedent of a joint agreement on the restitution of an important piece of cultural patrimony.

Even though Wagner's will had not yet been probated and the murals were not yet ours, we began our discussions with Mexico in July 1978 to take the first steps. As an institution, we had decided that we must discuss the situation with Mexico and see if we could work out some kind of mutually satisfactory agreement.

Our first contact was our local Mexican government representative, the Consul General in San Francisco. This was against the advice of several who felt that we would get hopelessly lost in the politics and bureaucracy of the Mexican government. Quite the contrary, the Consul General was extremely helpful and put us in touch with the National Institute of Anthropology and History (INAH) which has authority over all Pre-Columbian sites and objects in Mexico. It was with INAH that we had all our future discussions.

[2] Press release, Norton Simon Museum of Art at Pasadena, August 11, 1976.

From our preliminary research we concluded that the murals were definitely from Teotihuacán and were authentic. We were sure that they were of great quality, and were the largest concentration outside of Mexico. There are only about a dozen other Teotihuacán murals in American and European museums all of which had come out of Mexico in the 1960s. However, the specific location or structure at Teotihuacán from which these murals were removed was still unknown.

After our initial discussion with Mexico in July 1978, the Mexican government formally requested the U.S. Attorney General under terms of the 1971 Treaty of Cooperation to block the probation of the will in U.S. District Court and assist Mexico in their recovery of the murals. There was much legal maneuvering to keep the lawyers busy.

At the same time we were also very busy. Our trustees adopted a four-point position that would guide us in the discussions we hoped to carry out with Mexico.

1. The museums would consult with the Mexican officials and specialists on the identification and methods of preservation of the murals.

2. The museums would consult with Mexican specialists and others on the proper disposition of the murals.

3. The murals would not be moved until they were made stable.

4. Whatever the ultimate disposition, we hoped to build a positive mutual relationship with Mexico.

In our discussions we recognized that we were willing to voluntarily return to Mexico some or all of the murals. The legal issues began to be resolved in late 1978 when the court rejected Mexico's claim under the 1971 treaty. The court reasoned that Mexico had no case because the treaty is not retroactive and there was significant evidence that the murals were in fact out of Mexico and in the United States in the 1960s. This evidence included bills of sale from Mexico and a sworn and notarized affidavit by Wagner which documented that the murals were in his possession in San Francisco in 1970. And most importantly, they had been offered for sale through a couple of well-known Pre-Columbian art dealers in southern California.

With the legal issue resolved, the will was probated. The other legatees were convinced that they should not try to claim any of the murals in lieu of the museums' not paying the cost of the estate, because they would have received these priceless treasures with the same legal and ethical concerns that the museums faced; and the museums were in a much better position to resolve the issues than were private individuals.

With the probating of the will, the murals became the property of the City and County of San Francisco under the jurisdiction of The Fine Arts Mu-

seums of San Francisco. By city charter, it is illegal to give away city property without obtaining something of equivalent value. So we could not just return the murals to Mexico, because we had to receive something of value in return.

The laws were in conflict—by U.S. law we owned the murals and by Mexican law and belief Mexico owned them. To resolve this impasse, we chose to try to find a compromise that would allow both sides to benefit, while, of course, protecting the murals.

Right after the murals were distributed to us we began very serious negotiations with INAH, and in November 1978 we invited their representatives to San Francisco to view the murals. Their representatives made several visits, along with other North American art historians, archaeologists, and conservators. The murals were available so the experts could photograph them and perform detailed examinations. We visited Mexico to meet with the INAH officials and see the Mexican conservation center at Churubusco.

In 1979 we agreed with INAH on a general ten-point approach for the joint care of the murals, the voluntary return to Mexico of some of the murals, and the possibility of a series of joint educational and exhibition programs with INAH. These ten points were later condensed to four. Negotiations seemed to be going along very smoothly and in May 1979 we arrived at a final draft of an agreement with INAH's lawyer in San Francisco. Then something strange and unexplained happened. For nearly a year we heard nothing from INAH, despite repeated phone calls and attempts to contact them. We were mystified. I speculate that what may have happened is that after their lawyer had worked out the agreement in San Francisco, he went back to Mexico, and the Director General of INAH was unable to agree to the terms. In any event, García Cantú, who was then Director General, sent us a letter in February 1980 with a proposed new agreement which essentially threw out everything we had been discussing for the last eighteen months. It stated that Mexico wanted all the murals back and wanted the museums in San Francisco to pay all costs for their conservation and return to Mexico. We felt like we had been betrayed and were not sure why. This demand was directly opposed to the 1970 UNESCO Convention which clearly says that the costs of the restitution of cultural property is the responsibility of the country requesting it. In other words, Mexico should be responsible for paying all costs if San Francisco agreed to the demand for restitution.

Probably the single most important document that we used as a guideline from this point forward was the 1979 UNESCO-commissioned study done by the International Council of Museums (ICOM) entitled "Study on the Principles, Conditions, and Means for the Restitution or Return of Cultural

Property in View of Reconstituting Dispersed Heritages" (UNESCO 1979, re-printed in *Museums*). The study had some very significant sections which were germane in our thinking and in the final resolution with Mexico.

Section 10 says, "Only those objects that are indispensable to people in understanding their origin and culture should be subject for request for restitution." And Section 31 states, "It would thus be preferable that the transfer of property remain relatively exceptional, given, on the one hand, the serious legal and practical difficulties involved in this procedure [in this case, the direct conflict of our laws], and on the other hand, of the availability of technical methods which are much more flexible and easier to implement at the simple level of museum institutions, and which lead to practically identical results. Such is the case for long-term loans, in particular. . . ." An example of such a loan is a Mayan stela at the Los Angeles County Museum of Art which is on long-term loan from Guatemala.

Those two sections of the ICOM study reinforced our feeling that we were taking the proper ethical stance since the international museum community had essentially validated our position. This gave us the encouragement we needed to proceed and push harder with our colleagues at INAH.

In concluding the negotiations we worked with INAH for another year and eventually returned to the essentials of the four-point agreement that had been worked out earlier in San Francisco.

The agreement, concluded in December 1981, stipulated:

1. The museums would voluntarily return to Mexico a minimum of fifty percent of the murals to create a positive moral climate and precedent. INAH would pay the transportation for the murals' return.

2. The museums would raise funds to pay for a joint conservation and education project at The Fine Arts Museums of San Francisco. INAH would provide conservators to work with our conservators on the consolidation and strengthening of the murals.

3. The murals returned to Mexico and the murals staying in San Francisco would each be exhibited and each party would credit the other's involvement and participation.

4. We would continue to work together to develop future exhibitions.

The Mexican government changed completely in late 1982 and there was about a six-month hiatus during which nothing happened on the mural project. When the new INAH administration took over, this project was not high on their priority list. Meanwhile we made some initial inquiries to determine if there was interest from corporations or foundations in funding this project. In January 1984 I went to Mexico to meet Dr. Enrique Florescano Mayet, the new Director General of INAH, and, very importantly, to determine if INAH still recognized our agreement. Dr. Florescano and his staff

were very receptive and made it clear that not only was the agreement in force but that we should resolve all the details of the joint conservation program.

We were very fortunate in our fund raising and received grants from CITICORP, the National Endowment for the Arts, the National Endowment for the Humanities, and the Fleishhacker Foundation in San Francisco. In May 1984 we began the joint conservation project which was done as an exhibition. We used two adjacent galleries with a window between them. One was the lab where the conservation team worked on the murals in view through a window from the other gallery. The second gallery served as an education center which included a description of Teotihuacán, a few untreated murals, a discussion about the issues involved in the restitution, and a video tape showing the entire conservation process on one mural from beginning to end. This was especially useful, as visitors who looked in on the conservation might see somebody meticulously scraping the plaster off the back of a mural for hours.

Our problems were not fully resolved at this point because the actual conservation work led to some substantial disagreements in approach. For the past fifteen or so years at their Churubusco lab, the Mexicans had been developing a technique for entirely removing the backing of murals. This involved adhering cloth to the front of the mural and chipping off all the backing, then adding a lightweight styrofoam backing. We didn't like this technique for several reasons. First, in one of the experimental tests we saw that there was a lot of the pigment left on the surface of the covering fabric after it had been pulled off the mural's surface. Second, we didn't think it was structurally necessary. And most importantly, the adobe material on the back had shells, plant fiber, and other materials embedded in it that someday could be of use in figuring out more about these murals. We determined that we must find a way to consolidate the murals using a mounting system, as well as a packing and storage system, that would protect their physical integrity. We succeeded in this and were able to convince our Mexican colleagues that this jointly developed system had considerable merit.

In February 1986 after all the murals were conserved and the backing system was in place, about seventy percent of the murals were returned to Mexico. Coincidentally, ten years to the day that Wagner died, the Mexican government inaugurated an exhibition at the National Museum of Anthropology on the repatriated murals from Teotihuacán. Dignitaries were there—American Ambassador John Gavin, the Minister of Public Education Licenciado Miguel González Avelar, the Minister of Foreign Affairs Bernard Sepúlveda, and Dr. Florescano, the Director General of INAH. The Mexican government and press made a lot out of the event, which I think was terrific because we

The 1986 opening exhibition celebrating the return of the Teotihuacán murals from the Fine Arts Museums of San Francisco to the National Museum of Anthropology in Mexico City also celebrated the successful culmination of a decade of negotiations regarding the murals. Pictured discussing some of the fragments are (left to right) **Mario Vásquez,** Mexican archaeologist; **Marcia Castro Leal,** Director of the National Museum of Anthropology; **John Gavin,** United States Ambassador to Mexico; **Licenciado Miguel González Avelar,** Mexican Minister of Public Education; **Thomas K. Seligman,** The Fine Arts Museums of San Francisco; **Bernard Sepúlveda,** Mexican Minister of Foreign Affairs. *Photo courtesy of USIS.*

wanted this cooperative project to become a precedent, a model that others could look to and, we hope, follow.

Currently we are working on a joint exhibition and catalogue focusing on the art of Teotihuacán which will be co-curated by scholars from INAH and our museums. We hope this exhibition will be shown in two or three museums in Mexico and two or three in the United States in the early 1990s.[3]

Whose moral responsibility is it to develop this kind of solution? There were moments in our long and sometimes frustrating negotiations with Mex-

[3] For further discussion of the restoration of the Teotihuacán murals, see essays in Berrin 1988.

ico when we could have said, "Forget it. Your counter offer is ridiculous. We reject it. Our law says they're ours; we have them and we will keep them. Adios, Mexico." We certainly could have done this, but we didn't believe it was morally right. I think it is our responsibility as well as the other country's responsibility to negotiate in good faith. We have to see it as a two-way street; we both have to see the moral responsibility, even though we may have different perspectives as to the why. One issue I am very sensitive to and became increasingly aware of during this whole process is the question, are we becoming moral imperalists? It seems quite clear that we are viewed as cultural imperialists, and are we now guilty of trying to impose our new-found values on the responsible methods for dealing with another culture's property on that culture? It is something that troubles me.

Another question to ask is whether preservation or educational consid-erations should override national sovereignty? Being a museum profes-sional, I must answer yes. Conservation concerns have to override all other concerns. If the object is damaged or destroyed, who benefits? Obviously, no one. Educational considerations, I think, are much more subtle. Our dis-cussions with Mexican authorities led me to understand that they see this agreement as very positive educationally. National treasures and especially Teotihuacán are used extensively by Mexico in advertising for tourism and to promote an awareness and understanding of Mexico's important history. Most Americans think Teotihuacán is an Aztec site rather than a city built hundreds of years earlier by a completely different culture. There is a lot of education that needs to be done and both sides see the validity in having murals here and in Mexico which help to inform our citizens.

Let me close with two related questions that have been posed to me by colleagues, particularly from the museum community. Does this voluntary return of objects compromise the museum's stated mission to collect ob-jects? Are we violating that responsibility—that trust—by this kind of volun-tary return? And do agreements like this open the floodgates to requests for restitution?

Since the Cultural Property Implementation Act (P.L. 97–446) was en-acted into U.S. law on January 12, 1983, there have been only three requests for restitution. The first country—and for some time, the only country—to proffer a request for restitution under the act was Canada. The second was El Salvador, then Bolivia. Hardly a flood. I am convinced that the floodgates are not going to be opened by taking an action that is defensible from a moral position and also realizable from a legal one.

After all this time and energy I am convinced that ethical considerations are much more important than legal ones. It is easy for nonlawyers to be intimidated by the weight of the law and the force of the courts, but in my

judgment, the ethical considerations are vastly more important if you have the time, willingness, patience, and endurance to pursue them.

REFERENCES

American Association of Museums
> 1978 *Museum Ethics.* Preface by Giles W. Mead. Washington, D.C.: American As-
> sociation of Museums.

Association of Art Museum Directors
> 1971 *Professional Practices in Art Museums.* New York: Association of Art Mu-
> seums Directors.

Berrin, Kathleen, (editor)
> 1988 *Feathered Serpents and Flowering Trees: Reconstructing the Murals of
> Teotihuacán.* San Francisco: The Fine Arts Museums of San Francisco.

Coggins, Clemency
> 1969 Illicit Traffic in Pre-Columbian Antiquities, *Art Journal* XXIX/1 : 94–98.

The President of the United States
> 1972 *Message from the President of the United States Transmitting the Conven-
> tion on the Means of Prohibiting and Preventing the Illicit Import, Export, and
> Transfer of Ownership of Cultural Property.* Washington, D.C.: U.S. Govern-
> ment Printing Office.

Senate and House of Representatives of the United States of America
> 1983 *Title III: Implementation of Convention on Cultural Property.* Washington,
> D.C.: Public Law 97–446, 97th Congress.

United Nations Educational, Scientific, and Cultural Organization
> 1970 *Convention on the Means of Prohibiting and Preventing the Illicit Import,
> Export, and Transfer of Ownership of Cultural Property.* Paris: UNESCO.

United Nations Educational, Scientific and Cultural Organization
> 1979 Study on the Principles, Conditions, and Means for the Restitution or Return
> of Cultural Property in View of Reconstituting Dispersed Heritages. *Museums,*
> vol. XXXI, no. 1. Paris: UNESCO.

United States of America and the United Mexican States
> 1971 *Treaty of Cooperation between the United States of America and the United
> Mexican States Providing for the Recovery and Return of Stolen Archaeologi-
> cal, Historical, and Cultural Properties.* Washington, D.C.: Ex. Doc. 91-K.

Part I

In the introduction to this book, Warren tells us that the language we use and the questions we ask reflect our conceptual frameworks—the world view which we bring to the issue of the ethics of collecting cultural property. This approach, which is both anthropological and philosophical, can help us understand the perspectives presented by the "victims" in the first section of this book.

Nichols, Klesert, and Anyon (Chapter 1) in their very title, "Ancestral Sites, Shrines, and Graves" establish a claim of legitimacy to enter the debate—a debate which, as Sassoon (Chapter 4) notes, has generally excluded the participation of the descendants of the people who generated the heritage items now so avidly sought by others.

Nichols, Klesert, and Anyon note the historical basis of the long-standing value conflict between Native American and Euro-American cultures regarding questions of use and ownership, and emphasize that cultural properties "often have a religious and cultural significance to Native Americans that has usually been ignored by the dominant Euro-American culture." Native American sites and artifacts have not been considered a national "patrimony" because of the alienation of Euro-American and Native American cultures, and because of the prevailing private-property ethic. For many Native Americans, looting is not just the destruction or alienation of property, but is considered sacrilegious as well.

Case studies from the Navajo Nation, the Zuni Nation, and the Abenaki Tribe illustrate these points. The cultural disjunction between the Navajo and the pre-

Christy A. Hohman-Caine

historic puebloan (Anasazi) is recognized by the Navajo, but the sites and artifacts nevertheless have an explanation and place within Navajo culture, which considers them as sacred places of the dead. The removal of artifacts from these sites thus becomes an affront to the religious beliefs of the Navajo.

The situation with the Zuni is much the same, and case examples given emphasize the arbitrariness (to the Zuni, as well as many other Native American groups) of the notion of ownership as defined by the Euro-American legal system.

The Abenaki examples push their perspective even further, since the Abenaki have no reservations over which they can exert direct influence regarding heritage preservation. The Abenaki examples reinforce the observation made earlier in the paper that the development of federal legislation regarding cultural resources and increasing Native American activism on the issue have developed during the same recent decades.

The Abenaki story shows that archaeologists and Native Americans can work cooperatively on issues of mutual concern, such as protection and preservation, and that differences in values and beliefs do not necessarily have to be framed or resolved within the hierarchical, adversarial perspective examined by Warren.

The motives of looters (and collectors) are seen as relatively unimportant by Nichols, Klesert, and Anyon, since the effects are, in any case, "destruction and desecration." They reject the "rescue" and "means-ends" arguments and move toward developing the perspective which Warren urges on us—one which eschews questions of property ownership and focuses instead on consensus for preservation and conservation.

The perspective of the "victim" is given a slightly different turn by Early in her chapter on artifact trafficking in Arkansas. The archaeological profession is seen as the primary victim, with the associated loss to the public, even though the public may not presently see that they are also the victims when sites are looted. To Early, an analysis of the motives of those who remove and sell artifacts outside of the standards developed in professional archaeology can be useful in "knowing the enemy." Understanding the organization and motivation of the hierarchy of "gravediggers," "dealers," and "financiers" may help archaeologists develop ways of controlling their behavior.

Early's discussion of efforts at legal control of these activities shows the problems involved and the different value perspectives of archaeologists, Native Americans, and collectors. The framing of the problem is definitely adversarial, where the debate is in terms of who has the right to control these properties. Early advances the Scholarly Integrity Argument discussed by Warren, and frames the debate in normatively dualistic terms as between

Native American excavators work with the state archaeologist in Minnesota to uncover and preserve their past through controlled excavations. Jim Harrison of the Leech Lake Band of the Minnesota Chippewa Tribe uses a pentrometer and a 50 cm. recording grid to record soil density within a house feature at 21-BL-40, the Ekstrom Site, an archaic village site within the borders of the Leech Lake Reservation and the Chippewa National Forest of northern Minnesota. Excavators kneel on pieces of board to prevent disturbance of soil and artifacts, such as cracked rock at lower right, left *in situ. Photo courtesy of Christy Hohman-Caine.*

Science and anti-science. This approach contrasts strongly with that of Nichols, Klesert, and Anyon who see the whole hierarchy/rights question as a barrier to resolving the problem.

The contrast between the philosophical approaches underlying the articles by Nichols, Klesert, and Anyon and by Early merits thoughtful consideration. Even though both are advocating preservation and conservation and, thus, may be seen to be on the "same side" of the issue, the contrast in their conceptual frameworks speaks volumes about why archaeologists and Native Americans have only rarely cooperated in achieving their mutually desired ends.

The situation which Early describes, where collectors try to take on some of the respectable trappings of professional archaeologists through the mechanisms of mounting their own exhibits and catalogues, is only a slightly more extreme manifestation of the collector-archaeology antagonism seen throughout the United States. Cooperation between collectors and archaeologists is a fine ethical line, and Early delineates in detail some of the major value differences, ethical dilemmas, and justifications involved.

The levels of collecting noted by Early also apply with emphasis when discussing looting outside the United States. Pendergast and Graham note that in Belize even knowing the extent of the problem (except to know that it is great) is difficult due to the nature of the landscape and the fact that professional archaeologists are outnumbered and out-financed.

A point relevant to the framing of the ethical questions involved and, thus, to the nature of the solutions, is thoroughly discussed in this chapter. Belize has very strong laws protecting archaeological sites: yet, looting is endemic. The major effect of the law is to demonstrate to other countries that Belize does have a concern about its heritage and to set the legitimate stage for one of the "3 Rs"—repatriation. Pendergast and Graham feel that the laws are moot in their actual effect since enforcement and conviction are rare to impossible.

In what amounts to almost a solution of despair, the authors argue that those who are the root source of the problem—whom they define as the collectors at the top, not the looters at the bottom—need to be subjected to public embarrassment through raid and seizure. Sassoon, in discussing solutions to the loss of Nepal antiquities, comes to a similar conclusion (Chapter 4). This is not a new solution and, as I can personally testify regarding a case in which I was involved, sometimes it does work, but in other situations it will be stopped cold by the prevailing "rights" ethic. Such a solution aims at redefining the hierarchy-rights perspective, but does not transform it.

Unlike many of the other authors, Sassoon immediately puts collecting into the moral realm, and dismisses the assertions of rights defined by

scholars, collectors, or anyone other than those he sees as the true victims—indigenous peoples. He sees the debate as having been, for too long, between dealers/collectors and scholars operating primarily within what Warren would call the "hierarchical" model.

He defines some of the "biases" in the underlying framework debate and sees "devastation caused by the foreign imperative to study, catalogue, and collect," which may be detrimental to the "cultural integrity" of Nepalese or other indigenous peoples. These are strong words but a perspective worth exploring. Yet Sassoon argues only for rechanneling this avarice into a revitalized concept for patronage and the collecting (and thus promoting) of contemporary non-Western art. The assertion that there is no necessary right to study or collect gets at the heart of many value conflicts, and I only wish to see a fuller discussion of the issue, particularly as seen in the light of Warren's framework. The notion that all things (realms, values, objects) must necessarily, by right, be open to examination and, thus, possession (whether physical or perceptual), is a strong Western value which lies, unquestioned, at the basis of many conflicts ranging from reburial of human remains and study of sacred artifacts, to conservation and repatriation.

Seligman's discussion of the resolution of the Teotihuacán mural case, although it was resolved to the mutual satisfaction of the major parties involved, raises some important questions. The legal issues of the case were resolved first (who legally owned the murals—Mexico or the United States?). U.S. law and Mexican law were diametrically opposed on the matter, but since the murals were in the United States, the legal system of the country of location (not origin) prevailed in fact. That the case did not end there is an excellent example of how the relevant ethical issue was not solved by appeal to legal principle.

The guidance of extra-legal standards was found to be extremely important, for example, and the issue was finally resolved through compromise in which both major parties were able to achieve goals important to them.

The article leaves us with some real thought-provokers, in spite of the success involved. "Are we becoming moral imperialists?" asks Seligman. "Should preservation and education override national sovereignty?" Since he frames this latter question in a hierarchical, rights framework, Seligman answers in the affirmative.

All these articles illustrate how difficult it is, even from the perspective of the victim to cease framing the issue within the dominant perspective. This might not be the problem and might be a matter for only philosophers to analyze were it not for the very real consequences of defining the problem in a way which offers few, if any solutions. The feeling of despair evoked even when successful resolutions are discussed, shows us that the victims,

whether indigenous peoples, Third World countries, archaeologists, schol-
ars, or museums are, in spite of their collective power and control over the
mechanisms of legality, not able to achieve their ends. Perhaps our ends are
not convincingly framed to the larger world. When the argument appears to
be over right to control, not preservation and stewardship, the public ap-
pears to be indifferent, and rights embedded in historical precedence (pri-
vate property, free enterprise) prevail.

The important legacy of these articles is that they take some of the steps
toward changing that situation. As Warren urges us to do, they make more
visible the conceptual framework of the debate over cultural properties and
they start us rethinking how to move the resolution of this conflict from
a value-hierarchical model toward a compromise or consensus model—
models which may offer solutions that can be realized.

The Cultural Stewardship
Question: Looking for Options

The Museum and Cultural Property: The Transformation of Institutional Ethics

Like most museum directors in the arts I occasionally have confronted ethical issues in connection with collecting works of art for my museum. As an administrator I am usually tempted by the desire to solve problems by issuing administrative mandates and enunciating clear-cut administrative decisions. You will probably find my position direct and easy to comprehend, although you may not agree with it. My own area is fifteenth-and-sixteenth-century European art; I have never been deeply or actively involved in the collecting or study of Pre-Columbian art, Southeast Asian art or, until recently, the art of classical antiquity. I have no special expertise in these issues, but I do have some ideas about them which I hope may be of use to the reader.

A few years ago I served as president of the Association of Art Museum Directors, a group of about one hundred fifty directors of American museums with annual budgets of over one million dollars. During my tenure as president, the Cultural Property Repose Act was proposed in the United States Senate for the first time. The alleged purpose of that legislation—which has never been enacted, by the way, despite several attempts—was to protect American museums from capricious or arbitrary claims by foreign governments on cultural property in American museum collections. The first draft of that legislation (which had as its primary goal a statute of limitations to protect the museum) provided that any object

Alan Shestack

held by a museum for two years was protected against seizure or claims by foreign governments regardless of how that property was originally obtained. In other words, if this legislation had become law, an American museum would have been allowed to acquire an illegally exported or stolen piece, stow it in a storeroom for two years, and then be protected by Uncle Sam from foreign government claims to that property. The draft legislation was amended a few times and it finally included the requirement that the American museum exhibit the object in question during the two years rather than merely have possession of it. In my capacity as president of the museum directors, I was asked by several senators' staffs if I and my colleagues would endorse the legislation and if I would testify before a senate committee on the need for such a law. I brought the issue to the floor of the next meeting of the museum directors after circulating copies of the proposed legislation to the entire membership.

The issue was discussed at some length, with two museums speaking for the repose act and about twelve against it. The final vote was ninety-nine to seven against endorsing the repose act. I was instructed to write on behalf of the museum directors' association to the several congressmen and senators sponsoring the legislation to say emphatically that our profession not only did not endorse the act, but that we were overwhelmingly opposed to it. We felt that it was a kind of *carte blanche* to thieves and pillagers of archaeological sites and to those museums that engaged in illegal practices, suggesting that their activities were acceptable and that they would be protected by our own government if only they could hide the objects that they bought or exhibit them in rather inconspicuous places. My letter back to the various congressmen and senators suggested that there was a need for some kind of legislation protecting against capricious claims, but for our association to take such legislation seriously, it would have to include some or all of the following minimum requirements:

1. The object in question must be put on prominent or conspicuous display in a gallery with public access for a minimum of five years rather than two years. The object could not be displayed in a storeroom or in a director's or curator's office.

2. The work should be published at the outset of the five-year period, not in the journal of the museum or in a monthly newsletter, but in some internationally acknowledged or recognized journal. The five-year statute of limitations would not begin to run until the publication actually appeared.

3. We also suggested the creation of a registry, some kind of formal published listing, even a few pages in small type in every fourth issue of the *Art Bulletin* or in some designated archaeological journal in which all

museum acquisitions of monumental sculpture or fragments of monumental sculpture or architectural elements, at the very least, be listed. The purpose of this requirement was to make it easy for foreign governments or their friends or agents to determine if a public institution in the United States had acquired an object which had been illegally or improperly removed from its site or place of origin.

The Cultural Property Repose Act disappeared from public discussion for a few years, but it was revived again late in 1985 when a senate committee once again held hearings for such legislation. Directors of two other museums testified as to the pressing need for such legislation. But when these two individuals came back to the Art Museum Directors' Association at our January 1986 meeting to ask the association to consider changing its position and endorse the Cultural Property Repose Act, they again lost the vote by an overwhelming majority. When Paul Perrot, Director of the Virginia Museum of Fine Arts in Richmond spoke about the need of American museums to condemn rather than endorse the Cultural Property Repose Act (it was seen by him as an attempt to help museums collect illicitly obtained artifacts), he got a round of enthusiastic applause. The two other speakers, the endorsers of the act, were met with polite silence.

This sort of action suggests that American museums, heretofore naive about the looting and mutilating of archaeological sites or unconcerned about the problem, are finally becoming more sensitive to the issues. I believe American museums are more willing than ever to discuss these issues and to help seek solutions instead of being part of the problem. In fact, if you read the mission statements of most art museums you will find that we claim among our highest priorities the preservation of works of art for future generations. I personally find—with most of my colleagues—that this claim, or this goal, is very hard to reconcile with turning our backs on the pillaging or destruction of significant cultural remains.

I have to admit that while I was Director of the Minneapolis Institute of Arts, I was a little embarrassed by the presence in that museum of a brutalized stela from Piedras Negras in Guatemala—an object the museum acquired in the 1960s. [It was included in Clemency Coggins's 1969 list of stolen Maya monuments.] The object was obviously mutilated in the process of being removed from its original site. It is in wretched condition now, hardly enjoyable to look at; I can hardly imagine why my predecessors here wanted it, given its state at the time. And there it sits. I think if the Guatemalan government wanted it back, I would be only too happy to give it back. But I cannot imagine why they would, in fact, want it now.

There is another object in the Minneapolis museum which embarrassed me even more. It is a Greek fourth-or-third-century BC terracotta head. When

I was director of the Yale Art Gallery, I had the piece on approval in my office in New Haven, Connecticut for about a week. I had seen it in a dealer's gallery in New York and liked it very much. Not being a specialist I was wary of making a commitment to buy it and asked if I could take it back to Yale to show it to some specialists in ancient art. The dealer granted me permission, and I actually took it on the train that afternoon.

The next day I called a classical art scholar on the art history faculty at Yale to come to my office and take a look at this object. He asked if he could pick it up and take a look inside the hollow head. I said, "Well, with tender loving care you may pick it up." He did so, and after running his hand around the inside of the hollow terracotta head, asked, "Where did this come from?" He explained, "The reason I ask is that the soil on the inside of this is still ever so slightly moist. It is as if it has been excavated in the last month or two. It can't be something that has been out of the ground very long." I said, "Well thank you for tipping me off," and I put my hand inside and felt around. Sure enough it didn't feel totally dry; it wasn't sandy, it was a little moist.

So I called the dealer and said, "Could you tell me a little bit about the history of ownership of this object, or at least when it came into this country?" His answer to me was, "Better not to ask." I said, "Pardon me?" He said, "Believe me. You won't get into any trouble. No one knows where it came from. There's no one who's looking for it. You can't even identify the country of origin with any certainty." So I said, "Well, when you say 'Better not to ask' that makes me want to not buy it," and the very next day I returned it to New York.

While I served as Director of the Minneapolis Institute of Arts, we had on approval from a dealer in England a New Guinea mask which everyone here agreed was an extremely powerful and wonderful object. We had board members who were ready to contribute toward the purchase of this highly desirable piece. But our intrepid Curator of Pre-Columbian, African, and Oceanic Arts, Louise Lincoln, asked the dealer if we could have copies of the papers showing that it had come out of New Guinea legally. We were actually told that such papers existed. But the xerox copies we were promised just never came. And Louise then found out from a colleague who does fieldwork in New Guinea that it was suspected that this particular object had been smuggled out by a French art dealer. A short meeting in my office led to a decision to return the mask to the dealer as soon as possible. It was our unanimous opinion that the improvement of our collection through the addition of this superlative piece was not worth it, since by buying it we would not only be risking our reputation, but would be encouraging or at least

**This Chacmool statue, similar to several exhibited in museums in Mexico, was purchased by the Minneapolis Institute of Arts in 1947. It was said to be from "near Chichen Itza." In 1958 the piece was loaned for an exhibition which toured various European cities for two years before it was discovered to be a fake. In 1985, the Minneapolis Institute of Arts used the Chacmool, clearly identified as a fake, in an exhibition called "Problems in Connoisseurship and Conservation." Examples such as this illustrate problems museums face when dealing with unprovenanced objects.
Photo courtesy of the Minneapolis Institute of Arts.**

seeming to be encouraging, or winking at, illicit activity in the international art market.

I should add that it is not easy psychologically to come to a decision of that kind. Museum professionals are acquirers; we are inherently greedy collectors. Most of us go into the profession because the desire to accumulate and bring together objects of quality is in our blood. We are personally and professionally devoted to adding to and improving our holdings—that is

what makes us tick. And to consciously or intentionally turn down a highly desirable object we can afford to buy on the basis that we suspect that it might have been removed illegally from its country of origin—and also knowing that it will end up in the collection of a rival institution or an unscrupulous private collector is a very hard thing to do. But those museums which do so, it seems to me, can and should apply a certain degree of moral pressure on the others.

If you put it in its most simplistic terms, the "good guys" can in fact persuade the "bad guys." In my twenty years as a member of the Association of Art Museum Directors, I have seen unethical or illegal practices which were relatively common at one time virtually disappear. I think the same thing can happen in the arena of international trade. The mood is right and the time is right, although with some of our museums and some of my colleagues, it is going to be a tough fight.

One midwestern museum director said to me recently that when he directed a museum with modest purchase funds it was easy to be on the side of virtue and goodness, but now that he has several million dollars a year for the purchase of art, it has become impossible to ignore tempting objects of all sorts. "After all," he said, "We're hired to build and improve the collections and if we pass things by, those things will certainly end up in other collections. If that happens too often our trustees will gradually come to view us as unsuccessful directors." The director of course serves at the pleasure of the board, and directors are constantly being fired. In the museum directors' association, about ten percent of the memberships are usually vacant at any given time, usually due to recent dismissals. A number of the directors feel that they act at their own peril if they adopt moral or ethical attitudes about cultural property which would seem to the collectors on their boards of trustees to be a kind of holier-than-thou attitude.

Often the biggest problem the museum director faces in this collecting activity is not the museum's activity but the collecting activity of his or her board members, especially if those people occasionally present the museum with an object. You cook your own goose very quickly if you tell a museum member or board member that you will not accept their gifts on quasi-legal and ethical grounds.

What do I recommend? What is my simplistic answer? Do I have a prescription for putting an end at least to the looting of cultural treasures?

I have some suggestions, and I have one concrete idea. I think we can make quick progress in certain areas since it seems to me museums would be virtually unanimous in condemning clandestine excavations and the pillaging of archaeological sites. No one with any shred of professional integ-

rity could avoid agreeing with the condemnation of the decimation of monumental sculpture or architecture—those monuments that are attached to the ground as it were. And I agree with Paul Bator in his excellent book, *The International Trade in Art,* that to be effective, laws must be specific, reasonable, and enforceable.

I would thus argue that any law adopted should focus on cultural property of great importance to the cultural history of the place of origin, as the UNESCO Convention would have it. It should focus on countries whose cultural patrimony is in critical jeopardy—countries such as Guatemala for example—and also on those objects that were clearly stolen from museums, such as the treasures that were taken from the National Museum of Anthropology in Mexico City in December 1985. Obviously those thieves deserve to be strung up by their toes. But I do not believe one can police or control the present illegal traffic with our current customs apparatus and procedures. I would suggest that monumental sculpture, or fragments thereof, as well as architectural elements be the primary focus of legislation, together with such items as the *Afo-A-Kom* which for the citizens of Cameroon, is more than a sculpture: it is a unique and central symbol of their religious and cultural traditions. [See Merryman and Elsen 1987: 56–58 for a discussion of this case.]

The problem with the UNESCO Convention is that it is excessively general. In the United States it has never been given the teeth of strong implementing legislation. We should be pressing Congress to tighten that legislation for many reasons. From the museum's point of view, stringent unequivocal federal laws would make it easier for museum staff to confront the local collectors and refuse their proposed gifts to the museum. Strong laws would give the director not just moral grounds but compelling legal ones. It would also help sanitize the marketplace and discourage unscrupulous dealers.

I should point out that all laws are divided into retrospective and prospective activity. The laws I am proposing cannot be ex-post-facto; they must go into effect on a certain date in the future—as soon as possible as far as I am concerned—and all previous activity would be excused. Only by doing this would we get a consensus among museum directors so that they would support this legislation. If we say we are going to examine their acquisitions of the past twenty years, they will all be against it. But if we say, "Whatever you did in the past will be excused," there would be wide support. Only from the date the legislation is enacted would it become supportable and acceptable. This legislation, by the way, would not prohibit the initiatives of individual museums to negotiate with foreign governments about the return of

important cultural property—the kind of arrangement that the Fine Arts Museums of San Francisco made with the Mexican government concerning the collection of Teotihuacán murals bequeathed to them (see Chapter 5).

Essentially what I propose is that the buyer of cultural property, or the donee, in the case of museums, must ask the donor or the seller where the object came from, insisting on proof of ownership—legitimate ownership—and insisting on an answer that is documented and verifiable. The presumption would be that anything not so documented was imported after the arbitrary cutoff date that I am suggesting and such objects would not qualify for tax deductions on the part of their donors since it would be illegal to acquire them or, in the case of museums, to accept them as gifts. Museums would thus be forced to boycott objects illegally gotten if they were obtained after the arbitrary cutoff date. The law might further require the reporting to federal agencies of anyone suspected of illegal trafficking. I think most of my colleagues, even those who are ethical in their own behavior are very hesitant about going to a federal agency and reporting their colleagues or dealers they know or suspect are engaging in this activity.

Some may think what I am proposing here is radical and unrealistic and beyond the realm of possibility. And yet it exists in the arena of environmental controls and endangered species protection. There is an international convention, known as CITES, the Convention on International Trade in Endangered Species. It was first proposed to the United Nations and was adopted by the UN as a convention and is now incorporated into American law. It prohibits the importation of ivory, zebra skins, or other parts of endangered animals. These materials are all confiscated at our borders. It seems to me that if Congress could be made to see and understand the United States' international obligations in the area of endangered species—if we can manage to protect elephants and zebras—why cannot we also protect the heritage of Guatemala and of other countries whose heritage is at risk?

I think we can have laws that are enforceable and effective in the realm of art and artifacts. Think what a dampening effect there would be on this trade if American museums were threatened with the loss of their tax exempt status if they had, say, three violations of the law in international art trade. To make it all work there have to be laws with sanctions and clear-cut penalties for offenders. Otherwise, all the words that you will hear or read on this subject will merely be a cathartic exercise which makes us feel better about our concern for the problem but which probably will not in the long run help achieve the ends most of us seek.

REFERENCES

Bator, Paul M.
 1983 *The International Trade in Art.* Chicago: University of Chicago Press.
Coggins, Clemency
 1969 Illicit Traffic of Pre-Columbian Antiquities. *Art Journal.* Fall: 94–98.
Merryman, John Henry and Albert E. Elsen
 1987 *Law, Ethics, and the Visual Arts.* 2nd ed. 2 volumes. Philadelphia: University of Pennsylvania Press.

Collecting Pre-Columbian Art

The collecting of art is an ancient and time-honored practice. Collecting can be fascinating, fun, and intellectually stimulating—it can be the source of ideas and accumulated knowledge. Serious collectors have assembled for themselves and future scholars materials which complement and enhance the materials collected by archaeologists. Very often the serious collector is a scholar who is concerned with certain aspects of a civilization, such as musical instruments, clay seals, mirrors or ritual paraphernalia. The collector is intent on marshalling certain types of artifacts so that an assemblage will make a point or amplify our picture of the ancient world and its way of perceiving things. The archaeologist and the collector are embarked, essentially, on the same journey. Both assemble materials and attempt to deduce from them certain ideas about ancient American civilization. The archaeologist has the privilege of working directly in the ground—the collector salvages what others have found and holds it in trust for future generations.

Collecting, itself, goes back to ancient times—the Alexandrian Library or Pergamum, for instance, or the many collections of art from all over the Ancient World in Rome. Collections of Chinese painting and calligraphy were made by scholars, painters, and emperors (who were often scholars in their own right). The Medicis collected avidly, as did the popes. The very art of the Renaissance sprang out of the antiquities so avidly collected by the artists' patrons. And these collections are

Gillett G. Griffin

the nuclei of our great national museums—the Louvre, the British Museum or the Vatican.

Museums in many cities in America—particularly New York, Cleveland, Philadelphia, St. Louis, Boston, Detroit, San Francisco, and Minneapolis, as well as our national collections in Washington, have relied upon the individual collectors who have given the great museums the depth and direction which allows them to rival their peers in Europe. It has been the Morgans, the Mellons, Kress and many others who have helped to establish our museum patrimony.

Pre-Columbian art was sent back to Europe by Cortez. It was not the gold, but Aztec utilitarian goods that Albrecht Dürer saw in Antwerp and wondered at on his tour to the Netherlands in 1520 (Conway: 1956). Feathered textiles and wooden objects, as well as jade and obsidian found their way to Madrid, Rome, Vienna and, eventually to London, Paris, and Berlin.

It was, however, Robert Woods Bliss who may be credited as the first serious collector of Pre-Columbian material as great art. In 1912 he bought his first Olmec jade figure in Paris (Lothrop: 1957). He and his wife shared a passion for Byzantine art. She also collected books on gardening and created a series of topical gardens based on great European gardens, while he truly pioneered in the collecting of Pre-Columbian art. Dumbarton Oaks, their home in Washington, now a museum, is enduring testimony to their passion for collecting, their acumen, and their taste. They wanted their collections to be shared by the people of Washington and by visitors, foreign and domestic. For Robert Woods Bliss ancient American art was as important and as great as any art in this world and a heritage which should be shared.

Thus, Robert Woods Bliss established at Dumbarton Oaks an international center with a great library and a foundation for scholarship to study the beauty, function, and meaning of Pre-Columbian art and architecture. Under the guidance of Elizabeth P. Benson, through fellowships and international conferences, much of our present knowledge of iconography, epigraphy, and the interpretation of archaeological finds has been arrived at in Dumbarton Oaks. And all of this has been made possible through the foresight of a great collector, Robert Woods Bliss.

There have been other concerned and involved collectors, such as George G. Heye, who through his passionate interest in Native Americans and their artistic accomplishments, accumulated what is probably the greatest resource of Native American art to be gathered together in one place, the Museum of the American Indian in New York City. His collection embraces the arts of all Native Americans in both continents, from ancient times to the

What began as the private collection of Robert Woods Bliss, Dumbarton Oaks serves as a research center for scholars and a museum of Pre-Columbian art. Dumbarton Oaks hosts annual conferences and awards stipends for scholars who use its research facilities. *Photo courtesy of Dumbarton Oaks Research Library and Collections, Washington, D.C.*

twentieth century. His collection is also a public resource and is of the utmost importance to scholars and Native Americans themselves.

But the ideal example of the collector-scholar is Miguel Covarrubias. Covarrubias was a painter, illustrator, designer, anthropologist, scholar and, above all, a collector. He worked for a number of years in New York as an illustrator and caricaturist for *Vanity Fair* and *The New Yorker.* In Mexico, his native country, he was fascinated by the Indians, the ancient civilizations and the iconography of those ancient civilizations. He was one of the discoverers and early champions of the Olmec—the first great civilizations of Mesoamerica. He used his very great artistic abilities to untangle the welter of forms, icons, and symbols which confront and confuse the initiate to Pre-Columbian art. He created scholarly, beautifully illustrated, well-written

(maybe the best written) books on the anthropology, archaeology, and art of his native Mexico, and also works on Central America, North America, and Bali. Above all, he was a collector and he used his collecting to learn and to teach and eventually to excite the world to the greatness, depth, and diversity of ancient American art.

In Mexico he gathered about him, encouraged, advised, and inspired a group of collectors. Most of these were foreigners or expatriots—for the Mexico of that time was still ambiguous about its native and mestizo roots. He and his circle of collectors enthusiastically acquired materials from sites which the archaeologists were hesitant or unable to explore. He was at all times close to and worked with the archaeologists. Although a number of the collectors are now dead, most of the material from their collections remains in the National Museum in Mexico today, though several pieces are to be found in great museums in the United States and Europe.

Having described other collectors and their legacies, let me briefly explain my personal background and how I became a collector. Collecting, in some miraculous way, has helped to create my life and its directions.

I have always been interested in ancient and beautiful objects. While at school in New England at the age of fourteen, I bought the middle fragment of an eighteenth-century children's book, filled with crude woodcuts, in an antique shop. The fragment, which I believed was a *New-England Primer,* fascinated me and precipitated the avid collecting, over the next ten years, of some 750 illustrated children's books, printed in New England before 1846. In pursuing these rare books I became interested in early binding, paper, typefaces, and illustration, as well as the writers and publishers of children's literature over that long period of nearly 150 years. Collecting also introduced me to rare book dealers, curators, librarians, and other collectors. But by the time I reached college, the collecting of early children's books had become too difficult and prohibitive. The sources of early American children's books had dried up and my discovery of and interest in art history, as such, had awakened. But my exposure to the world of books, printing, and typography had paved the eventual way for my first career—that of Curator of Graphic Arts in the Princeton University Library.

While at college, I bought an early Japanese print for two dollars. This precipitated an interest which became passionate and initiated a collection of Japanese prints, bought at a time when no one was interested in them and therefore they were affordable. To understand and fully appreciate them I turned to friends that I had made at the New York Public Library, while collecting children's books. They not only taught and guided me, but one of them insisted that I visit a shop which sold ancient Chinese ceramics. I bought a simple Northern Song Dynasty (tenth century) bowl with the ghost

of Song calligraphy on its foot, for eight dollars. It occurred to me for the first time that even a poor student could afford to buy beautiful ancient art. I discovered that, as with the rare book dealers who had become good friends, art dealers were generally highly intelligent, scholarly, and well-informed and were more than delighted to share their knowledge and to teach a young student. Soon, every bit of money that I could spare went into the purchasing of ancient art.

It may have been the year after I had bought my first Japanese print that I noticed an ancient Pre-Columbian clay figurine fragment in the dust and rubble in the window of a junk shop. I bought it for twenty-five cents. A fellow student, who was fascinated by American Indians, suggested that I take it to George Kubler, one of Yale's great art historians, and an expert in Pre-Columbian art history. He let me attend his class that afternoon, where I listened enthralled for three hours. For the first time I became aware of such site names as Teotihuacán, Tiahuanaco, Tlatilco, Tikal, Tenochtitlán and Tula. Afterwards Dr. Kubler looked at my fragment and guessed that it probably dated somewhere close to 400 BC and came from the Valley of Mexico. That class lecture and encounter with Dr. Kubler hooked me on Pre-Columbian art.

As the years went by, the emphasis of my art collecting veered more and more toward the fascinating and enigmatic world of ancient America. It was not until my parents died, in 1961, that I was first able to go to Mexico. Then I found myself going as often as I possibly could, to see firsthand the areas from which my pieces had originated, and which I had known only through drawings, photographs, and plans. It is important to me to breathe the air in a place, to see where the sun comes up and sets, the peculiarities of each terrain, and how it feels to walk in the architecture.

At one point I decided that I had to get back to painting, which I had studied in college, and creative work in general, so I resigned from my delightful job in the library to go to Mexico for a year to study, travel, and paint. While I was gone I lent much of my collection to The Art Museum. The next year I was asked if I would become the first Curator of Pre-Columbian Art at The Art Museum at Princeton. Several years later I was asked to teach Pre-Columbian art in the Department of Art and Archaeology at the University.

It had been my privilege to teach in a great institution, using original works of art. I am sure that my students have benefited from actually seeing and in some cases actually handling them. Princeton has hosted a number of important scholarly conferences, given seminal exhibitions, and published the results of these. Therefore I can empirically say that collecting can be positive and beneficial. The collection has been a magnet for scholars and ideas.

Pre-Columbian art is relatively new on the collecting scene. Stigmatized as "primitive" by many museums and most art historians, it has been over-looked, generally, by collectors. Picasso, Braque, and Matisse drew atten-tion to African and Oceanic art. The boldness, vigor, and size of much of this art made it dynamic and, somehow, accessible to the adventurous collector. Museums awarded "primitive art" dramatic space. Most Pre-Columbian art could only be found in ethnographic museums. Pre-Columbian art seemed unapproachable to most people. Even in Mexico—with the exception of its great twentieth-century painters, Rivera, Covarrubias and Tamayo—Pre-Columbian art was considered something of a cultural embarrassment.

There have always been a few libidinous collectors who have tarnished the reputation of collecting: those who acquire primarily as an investment, for personal glorification or just plain greed. These persons are not neces-sarily knowledgeable in the field or even care much about it. They tend to use dealers or experts to select and authenticate for them. Often these people have wealth and use it for power. There have been voracious or un-scrupulous collectors throughout history, in every major civilization and, unfortunately, they are the same ones who create fashions in collecting and push the prices up; they often make off with the finest pieces and generally give collecting an unsavory reputation.

In some countries wealthy and powerful nationals have rewarded or even hired looters to bring materials to their collections. Some of these nation-als—wealthy as they are—have added to their coffers by selling to the inter-national market. In areas where corruption is the rule from the government on down, outside pressure can have little effect.

In most Third World countries governments change regularly, and with them the chiefs and staffs of departments, such as anthropology and ar-chaeology, which are appointed politically. Often those in charge of pre-cious national patrimony have let it be destroyed through graft, avarice, or indifference.

Of the thousands of ancient sites in Mesoamerica or the Andean area, well-trained archaeologists can only hope to work on a few. The modern countries which serve as the custodians of their ancient civilizations's re-mains are seldom wealthy. Their archaeological staffs are often limited by insufficient funds, and in some cases inadequate training. In many of these developing countries, important archaeological complexes have been de-stroyed by urban sprawl, oil refineries, or hydroelectric projects, which threaten to flood vast areas. Add to that nationalism, which generally resents foreign intrusion, and one is presented with a frustrating picture of an enor-mous problem.

In countries such as Mexico and Guatemala, where many rural areas

were once the seats of ancient civilizations, the poor farmers often find things while plowing, or working their lands. It has happened more than once that modern cemeteries overlay ancient ones. Many important pieces are chance finds. Most of these are reported and go to regional museums, but for the farmer who has a large family to feed and no money it is a temptation to sell. Often the governments seize material without recompensing the finder, or simply have no money to pay him. The ideal situation would be to have enough capital and power to systematically explore ancient American sites by proper archaeological teams over a period of more than a century— providing that all of the material was properly published within a reasonable time. Under such ideal conditions it would be hoped that the most important materials be housed in regional museums and all material be made available for study. But those who are experienced in Latin America realize that this dream is hopeless.

It is not only the indifference and corruption that might trouble us about Third World countries. Archaeologists are not always without blame. Archaeology, as with many sciences, has put itself on a pedestal—it has become sacrosanct. Archaeologists, like art historians and critics, write using a technical jargon which makes their reportage impenetrable to the lay masses. Take a pivotal site, like La Venta, for instance. It was never even mapped properly, before it was destroyed by the government to make way for oil refineries. Its ceramic sequences, awaiting study for publication, were stored in a basement which flooded, destroying all labels, leaving us mouldering bags of sherds which are now useless. If archaeologists do not publish soon after excavation, their material loses meaning and is withheld from the scholarly community. If they are careless about interpreting and recording what they excavate, they can, in effect, be more destructive than looters, for they leave nothing for salvage. And so La Venta is itself destroyed, its monuments scattered, its archaeology buried in the opaque technical reports of salvage archaeology. Only in Parque La Venta, some eighty miles away, to which the stone monuments were removed (and which is being destroyed by acid rain), and the museums in Villahermosa and the National Museum in Mexico can one sense the glorious achievement of the late Olmec civilization.

Archaeologists working in a Third World country may have their hands tied politically or they may be hobbled by lack of funds. If they are foreigners, their projects may be refused for nationalistic reasons, but once in a while archaeologists, themselves, miss the mark. They may fail to grasp the true character of a site, explore it totally, or they may misinterpret its contents.

An example of a major site which was at first ignored by archaeologists,

then was caught between two schools of archaeology, is Tlatilco—one of the most important Preclassic sites in Mexico. In the early 1940s an expanding Mexico City found a rich source of clay for bricks near the tiny *barrio* of Tlatilco, now a part of Naucalpan. The deep beds of clay had been melted down from the walls of ancient adobe huts (1400–1150 BC), originally on the old lake shore. The brick workers found the clay plentiful, but full of impurities—human bones, bits of jade, pottery vessels, and hundreds of distinctive clay figurines, which were called by collectors and later archaeologists "pretty ladies."

Miguel Covarrubias immediately saw the importance of the site and urged the National Institute of Anthropology to dig. Reluctantly, after years of delay, during which time treasures were bought from the brick workers by collectors and dealers and museums all over the world, they dug. Two principal Mexican archaeologists oversaw the work: one was interested in the human bones found in the graves, the other was interested in the ceramic contents of the graves. One threw out what he considered redundant clay pieces, the other threw out many of the bones. A friend living in Mexico a few years later, under the influence of Covarrubias, began to collect Pre-Columbian clay seals. As a scholar he consulted archaeological reports and noted that the Tlatilco excavations had yielded hundreds of Olmec-period seals. When he went to the Museum storeroom to study them he found that only a token few remained. Some has possibly been discarded, but many had apparently been sold out the back door of the Museum, for over the years, many eventually found their way to his collection. He has since given his seal collection to another museum in Mexico.

This poses a serious problem which must be faced. Are Third World museums always reliable custodians of their patrimony? When the great new Museum of Anthropology and Archaeology opened in Mexico in 1967, collectors living there eagerly gave some of their finest pieces to be a part of the greatest museum in Mexico. The same collector friend, described above, had just bought a splendid Olmec jade figure at Tlatilco from the most reliable dealer there. Several months later I brought Michael Coe, the foremost archaeologist of Olmec material, to my friend's office to see his collection. Coe said to my friend, "I am sure that the jade piece which you gave to the National Museum is not from Tlatilco, but is from the Olmec Heartland." Coe went back to his library and returned the next day with the catalogue of the old Museum, which had been located on Calle Moneda. There, in a full-page illustration, was the piece which my friend had purchased at Tlatilco and had immediately given to the new Museum at Chapultepec. It had been dug up by Matthew Stirling years before at La Venta, and for years had been a central piece in the old Olmec Hall. In the few weeks that it took to move the

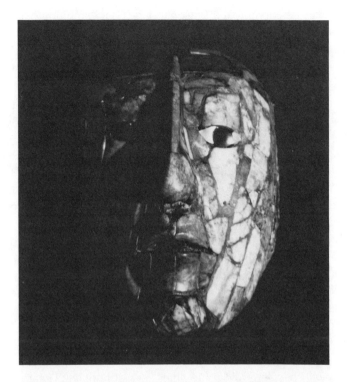

This famous mosaic jade mask from the tomb in the Temple of the Inscriptions in Palenque, Chiapas, Mexico, was one of the over a hundred national treasures stolen in late 1985 from the National Museum of Anthropology in Mexico City. Most of the pieces were recovered in June 1989 and returned to the museum. The thieves had hidden the objects in a suburban Mexico City house after finding they could not fence such well-known objects. *Photo by Lawrence G. Desmond.*

collections from one museum building to another it had gone out the back door of the old building, changed hands several times, and had been re-given to the same museum in the new building. Nobody had recognized it! Is this responsible custodianship? What guarantees that a piece will remain even in the National Museum?

One must also confront the theft from the National Museum, that took place on December 24, 1985. It was patently an inside job. I was told by Carlos Monsivais, a Mexican journalist who lectured at Princeton a year later, that the original security force (of seven men) had been fired several months before and replaced by a new crew. At the time of the robbery the

new force was celebrating at a seasonal party. The exhibition cases, which have no alarms, were simply opened, the glass fronts gently placed on the floor, leaning against the back wall next to each case, and the carefully selected works of art—some of the greatest treasures of Mexico—were lifted out. According to the journalist, shortly after the robbery Mexican newspapers reported that the haul had been offered back for ransom, but the government had refused to pay. Imagine that happening in the National Gallery of Art in Washington!

In recent years a healthy nationalism has been asserting itself, and museums and collections have played an important part in this self-realization. It is vitally important that people find in their homeland their heritage, their roots, and pride in their distinctive ancestry. Too often Third World countries have attempted to emulate Europe or America in their efforts to become "modern." In so doing they have rejected the richness of their own special heritage. Again and again we have seen local crafts abandoned in favor of imported plastic substitutes. This once-diverse planet is too-rapidly becoming One World in the wrong places for the wrong reasons. Fortunately many peoples are looking back to their ancient past, but sometimes it is too late. I have watched in Mexico the difference in pride that the National Museum has brought, changing from a sleepy, dark museum housed in an old palace, to a modern architectural wonder filled with Indian and mestizo peoples, absorbing with pleasure and pride, their special heritage. Great public figures in Mexico, such as Rivera, Covarrubias, and Tamayo have created important collections and reinforced a sense a pride in the Pre-Columbian cultures of Mesoamerica. Private individuals also have attempted collections, such as the Popol Vuh Museum in Guatemala, the Museo Frissell in Oaxaca, the collection of Carlos Pellicer in Tabasco, and the Larco Herrera and Amano collections in Lima. These all have brought a special pride to the peoples of these areas. And it is likewise important in America that our Latin population finds itself and its heritage in the museums and collections of this country.

Many of the treasures of Tlatilco were bought at the site from the brickworkers by collectors and dealers before the archaeologists began systematic digging, and these pieces are in museums all over the world. It is fortunate that the collectors got them before they were all destroyed in the process of brickmaking. Today, tract housing covers all of Tlatilco and there is no hope of further excavation. Another extraordinary group of clay pieces began to appear on the market from an area which archaeologists were afraid to explore—central Guerrero. The area surrounding the Balsas River had the reputation of being hostile both in terms of its people and its terrain. In the late 1960s a variety of fine clay objects began to surface from the area

of Xochipala. The style appeared to be very early and extraordinarily sophisticated—especially a series of miniature clay portraits which surpassed, in quality, anything seen before. Fascinated by them and having always been interested in Guerrero, I purchased what I could manage and tried to keep track of whatever I could not. Together with Carlo Gay, an expert on the Formative art of Guerrero, we put together the first, and so far the only exhibition on that specific material, at Princeton (Gay: 1972). Before our exhibition or any catalogue, before the name of the style was generally known, forgers had already been at work. We included some of these resourceful fakes in the exhibition by way of instruction, for counterfeits can teach us a lot. A good Mexican friend, who was curator and designer of the Olmec section of the National Museum of Mexico at the time, tried to get the Museum to buy an example—to convince them that one, at least, should be represented there. But they would not spend the money. Xochipala pieces are in collections in Europe, the Far East, and America, but none that I know of is in the National Museum in Mexico.

If Miguel Covarrubias were alive today he would probably be out of favor in Mexico, his own country. He was above the corruption of his time and undoubtedly the bureaucrats and politicians of today would scorn him. He surely would have become the scapegoat of the 1970s—partly because of his universal interests and friendships, and partly through his collecting and deep feelings and beliefs in the ancient and modern Indians, who he felt to be the very backbone of Mexico. He took pride in and saw the beauty, truth, and importance of the works of the ancients. He championed collecting as a vehicle for understanding and appreciating those cultures, and felt that the world should share with Mexico in them. Far from being a chauvinist, he was a universalist. Few true descendants of the ancient artisans are in control of their patrimony at the present time. It is mestizos and politicians who use the ancient material as a political football.

Purists would try to stop collecting. I have heard someone quoted who would rather see art destroyed than have it outside of its country of origin. We are listening to the hoary voice of iconoclasm.

Collectors and museums should be able to add to and amplify their holdings. If American institutions are prevented from collecting world art, and cease to acquire material to add to our cultural heritage, others will step in and take our place. Neither Germany, nor Switzerland, nor England, nor Japan will ever ratify the UNESCO Convention whereby they would accept the obligation to protect their own and other nations' cultural property from illegal import or export. They still acquire and will continue to do so. Recently the winds of prohibition have been stirring in America, but we should never forget that we have had our own disastrous fling with Prohibition.

Collecting can be positive and creative. In my own collecting I have not concentrated on buying only masterpieces, though one always favors the piece which will excite the viewer and possibly involve him or her in the beauty of an ancient culture. But rather I have felt it very important to buy certain objects, even fragments, to keep track of them or because they reflect some cultural phenomenon which might be important for study. My collection, not unlike those of most of the serious collectors that I have known, has always been open to scholars, students, and anyone interested in the field. The collection has been available for loan and used for colloquia. I teach using original material, because I believe that a hands-on experience is necessary to the true understanding and recognition of ancient works of art. I collect fakes and I teach with them. It is important to keep track of what fakers are making and their work. Not only individual but even fake art styles have been invented by clever fakers, whose work has sometimes become accepted by unsuspecting scholars (see Litvak King's discussion of Brígido Lara, Chapter 13).

I feel that I am not the owner, but only the custodian of the works which I have assembled, and my goal has been to pass them on to the world in an ordered way, so that they will add to the knowledge of present and future generations. And this, I believe, is the true goal of the serious collector: to assemble disparate works of art, put them in meaningful order and to bring to the attention of the world the beauty and integrity of the art of civilizations which we are just beginning, through archaeology, iconography, and epigraphy, to understand.

Collecting, at its best, leads the collector into uncharted and unexpectedly fertile areas. It can open new fields of study and new approaches to thinking for the collector and future scholars. The juxtaposing of seemingly unrelated material often produces a fresh and revealing insight into ancient culture and its iconography. It can, as well, establish new paths in scholarly research. The assembled legacy of a serious collector becomes the grist of future scholars. True collectors, by necessity, become scholars in the field in which they collect. They gather with a viewpoint, to amplify aspects of a civilization, or to reinforce theories or beliefs. In spite of the specific directions of any collection, its materials become a source for scholarship in succeeding generations.

REFERENCES

Conway, William Martin
 1956 *The Writings of Albrecht Dürer.* New York: The Philosophical Library. Pp. 101–102.

CHAPTER 7

Gay, Carlo T. E.
> 1972 *Xochipala, The Beginnings of Olmec Art.* Princeton: Princeton University Press.

Lothrop, S. K.
> 1957 *Robert Woods Bliss Collection, Pre-Columbian Art.* New York: Phaidon Publishers, Inc. P. 7.

International Control Efforts: Are There Any Good Solutions?

The United States, both legally and culturally, is unique among the nations of the world in its attitudes toward cultural property. Harris (Chapter 10) provides an excellent survey of U.S. import laws that affect this kind of material. A disparate and often confusing assortment, they reflect this country's ambivalence and lack of coherent policy regarding cultural heritage. Furthermore, the United States is almost alone in having no export restrictions of any kind on its own cultural property: no laws would prevent Mount Vernon from becoming an amusement park in the middle of Tokyo. Until the 1983 passage of legislation to implement the UNESCO Convention on Cultural Property (Chapter 9), the United States had no comprehensive policy at all regarding the international movement of cultural property. But while the full UNESCO Convention deals with export as well as import and urges signatory nations to take steps to protect their own cultural patrimony, the U.S. implementation is limited to measures restricting the import of objects from abroad.

The United States does have some laws intended to protect important cultural property domestically, such as the Archaeological Resources Protection Act (ARPA), the Historic Preservation Act, and various provisions of the tax code (e.g., deductions for donations to museums). What is important to recognize about these laws, in contrast to those of other countries, is that they

Ellen Herscher

are all based upon ownership, and that almost all cultural property in the United States is privately owned. Thus an archaeological site on federal lands is protected under ARPA—because the government owns it—but a site on privately owned property, perhaps of much greater significance, is at the disposal of the owner. One result of this situation has been the appearance of the Archaeological Conservancy and similar groups. A typically American approach to the protection of cultural property, this private organization buys important archaeological sites. In almost any other country in the world, it would be the government's responsibility to protect these sites.

Since most other countries have taken unilateral steps to protect their cultural heritage, the limited nature of U.S. laws raises an ethical issue not addressed by Mr. Harris. Since what is imported into this country had to have been exported from somewhere else, what is legal in the United States may at the same time be breaking the laws of another country.

Nations use three basic types of laws to protect their cultural property (Bator 1983: 37–41). The first of these is selective export controls, or screening, intended to retain only the most important objects while allowing a generally free trade. Such a system is used, for example, in Canada, Japan, and the United Kingdom. The second system involves total export restriction, or embargo, an approach used by some Latin American and Mediterranean countries, the Soviet Union, and the People's Republic of China. Finally, numerous countries (e.g., Mexico) simply declare national ownership of certain types of cultural property (e.g., Pre-Columbian antiquities), including property still undiscovered. For example, an archaeological site in the jungle of Campeche or Quintana Roo is considered to be owned by the Mexican government even if it has not been discovered, mapped, or excavated. What all these laws have in common is the concept of a "national cultural patrimony" as something important to the nation as a whole and distinct from private ownership or possession.

In addition to these unilateral efforts, a number of governments have entered into international agreements to help regulate the trade in cultural property; Harris (Chapter 10) surveys those that affect the United States. There are also some bilateral treaties (Belgium and Zaire, the Netherlands and Indonesia), and a Council of Europe Convention is in draft form.

Since the illicit traffic in cultural property is, like narcotics, an international problem, these multilateral approaches seem to hold great promise, although the chronicle of the implementation of the UNESCO Convention by the United States clearly demonstrates the practical obstacles to their effectiveness (Herscher 1983:350). Certainly the Cultural Property Implementation Act (Chapter 9) is an important piece of legislation, but the aspects of the UNESCO Convention that it does not include show how inter-

national agreements will be adjusted to suit domestic priorities (Clark 1986). Due to the nature of the U.S. political and economic systems, this "ratification" of the convention includes no provisions for export permits, dealer registration, regulation of museums, nor does it recognize the definitions of cultural property used by other signatories. (For the full text of the Cultural Property Convention, see UNESCO 1983:57–70. For extensive discussion of the relevant provisions, see Merryman and Elsen 1987:91–107.)

As a result of these political realities, nongovernmental measures to control the illicit traffic are extremely important. These usually take the form of ethical codes or policy statements adopted by groups or individual entities. Foremost among these statements are those of the International Council of Museums (ICOM), the worldwide professional organization of museums and museum staff, which restrict museums' acquisition of objects of illicit origin. These include "Ethics of Acquisition" (1970, published in Burnham 1974:194–197), and the comprehensive "Code of Professional Ethics" (1987, excerpts in Herscher 1987a). Adherence to the last is now a precondition for ICOM membership. Also influential are the guidelines contained in "Study on the Principles, Conditions and Means for the Restitution or Return of Cultural Property in View of Reconstituting Dispersed Heritages," written by a UNESCO-sponsored group (Ganslmayr *et al.* 1979), although the intergovernmental committee established to facilitate negotiations for returns has produced few concrete results (cf. Chapter 5).

Several national museum associations, including those of the United States, the United Kingdom, Australia, South Africa, and New Zealand, also have published codes of ethics for their members that include guidelines regarding acquisitions. Finally, many individual museums have adopted formal policies on acquisitions that address the issue of illicit trade (e.g., Meyer 1973:254–262), though these vary widely in their particulars (Chapters 5 and 6).

Outside the museum field, the Archaeological Institute of America (AIA) has taken one of the strongest positions on treatment of objects with doubtful provenances. Its popular magazine, *Archaeology,* accepts no advertisements for antiquities, even those of legitimate origin. Its scholarly periodical, the *American Journal of Archaeology,* will not publish articles on objects in public or private collections acquired after December 30, 1973, unless their legitimate origin can be documented. The same restriction applies to papers presented at the Institute's annual meeting (Ridgway and Stech 1982). The cut-off date is that of the AIA governing council's passage of a resolution in support of the UNESCO Cultural Property Convention.

In 1984 the fine art and antiques trade of the United Kingdom, including the major auction houses of Christie's and Sotheby's, adopted a "Code of

Practice for the Control of International Trading in Works of Art" (Herscher 1987b). While ostensibly providing strict guidelines for the dealers' activities, the actual requirements of this code hinge on the possibly subjective interpretation of such phrases as "to the best of their ability," "reasonable cause to believe," and "reasonable doubt." Some skeptics suggest that the real value of this code actually lies in public relations.

These multilateral efforts show the development of three basic concepts that are changing the way people think about cultural property. First among these is the growing acceptance of the existence of a "common cultural heritage" that is distinct from ownership of particular objects or monuments. Material included in this class is recognized as benefiting all people and confers a common responsibility for its protection. The 1954 Hague Convention for the Protection of Cultural Property in the Event of Armed Conflict (UNESCO 1983:17) was among the first formal statements of this concept. The Convention concerning the Protection of the World Cultural and Natural Heritage, adopted in 1972 with the strong leadership of the United States, makes it most explicit. Its preamble reads, in part:

> . . . deterioration or disappearance of any item of the cultural
> or natural heritage constitutes a harmful impoverishment of
> the heritage of all the nations of the world. . . . it is incumbent
> on the international community as a whole to participate in
> the protection of the cultural and natural heritage. (UNESCO
> 1983:79–80)

Secondly, there has been a growing rejection of material—whether for sale, acquisition, scholarship or other purposes—that has been illegally exported from its country of origin. This attitude extends the concept of what is "illicit" beyond the borders and laws of the country in which the object in question may currently reside and acknowledges the right of all nations to define and control their own cultural property. Canada's Cultural Property Import and Export Act, for example, treats any object illicitly exported from elsewhere as an illicit import into Canada.

Thirdly, there is growing recognition that the repatriation of objects is sometimes appropriate, even when their acquisition at some time in the past may have been fully legal. No one is calling for the emptying of the world's museums, in spite of alarmist comments to that effect, but certain items— for example Hungary's Crown of St. Stephen—are acknowledged to be so central to a particular national identity that they should be returned.

Nevertheless, there remains strong resistance to these emerging ethical concepts. The American belief in the free enterprise system continues to combine with a romantic glorification of collecting that fails to recognize the

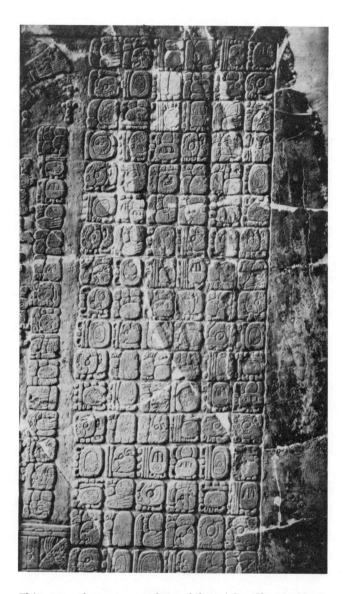

This carved stone was looted from the Classic Maya site of Palenque in the 1800s, and was later returned by the Smithsonian Institution. Charles Rowe was looking at drawings of Palenque by Waldeck and others and noticed that the piece was shown in place in the Temple of the Cross. He arranged to have the stone sent back to Mexico where it is now—an excellent example of international cooperation. *Photo courtesy of the National Geographic Society.*

major changes in global politics, economics, archaeology, and museums since the nineteenth century. Collecting objects does not necessarily "save" them from destruction and most museums now are more worried about properly storing and caring for the collections they already have (Washburn 1984).

Another source of difficulty, especially in the United States, is a kind of cultural egocentrism that attempts to judge other nations' views of their cultural heritage according to our own almost unique emphasis on private ownership. The United States, although in the extreme minority of nations without export laws of their own, still frequently seeks to define what should be included as part of cultural patrimony, thereby at least indirectly judging the laws of other nations with very different cultures, histories, and resources. This approach is most evident in the definitions contained in the Cultural Property Implementation Act, which do not cover various classes of material regarded as important by even as similar a nation to the United States as Canada (Clark 1986). The attitude is also reflected in the recent arguments for overriding the McClain decision by those who do not want to recognize the right of other countries to declare national ownership of some kinds of cultural property (Chapter 11).

Given this background, what are the most effective ways of preserving and protecting the cultural resources of archaeologically rich countries? There is much empirical evidence for what does *not* work. Sites themselves can never be fully guarded, since some are entirely unknown until looted material begins to appear on the market. Neither can a system of selective export controls like those of Japan and the United Kingdom deal effectively with archaeological material that was unknown and unowned until it was looted. Furthermore, such a system requires societal conditions, such as stability, affluence, and a law-abiding tradition that may not exist in antiquities-rich countries (Bator 1983:48–49).

A total embargo on exports clearly does not work either, except in highly controlled societies such as the Soviet Union and the People's Republic of China. Instead, since most countries have inadequate means to enforce it, a total prohibition of exports creates a flourishing black market (Bator 1981:41–43). Even in countries with considerable enforcement ability, border controls are in conflict with the general trend toward more open international movement.

In trying to find a workable, more constructive approach, it is first necessary to accept that nothing is going to be completely successful. Thus, less than one hundred percent effectiveness should not in itself be grounds for discarding a particular course of action. The search for a more effective method must also begin with the recognition of two basic principles: (1) in

National Geographic Archaeologist George Stuart examines potsherds on the floor of the cave at Naj Tunich, Guatemala, which were left by looters who visited the site shortly after it was first located. One of the formations in the cave was intact on the day of its discovery, but several weeks later someone tried to saw it off so they could sell the drawing of a ball player. Detection and deterrence of looting at remote sites is difficult; educating the public and reducing the demand for illicit objects may hold more promise. *Photo courtesy of the National Geographic Society.*

dealing with a large system in which supply and demand are linked, such as narcotics and weapons as well as antiquities, only an effort based on international cooperation will be productive; and (2) no laws or penalties provide deterrence unless there is a strong possibility that one who violates them will be caught.

The complexity and scope of the looting problem preclude a simple, one-track approach, although such suggestions are frequently made (e.g., legalize exports or guard sites better). In reality, only a multifaceted, balanced combination of legal, diplomatic, economic, and educational means will

have any effect. These measures should aim to accomplish three objectives: improved detection, increased deterrence, and reduced demand.

Significantly improved detection of looting at its site of origin will come only with the acceptance by all nations that this is a jointly shared responsibility. International technical assistance could considerably improve the protection of known sites in countries without adequate means of their own. The importing countries in particular can share security technology, provide training, and assist in the compiling of inventories. One current example of such cooperation is found in an agreement between Belgium and Zaire (van Geluwe 1979) and this has been the objective of many UNESCO and ICOM projects.

To increase deterrence, the United States needs to strengthen its import restrictions. While American art dealers, in particular, frequently argue that such restrictions only divert trade to other countries, the market is not infinite in capacity. Eliminating one segment will reduce the demand as a whole, and the United States remains the principal consumer for many types of antiquities.

As Harris (Chapter 10) makes clear, current U.S. laws pose few impediments to the import of antiquities from any source. The Cultural Property Act does provide for the imposition of limited import restrictions, but the complex mechanisms of this law have, at least so far, delayed the achievement of concrete results. What is needed are clear, unambiguous, and permanent restrictions, such as those in the 1972 law on Pre-Columbian monuments.

The deterrent value of import restrictions is not primarily in interdiction of contraband at U.S. borders. This will always be difficult to effect, although customs procedures are intrinsically better suited to screening things coming into a country than objects leaving one (hence the inherent weakness of export laws). But more importantly, import restrictions create a situation in which objects continue in a state of illegality, even after they have eluded detection at the border. Thus illicitly imported antiquities would be vulnerable to seizure by U.S. Customs at any time they are discovered (subject to any statutes of limitations). Clearly this greatly increases the possibility that a person violating import laws will be detected. Current examples, such as the Endangered Species Act and the 1972 Pre-Columbian Monuments Law, have demonstrated that import restrictions can indeed be effective in protecting categories of goods endangered at their sources.

Opposition to import restrictions in the United States has typically cited the ideal of "free trade," but in fact all countries—including the United States—have always restricted trade, in goods ranging from narcotics to animals to Japanese automobiles, when it was considered in the public interest

to do so. The only real question is whether cultural property, for public policy reasons, should be designated a special category of goods.

Interestingly, the art dealer community and some museum directors have made just such an argument, although for quite different ends, in advocating two other kinds of federal legislation. One, the proposed amendment to the National Stolen Property Act that would overturn the McClain decision (Chapter 11, and Herscher 1985a), would treat cultural property differently from subsurface natural resources, such as oil and gas, for which some nations claim national ownership. The other, the Cultural Property Repose Act (Herscher 1985b, 1986), would exempt stolen cultural property from the standard statutes of limitations governing the recovery of any stolen goods. While neither of these proposals has been enacted into law, they do seem to open the doors to special treatment of cultural property.

Nevertheless, the customary secrecy of the art trade works strongly against deterrence (Bator 1983:84) and makes it, in a practical sense, extremely difficult to distinguish illicit material from that of legitimate origin once it has entered the country. Thus measures that would open up that trade to public scrutiny would assist deterrence. France has laws that require dealers to keep records of their sales, check the provenance of objects, and guarantee title, but such a bureaucratic approach would probably meet with little success in the United States. American dealers could also follow the example of the United Kingdom by voluntarily adopting a code of ethics, although again there is no assurance that such a code would constitute more than lip service. In any case, the American dealer community in recent years has focused more attention on lobbying to protect their interests than in addressing ethical questions (e.g., Chapter 11, Herscher 1982, 1985a, 1985b, 1986). In fact, the adoption of import controls, with the requirement for export permits that would likely accompany them, could alleviate some of the dealers' complaints regarding the due process now being used by U.S. Customs, although the dealers have yet to acknowledge this benefit.

Finally, few would dispute the value of decreasing demand for illicit material as a way of decreasing the looting that supplies it. Effective means of reducing that demand, however, are not readily apparent. Experience seems to demonstrate that total embargo of exports is counterproductive in many ways, yet it remains the control mechanism of choice in many countries.

Many would take the economic approach and advocate the creation of a legal market within the countries in which none now exists as a way of reducing the demand for illicit material. Certainly the active and orderly legal exchange of cultural property is widely considered beneficial to all parties concerned, yet most embargo-maintaining countries reject the notion that

they should replace their method with some kind of screening system. This position is partly based upon practical considerations: screening requires trained personnel and a cultural sophistication capable of making irrevocable judgments regarding what to keep and what to let go, conditions not yet achieved in many countries just recently emerging into national awareness. But embargoes also stem from the philosophical position that cultural property is the heritage of the nation and not something to be enjoyed only by those with the financial means to acquire it for their personal benefit. Thus some countries, such as Cyprus, that permit no private trade in antiquities, are willing to export to foreign museums and universities for educational and public purposes.

In any case, in spite of its popular appeal, there is no real evidence that a screening system would actually be helpful in protecting archaeological material. Indeed, a strong case has been made that any market will foster looting (Bator 1983:26). Moreover, there is little incentive to adopt a screening system when importing nations do not require an export permit and make no effort to distinguish between what is legal and what is not.

The orderly exchange of cultural property can be achieved by loans as well as commerce, a method more acceptable to many exporting countries. Both Turkey and Italy have recently shown increased flexibility in making temporary loans, which permitted the U.S. tour of the "Age of Suleyman the Magnificent" exhibition and a 1988 exhibit of Roman portrait sculpture at Emory University. Such exhibitions are seen and enjoyed by many more of the public than could ever purchase antiquities of any kind for their own use.

Ultimately, changing attitudes on ethics probably will be the most effective means of reducing the demand for illicitly acquired objects. Laws at best can only be incompletely enforced, but the existence of the laws and the efforts to achieve their passage have themselves an educational effect. Other educational efforts are now widespread as well, including articles in the popular media (e.g., *National Geographic*), museum exhibits, programs involving amateurs in archaeological projects, and special discussions, meetings, and symposia.

As George Stuart's remarks (Chapter 15) reveal, education does work and attitudes about collecting have changed and are continuing to change (although some, such as Griffin [Chapter 7], refuse to acknowledge it). In a foreword to the catalogue of a 1985 exhibition of objects from their collection at Brown University, a couple described how they stopped collecting after hearing the concerns of professional archaeologists. An archaeologist working in Honduras has described how a local collector gave up the practice after working on a real excavation and learning what scientific archaeol-

ogy does. Museums, as discussed by Shestack in Chapter 6, have publicly adopted new self-regulating policies and ethical codes. Even given the most cynical interpretation, the fact that the United Kingdom art trade felt the need to adopt a formal code of practice is an indication of the state of public opinion.

Prohibition failed in the United States because most people did not agree with it and, in the face of such widespread opposition, there were not enough law enforcement resources available. Statistics show, however, that in the 1980s consumption of hard liquor has voluntarily declined in the wake of strong public attention to the health, safety, and social detriments of alcohol.

Antiquities collecting is not as widespread as drinking alcoholic beverages nor as smoking. But as changes in these activities indicate, education and awareness of detrimental effects can influence human behavior—albeit slowly. The real question is whether a sufficient change in attitudes about collecting will come in time to save the world's archaeological heritage.

REFERENCES

Bator, Paul M.
 1983 *The International Trade in Art.* Chicago: University of Chicago Press.
Burnham, Bonnie
 1974 *The Protection of Cultural Property: Handbook of National Legislations.* Paris: International Council of Museums.
Clark, Ian Christie
 1986 Illicit Traffic in Cultural Property: Canada Seeks a Bilateral Agreement with the United States. *Museum* 151:182–187.
Ganslmayr, H., *et al.*
 1979 Study on the Principles, Conditions and Means for the Restitution or Return of Cultural Property in View of Reconstituting Dispersed Heritages. *Museum* 31(1):62–67.
Herscher, Ellen
 1982 Letter from Washington. *Journal of Field Archaeology* 9:522–531.
 1983 The United States Implements the UNESCO Convention. *Journal of Field Archaeology* 10:350–360.
 1985a The "McClain Override" Bill, S.605: Hearings Held. *Journal of Field Archaeology* 12:469–477.
 1985b Congress Considers "Repose" for Cultural Property: H.R.2389. *Journal of Field Archaeology* 12:477–480.
 1986 Senate Holds Hearings on Cultural Property Repose Act. *Journal of Field Archaeology* 13:332–338.
 1987a International Council of Museums Adopts Code of Ethics. *Journal of Field Archaeology* 14:213–215.

1987b Code of Practice Now Guiding United Kingdom Art Dealers. *Journal of Field Archaeology* 14:215–216.

International Council of Museums

1987 *Code of Professional Ethics.* Paris: International Council of Museums.

Merryman, John Henry and Albert E. Elsen

1987 *Law, Ethics, and the Visual Arts.* 2nd ed. Philadelphia: University of Pennsylvania Press.

Meyer, Karl E.

1973 *The Plundered Past.* New York: Atheneum.

Ridgway, Brunilde S. and Tamara Stech

1982 Editorial Letter. *American Journal of Archaeology* 86:1–2.

United Nations Educational, Scientific and Cultural Organization (UNESCO)

1983 *Conventions and Recommendations of UNESCO Concerning the Protection of the Cultural Heritage.* Paris.

van Geluwe, Huguette

1979 Belgium's Contribution to the Zairian Cultural Heritage. *Museum* 31(1): 32–37.

Washburn, Wilcomb E.

1984 Collecting Information, Not Objects. *Museum News* 62(3):5–15.

U.S. Implementation of the UNESCO Cultural Property Convention

On September 11, 1987 the United States imposed import restrictions on Pre-Columbian artifacts from a specific region of El Salvador. With this action, the United States took the first action by any country to prohibit entry of another country's artifacts under Article 9 of the 1970 UNESCO Convention on the Means of Prohibiting and Preventing the Illicit Import, Export and Transfer of Ownership of Cultural Property. The willingness of the United States to respond to requests of other countries has given new life to the Cultural Property Convention. Of the sixty-five countries that are party to the Convention, the United States is the only one that is considered a major art importer. This paper focuses on the procedures established by the U.S. Government to carry out Article 9 of the Convention and how it responded to its first emergency request for import restrictions.

THE UNESCO CONVENTION

The Convention on the Means of Prohibiting and Preventing the Illicit Import, Export and Transfer of Ownership of Cultural Property was adopted by the United Nations Educational, Scientific and Cultural Organization (UNESCO) at its sixteenth session on November 14, 1970. The Convention represents a growing concern that the art market's high demand for rare and unique antiquities is generating rampant pillaging of archaeological

Ann Guthrie Hingston

sites and ethnographic materials, particularly in countries with few re-
sources to protect their cultural heritage. It is a framework for international
cooperation to curb the illicit movement of looted antiquities and stolen art.
Drafted with U.S. assistance, the Convention's final text "was the product of
U.S. leadership in persuading a majority of UNESCO to adopt a moderate
and compromise position" (Bator 1983: 68).

The Convention encourages each country to protect its own cultural pat-
rimony as well as to join in an international effort to assist other countries in
curbing illicit trade in objets d'art. Articles 7(b) and 9 are concerned with
cooperation among nations. Article 7(b) calls for each state party to take
measures to prohibit the import of inventoried cultural property that has
been stolen from a museum or a religious or secular public monument or
similar institution located in a state party to the Convention. Article 9 pro-
vides that a state party whose cultural patrimony is in jeopardy from pillage
of archaeological or ethnological materials may call upon other state parties
that are affected. In such circumstances, state parties to the Convention
would participate in a concerted international effort to carry out necessary
concrete measures, including the control of exports, imports and inter-
national commerce in the endangered material.

Soon after the adoption of the Cultural Property Convention by UNESCO,
President Nixon submitted the Convention to the U.S. Senate for ratification.
In August 1972, the Senate gave its unanimous advice and consent to ratifi-
cation of the Convention, subject to one reservation and six understandings.
The United States reserved "the right to determine whether or not to impose
export controls over its own cultural property" (U.S. Senate 1972) called for
under Article 6 of the Convention. In addition, the Senate noted that: "The
United States understands the provisions of the Convention to be neither
self-executing nor retroactive."

The Senate's action was not sufficient to implement the Convention in
the United States. There was no legal authority to seize artifacts solely on the
basis that they were illegally exported from another country. New legislation
was required to enable the U.S. Government to respond to requests for assis-
tance under Article 9 of the Convention. For ten years there was active de-
bate among competing interests about the Convention's implementation.
The Society for American Archaeology, the Archaeological Institute of Amer-
ica and the American Association of Museums testified in support of imple-
menting legislation. The primary voice in opposition was the American As-
sociation of Dealers in Ancient, Oriental and Primitive Art.

The Department of State testified in support of implementing legislation:
"The legislation is important to our foreign relations, including our inter-
national cultural relations. The expanding worldwide trade in objects of ar-

chaeological and ethnological interest has led to wholesale depredations in some countries, resulting in the mutilation of ceremonial centers and archaeological complexes of ancient civilizations and the removal of stone sculptures and reliefs. In addition, art objects have been stolen in increasing quantities from museums, churches, and collections. The governments which have been victimized have been disturbed at the outflow of these objects to foreign lands, and the appearance in the United States of objects has often given rise to outcries and urgent requests for return by other countries. The United States considers that on grounds of principle, good relations, and concern for the preservation of the cultural heritage of mankind, it should render assistance in these situations" (U.S. Senate Committee on Finance 1982: 23).

In the absence of implementing legislation, the Department of State took several measures to assist other countries in curbing the loss of their cultural heritage. The wanton pillage and destruction of Pre-Columbian monuments in the 1960s led the U.S. Congress to pass a 1972 Pre-Columbian Monumental and Architectural Sculpture and Murals Statute prohibiting the importation of such material without an export permit issued by the country of origin. In 1971, the United States and the Government of Mexico entered a treaty of cooperation providing for the recovery and return of stolen archaeological, historical, and cultural properties. Executive agreements were entered by the United States with the Governments of Peru (1981), Guatemala (1984), and Ecuador (1986) for the purpose of cooperating with the recovery and return of stolen cultural property. These agreements do not alter U.S. law or provide U.S. import restrictions. They do provide streamlined procedures for the return of stolen art.

In December 1982, as the 97th Congress drew to a close, implementing legislation was passed. The Convention on Cultural Property Implementation Act (Title III, P.L. 97–446) was signed by President Reagan on January 12, 1983. Later that year the U.S. instrument of acceptance, with its one reservation and six understandings, was deposited with UNESCO. It went into effect on December 2, 1983. The withdrawal of the United States from UNESCO in 1985 did not alter the Act or the commitment of the U.S. Government to carry out its obligations under the Convention.

THE CONVENTION ON CULTURAL PROPERTY IMPLEMENTATION ACT

The Cultural Property Act is a compromise measure. It grants to the President the authority to impose import restrictions but only in certain circum-

stances and only after considering the views of concerned interest groups. The President may impose import restrictions only on designated types of archaeological and ethnological material on a country-by-country basis. Archaeological material must be: "of cultural significance; and at least 250 years old; and normally discovered as a result of scientific excavation, clandestine or accidental digging, or exploration on land or under water." Ethnological material must be: "the product of a tribal or nonindustrial society and important to the cultural heritage of a people because of its distinctive characteristics, comparative rarity, or its contribution to the knowledge of the origins, development, or history of that people" (U.S. Convention on Cultural Property Implementation Act 1983: Section 302).

For a country to receive the benefits of U.S. import restrictions, the Act requires that it be a state party to the Convention and formally submit a written request to the President. If the President decides to take action in response to a request, he may impose restrictions in one of two ways. For emergency situations, he may act quickly and impose emergency restrictions. Otherwise, restrictions may be imposed after negotiation of a bilateral or multilateral agreement. Import restrictions may be imposed for five years but may be extended for three or five year periods. Before the President may take action, he must make certain determinations. For a situation that is not an emergency, according to Section 303 of the Cultural Property Implementation Act, the President may impose import restrictions if he determines:

"A) that the cultural patrimony of the State Party is in jeopardy from the pillage of archaeological or ethnological materials of the State Party;

"B) that the State Party has taken measures consistent with the Convention to protect its cultural patrimony;

"C) that

i) the application of the import restrictions . . . with respect to the archaeological or ethnological material of the State Party, if applied in concert with similar restrictions implemented, or to be implemented within a reasonable period of time, by those nations (whether or not State Parties) individually having a significant import trade in such material, would be of substantial benefit in deterring a serious situation of pillage, and

ii) remedies less drastic than the application of the restrictions . . . are not available; and

"D) that the application of the import restrictions . . . is consistent with the general interest of the international community in the interchange of cultural property among nations for scientific, cultural and educational purposes."

If the President determines that an emergency condition exists, accord-

ing to Section 304 of the Act, he can impose emergency import restrictions immediately. An emergency condition exists when any archaeological or ethnological material of a State Party is:

"1) a newly discovered type of material which is of importance for the understanding of the history of mankind and is in jeopardy from pillage, dismantling, dispersal, or fragmentation;

"2) identifiable as coming from any site recognized to be of high cultural significance if such site is in jeopardy from pillage, dismantling, dispersal, or fragmentation which is, or threatens to be, of crisis proportions; or

"3) a part of the remains of a particular culture or civilization, the record of which is in jeopardy from pillage, dismantling, dispersal, or fragmentation which is, or threatens to be, of crisis proportions;

"and the application of the import restrictions . . . on a temporary basis would, in whole or in part, reduce the incentive for such pillage, dismantling, dispersal or fragmentation."

So that the President would have the benefit of the expertise and views of archaeologists, art dealers, the museum community, and the general public, the Act established the Cultural Property Advisory Committee. The Committee was placed at the U.S. Information Agency (USIA), the federal agency that operates the U.S. Government's overseas educational, cultural, and information programs. The Act requires that each request for import restrictions be referred to the Committee for review and investigation. The Committee's recommendations must be considered by the President, if submitted to him within 90 days for emergency requests and 150 days for requests for agreements. Congress intended for the President to rely heavily on the Committee's advice and therefore requires the President to report to the Congress his actions and whether they comply with the Committee's recommendations.

Beginning in 1983, the Reagan Administration took a number of steps to carry out the Cultural Property Act. The President appointed eleven private citizens to serve on the Cultural Property Advisory Committee and designated Michael J. Kelly as the Committee's chairman. As required by the Act, the President appointed members to represent the four interest groups. Since 1984 the President has made three rounds of appointments. The three experts in archaeology, ethnology, and anthropology who have served on the Committee since 1984 are: Dr. Clemency C. Coggins, Associate in Pre-Columbian Art at Harvard's Peabody Museum of Archaeology and Ethnology; Dr. D. Fred Wendorf, Jr., Distinquished Professor of Prehistory at Southern Methodist University; and Dr. Leslie E. Wildesen, Colorado's State Archaeologist.

The Committee's three experts in the international sale of art have been: James G. Crowley, III of Spartanburg, South Carolina; James Berry Hill of Berry-Hill Galleries, Inc. in New York City; Alfred E. Stendahl of Stendahl Art

Galleries in Los Angeles. In 1988, the President appointed Glenn C. Randall, a Washington, D.C. antique dealer, to replace Mr. Hill.

Representing the museum community have been: Dr. Patricia R. Anawalt, Consulting Curator of Costumes and Textiles at the Museum of Cultural History of the University of California, Los Angeles; Arthur A. Houghton, III, former associate curator of antiquities at the Getty Museum, Malibu, California. In 1988, when Mr. Houghton's term expired, the President appointed Thomas K. Seligman, Deputy Director for Education and Exhibitions of the Fine Arts Museums of San Francisco to fill the position.

The general public is represented on the Committee by: James W. Alsdorf, Chairman of the Board and Director of Alsdorf International, Ltd. of Chicago; Michael J. Kelly, the Committee's chairman, who is Chairman of the Board and Chief Executive Officer of Kelco Industries, Inc. of Woodstock, Illinois; John J. Slocum, a former Foreign Service Information Officer who is a Council Member of the American Numismatic Society and Trustee of the Archaeological Institute of America from Newport, Rhode Island.

The Cultural Property Advisory Committee is supported by a professional staff at the U.S. Information Agency, which serves also as a resource for the federal government, the international community, and domestic constituencies on U.S. policy and laws governing the trade in antiquities.

In March 1986, by executive order, the President delegated most of the Presidential functions in the Act. The Director of the U.S. Information Agency was delegated the authority to receive requests from other countries and to decide whether the United States should impose import controls on endangered archaeological and ethnological material. (He subsequently redelegated these functions to USIA's Deputy Director, Marvin L. Stone.) The Secretary of State was delegated the authority to negotiate cultural property agreements with the participation of USIA officials. The Secretary of the Interior was delegated the authority to carry out the enforcement functions in the U.S. territories and other areas not under the jurisdiction of the U.S. Customs Service (U.S. Presidential Executive Order 1986).

The U.S. Commissioner of Customs issued for public comment interim regulations for enforcing the Cultural Property Act during summer of 1985. The final Customs regulations (19 CFR 12.104) went into effect on March 31, 1986.

EL SALVADOR'S REQUEST FOR EMERGENCY IMPORT RESTRICTIONS

On March 13, 1987, the Republic of El Salvador presented to U.S. Ambassador Edwin Corr a formal document requesting emergency import restric-

tions under Article 9 of the UNESCO Convention. It gave the United States the first opportunity to thoroughly review and act on a request in the manner required by the Cultural Property Act.

El Salvador's request focused on Pre-Hispanic archaeological material from the southwestern corner of El Salvador, a region of sixty-six square miles on the coastal plain, bordering Guatemala. The region has numerous archaeological sites, including eight known sites (El Carmen, Cara Sucia, El Tacachol, Aguachapio, La Caseta, Nueva York, El Cajete, and El Guisnay) dating from 1500 BC to AD 1550. According to the request, the cultural history of the region is based mostly on the analysis of artifacts collected from the surface of looted sites.

Of the eight known sites, only Cara Sucia has been partially excavated. The request described it in detail. Cara Sucia is first mentioned by historian Dr. Santiago Ignacio Barbarena in the late nineteenth century, when he reported the discovery of a jaguar head stone sculpture and other artifacts found in the area. The site plan and the objects discovered there suggest that Cara Sucia was a regional capital for more than one period of its history, and that the site was occupied through various cultural stages. There is speculation that during the Early Preclassic Period (1200–800 BC), Cara Sucia represented the southernmost expansion of a people who spoke a language ancestral to Mayan. Remains dating from 400 BC to AD 250 indicate that the site was related to the cultural centers of Kaminaljuyú (Guatemala) and Chalchuapa (El Salvador). These remains were sealed by a volcanic eruption in the third century AD (El Salvador Ministry of Foreign Affairs 1987).

Cara Sucia's most important era was the Late Classic Period (AD 600–900) when it was the southernmost site of the Cotzumalhuapa culture, which it possibly shared with Veracruz (Mexico) and the coastal zone of Guatemala. It was during this period that an acropolis, two ball courts, temples, and rectangular houses were built. Ceramic artifacts have been found from this period that indicate the introduction of new techniques and forms of ceramic art. It appears to have been an important center for the production of molded figurines and whistles (El Salvador 1987: Appendix VII).

El Salvador's request reported that there has been intensive looting destroying its archaeological heritage in this region which began with the 1980 national land reform program. It reported that "more than 5,000 pits had been dug, damaging or destroying burials, remains of structures and other archaeological features which could have contributed to the knowledge of this region's prehistory" (El Salvador 1987: 15). The most destructive looting had been conducted by teams of professional looters who search for saleable items—stone sculptures, decorated ceramic vessels and figurines, and jade objects.

Ceramic figurine from El Salvador's Cara Sucia region, a Pre-Columbian center for the production of figurines and whistles. While this piece is in a private collection in El Salvador, many similar pieces have found their way onto the international antiquities market, causing the El Salvador government to request assistance from the United States to curb illegal import of objects from this region. *Photo courtesy of USIA.*

The request indicated that artifacts looted from this region were making their way to collectors in Guatemala, El Salvador, and the United States. It asserted that "the international antiquities market, in particular that related to the United States, has encouraged many national collectors to traffic their artifacts and at the same time motivates them to acquire more archaeologi-

cal materials" (El Salvador 1987: 5). El Salvador further stated that in recent years the United States had become the major market for its artifacts.

To support its claims El Salvador provided their customs records that show that thirty percent of the cases in which artifacts were confiscated involved U.S. citizens. Also provided were examples of individuals selling Salvadoran artifacts in the United States. The request quoted Stanley Boggs, an archaeologist with forty years of research experience in El Salvador, as saying that he estimates more than 30,000 Salvadoran archaeological objects are now in foreign collections, primarily within the United States (El Salvador 1987: 5).

The Government of El Salvador cited the measures it has taken to protect its cultural heritage and to discourage looting in the Cara Sucia region: El Salvador's 1903 law prohibits the export of antiquities, including archaeological objects; the 1973 Penal Code prohibits illicit traffic in cultural property in general; the national constitution of 1983 declares the country's artistic, historic and archaeological wealth as cultural treasures under the state's protection and liable to special laws for its preservation. Also, the Salvadoran Government said that it intends to draft a new and more comprehensive law for the protection of its cultural property that "will provide broad and strong protection for the cultural treasures of El Salvador" (El Salvador 1987: 3). The request cited public and school programs conducted by El Salvador's Dirección del Patrimonio Cultural. Included in the request was a copy of a poster emphasizing the importance of Cara Sucia to El Salvador's heritage. It had been distributed in Salvadoran schools.

The Salvadoran request presented a strong argument that the illicit trade in their antiquities had reached a degree of intensity and sophistication that was beyond the present resources of its government to control. It requested U.S. Government's help in restricting the market for the material so they could excavate the region and enact stronger legislation.

REVIEW BY THE CULTURAL PROPERTY ADVISORY COMMITTEE

On April 21, 1987, USIA's Deputy Director, Marvin L. Stone, referred the Salvadoran request to the Cultural Property Advisory Committee for review and recommendation, with nine of the Committee's eleven members present. Absent were James Alsdorf and James Berry Hill. There was an immediate consensus that the Committee should recommend emergency import restrictions. Members commented on how well the request had been prepared, that it was substantive, and unique in its historical context. Committee member Clemency Coggins reported on her trip to El Salvador in September 1986 when she viewed some of the archaeological sites under discussion.

Dr. Coggins reported to the Committee that she is unaware of any other archaeological park in Mesoamerica that represents such a span of history. At El Guisnay she saw several large mounds that had been gutted and recently looted. In a nearby town, she visited a store where a local resident described the looting of tombs at Cara Sucia and in the area that had yielded jades, figurines and other saleable objects. He described how runners would visit Cara Sucia regularly to pick up looted material for sale in Chalchuapa, a major transit point for the region as well as the location of a well known archaeological site. Dr. Coggins said she was told of fencing and of faking operations in Chalchuapa where jades were apparently being produced for the modern market (Cultural Property Advisory Committee [CPAC] 1987: 10).

One member, Alfred Stendahl, a dealer specializing in Pre-Columbian art, commented that he did not think that U.S. action on Salvadoran artifacts would matter significantly to dealers, collectors, and museums, for the objects were not demanding high prices in the art market.

As the review continued, members focused on how to describe accurately the situation in the Cara Sucia region and whether, in their view, it met one of the Act's three definitions of an emergency condition. The Salvadoran request had cited definition number three of an emergency condition: that is, archaeological material from the region is "a part of the remains of a particular culture or civilization, the record of which is in jeopardy from pillage, dismantling, dispersal, or fragmentation which is, or threatens to be, of crisis proportions" (Convention on Cultural Property Implementation Act 1983: Section 304(a)). Some Committee members felt that definition number two was more appropriate, that archaeological material from the region "is identifiable as coming from a site recognized to be of high cultural significance if such site is in jeopardy from pillage, dismantling, dispersal, or fragmentation which is, or threatens to be, of crisis proportions." Since this was the Committee's first emergency request, the members were concerned that their recommendation be soundly based. All agreed that the "application of the import restrictions set forth on a temporary basis would, in whole or in part, reduce the incentive for such pillage, dismantling, dispersal or fragmentation."

As required, the Committee not only reviewed the document provided by the Government of El Salvador, but also conducted its own investigation of the situation in the Cara Sucia region. Committee member Alfred Stendahl interviewed art dealers knowledgeable about the trade in Salvadoran artifacts and learned that the extensive looting of the Cara Sucia region had resulted in a flood of Salvadoran artifacts entering the U.S. market several

years before. He learned that not much was coming from the region at present due to the civil unrest, but that objects from the region were known to travel through Guatemala and be sold as Guatemalan artifacts. He found that often Salvadoran artifacts were collected by local citizens, some of whom after taking up residence in the United States, would sell their collections (CPAC 1987: 10).

The Committee's investigation included an examination of printed literature on archaeological activities in the area. Of special interest were studies conducted by Arthur Demarest of Vanderbilt University and E. Wyllys Andrews, V, of the Middle American Research Institute of Tulane University. A November 21, 1983 article from the *Christian Science Monitor* was uncovered. The article described measures taken by the Republic of El Salvador to protect the Cara Sucia site from looters with assistance of a grant from the U.S. Agency for International Development (CPAC 1987: 11).

The Committee felt that it needed to see a broader representation of artifacts from the Cara Sucia region. The request contained photographs of typical ceramic and stone artifacts provided by El Salvador's David J. Guzman National Museum. The Committee wondered whether they could locate jade objects from the region and whether the region had yielded gold objects. Catalogues from U.S. auction houses, galleries, and museums were examined and provided a few samples. The Committee informally asked El Salvador for photographs of other objects. Color slides of Pre-Columbian objects found in the Cara Sucia region, presently in private collections in El Salvador, were provided to the Committee.

The Committee's report was drafted by members of its Drafting Subcommittee (Clemency Coggins, Arthur Houghton, Michael Kelly, and Alfred Stendahl). The final two drafts were circulated and commented upon by all members, including James Alsdorf who had subsequently had an opportunity to review the request. There was unanimous agreement that the Committee should recommend import restrictions (CPAC 1987: 1).

The Committee's report was submitted within the ninety-day period required by law, on July 19, 1987, to USIA's Deputy Director, Marvin L. Stone. The report outlined the case presented by El Salvador and described the Committee's efforts to investigate the situation. The Committee found that an emergency condition applied in the Cara Sucia Archaeological Region under Section 304(a)(2). Their specific findings were:

1. The Committee finds that the Cara Sucia Archaeological Region includes: El Carmen, Cara Sucia, El Tacahol, Aquachapio, La Caseta, Nueva York, El Cajete and El Guisnay, but is not necessarily limited to them. Other locations within the Cara Sucia Archaeological Region may be added to the above.

2. The Committee finds that the archaeological material of the Cara Sucia Archaeological Region meets the criteria of an emergency condition under Section 304(a)(2) in the following way:

a) The archaeological material is identifiable as coming from the Cara Sucia Archaeological Region which is of high cultural signficance. The Committee's investigation has given it specific familiarity with the Cara Sucia Archaeological Region and its artifacts. The Committee's research supports the information provided in the Salvadoran request. The Committee has found that the Cara Sucia Archaeological Region is of high cultural significance in that it represents almost three millenia of occupation, beginning with a culture that produced some of the earliest known Mesoamerican pottery. Late in Preclassic times a sculptural tradition in this region produced stylized stone jaguar heads unlike any others—suggesting the presence of a regional center which is otherwise archaeologically unknown. During the Classic and Postclassic periods, the Cara Sucia Archaeological Region served again as an important regional center and as a mediator of cultural traditions that linked Mexican cultures with peoples to the south. The site of Cara Sucia itself is classified as being of primary order because its structures are of great importance.

The Committee has conducted an investigation of what objects come from the Cara Sucia Archaeological Region. It is apparent that the objects from the region are culturally significant, at least 250 years old and have been discovered by scientific excavation or clandestine digging. The Committee finds that the archaeological objects from this region are primarily ceramic and stone artifacts, although undocumented jade and metal objects have also been found there. Ceramic objects include figurines, whistles, molds, seals, plates, vases, jars, effigy vessels, ladle censers, drums, and miniature bottles. Stone sculptures from this region include "jaguar heads," "death sculpture," and "hachas."

Even though the Cara Sucia Archaeological Region has been disastrously looted, protection of the region will still preserve invaluable archaeological information and clues to the prehistory of El Salvador and the origins and interrelationships of ancient Mesoamerica. The Committee finds the material of the Cara Sucia Archaeological Region is of importance today, even though the archaeology of the region is incomplete. Only by the protection and controlled archaeological excavation of these sites will the full importance of the Cara Sucia Archaeological Region eventually be understood.

These Pre-Columbian *hachas,* flat carved stones re-
sembling a human or animal head possibly used in
conjunction with playing of the Mesoamerican ball-
game, are believed to be from El Salvador's Cara Sucia
region. Alarming destruction of archaeological re-
mains in the area, caused by looters looking for ar-
tifacts such as these to sell on the international art
market, led to El Salvador's emergency request to the
U.S. government to stop import of such goods into the
United States. In 1987 a five-year import embargo was
imposed. These pieces are from a private U.S. collec-
tion. *Photo courtesy of USIA.*

b) The Cara Sucia Archaeological Region is in jeopardy from pillage
which is, or threatens to be, of crisis proportions. . . . Information
supplied by El Salvador in the request is confirmed by observations of
Dr. Coggins and other archaeologists and antiquities "runners" who
have been to the region. This is supported further by an article in *The
Christian Science Monitor* that reported destructive looting at the site:
"More than 600 people were hired to dig trenches into the temples,
ball courts, and structures at Cara Sucia. More than 50 percent of the

Indian city was destroyed . . . Looters still manage to get into the archaeological sites to smuggle artifacts to swank galleries in the United States and Europe" (Hedges 1983: 23).

c) The imposition of emergency import restrictions on a temporary basis would, in whole or in part, reduce the incentive for pillage and the illicit dispersal of the material from the Cara Sucia Archaeological Region. From the information provided by El Salvador and its own investigation, the Committee finds that the United States is a major consumer of archaeological material that is illegally exported from El Salvador. The Committee agrees with El Salvador that the application of import restrictions on objects from this region would help stem the clandestine trade and reduce the motivation for looting within El Salvador. If import restrictions are applied by the President, the Committee will conduct a continual review of their effectiveness as required by the Cultural Property Act (CPAC 1987: 11–13).

Based on its findings, the Cultural Property Advisory Committee made a series of recommendations to the President. The Committee recommended that emergency import restrictions be imposed on archaeological objects from the Cara Sucia Archaeological Region to begin on date of promulgation and extend for the full five years to March 13, 1992 (CPAC 1987: 14).

The Committee recommended that specific categories and objects listed in their report be subject to import restrictions. However, the Committee also advised that if new materials and new locations are discovered in the Cara Sucia region, the list be amended. Further, the Committee recommended that the President, before the end of the five years, consider another report by the Committee as to whether the emergency import restrictions should be extended for three more years, as is allowed by the Cultural Property Act (CPAC 1987: 14).

Since the restrictions on Salvadoran artifacts would be the first action by the U.S. Customs Service under the Cultural Property Act, the Committee urged that the U.S. Customs Commissioner and the U.S. Information Agency's Deputy Director consult on their joint responsibilities with special attention to the need to alert U.S. citizens of the imposition of the import restrictions. Art dealers, archaeologists, museum officials, those who travel to El Salvador or puchase Pre-Columbian material from the region should be informed. The Committee offered to assist U.S. Customs officials by providing a list of experts in Pre-Columbian art to assist in identifying objects from El Salvador. The Committee also asked the U.S. Customs Service to provide "timely reports of seizures made, or legal action instituted under the Cultural Property Act, so that the Committee will be able to carry out its Congres-

sionally mandated function to conduct a continual review of the effectiveness of the import restrictions" (CPAC 1987: 15).

The Committee concluded its report by expressing its concern for the wanton looting in the Cara Sucia region and the destruction of evidence of civilizations that inhabited the area. The Committee recommended that archaeologists be encouraged to excavate the region and that special efforts be made to assist El Salvador's National Museum in preserving and protecting important artifacts of its cultural heritage (CPAC 1987: 15).

IMPOSITION OF IMPORT RESTRICTIONS

USIA's Deputy Director reviewed the Committee's report, consulted with the Secretary of the Treasury and the Secretary of State, and signed the Presidential determination that U.S. import restrictions be imposed on artifacts from El Salvador's Cara Sucia region. His determination and the list of typical artifacts from the region were published in the *Federal Register* on September 11, 1987. Since that day, importers of artifacts from El Salvador's Cara Sucia region have been required to provide proof to U.S. Customs that the objects left El Salvador with the permission of the Salvadoran Government. If such documentation is not provided to U.S. Customs at the time of entry, the item is detained at the risk of the consignee. Should the documentation not be provided within ninety days, or should the importer state in writing that no attempt will be made to secure such documentation, the item will be seized and forfeited (U.S. Customs Service Information Exchange 1987: 1).

Immediately, the U.S. Customs Service headquarters notified all Customs field offices of the import restrictions. A U.S. Customs compliance circular, incorporating twenty-eight pages of photographs of representative objects from the Cara Sucia region, was distributed in November 1987 to all Customs officers to advise them of procedures for handling objects detained and seized under the new import restrictions. Also, Customs' automated cargo selectivity system was placed on alert requiring all entries of artifacts from El Salvador to be reviewed by an appropriate import specialist commodity team.

The Cultural Property Act requires only that notice of import restrictions be published in the *Federal Register.* To inform the public in the United States and abroad of the imposition of the restrictions, the USIA and U.S. Customs Service undertook a number of additional efforts. Hundreds of press releases and factsheets on the U.S. action were distributed to the media, focusing primarily on periodicals read by the museum, preservation, art dealer, and archaeology communities. A briefing was held for the domestic and foreign press at USIA's Foreign Press Center in Washington, D.C. on Sep-

tember 15, 1987. A videotape of the briefing was shown at a news briefing at the U.S. Embassy in San Salvador several days later. The U.S. Information Agency's news outlets covered the story well. Voice of America aired an editorial to Latin America in support of U.S. action under the Convention and USIA's wireless file offered it as a news story to newspapers throughout the world.

On October 29, 1987, U.S. Commissioner of Customs William von Raab and Cultural Property Advisory Committee member Dr. Clemency Coggins participated in a live television program on USIA's Worldnet. They answered questions posed by journalists and government officials in San Salvador, Tegucigalpa, Guatemala City, and San Jose about U.S. efforts to curb illicit trade in antiquities. The program received favorable coverage in newspapers and news programs throughout Central America.

The U.S. Information Agency's efforts to carry out the UNESCO Convention have not been restricted to the application of import restrictions. Recognizing that sites and artifacts conserved and well protected are less tempting to casual looters, the Cultural Property Advisory Committee urged USIA to do more programming that would engage professionals in serious discussions as to effective public policy, legal and technological approaches to combating looting. Under the theme of "Preserving Cultural Heritage," USIA has sponsored increasing numbers of such projects in recent years. For example, in 1987–88, the Agency's International Visitors program sponsored three projects that brought together archaeologists and cultural and foreign ministry officials of Central and South American countries with their U.S. counterparts for discussions on methods for curbing looting and preserving antiquities. Worldnet interactives have featured discussions by U.S. experts on topics such as the conservation of adobe structures and the training of museum conservators. To maximize resources, the National Park Service and USIA signed an interagency agreement in October 1988 to do more to assist the efforts of other countries in protecting and preserving their historic and archaeological sites and care for their cultural patrimony.

OTHER REQUESTS FOR IMPORT RESTRICTIONS: CANADA, BOLIVIA AND PERU

Since action was taken by the United States on El Salvador's request, two other countries have requested emergency assistance under the Convention—Bolivia and Peru. On March 14, 1989, the United States responded favorably to an emergency request of the Government of Bolivia to help protect antique ceremonial textiles, remnants of the Aymara culture, belonging to the Andean community of Coroma. Acting upon the unanimous recommen-

dation of the Cultural Property Advisory Committee, USIA Deputy Director Stone found that the record of the Aymara culture was in jeopardy from the dispersal and fragmentation of Coroma's antique textiles under section 304(a)(3) of the Act. This was the first application of import restrictions under the Convention to ethnological material. In June 1989 Peru's request for emergency import restrictions on certain of its archaeological material was referred to the Cultural Property Advisory Committee for review.

The first request for a bilateral agreement that would deny entry of illegally exported archaeological and/or ethnological materials was submitted to USIA by the Government of Canada in 1985. In reviewing Canada's request, the Committee focused on the specific findings required by the Act before the U.S. may negotiate such an agreement. (See Section 303, quoted above.) Of central concern to the Committee was the current state of jeopardy of Canada's cultural patrimony and whether certain of its archaeological and/or ethnological materials are being subjected to pillage. Also of concern was whether the United States or any other country has a significant import trade in such pillaged artifacts. Numerous archaeologists, art dealers, and museum officials in the United States, Canada, and Europe were interviewed. The views of the American Association of Dealers in Ancient, Oriental and Primitive Art were provided to the Committee in a public hearing and duly considered by the Committee. The Committee's report of its findings and recommendations was submitted to USIA's Deputy Director, Marvin L. Stone, and to the Congress on October 14, 1988. As of July 1989 no decision had been made by Mr. Stone on Canada's request.

IMPACT OF U.S. RESTRICTIONS

What impact has the imposition of U.S. restrictions had on the Cara Sucia region and the market for Pre-Columbian artifacts in the United States? Scholars believe that the Cara Sucia Region may soon yield knowledge and artifacts of unknown Pre-Columbian civilizations. Students of Arthur Demarest of Vanderbilt University began excavating at El Carmen in the Cara Sucia region in May, 1988. Cultural officials in El Salvador report that when they visit the area they hear fewer stories of looting parties raiding the area at night. Also, the Government of El Salvador passed an interim law strengthening its ability to control the export of its cultural patrimony.

The Cultural Property Advisory Committee continues to monitor the situation. A researcher sent to El Salvador during the summer of 1988 to assess the situation reported that not only has looting in the Cara Sucia region been reduced dramatically but looting in other areas of El Salvador has been curbed, also.

Since import restrictions were imposed U.S. Customs has become more active in detaining and seizing Pre-Columbian artifacts and are seeking more professional guidance in identifying them.

The attention paid to the imposition of import restrictions by the United States on El Salvador's artifacts has caught the attention of other countries. At present countries in Central and South America and the Middle East are preparing requests for U.S. assistance to limit the illicit market for objects of their cultural patrimony. Only in time will we know whether the imposition of import controls by the United States serves as an effective deterrent to looters and those who profit from trade in looted art.

REFERENCES

Bator, Paul
1983 *The International Trade in Art.* Chicago: University of Chicago Press.
Cultural Property Advisory Committee
1987 *Report of the Cultural Property Advisory Committee to the President and Congress Regarding the Request of the Republic of El Salvador for U.S. Import Restrictions Under the Convention on Cultural Property Implementation Act.* (Title III, Public Law 97-446), July.
El Salvador Ministry of Foreign Affairs
1987 *Request to the Government of the United States for the Protection of the Cultural Patrimony of El Salvador,* Document No. AJ/2795, March 13.
Hedges, Chris
1983 Despite War, Salvador Salvages Endangered Forest, Ancient City, *The Christian Science Monitor.* November 21, p. 23.
United Nations Educational, Scientific and Cultural Organization
1970 *Convention on the Means of Prohibiting and Preventing the Illicit Import, Export and Transfer of Ownership of Cultural Property,* 16th Session, November 14.
U.S. Convention on Cultural Property Implementation Act, Title III, Public Law
1983 97–446, as amended.
U.S. Customs Service
1986 Customs Regulations Amendments Concerning Convention on Cultural Property Implementation Act, 19 CFR Parts 12 and 178, *Federal Register:* Vol. 51, No. 39, pp. 6905–6910, February 27.
1987 Import Restrictions on Archaeological Material from El Salvador, *Federal Register:* Vol. 52, No. 176, pp. 34614–34616, September 11.
1987 Import Restrictions on Archaeological Material from El Salvador, *Federal Register:* Vol. 52, No. 176, pl 34614.
1989 Import Restrictions on Cultural Textile Artifacts from Bolivia, *Federal Register:* Vol. 54, No. 48 pl 10618.

U.S. Presidential Executive Order No. 12555, March 10.
1986
U.S. Customs Service Information Exchange
1987 Other Agency Compliance Circular No. 202, *Import Restrictions—Cultural Property from El Salvador.* November 16.
U.S. Senate
1972 *Resolution of Ratification of the Convention on the Means of Prohibiting and Preventing the Illicit Import, Export and Transfer of Ownership of Cultural Property,* August 11.
U.S. Senate Committee on Finance
1982 *Report on H.R. 4566,* No. 97–564, September 21.

Part II

Gillett Griffin has provided a straightforward position statement of the serious scholarly collector. Citing his own experience and examples of other collectors, Griffin argues that private collecting can be positive and beneficial. At the same time, Griffin deplores the activities of unscrupulous collectors who loot, defile cultural properties, and break the law.

To further his argument for private collecting, Griffin takes archaeologists to task for overlooking important sites and for being tardy in publishing the results of professional excavations. Griffin also questions the reliability of Third World museums as custodians of their own cultural patrimony, citing the example of the unfortunate 1985 theft of artifacts from the Mexican National Museum of Anthropology.

Personal fulfillment, stimulation of intellectual curiosity, and preservation, while offered as justifications for private collecting, are weak arguments for activities that inevitably result in tragic losses of objects and information from the archaeological record. It is the demand for illicit cultural property created by private collecting that fosters the looting that supplies illicit material. In Mexico and Central America looting continues at such an enormous scale (see Litvak King, Chapter 13; Guthrie, Chapter 9) that it is viewed as the most serious threat to the cultural patrimony of some countries. No one can make a creditable argument that collecting does not contribute to this looting.

The papers by Herscher, Shestack, and Guthrie each look at different ways in which legislation is being used

Orrin C. Shane, III

or perhaps can be used to stem the illicit flow of cultural objects from their countries of origin. While many agree that looting could be decreased, the means by which this might be done are not clear. Ellen Herscher reviews some existing and proposed international control efforts, finding that most such efforts have limited effect at best. One exception may be the UNESCO Cultural Property Convention and its recent implementation by the United States (described here by Ann Guthrie). While it remains to be seen if this legislation will stem the wholesale destruction of Cara Sucia and nearby sites in El Salvador, there is hope that this kind of legislation can stop the importation of illicit objects and thereby collapse the American market.

Herscher concludes that "changing attitudes on ethics will probably be the most effective means of reducing the demand for illicitly acquired objects." Although prohibition can be only incompletely enforced, Herscher is hopeful that education is an appropriate and effective means of changing attitudes about collecting. Just as education has reduced alcohol abuse and smoking in this country, so education may also decrease the demand for illicit artifacts that drives Third World looting.

With regard to changing ethical standards and education, Alan Shestack makes two important points. First, he offers some concrete proposals for museums, which if taken up, would greatly reduce the market for illicit artifacts. Although Shestack's proposals need further development, I would agree that the ethical climate in American museums today has changed, and that such legislation as Shestack proposes would be acceptable to the vast majority of institutions.

Another means by which the demand for cultural property by museums may be reduced is through collection-sharing programs. Museums that already have large collections might share these objects with other museums through public interpretive exhibitions and educational programs. One model for such collection-sharing is the program established by the Peabody Museum of Archaeology and Ethnology at Harvard University, whereby the Peabody's collections were made available to other institutions where exhibitions were developed for local and national touring venues.

All of the authors in this section in one form or another express the importance of public education as a means of changing attitudes and ethics about collecting. It is my own opinion that archaeologists and other humanities scholars who deal with cultural properties have generally done a very poor job of educating the public about what they do. The methods used by archaeologists to reconstruct the past are not appreciated or understood by the general public. Nor does the lay person understand what is lost when an object is ripped from its prehistoric context to be sold on the market.

In Minnesota, Wisconsin, and Iowa, and in some other states, profes-

sional archaeologists have organized training programs aimed at developing a paraprofessional corps of avocational archaeologists from the ranks of collectors. In Minnesota, this program offers the opportunity to educate collectors about the issue of the losses resulting from unscientific archaeological exploration, and the results have been rewarding. Not only do local collectors now look out for known sites and report suspicious activities to the professional archaeologists; they also keep watch for unannounced construction or development, and assist in field reconnaissance and emergency excavation. What is perhaps most rewarding about these programs is the positive ethical response from the public. On many occasions I have had collectors respond that they never realized the importance of the contextual records professional archaeologists keep; nor did they realize what was lost when they collected without basic documentation of their specimens.

Changing the attitudes of collectors and the general public in the United States may do nothing to directly interdict the flow of illicit artifacts from the Third World and elsewhere. However, I do believe that these educational efforts are succeeding in changing the ethical climate for museums and other institutions that collect and hold cultural objects. Such education may allow boards of trustees of museums to accept proposals like Alan Shestack's, or make it more acceptable for the government of the United States to implement more specific customs legislation under the UNESCO Convention.

Cultural Property Regulations:
Perceptions and Conditions

From the Collector's Perspective: The Legality of Importing Pre-Columbian Art and Artifacts

INTRODUCTION

It has been stated that the total value of stolen or smuggled objets d'art involved in international trafficking runs to over one billion dollars annually. This is second only to narcotics (Nafziger 1985: 835). Indeed, some entrepreneurs combine both art and dope. We learn of one James Issacs, a London pet shop operator, who was recently convicted for importing into England some $200,000 worth of pure cocaine, concealed in the leather bindings of Spanish colonial art books sent from Peru (*London Times*, September 20, 1985: 4). However, our examination here shall be limited primarily to the legality of collecting Pre-Columbian art and artifacts from the perspective of the serious collector. Consideration shall not be made of the law as it may apply to a dealer in such goods, nor to an art museum, for the legal concepts involved for such persons and entities may be somewhat different. Review shall not be made of foreign law either, except indirectly, for the underlying assumption is that the hypothetical collector has gathered his or her art and artifacts and is returning to the United States. This chapter shall primarily set forth the actual U.S. legal restrictions and precedents, or lack thereof, currently in place

Leo J. Harris

or pending, as of November 17, 1987. The law clearly is in a period of evolution.

It is interesting to note the increasing awareness in the legal community of the problems underlying the international traffic in art and artifacts. For example, the prestigious Phillip C. Jessup 1986 International Moot Court competition, which involved 250 law schools throughout the world, used the international removal of art treasures and the related issues of restitution and extradition as the basis for its 1986 proceedings. [For a discussion of the fictitious case used in the competition, see Nafziger 1987.]

No position is being taken here on the ethics or morality of collecting Pre-Columbian art and artifacts, for that has been convincingly done by others. The seminal work is Paul M. Bator's *The International Trade in Art.* A more recent legal analysis has been given by Armstrong *et al.* in *Art Importation and Ownership: The Impact of International Agreements, Foreign Ownership Claims and American Laws and Regulations.* Policy implications of the restitution of cultural property have been addressed by Thurstan Shaw in his "Restitution of Cultural Property," and by John Henry Merryman in his "Two Ways of Thinking about Cultural Property." In summary the author's advice will be, (for those who are fluent in legal Latin), "De minimus non curat lex." Those who do not know Latin will have to finish reading this chapter.

SETTING THE STAGE

Many western hemisphere countries (Mexico, Peru, Chile, Bolivia, Venezuela, the Dominican Republic, and Costa Rica) presently have laws, some old and unclear, some recent and precise, which either (a) vest the ownership of all art and artifacts found or to be found in the country concerned, or (b) prohibit the unauthorized exportation of such objects. For example, there is Mexico's Ley Federal Sobre Monumentos y Zonas Arqueológicas, Artísticas e Históricas (Law Concerning Monuments and Archaeological, Artistic and Historical Zones). Further, the 1945 Constitution of Ecuador provides in Article 145 that all artistic and historic objects executed in the country constitute national treasures and are under the safeguard of the State. One can also trace foreign laws regarding the sanctity of art and artifacts as far back as 1466 when Pope Pius II prohibited the export of collected art from the Papal States, or even to a 1523 Decree of Carlos II of Spain, regarding Indian cultural property in Mexico (Nafziger 1985: 836, 844). By way of comparison, the United States claims title to all cultural property found on federal lands.[1] These current foreign laws are of concern to the person who

For centuries the elaborately decorated stone struc-
tures of Hormiguero stood undisturbed in the Cam-
peche forest, miles from the nearest settlement. The
site was visited periodically by guards from other
sites, who told of artifacts visible on the surface and
pristine painted stucco niches holding Maya pottery.
But in 1974 the site was heavily looted and pottery and
stucco fragments were left strewn about haphazard pits
dug into structures in the search for burials. By Mexican
law the government claims ownership of sites like Hor-
miguero, and their contents cannot be exported with-
out permission. *Photo by Phyllis Messenger.*

is collecting art and artifacts in the country involved but, with the one excep-
tion to be considered later, these laws historically have neither been recog-
nized nor enforced by U.S. courts. There is one overriding general rule in
this regard which has long been the rule, at least until recently. That is, the
fact that an object has been illegally exported from a country does not in any
way affect the legality, or lack thereof, of importing the object into the United
States.[2] Or, as stated differently, the possession of any object lawfully in the
United States cannot be disturbed solely because it was illegally exported
from a foreign country.

Allow me to digress briefly with respect to cultural property found on federal (i.e., national park or national forest) or Native American lands. Under the 1979 Federal Archaeological Resources Protection Act it is a crime (subsequent to October 31, 1979) to (a) excavate and remove and/or (b) sell, buy, exchange, or transport in interstate commerce any archaeological items (other than arrowheads) found on federal or Native American lands. Now, let me tell you about Mrs. Louise Pribble, a farm wife living in Dove Creek, Colorado. According to the Denver *Post,* federal agents with a search warrant that day took from the mantle above Mrs. Pribble's fireplace "an ancient Indian mug, ladle, and some kind of basket strings" which she had had for the previous twenty-five years. Mrs. Pribble was not alone. Her house was one of eighteen homes searched in Utah, Colorado, and Arizona by the "Federal Artifact Looting Task Force." For those not acquainted with this bureaucratic terminology, a "task force," better known in the government legal profession as a "strike force," is an inter-agency working group of federal lawyers and agents. Such strike forces are normally established to fight aspects of organized crime and the narcotics trade. In Mrs. Pribble's case the authorities explained that they would study the seized items to see if they had been removed from federal land, and if so, criminal prosecutions would be brought. I submit that I am morally outraged at these described events. Under the facts as given the tactics are Gestapo-like. The full weight of governmental sanctions might be better used to fight against the real social ills which we are facing today.

PROHIBITIONS TO IMPORTING ART AND ARTIFACTS

Collectors meet the only visible obstacle to their collecting at the U.S. border. It is there that all physical objects brought from outside the United States are either subject to customs duty or are exempt from the payment thereof, under the Tariff Schedules of the United States (19 U.S.C. 1202). When prohibited by law, no entry of such items may be made at all. The U.S. Customs Service is made responsible to assess and collect all duties and to ensure compliance with the customs and related laws (see generally Strúm 1985). There are some four hundred different federal laws which either prohibit or greatly restrict the entry into the United States of diverse objects or goods, such as alcohol, firearms, animals, counterfeit coins, and narcotics. In our situation there are only three principal federal laws prohibiting the importation of Pre-Columbian art and artifacts at the border.

Monumental Sculpture or Murals

The Pre-Columbian Art Act of 1972 provides that no Pre-Columbian monumental or architectural sculpture or mural may be imported into the United States without a certificate of the exporting country that such export is not in violation of the law of that country (19 U.S.C. 2091–2095). In the absence of such certificate these objects may be seized, and can be forfeit. This law applies only to export of such monumental objects from Bolivia, Belize, Colombia, Costa Rica, the Dominican Republic, Ecuador, El Salvador, Guatemala, Honduras, Mexico, Panama, Peru, and Venezuela (19 C.F.R. Part 12.105). The regulations which implement this law make it clear that the law addresses only large and significant objects such as stelae, friezes, and lintels. The law does not address itself to the importation of small or movable objects.

Feathers

A number of Pre-Columbian artifacts include or are made from feathers. For example, there are the wall-size mantles or robes made by the various cultures in Peru. With exceptions not here relevant, the U.S. Tariff Schedules generally prohibit the importation of feathers (Tariff Schedule 1, Part 15, Sec. D).

The Convention on Cultural Property Implementation Act

This recent law is discussed in a later section of this chapter.

THE ROLE OF THE CUSTOMS SERVICE IN THE IMPORTATION OF ART AND ARTIFACTS

Except for the three preceding prohibitions on importation, the general rule governing the relationship of the entering collector and the U.S. Customs Service is that whenever any person enters or introduces any merchandise into U.S. domestic commerce by fraud or gross negligence through any materially false document or declaration, written or oral, then such merchandise may be seized, and unless duties or penalties are paid, the merchandise will be forfeited (19 U.S.C. 1592).[3] In addition, knowingly and willfully smuggling such merchandise based on false, forged, or fraudulent documentation makes the importing collector liable to criminal fines and jail.[4] The meaning of these rules is clear. Declare all art and artifacts appropriately and value them correctly. Then if the importation is not otherwise precluded, in the manner discussed later on, the Customs Service has no

hold on the collector and his or her art and artifacts. It is in this one single area that most collectors have problems.

A recent case concerning the importation of a jeweled monstrance (*United States v. One Eighteenth Century Colombian Monstrance*) is illustrative of these provisions. The vessel was imported into the United States in February 1981, but without valid export documentation from Colombia, and with entry documents which were factually misrepresented. In November 1982 the monstrance was seized by the Customs Service.[5] In subsequent proceedings in federal district court the United States successfully obtained forfeiture of the monstrance for fraudulent importation in violation of law (18 U.S.C. 545). Then after being exhibited in a Texas Gallery, the monstrance was returned to the Colombian government. Thus, collectors should be aware that mere passage of art or artifacts through U.S. Customs at the border does not assure subsequent lawful possession in the hands of the owner. In this case over a year and a half passed before legal proceedings commenced. Apparently it was concern over this or even longer periods of uncertainty that could affect the marketability of imported art and artifacts which caused, albeit unsuccessfully, the American Association of Dealers in Ancient, Oriental and Primitive Art to file a brief *amicus curiae* in this case before the court of appeals.

THE CASE OF STOLEN PROPERTY

As an exception to the previously stated rules concerning the importation of art and artifacts, when these art or artifacts have previously been "stolen," which term will be more clearly defined later on, then there are available either to the true owner or to the federal authorities various civil or criminal remedies.

Recovery of Stolen Art or Artifacts

Under the Anglo-American common law the true owner of a stolen object may sue in a state court for either (a) damages for a wrongful taking, or (b) the recovery thereof from the thief or even from an innocent, good-faith purchaser who was not aware of the source of the object. The object normally must be stolen, in its narrowest sense, that is, taken surreptitiously or by force from its true owner. The theory behind such an action is that a thief, or any person buying an object from a thief, will never have a good title as against its true owner. Since 1970 at least five foreign governments, including Guatemala, India, Rumania, Turkey, and East Germany, have gone to court to sue for recovery of their cultural property.[6] One of these pending suits is by the Rumanian Government against the Kimbell Art Museum of Fort Worth, Texas. This suit requested the return of an El Greco painting,

Angie Rosenberg

The African Art Collection
10/08/2010

ASSIGNMENT & DEBATE

1- Using the Open University document about Benin Bronze, discuss how it relates to cultural heritage issues.

2- Define the notion of Cultural Property and Cultural Heritage. How is it threatened or protected by collectors, art dealers and ultimately museums?

3- In *The Ethics of Collecting Cultural Property: Whose Culture? Whose Property?* by Phyllis Mauch Messenger, cite one particular article that raised some sensitive issues about the protection of cultural patrimony, explain the author's argument and defend or refute it.

4- Cite at least 3 different types of arguments raised by Karen Warren. What are the rewards and challenges they present?

5- **How can we effectively compare and contrast the plight of cultural heritage shared by Native American and African cultures?**

6- What is the argument raised by Leo Harris in his article "From the Collector's perspective" about?

7- **What is an oppressive conceptual framework about?**

8- Discuss the main argument raised in Sally Price's Paris Primitive book.

9- Explain how cultural difference is dealt with (or perceived to be) in France?

10- How would you describe the Museum of Quai Branly?

11- What ideas/ conceptual frameworks does the museum reflect? Elaborate.

12- **Would it be comparable with any museum you would know here? If so, which one?**

supposedly a part of that country's "cultural heritage." The defense of the Museum was that the painting was purchased in good faith from a New York City art dealer nine years previously. A more recent suit, filed on May 29, 1987 in Federal District Court in Manhattan, was by Turkey against the Metropolitan Museum of Art, seeking the return of a collection of gold and silver pieces dating from the sixth century BC which reputedly were illegally dug up by villagers in 1966 and sold to an international antiquities dealer. The dealer, in turn, sold them to the Museum in 1970 for 1.7 million dollars. The defense of the Museum is that it was "an innocent purchaser" of the objects from a reputable dealer, and that the statute of limitations had barred the suit.[7] Such suits are costly and time-consuming, however, and likely will occur only with regard to the most valuable of objects. Hence, there is no risk here for the ordinary collector.

The Possibility of Criminal Prosecution

The National Stolen Property Act (the NSPA) makes it a crime to receive, conceal, store, sell, or dispose in U.S. interstate or foreign commerce goods known to the holder to have been stolen.[8] Under this federal statute, enacted primarily for use against organized crime, the federal government must prove in order to convict (a) that the accused knew the goods were stolen, (b) that the goods were transported in interstate or foreign commerce, and (c) that the value of the goods exceeded $5,000. Obviously the federal government is not going to pursue the casual collector under the NSPA. Two interesting cases have interpreted the NSPA in recent years. The first case (*United States v. Hollinshead,* 1974) involved the theft of a prominent stela from its site in Guatemala, and the offering of this stela for sale to the Brooklyn Museum. The FBI seized the stela because it was imported without a proper customs declaration. The parties concerned were indicted and convicted under NSPA for transporting of stolen property. In this case the stela was a widely known piece and the Government of Guatemala could prove it was forcibly stolen from a national archaeological park.

The next and leading case, (*United States v. McClain,* 1979) involved the interstate and foreign transportation under the NSPA of a number of Pre-Columbian artifacts from Mexico. Evidence was produced that the artifacts were smuggled out of Mexico and the defendants negotiated for their sale in Texas. Eventually the defendants were convicted. The Government's case was based on the fact that Mexican law since 1897, but primarily in a 1972 statute, vested the ownership of all Pre-Columbian artifacts in the Mexican State, whether discovered or to be discovered, and whether or not the artifacts were ever in the actual possession of the Mexican Government. In this case the artifacts concerned were clearly exported out of Mexico, but there

were no allegations or proof that they were forcibly or surreptitiously stolen in the sense commonly understood in criminal law. This is the principal case in the area and it has, incidentally, been strongly criticized by many prominent legal scholars. The most common, nonlegal interpretation of the *McClain* case throughout professional museum circles is that a blanket legislative declaration of state ownership of all antiquities, discovered or not, in possession or not, is enough to support criminal sanctions under the NSPA when such antiquities are imported into the United States. In my opinion, however, the law is not that clear.

What is the real import of the *McClain* case to the casual collector? A number of tentative conclusions might be offered:

1. All artifacts imported from Mexico before 1972, the date of the relevant Mexican law, which are in the possession of collectors may not become the basis for prosecution under the NSPA. Likewise, all artifacts imported from any other country before the effective date of that country's law similarly may not form the basis for prosecution, as are all imported artifacts from countries with no such laws.

2. As to laws of any other country, such law declaring government ownership must be proven to be clear and not ambiguous, and the collector must be aware, whatever that may mean, of such law at the time of collecting. These are difficult matters to establish in a court proceeding.

3. The prosecution must also prove, with certainty, that the artifact came from the country with the law in question, and not from an adjoining country. In the *Hollinshead* case an issue was whether an artifact came from Guatemala, which had such a law, or from Belize, which did not.

4. In any event, no prosecution can occur if the value of the artifact is less than $5,000.

5. The NSPA concerns criminal liability, not ownership of the artifact. It is doubtful, according to many legal scholars, that any court would apply the foreign ownership theory of the *McClain* case to upset actual ownership or possession of artifacts which have been in the United States for an extensive period of time.

6. Since the legislative history of the NSPA gave no indication that Congress intended to apply it to the mere nationalization of artifacts by the country of origin, and since the same theory, namely a broad-based allegation of ownership by the foreign government concerned, also occurs in the 1970 UNESCO Treaty (to be discussed below), it is possible that Congress may make some legislative changes in this area. For example, a forcible or surreptitious theft may become a legally required basis for any future criminal proceedings. In fact, during the ninety-eighth Con-

gress, Senator Patrick Moynihan (Democrat, New York) introduced legislation to mitigate the effect of the *McClain* case. One bill, S. 1559, would in effect have provided that a declaration by a foreign government of national ownership of an artifact does not constitute the basis for prosecution under NSPA. Further, the bill provided that illegal export from a foreign country, and a defendant's knowledge of such export, likewise does not constitute theft or knowledge of theft for the purposes of the NSPA. The bill did not pass.[9]

7. A slightly different bill, S. 1523, was introduced on a bipartisan basis in the ninety-ninth Congress by Senator Charles McC. Mathias (Republican, Maryland) and Senator Lloyd Bentsen (Democrat, Texas). This bill would have imposed time limits during which claims could be brought by foreign governments for the return of stolen art. Under the bill all allegedly stolen property which had been in the United States for five years prior to the date of enactment would be safe from any recovery action by a foreign government. In addition, museums would be protected against such claims or suits after they had acquired and openly publicized or displayed an object for two years. Private collectors would likewise be protected after five years if for three years the object was publicized. Nonpublicized works would be protected after a period of ten years had elapsed. This bill did not pass either.

TREATY CONTROL OF INTERNATIONAL TRAFFIC IN ART AND ARTIFACTS

Under United Nations auspices, and bilaterally by treaty or executive agreement with other countries, the U.S. Government has committed itself to assist in the control of international traffic in art and artifacts. How effective has this commitment been?

The UNESCO Treaty and United States Implementing Legislation

The Convention on the Means of Prohibiting and Preventing the Illicit Import, Export and Transfer of Ownership of Cultural Property entered into on November 14, 1970 was negotiated under United Nations auspices, and at this writing is in force between sixty countries, including the United States and in Latin America, the countries of Argentina, Bolivia, Brazil, Cuba, the Dominican Republic, Ecuador, El Salvador, Guatemala, Honduras, Mexico, Nicaragua, Panama, Peru, and Uruguay. This Treaty established principles for the control of the transnational trade in archaeological and ethnological

materials. While the Senate gave its advice and consent to ratification in 1972, subject to the almost unheard of sum of seven reservations and under-standings, it was only on January 12, 1983 that the full Congress passed nec-essary implementing legislation to allow the United States to fulfill the obli-gations of states party to the Treaty.[10]

The treaty and its implementing legislation together will cover three situations of interest to the collector.

Actually Stolen Cultural Property: States party to the treaty obligate themselves to prohibit the importation of cultural property actually stolen from foreign museums and religious and secular monuments. Such items may not be imported and would be forfeit. For this portion of the treaty to be implemented, the federal authorities would have to prove the property was actually documented as belonging to the foreign entity; was actually stolen after December 2, 1983, the effective date of the legislation; and the request-ing country must bear all expenses of returning the property. In addition, if the importing collector cannot establish valid title to the property, but shows he purchased it for value and without knowledge it was stolen, then the re-questing country must repay the purchase price to the innocent purchaser.

Property Pillaged or in Danger Thereof: There are two principal remedies made available to the President for the protection of cultural property.

The first is a procedure in which emergency restrictions may on a tempo-rary basis be applied to control the importation into the United States of ar-chaeological or ethnological materials which have been (a) illegally ex-ported from another country which is a party to the treaty, and (b) are in danger of such importation to the United States. Pursuant to the request of El Salvador, U.S. import restrictions have been imposed under this procedure for a five-year-period on archaeological materials from the Cara Sucia Ar-chaeological Region of El Salvador, effective on September 11, 1987.[11]

An earlier request under this procedure was made in 1985 by Canada, and at this writing the request remains under consideration.[12]

The second remedy is more complex to initiate and is more far reaching in scope. States party to the treaty are encouraged to enter into bilateral or multilateral agreements with other states to apply jointly import restrictions upon archaeological or ethnological properties specifically identified as a part of a country's cultural patrimony then in danger of being pillaged. The statutory definitions in the implementing legislation are of interest in defin-ing the scope of this second procedure. "Archaeological material" must be over 250 years old, and be discovered through excavation, digging, or explo-ration on land or under water, and be of cultural significance. "Ethnological

material" encompasses primitive or tribal art (i.e., masks, idols, or totems), must be important to a culture or heritage, and must not be trinkets or other objects which are common or repetitive or essentially alike in materials, design, color, or other obvious characteristics with other objects of the same type. Clearly the latter definitions include most artifacts which are likely to be acquired by the casual collector. This bilateral or multilateral agreement procedure with third states would, in the case of the United States, be implemented by the President, who must officially determine (i) the cultural patrimony of the victim state is in jeopardy of pillage, and (ii) the victim state has taken measures consistent with the Treaty to protect its archaeological or ethnographic properties, and (iii) the application of U.S. import restrictions would be of benefit and no lesser remedies are available, and (iv) with a few technical exceptions, similar restrictions are also implemented by other countries having a significant trade in such materials. This procedure would not apply to the import of any materials pillaged either before December 2, 1983, or more than ten years prior to the importation, whichever is the latest. The key point clearly is (iv) above. In effect these agreement procedures are made contingent upon being adopted by the other major art importing countries, including France, Germany, England, Switzerland, Japan, and the Scandinavian countries. There is, at this writing, no indication this has or will occur and, accordingly, the procedure has no present effect on any collector concerned with the subject of this paper. To date, only Canada, the United States, and Italy among the major art importing countries have done so (Malaro 1985: 80). There is also an indication that France has completed, or is near to completing, its own ratification process (Hersher 1984: 80).

Other Bilateral Treaties

On July 17, 1970 the United States and Mexico entered into a Treaty of Cooperation for the Recovery and Return of Stolen Archaeological, Historical and Cultural Property. Interestingly enough, the treaty is patterned upon an earlier (1936) agreement with Mexico, dealing with the restitution of stolen motor vehicles. The only known instance in which Mexico has asked for assistance under the treaty was in July of 1978, concerning Pre-Columbian murals bequeathed to the de Young Museum of San Francisco, discussed by Seligman in chapter 5. This treaty defines "archaeological property" as art objects and artifacts of the Pre-Columbian cultures of outstanding importance to the national patrimony, including stelae and architectural features such as relief and wall art, or fragments thereof. The property must be the property of the government concerned. Each party agreed under the treaty to employ the legal means at its disposal to recover and return stolen archaeo-

logical property removed after the date of entry in force of the treaty. The United States attorney would, in implementing the obligations of the United States under the treaty, institute a civil action for the recovery of the property in the appropriate federal district court. Any recovered objects would be returned without charge. This treaty is of limited applicability to art and artifacts normally purchased by a collector as indicated in Article II thereof, which obligates the parties to permit international commerce in such property, consistent with the local laws assuring the conservation of national archaeological property. Finally, there is no treaty commitment for the United States to apply or interpret Mexican law in any implementing civil action.

Similar executive agreements have been entered into between the United States and Peru, Guatemala, and Ecuador. None of these agreements contain authority for the attorney general to institute civil proceedings on behalf of a requesting party.

Other Possibly Relevant Treaties

The recent discovery and salvage of Spanish treasure galleons off the Florida coast could bring still other concepts into play. The 1982 United Nations Convention on the Law of the Sea speaks briefly to marine archaeology and control of cultural property found within the seabed or in the so-called contiguous zone of coastal states.[13] Under this convention, not in force for the United States, all archaeological objects are to be "preserved or disposed of for the benefit of mankind as a whole." While signatory states agree to undertake this duty, yet suitable deference is specifically required to other international agreements, rights of identifiable owners, the applicable salvage law, and so on. How these matters might be reconciled is unclear. Coastal states who are signatories are even given jurisdiction to prohibit the removal of objects from the seabed. In this regard, legislation has been pending for some time before Congress to regulate the disposition of abandoned historic shipwrecks under the maritime jurisdiction of the United States.

The 1976 San Salvador Convention on the Protection of the Archaeological, Historical and Artistic Heritage of the American Nations is another visionary multilateral treaty which, while not in force either, should still be mentioned for completeness. This treaty provides that all exportation and importation of regional cultural property is considered unlawful, except when a member state in its domestic legislation specifically authorizes the exportation.

Finally, there is the theoretical threat that cross-border art theft or the violation of local antiquities laws could be the subject of extradition of the collector. Such may be feasible, for example, under the Extradition Treaty between the United States and Mexico.

CUSTOMS SERVICE PROCEDURES ON IMPORTING
ART AND ARTIFACTS

Of practical interest to the traveling collector is a Policies and Procedures Manual Supplement of the U.S. Customs Service, dealing with "Seizure and Detention of pre-Columbian Artifacts." This regulation authorizes Customs Service officers to detain any entering items of this type, whether or not they are properly declared and valued. Such items, if from Mexico or Peru, are then held and the respective embassy notified so that such embassy may request the return thereof. If the importer is aware of any relevant foreign law regarding ownership, and if the item or items seized are worth over $5,000, then consideration of prosecution under the NSPA is suggested. If the embassy wishes to assert a claim of ownership, and if the importer does not agree, the matter is then left for determination in federal court. If the respective embassy asserts no claim, and if the items are properly declared and valued, they are then returned to the collector. To this extent, albeit heavy-handed, these Customs Service procedures are in accordance with the relevant Mexican and Peruvian treaties and the NSPA. Procedurally speaking the regulation implements the discretional forfeiture authority of the Customs Service to return to the foreign government concerned items seized at time of entry. However, these Customs Service procedures also require notification of the embassy of any other Western Hemisphere country of origin if Pre-Columbian objects are imported from such places, and such objects may be held pending the raising of a claim by such embassies. It is this portion of the procedures which has been criticized by legal scholars as exceeding any existing legal authority of the federal government.

A recent example of a Customs Service enforcement action under these procedures may be of interest. During 1985 a customs agent brought an item to a Minneapolis museum for an opinion. The item consisted of three fragments of Western Mexican female figurines, fired pottery with no pigment, known in the trade as "pretty ladies." Such pretty ladies are stated to exist in many thousands. The three figurines were wired into a simple frame. The frame was mailed from Mexico by the sender, and was labeled simply "Pre-Columbian art." The declared value was fifty dollars. The questions asked by the Customs agent were "are they older than one hundred years?" and "are they Pre-Columbian art?" If so, he said, the frame could not enter since the importer had no exit permit from the Mexican government. If the figurines were fake, however, the agent said they could enter, with duty being based on the fifty dollar valuation. Of relevance in this connection is the 1970 United States-Mexican Treaty which guarantees international commerce in nondescript archaeological property which is not "of outstanding impor-

tance to the national patrimony." There are a number of readers who will presumably face such inquiries in their curatorial capacities in the future. Given the choice, how should they react to the questions of the customs agent?

SOME RECENT CASES AND PROCEEDINGS

On January 16, 1981 an importer brought into Dulles International Airport Pre-Columbian objects from Peru, and he declared them as worth $1,785. Based upon the suspicions of a customs agent, a well-known curator of Andean archaeology was consulted. Following a claim of ownership by the Embassy of Peru, the objects were confiscated, and the importer arrested. The Peruvian law named the State as ultimate owner of all cultural property found on Peruvian soil. The defense of the importer was that U.S. courts do not enforce foreign export laws, and there was no proof the objects were actually stolen. The case was apparently plea-bargained, however, when the importer agreed to the return of the objects of Peru. (*United States v. Bernstein,* 1982). The importer was given a $1,000 fine, a suspended sentence of one year, and 200 hours of community service. He pled guilty only to the charge of filing a false declaration with the Customs Service. Apparently the government was uneasy as to being able to mount a successful *McClain*-case type of prosecution, or was concerned that the precedent of *McClain* would be overturned.

According to testimony of the representative of the Society for American Archaeology on S. 1523, the bill proposed in 1985 to impose time limits on foreign government claims for the return of stolen art, the Customs Service has been involved with a total of seven cases for the repatriation of Pre-Columbian artifacts. In one case (*United States v. David Goldfarb,* 1981), artifacts were seized at the Dulles airport from a New York art dealer, allegedly underdeclared in quantity and value. Further artifacts were found in his residence, totaling some seven hundred items in all. The case was plea-bargained and the items were returned. In another case (*United States. v. Pre-Columbian Artifacts,* 1982) Peruvian gold masks and cloth and a Maya vase from Guatemala worth approximately $75,000 were seized from a Miami art dealer while being re-exported to the United States after an effort to sell them in Australia. No decision was rendered by the court, however, as the artifacts were voluntarily returned by the dealer. In a 1987 case, finally, (*New York Times,* August 15, 1987) 153 ceramic figurines confiscated in Miami from Fabio Magnalardo, an Ecuadorean citizen, were returned to the Ambassador of Ecuador. Magnalardo has previously pled guilty to making false statements on a customs declaration form concerning these figurines.

SOME CONCLUSIONS

It is difficult in a succinct and nontechnical manner to summarize the practical effect of the discussion set forth in this chapter upon the hypothetical collector. Suffice it to say that there is little legal risk to concern the collector of Pre-Columbian art or artifacts, if he or she is willing to suffer port-of-entry indignities from the Customs Service, and: (a) the items are not actually stolen; and (b) the items are not monumental artifacts or feathers; and (c) the items are valued materially less than $5,000; and (d) the items generally do not come from Mexico, Peru or El Salvador.

As a practical matter, with literally tens of millions of American citizens passing through busy airports or other ports of entry each year, the harassed customs agents are not likely to examine in any detail minor imports of art or artifacts appropriately valued, correctly documented, and declared. As we say in the law, "de minimus non curat lex," the law does not concern itself with small things.

NOTES

1. See the Antiquities Act of 1906 and the Archaeological Resources Protection Act of 1979, Title 16 United States Code, sections 432 and 470aa et seq. and *United States v. Diaz.* See, also, the American Indian Religious Freedom Act, Title 42 United States Code, section 1996, which seemingly can affect items which are found on or taken from traditional tribal homelands.

2. This early Supreme Court precedent goes back to 1825. See the case of *The Antelope.*

3. See also Title 19 United States Code, Sections 1481, 1484, 1485, 1497–99 and 1592.

4. Consideration should also be given to Title 19 United States Code, section 482, under which the Customs Service may seize material brought into the United States ". . . in any manner contrary to law."

5. The seizure was pursuant to Title 18 United States Code, sections 542 and 2314 which deal, respectively, with entry of goods into the United States by means of false statements, and with the transportation of "stolen" items in foreign commerce.

6. See, for example, *Kuntsammlungen zu Weimar v. Elicafon* (U.S. Court of Appeals, 2d Circuit, 1982) in which the German Democratic Republic recovered various paintings stolen in 1945, which were purchased by a U.S. citizen in 1946, and only came to light in 1969. See also *Menzel v. List* (New York Supreme Court, 1966) in which a refugee from Belgium was able to recover a painting seized by the Nazis during World War II which was found in the inventory of a New York City art dealer.

7. Reported in *New York Times,* June 2, 1987, "Turkey Sues Museum to Regain Antiquities"; *New York Times,* July 21, 1987, "Met Files Motion to Retain Artifacts"; and *The Economist,* October 17, 1987, p. 117, "Arts: collectors or looters".

8. Title 18 United States Code, section 2314 et seq. As to conspiracy, see Title 18 United States Code, section 371.

9. Discussed by Speser 1985; 1–3. See also S. 605, 99th Congress, 1st Session, the identical bill in the succeeding Congress, for which hearings were held on May 22, 1985. The bill did not pass.

10. Convention on Cultural Property Implementation Act. See also the regulations of the Customs Service at 19 Code of Federal Regulations. Part 12.104, and the explanatory pamphlet of the agency charged with implementation, "USIA: Information on U.S. Assistance Under the Convention on Cultural Property Information Act, P.L. 97–466," Washington: 1986.

11. See the News Release, United States Information Agency, September 11, 1987, "U.S. Restricts Import of Cultural Artifacts from El Salvador." The restrictions are contained in 52 *Federal Register* 34614, September 11, 1987, "Import Restrictions on Archaeological Material from El Salvador." (See also Guthrie, chapter 9.)

12. On October 2, 1985 Canada requested under the treaty that the United States place certain restrictions on the importation of designated archaeological and ethnological artifacts from Canada. It has been observed that the Canadian request significantly exceeds the relief which may be provided under the Act. See Clark 1986. Legally speaking, the narrow scope of the implementing legislation arguably constitutes still another reservation to the treaty. Initial background on the request contained in 51 *Federal Register* 8938, March 14, 1986, and 51 *Federal Register* 10701, March 28, 1986.

13. See, in particular, Articles 149 and 303.

REFERENCES

Code of Federal Regulations (CFR)
CFR, April 1, 1987.
Title 19: United States Customs Service, Treasury. Part 12.104 et seq., Cultural Property.
CFR, April 1, 1987.
Title 19: United States Customs Service, Treasury. Part 12.105 et seq., Pre-Columbian Monumental and Architectural Sculpture and Murals.

United States Code (USC)
USC, 1982 edition.
Title 16: Conservation. Section 432: Permits, regulations.

USC, 1982 edition.
Title 16: Conservation. Section 470 et seq.: Archaeological Resources Protection Act of 1979.

USC, 1982 edition.
Title 16: Conservation. Section 705 et seq.: Transportation or importation of migratory birds.

USC, 1982 edition.
Title 18: Crimes and Criminal Procedure. Section 317: Conspiracy to commit offense or to defraud United States.

USC, 1982 edition.
Title 18: Crimes and Criminal Procedure. Section 542: Entry of goods by means of false statements.

USC, 1982 edition.
Title 18: Crimes and Criminal Procedure. Section 545: Smuggling goods into the United States.

USC, 1982 edition.
Title 18: Crimes and Criminal Procedure. Sections 2314 et seq.: National Stolen Property Act.

USC, 1982 edition.
Title 19: Customs Duties. Section 482: Search of vehicles or persons.

USC, 1982 edition.
Title 19: Customs Duties. Section 1202: Tariff Schedules of the United States of America.

USC, 1982 edition.
Title 19: Customs Duties. Section 1481: Invoice, contents.

USC, 1982 edition.
Title 19: Customs Duties. Section 1485: Declarations.

USC, 1982 edition.
Title 19: Customs Duties. Section 1497: Penalties.

USC, 1982 edition.
Title 19: Customs Duties. Section 1498: Entry under regulations.

USC, 1982 edition.
Title 19: Customs Duties. Section 1499: Examination of merchandise.

USC, 1982 edition.
Title 19: Customs Duties. Section 1592: Penalties for fraud, gross negligence and negligence.

USC, 1982 edition.
Title 19: Customs Duties. Section 1618: Forfeiture.

USC, 1982 edition.
Title 19: Customs Duties. Sections 2091–2095: Importation of Pre-Columbian Monumental or Archaeological Sculpture or Murals.

USC, 1982 edition.

Title 19: Customs Duties. Sections 2601 et seq.: Convention on Cultural Property.

USC, 1982 edition.

Title 42: The Public Health and Welfare. Section 1996: Protection and preservation of traditional religions of Native Americans.

Court Cases

The Antelope.
Supreme Court of the United States, 1825, Volume 23 United States Reports, page 1233.

United States v. One Eighteenth Century Colombian Monstrance, Known as the Keeper of the Host of Santa Clara, 11.3 Troy Pounds of Gold with Approximately 1,500 Precious and Semi-Precious Stones and Pearls.
Circuit Court of Appeals, 5th Circuit, 1986.
Volume 797 Federal Reporter (second series), page 1370.

Kuntsammlungen zu Weimar v. Elicafon.
Circuit Court of Appeals, 2d Circuit, 1982.
Volume 678 Federal Reporter (second series), page 1150.

Menzel v. List.
Supreme Court of New York, May, 1967.
Volume 279 New York Supplement (second series), page 608.

United States v. Hollingshead.
Circuit Court of Appeals, 9th Circuit, 1974.
Volume 495 Federal Reporter (second series), page 1154.

United States v. McClain.
Circuit Court of Appeals, 5th Circuit, 1979.
Volume 545 Federal Reporter (second series), page 658; cert. denied., Volume 444 United States Reports, page 918.

United States v. Diaz.
Circuit Court of Appeals, 9th Circuit, 1974.
Volume 499 Federal Reporter (second series), page 113.

United States v. Bernstein.
District Court, Eastern District of Virginia, 1982.
Case No. 82-0019.

United States v. Pre-Columbian Artifacts, Peru and David Goldfarb, 1981.
District Court, Southern District of Florida, 1981.
Case No. 81-1320–Civ.

United States v. Pre-Columbian Artifacts, 1982.
District Court, Southern District of Florida, 1982.
Case No. 82-220.

Treaties and other International Agreements

Convention on the Means of Prohibiting the Illicit Import, Export and Transfer of Ownership of Cultural Property, entered into on November 14, 1970.
Volume 10, International Legal Materials, page 289, 1971. Also in Volume 823, United Nations Treaty Series, page 231; and in Senate Executive Document "B", 92d Congress, 2d Session, at pages 27–34.
Entered into force for the United States on December 2, 1983, but no TIAS number yet assigned.

Treaty of Cooperation for the Recovery and Return of Stolen Archaeological, Historical and Cultural Property between the United States of America and Mexico, entered into on July 17, 1970.
Volume 22, United States Treaties, page 494; Treaties and other International Agreements No. 7088.

Agreement between the United States of America and the Republic of Guatemala for the Recovery and Return of Stolen Archaeological, Historical and Cultural Properties.
In force as of August 22, 1984, but no TIAS number yet assigned.

Agreement between the United States of America and the Republic of Peru for the Recovery and Return of Stolen Archaeological, Historical and Cultural Properties.
Treaties and other International Agreements No. 10136.

Agreement between the United States of America and the Republic of Ecuador for the Recovery and Return of Stolen Archaeological, Historical and Cultural Properties.
Signed November 17, 1983, but no TIAS number yet assigned.

United Nations Convention on the Law of the Sea, signed December 10, 1982.
United Nations Document A/Conf. 62/122.

The 1976 San Salvador Convention on the Protection of the Archaeological, Historical and Artistic Heritage of the American Nations.
Volume 15, International Legal Materials, page 1350, (1976).

Treaty of Extradition between the United States of America and Mexico, signed May 4, 1978.
Volume 31, United States Treaties, page 5059; Treaties and other International Agreements No. 9656.

Other legal citations

Ley Federal Sobre Monumentos y Zonas Arqueológicas, Artísticas e Históricas. [Mexico].
Volume 312 Diario Oficial [D.O], page 16, 1972.

United States, 98th Congress, second session, 1985.
S. 1559: A bill to amend sections 2314 and 2315 of title 18, United States Code, relating to stolen archaeological property.

United States, 99th Congress, first session, 1986.
S. 605: A bill to amend sections 2314 and 2315 of title 18, United States Code, relating to stolen archaeological property.

United States, 99th Congress, first session, 1986.
S. 1523: a bill entitled the Cultural Property Repose Act.

Federal Register 51: 34614, September 11, 1987.
Public Notice: Import Restrictions on Archaeological Material from El Salvador.

Federal Register 51: 8938, March 14, 1986.
Notice of Request by U.S.I.A. concerning Canada.

Federal Register 51: 10701, March 28, 1986.
Notice of Meeting, concerning Canada.

United States Customs Service: Policies and Procedures Manual Supplement "Seizure and Detention of Pre-Columbian Artifacts." No. 3280-01, October 5, 1982.

Newspaper Articles
London Times
 1985 Books Cover for Cocaine. September 20.
Denver Post
 1986 Artifact Raids Enrage Collectors. May 5.
New York Times
 1987 Turkey Sues Museum to Regain Antiquities. June 2.
New York Times
 1987 Met Files Motion to Retain Artifacts. July 21.
New York Times
 1987 U.S. Yields Stolen Artifacts to Ecuador. August 15.

Periodicals
Clark, Ian Christie
 1986 Illicit traffic in cultural property: Canada seeks a bilateral agreement with the United States. *Museum* 38 (3).
Herscher, Ellen
 1984 The Antiquities Market. *Journal of Field Archaeology* 11: 226.
Merryman, John Henry
 1986 Two Ways of Thinking About Cultural Property. *American Journal of International Law* 80 (4): 831.
Nafziger, James A. R.
 1985 International Penal Aspects of Protecting Cultural Property. *The International Lawyer* 19 (3): 835.
 1987 *Misra v. Avon:* Law Students Discover and Excavate Cultural Property Law. *In* The Antiquities Market. *Journal of Field Archeology* 14 (2): 219–221.
Shaw, Thurstan
 1986 Restitution of Cultural Property. *Museum* 30 (1): 46.

Speser, Philip

1985 Washington Report. *Bulletin of the Society for American Archaeology* 3(1).

1984 Italian Court Returns Artifacts to Ecuador. *Journal of Field Archaeology* 11: 422.

1987 Arts: Collectors or looters. *The Economist,* October 17, p. 117.

Books and Other Sources

Armstrong, Colker, Kenety, Seidel, and Spencer

1986 *Art Importation and Ownership: the Impact of International Agreements, Foreign Ownership Claims and American Laws and Regulations.* Ft. Lauderdale: The ACNA Foundation Press.

Bator, Paul M.

1983 *The International Trade in Art.* Chicago: University of Chicago Press.

Malaro, Marie C.

1985 *A Legal Primer on Managing Museum Collections.* Washington D.C.: Smithsonian Institution Press.

Sturm, Ruth F.

1985 *Customs Law and Administration,* 3rd. Ed. New York: American Association of Exporters and Importers.

What is "Stolen"?
The McClain Case Revisited

The association of which I have had the honor to be president since its founding over fifteen years ago is a group of some sixty dealers in ancient, oriental, and primitive art. We are all pretty independent sorts, but when the United States became the first and still the last major art-importing country to ratify the UNESCO Convention on Cultural Property, we decided to band together to present a unified and informed voice on the international art market.

The debate on the implementing legislation for the UNESCO Treaty proceeded at a leisurely pace from the early 1970s well into that decade, and the several points of view began to reach consensus. But from 1977 to 1979 the case of *United States vs. McClain* was tried and appealed, retried and appealed, and it blew our earlier deliberations into a cocked hat. The definition of "stolenness" was at the core of *United States vs. McClain,* and it raised an issue in the UNESCO legislation which theretofore had not existed. One of the most important elements in the UNESCO legislation was the penalty for handling stolen art properties. My association had no problem with that, of course, for at that point the common understanding of "stolenness" was what you would teach your children.

But after *McClain* the common law notions of "stolen" were eroded. And we wanted to know just what "stolen" meant. Alas, we still don't know; and problems resulting from *McClain* still crop up on a regular basis.

Douglas C. Ewing

It is axiomatic that bad cases make bad law. McClain was a terrible case, and what it made was bad regulations, something far more difficult to fight because they are formed in secret by non-elected officials and are enforced unevenly, often by untrained people. The fallout from *McClain* is, in my view, insidious. I will give some examples later.

First let us return to those not-so-thrilling days of yesteryear and take a look at just what happened in that case. For an extended period during the 1960s and 1970s, an engineer from California named Joseph Rodriguez traveled frequently between Mexico and California. While in Mexico he occasionally acquired Pre-Columbian artifacts and took them home with him. His customs declarations were informal, which was not at all unusual for that time. During the mid 1970s, he decided to try to sell his collection. Four people—Patty McClain, Ada and William Simpson, and Mike Bradshaw—helped him in this project. They moved the objects to Texas, where everyone "knew" the money was and set about trying to sell them. It was in fact a pretty dull bunch of stuff, but the advertising for the objects caught the attention of a few people and arrangements were made for the collection to be viewed. On that occasion and several others, the sellers tried to enhance the interest in the objects by describing them as "stolen" and "smuggled out of Mexico" by a man who was "Chief of the Mexican Secret Service."

Further it was stated that the Mexicans claimed ownership of the items. The prospective buyers were, in fact, FBI agents and Mexican government employees. The sellers were soon arrested and charged with interstate commerce in stolen property and conspiracy to deal in stolen property under the National Stolen Property Act.

In their first trial, the judge allowed—indeed, even encouraged—testimony on Mexican law, and in his instructions to the jury he emphasized that ever since 1897 ownership of Pre-Columbian objects had been vested by statute in the Mexican government even though private people were allowed to possess them. The defendants were convicted. On appeal, the Federal Court of Appeals for the Fifth Circuit reversed the conviction, holding that the trial court had erred in charging the jury on the basis of the 1897 law, saying, "The instructions given at the trial in this case were clearly in error as to Mexican law."

The case was retried and the defendants were convicted again, and the convictions were again appealed. My association served as *amicus curiae* in both of the appeals.

The second appeal, known as *McClain II* is what interests us most. The court of appeals reaffirmed that the National Stolen Property Act does, in fact, apply to property illegally exported from a country that asserts owner-

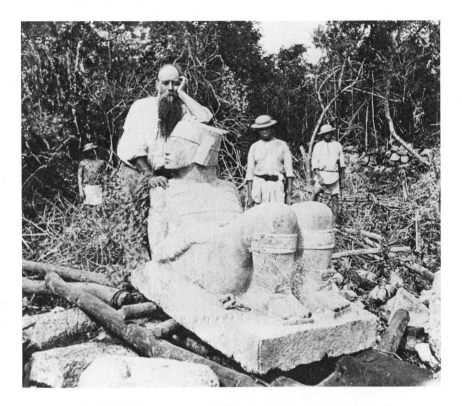

In 1875 Augustus and Alice Le Plongeon excavated at Chichen Itza, Yucatan. Their findings included this now-famous reclining figure, which they called Chaacmol. When they sought permission to take it out of Mexico for exhibition in the United States, they were stopped and the statue was confiscated by the government, even though at the time Mexican law gave them some legal rights to objects they excavated. Later the Le Plongeons editorialized against looting and site destruction, which they identified as a serious problem a century ago. *Photo by Alice Dixon Le Plongeon, courtesy of the Philosophical Research Society, Los Angeles.*

ship by nothing more than legislative declaration. The court found, however, that the jury had received yet again instructions based on the 1897 law, and not, as had been urged, on the 1972 law, the modern version of the old legislation. The court ruled that the pre-1972 law was so ambiguous and unclear that, quoting from the opinion, "Our basic standards of due process and no-

tice precluded us from characterizing the objects as stolen" if they had been exported from Mexico before 1972. The court reversed the convictions for the substantive offense (see Bator 1983: 74).

But let us remember what the defendants told their prospective clients. They asserted stolenness, and this proved to be their well-deserved downfall. The court of appeals upheld their conviction of conspiring to traffic in stolen goods and off they went to the slammer. They were convicted for what they had said, not for what they had done.

Even though I am not a legal scholar, two things strike me as very curious about this case. First of all, has there ever been another example of the use of foreign law to prosecute United States citizens in a United States court? And is not the application of a circuit court's ruling supposed to be confined to its circuit? But the national effect of *McClain* was quick and blind. The U.S. Customs Service issued a manual supplement entitled, "Seizure and Detention of Pre-Columbian Artifacts," referring to *McClain* as justification for seizure of objects, "inasmuch as the artifacts are the property of the [foreign] government." The artifacts are understood to be the property of the foreign government. No law had been passed, no hearings had been held, public interests had not been consulted, there had not even been judicial clarification of the *McClain* court's rulings. Any Pre-Columbian objects entering this country from whatever source and under whatever circumstances were presumed to have been stolen. [See Merryman and Elsen 1987: 118–24 for additional discussion of this case.]

Now there is a fundamental rule in law, emphasized by legal scholars in this field, and reinforced by Judge Wisdom in his opinion in *McClain II*. Illegal export in and of itself does not determine illegal import. "Phooey!" said Customs, and here are some of the results:

In 1985 a Paris auction house was consigned a collection of Pre-Columbian art which had been legally acquired in Mexico and which had had a documentable presence in France since 1929. Could these be exhibited in the United States and returned to France without the threat of seizure, the French auction house asked our Customs Service. "No," was the reply.

Recently, an internationally known anthropologist and distinguished former museum director, a man of impeccable academic and personal credentials, began what may be a long struggle with Customs. During the 1950s and 1960s he had assembled important collections in Peru with the full knowledge and permission of Peruvian authorities. He stopped collecting in 1972, brought his collections to this country, and then, because of an academic appointment, moved to yet another country, taking his collections with him. Now these collections are not groups of major objects without which the Peruvians could not perceive their national heritage. On the contrary they

are a series of comparably minor objects, which would help scholars and the public in this country to understand the multiplicity and richness of Peruvian cultural history. Nor are these collections even claimed by Peru. This gentleman tried to bring a few of his own objects back into his own country, and they were seized by Customs. Even though the objects have since been returned, after a considerable legal struggle, Customs has said it will give no assurance of safety if further attempts to import the collection are made. Indeed what Customs has said is that it might look the other way if a few objects are imported, but not if the whole group of collections is brought in.

So this incredibly short-sighted and arrogant position encourages the fragmentation of the collections whose academic value lie in their size, scope, and representation. And this potential destruction is prompted solely by overzealous Customs agents using a misinterpretation of a district court's ruling.

And here's another corker. There is an important Colombian colonial religious object which was made in the eighteenth century by an artist imported from Spain. This object belonged to the convent which had commissioned its manufacture, and the convent became impoverished. With the permission of the presiding bishop, it was offered for sale by the nuns to the Colombian government at a very low price. Its purchase was refused. It was then offered to the government by an agent acting on behalf of the nuns. And the purchase was again refused. The object was sold by the nuns to a dealer in Bogota, who again offered it to the government, with the third refusal. Finally it was sold to another dealer who took it out of Colombia, showing it to Customs agents at the Bogota airport. It was brought to New York and declared at Customs there, then taken to Texas and sold to a dealer. He offered it to a local museum whose specialty was Spanish Colonial art. A young curator there, in a burst of misplaced zeal, notified Customs that she had been offered a "stolen" national treasure. Customs seized the object without the legally mandated show cause order, apparently asked Colombia if it would like the object returned free, and prompted Colombia to present its ownership case in court. The basis of the government's claim was first stated to be a treaty between the United States and Colombia. When it was pointed out that no such treaty existed, the government's attorney cited *McClain* and sought a prosecution under the National Stolen Property Act. But Colombia, unlike Mexico, does not even have a statute *asserting* ownership of so-called national treasures. Here's the best part. A local court agreed with the Department of Justice's stand and excluded the bonafide purchaser's position in the proceeding. Is any property safe in this country? The appeal on this case was recently heard, and all of us involved—and we really all are involved, whatever your views may be—await with great concern.

And what has all this to do with the hearings on the UNESCO legislation,

where we started out? Simply that the sections which dealt severe penalties for transporting and selling stolen cultural property, sections which had not been in the least controversial before then, were now devilish indeed. Who could say what was and what was not "stolen"? Especially when at any time an object could become stolen, not by an act, but by a declaration.

We sought clarification of this issue before supporting a bill which many of us had worked on so diligently for so long. We were informed that only the committee on the judiciary could define "stolen" since it was a legal issue, not a trade one. With the assurance that all the involved parties would support separate legislation defining "stolenness" and with the understanding that such a bill was part and parcel of the Cultural Property Bill, we agreed to support the UNESCO enabling legislation and it became law. The parties which agreed to support the stolen property document were Senators Dole, Matsunaga, and Moynihan, and the Departments of State, Justice, and the Treasury. Each of the senators and the authorized representatives of the departments told me to my face of their unqualified support. Yet when hearings on the bill were held, only Senators Dole and Moynihan kept their word. Indeed the three government departments actually opposed the bill, in whose drafting they had been involved, citing one excuse or another for their treachery. Need I say I was appalled?

So where does all this leave us? We have heard many points of view about this enormously complex issue of the ethics of collecting. Many of us will never agree, and that is to be expected. But it seems to me that some issues can be resolved. And the settling of those issues will allow us to turn our attention in unison to the real questions, which are: How is cultural property best served? Where does it have a legitimate presence? How can we best protect archaeological sites known and unknown? How can art-rich countries be persuaded that our interest in their cultures is not cultural imperialism, that it is in fact our most accessible means of understanding them? I have a suggested solution. It should not be difficult to achieve. Throughout the decade-long series of debates and discussion and extraordinary congressional mark-up sessions, it was acknowledged by all parties, private and public, that what we were in fact doing was formulating a national cultural property policy. All interests were well represented, all points of view from the most radical to the most conservative, were expressed. Problematic situations were anticipated. The resulting document, the U.S. Convention on Cultural Property Implementation Act (Public Law 97–446 Title III) is not perfect. But if memory serves me, our system requires that law must be made by the legislative branch of our government and enforced by the executive. In the aftermath of *McClain,* that legislative process has been circumvented in a most extraordinary fashion by Customs. And if this kind of

arrogant and extralegal behavior continues, it will make no difference if consensus is reached, nationally or internationally. Customs will continue its own wayward course.

REFERENCES

Bator, Paul M.
 1983 *The International Trade in Art.* Chicago: University of Chicago Press.
Merryman, John Henry and Albert E. Elsen
 1987 *Law, Ethics, and the Visual Arts,* 2nd ed. 2 volumes. Philadelphia: University of Pennsylvania Press.
U.S. Convention on Cultural Property Implementation Act, Title III, Public Law 97–446.
U.S. Customs Service
 1982 Seizure and Detention of Pre-Columbian Artifacts. *Policies and Procedures Manual Supplement.* No. 3280–01, October 5.
United States v. McClain
 Circuit Court of Appeals, 5th Circuit, 1979. Vol. 545 Federal Reporter (2nd series), p. 658; cert. denied, vol. 444 U.S. Reports, p. 918.

The Need for Enforcing Regulations on the International Art Trade

A traveler returning home passes through U.S. Customs. An art object purchased while abroad is seized as a possible illegal import. "But, I bought it in good faith." This response to the law enforcement officer may or may not be true. If the merchandise was illegally removed from its owner, title did not pass and one is merely an unauthorized possessor of another's property.

According to Aquinas, men and women in society live under law. Law achieves its results by imposing moral obligations rather than outright force on those subject to it. We exist in the midst of realities, which we must recognize and respect if we are to live a human life. If laws are just, they are derived from eternal law such as the Commandment, "Thou Shalt Not Steal."

Therefore let us examine why law enforcement control of the U.S. art trade is necessary. The subtitle of a September 1973 *Argosy* magazine article by Milt Machlin entitled "Antique Smuggling" was "Second only to narcotics in international crime." What a shocking statement in its magnitude. Is it true? If so, what is being done to contain the problem? Two thousand years ago, Pontius Pilate defiantly questioned, "What is truth?" Through the centuries a good answer might be "that which corresponds to reality." The following realities should spell out the problem in vivid colors.

Some years ago, the U.S. Customs Service in Washington D.C. sought the aid of a noted Smithsonian Institution

Charles S. Koczka

expert to appraise a large artifact seizure which had been brought from Peru by a New York art dealer. Shocked at the harm to the archaeological record, which was the price of introducing the four art-filled suitcases into the commerce of the United States, this good public servant stopped his inspection. Unable to look at the rest of the contraband, he retired to his home. Within a few hours, he suffered a fatal heart attack.

Later that year the assistant curator of Peru's National Museum of Anthropology and Archaeology in Lima visited a U.S. Customs storage room which contained $1,300,000 worth of additional Peruvian antiquities seized by search warrant from this same art dealer's New York residence. With saddened eyes, he examined the contents of the vault and called it a finer cross section of Peru's cultural history than existed in his country's museum. This art was returned to the people of Peru, but the art dealer, while admitting his wrong in court, did not spend one day in jail.

A few years later, this writer arrested a Roman Catholic priest affiliated with the United Nations Vatican office. He had smuggled two paintings stolen from two different locations in Italy into New York. With the aid of three accomplices, he sold the loot to an informant of mine. After admitting his crime in public court, he never spent one second in jail. I personally thought the prison system could use a chaplain on the inside to better relate to the other inmates.

In mid-1986, I arrested an employee of an innocent foreign consulate for attempting to smuggle past U.S. Customs a rare eighth-century stone deity illegally removed from India. It had been invoiced as bedsheets. Investigation led to the recovery in India of fifty other stolen artifacts awaiting illegal export. In India one of her co-conspirators admitted to police her direct involvement in their international conspiracy which smuggled art from Bombay and Nepal to Switzerland and on to New York. Yet the office of the U.S. Attorney, Eastern District, New York (EDNY) declined to prosecute on the grounds that the United States could not afford to transport the cooperating defendant to the United States from India for a court appearance. Yes, the artifact was returned to India, but the unindicted smuggler went free with the aid of three high-priced law firms.

Some years ago, I attempted to have prosecuted art collector and museum director Norton Simon and New York art dealer Ben Heller for their involvement with the smuggled tenth-century bronze statue of Siva Nataraja, which had been stolen from a South Indian temple where it was an object of worship. The office of the U.S. Attorney declined to prosecute. Questioned about smuggling, Simon was forthright, "Hell, yes, it was smuggled." The *New York Times* quoted Simon as saying, "I spent between fifteen and six-

teen million dollars over the last two years on Asian art, and most of it was smuggled. I don't know whether it was stolen" (Hess 1974: 136).

In the early 1970s, a retired New York bank vice president used his attache case to smuggle into the United States from Mexico City the fourth known surviving Pre-Columbian Maya codex, which came to be known as the Grolier Codex, named after the Grolier club in New York City where it was first publicly displayed. When presented the facts of my investigations, Houston's U.S. Attorney declined to prosecute, believing it lacked jury appeal as the smuggler was elderly and had not been paid to carry out the theft. Eventually the codex was returned to the people of Mexico.

On two occasions when leading auction houses in New York were presented with hard evidence that they possessed stolen art works, they refused to surrender them to me. It took federal search warrants to recover the victim's property. Fortunately, most art dealers voluntarily turn over stolen art, as news media publicity of selling stolen art would not be good for business.

The above examples of plundered art serve to paint a realistic picture of this international problem. But what about the much less known national artifact looting?

People have lived on this North American continent for thousands of years, leaving behind them reminders of their lives, evidence of their societies, clues to their cultures. These clues constitute our cultural resources, the material remains of former times and previous occupants which are scattered over the landscape. Nonrenewable cultural resources include such prehistoric sites and structures as pueblos, rock art, caves, and burial grounds. These resources must be managed and used intelligently for public education and enjoyment, excavated to increase scientific knowledge, or salvaged to preserve data.

But along come the greedy grave robbers into the Mesa Verde Ruins in Colorado or Utah's San Juan County so rich in Anasazi dwellings with their beautiful pottery and baskets. As District Forest Ranger Bob Day stated in the May 10, 1986 Salt Lake *Tribune*, "Vandalism has increased dramatically in the last decade. A study ten years ago showed that the sites were eighty to ninety percent intact, while a study of those same sites done in 1985 showed only ten to twenty percent remained intact."

When an overworked Colorado FBI agent phones with the names of suspected receivers of such plundered artifacts, I quickly recognize them as New York art dealers. And if buyers are not available in the United States, then a Japanese collector might buy them.

On February 14, 1979 I addressed the International Symposium on Art Security at the University of Delaware. One person in the audience was jour-

The Grolier Codex, said to have come out of a cave near Ocosingo, Chiapas, was smuggled into the United States in the 1970s. Its provenance was unknown and there were questions about its style, so many Mayanists including Eric Thompson did not believe it was authentic. Michael Coe did, however, and now most scholars agree it seems to be authentic, since it pictures a complicated Venus calendar. The Grolier is one of only four existing Pre-Columbian Maya codices, none of which has a provenance. The codex remained briefly in New York, and was exhibited at the Grolier Club. Then its arrival in the United States was investigated by U.S. Customs and the codex was returned to the Attorney General of Mexico by a Mexican citizen. *Photo courtesy of Charles Koczka.*

nalist Peter Watson from Great Britain. Peter was preparing to enter into the seamy side of the multi-billion dollar business of art disguised as a corrupt art buyer. With some assistance from me, Watson verified in his book, *The Caravaggio Conspiracy,* what Lord Duveen said in the early part of the century, "Europe has the art, American has the money." This truism applies to illegitimately obtained art as well as legally saleable material.

Let us look at what is legally saleable art. As an example, an amateur painter sells one of her works to you, a collector of trivia. You receive, along

with the possession of the work, good legally transferable title to it. The same principle applies to dealers, museums or insurance companies investing in art. It is an ethical business transaction. Now, imagine you are a European citizen with legal ownership of a "museum quality" art work. When you visit a major auction house to sell that work, a strong recommendation might be made to have it sent to New York to obtain top auction sale prices (assuming that its export does not violate the domestic laws of your particular country). Provided all taxes are properly paid, the above illustrations are "Sunday school" examples of the legitimate art trade engaging in the free enterprise system predicated on the economic laws of supply and demand. If life were so clean, there would be no need for a book entitled "The Ethics of Collecting Cultural Property" or for my very occupation as a criminal investigator with the U.S. Customs Service.

Now for some journalistic voices, who have been crying in the wilderness of art collecting. Quoted in Paul Bator's *The International Trade in Art* is archaeologist Clemency Coggins in 1969 saying, "In the last ten years there has been an incalculable increase in the number of monuments systematically stolen, mutilated and illicitly exported from Guatemala and Mexico in order to feed the international art market. Not since the sixteenth century has Latin America been so ruthlessly plundered." Coggins' detective work traced a substantial portion of this stolen and mutilated art from the jungles of Central America into some of America's most respectable museums. The world could no longer pretend that looting of ancient art was a matter involving only a few obscure peasants, corrupt local officials, and unscrupulous dealers. Splendid national treasures, stolen or mutilated could within a few years find their way into the halls of America's most sumptuous museums. Bonnie Burnham, formerly of the International Foundation of Art Research, is a noted expert on stolen art in the United States. In her 1978 study, *Art Theft, Its Scope, Its Impact and Its Control,* she wrote, "The traffic in stolen works is manifestly international, with the United States a frequent recipient of illicit items" (1978: 38).

Italian stolen art authority Keith Middlemas writes in *The Double Market, Art Theft and Art Thieves,* "The demand comes principally from receivers in America who have sufficiently legitimate contacts to pass Italian masterpieces onto the market with a specious provenance attached or from European dealers supplying the so-called art investment funds run by private banks, usually to remain for a generation or two until the statutes of limitations have run out" (1975: 63). "The chances of recovering anything stolen in Europe decline sharply the moment the shipment has left for America. So large is the quantity of antiques entering the U.S. that inspection at the ports

and airports is impossible. The big receivers are importers of what is stolen elsewhere rather than managers in the robbery itself. Almost impregnably secure, they can afford to be lax" (1975: 72).

Author Hugh McLeave writes in *Rogues in the Gallery, the Modern Plague of Art Thefts,* "With few antiquities and a dearth of classical paintings and sculpture to fill its hundreds of museums and galleries, the United States has to import vast quantities of art; thus much of the pillaged treasures from European public and private collections filters into the U.S.A." (1981: 7).

Veteran journalist John L. Hess summed it up in his book, *The Grand Acquisitors:*

> After World War II, . . . the spectacular boom in art prices and in the collection of primitive and ancient artifacts have given rise to pillage on an industrial scale. Thousands of peasants eke out their livelihood from it; hundreds of dealers and corrupt officials make fortunes from it. The passionate and underpaid devotees of archaeology watch aghast while the history of antiquity disintegrates before their eyes. . . . Every American museum that collects ancient art is, or was until recently, a knowing receiver of stolen goods. The antiquities collection of the greatest of them all, the Metropolitan Museum of Art, was in fact founded on loot (1974: 134–135).

"But I bought it in good faith." A fitting response might be to the U.S. art purchaser of uninvestigated provenance, "To thy own self be true." Are we pointing the finger of guilt unfairly at these "gentleman" art merchants? Let's hear their side. In his book *The Plundered Past,* Karl E. Meyer quotes New York dealer Andre Emmerich, "I think that this country more than any other has a special claim to the arts of all mankind" (1973: 28). Webster's *New Collegiate Dictionary* defines "claim" as follows: "To ask for, or seek to obtain, by virtue of authority, right or supposed right; to demand as due." When Adolf Hitler's Nazis raped the available art of Europe from its rightful owners, the free world was justifiably angered and demanded its return at the end of World War II. But when a New York art dealer in a talk on illegal art traffic says one country should have a claim to the arts of all humankind, no moral protest is heard. Were a thief to take a prized possession from such a dealer, law enforcement would be expected to recover it for him. That is exactly what the plundered nations are now requesting. Give us back our property and stop importing new loot!

In Milton Esterow's book, *The Art Stealers,* one reads of Lowell Collins, identified as an "expert in pre-Columbian art." Broad philosophical questions do not bother Collins, who said "What the hell! As long as U.S. laws are

not broken, it's all right. After all, these things are not appreciated in those countries. They're brought here and given a home. Now cultured people can see them" (1973: 2). Mr. Collins, I would not be so sure no U.S. law has been broken. A truly cultured person would be allergic to plunder. One Madison Avenue dealer once told me that he considered himself a saviour of Eastern art, for if he didn't encourage its illegal removal from its country of origin, the objects might be broken up and used as road construction material. He added that if I didn't stop investigating his business, he would retire to writing dirty books. Others in the art market complain that it is the refusal by foreign governments to sell their cultural patrimony that encourages the black market in art. That is like saying, "If you don't sell it to me, then I'll steal it." Are we as a nation obstinate in not offering for sale the Liberty Bell to foreign collectors? Another rationalization is that illicit traffic of antiquities is going to continue anyway, so why doesn't America get its share before another country does. Many say poor countries do not protect their rich artifacts. Did Hitler have a right to invade Poland in 1939 because it was poorer and weaker? And when every other excuse fails, the art market may say, "That's the way business is done. I am only trying to make a living." If breaking the law, be it foreign or domestic, is required to be in business, then one is in the wrong business. One is simply a fancy dressed, well-fed, affluent criminal by omission or commission. In the words of Thomas Hoving in his 1968 commencement address at Bennington College, "The only questions that really matter ultimately in life are moral ones."

While one cannot prove with scientific precision that this voracious art market appetite has caused museum break-ins, the pillage of archaeological sites and the looting of churches, the art buyer makes the market. If art plunderers knew there would be no buyers for their spoils, there would be no spoils. Similarly, if drug addicts (be it cocaine, heroin, alcohol, or tobacco) stopped their addiction, such drugs would not be produced for U.S. consumption.

An individual art dealer, collector, or museum would never think of purchasing a piece of residential or commercial real estate from a person simply because he or she said they owned it (i.e., had legally transferable title). One would invest the time and money in obtaining a title search to guarantee ownership. This is a normal business practice. One buys a television with appropriate guarantee/warranty from a legitimate seller of that manufacturer's goods, not off the back of a truck near a pier. These are normal (i.e., moral) procedures.

The good people of any country's society do not wish to place an unreasonable burden on the art market or law enforcement or medical doctors. Just as malpractice (or bad practice) is a failure to practice medicine ac-

cording to standards in a given community (i.e., the nation), then it follows that there must be national standards of care. Any physician who wants to avoid a court appearance would be advised to adhere to those standards. The same applies to the U.S. art market. Buy only what is legally exportable material. Obtain written approval from the country of origin. This would be a key selling point in the object's provenance. Just as an art consumer checks the authenticity of a piece with specialized reference texts or noted academic art specialists to avoid buying or selling a fake, the other side of the coin should be an advance check on the legality of sale. Inspect the customs entry papers. If there are none, it probably entered illegally. Let us be clear, direct, and straightforward in our private and business dealings.

This procedure should apply to auction houses who still hide behind the admonition, "Buy at your own risk. We make no representation as to the authenticity or legality of an art work created prior to 1870 offered for sale. Nor do we warranty the seller's title." What a cop out! If I were to visit a fashionable perfume salon to purchase a bottle of Chanel No. 5 and the salesperson stated the store policy as, "We make no claim as to its authenticity or legality," I would quickly walk out, never to return. The collector, too, must be respectful of the law. When a thief of the Mona Lisa was caught and asked why he stole it, his response was, "I fell in love with it and had to have it." As human beings, we all love what is beautiful. But a normal person does not kidnap a beautiful woman because of this attraction. A woman belongs to herself or part of a family relationship. We expect a child to act spoiled, "I want it. I must have it." As adults, we believe that self-discipline of our immature desires is appropriate behavior. Buying legally acquired art is appropriate behavior.

But what about the museums—those secular cathedrals that are subsidized by the general public through tax deductions, tax exemptions, direct city subsidies, and paid admissions. The same moral prohibition against encouraging the abuse of humanity's past applies. No entity, even if it be a tax-exempt foundation, is exempt from ethical behavior.

When an artifact is being considered by a museum's acquisition committee, can the appropriate curator identify its country of origin? If that person cannot, then a different employment seems in order. If acquired by the museum, will the object be identified on its name plate as to its origin, "Unknown Central American Site"? If legality of ownership is uncertain, the museum should supply photos and a description of the considered art to the country of origin. The piece should not be acquired until a written approval is obtained from the appropriate minister of culture in that country.

I await the day when a prominent museum displays at its public entrance a clearly seen statement indicating that the contents therein have been le-

gally obtained with the full approval of their countries of origin. Far too often the financially supportive public is entering a magnificently adorned warehouse of stolen or illegally exported artifacts euphemistically called a museum. Yes, illegally exported art does not belong on display or hidden in a museum basement waiting for memories to cloud or laws' limitations to expire. For example, I investigated a 2.2 million dollar Poussin painting in the Cleveland Museum of Art. Its former director, Sherman Lee (an acclaimed celebrity of the Art Dealers Association of America), sought to purchase the painting from its legal owner in France. Lee, as well as its French owner, were carefully advised at the Louvre on the procedures to legally obtain an export permit for the painting.

When it arrived in Cleveland, unframed and rolled up in a suitcase, without such a French government export document and without any evidence that it was legally imported into the United States according to U.S. Customs requirements (it was fraudulently declared as a picture with no value), it was purchased and displayed. Mr. Lee was banned from travel to France. But the Office of the U.S. Attorney once again declined to prosecute anyone for violation of U.S. Customs laws after I had obtained an arrest warrant for the Frenchman, who is now in Canada. After years of pressure, the Cleveland Museum of Art agreed on March 27, 1987 to lend to the Louvre over the next twenty-five years this Poussin painting for exhibition. French charges against Mr. Lee were terminated.

Then there are the corrupt bribe takers, grave robbers and dealers within the victimized country of origin. We will be prevented for ages from enjoying the fruits of their culture. Acts of greed disturb the balance on which personal and communal feelings of security are based. Every unsolved crime has a demoralizing effect on the community. The skin of civilization is thin and fragile. Not even the final resting-places for the dead are permitted to be at peace.

How would we as Americans react if we learned that the tombs of Washington, Lincoln, or Kennedy were so desecrated and their material contents displayed in the art capitals of the world? A decent person earning say only $200 a year has the same capacity for respect and pride in his or her ancestors' cultural achievements as a Texas millionaire. The U.S. financial backer with manicured fingers living more than a thousand miles away from the plunder site is still a brother-in-crime with the *huaqueros*. The Maya grave artifacts of Rio Azul, Guatemala, do not belong on 57th Street in New York City or in Scottsdale, Arizona. Neither does the heritage of Mexico belong on the seller's table of a former government leader's wife living in Paris. A thorough house cleaning from within and without is needed.

Appearing in the September 9, 1986 *New York Times* was the following

headline, "Looters Imperil Unknown People's Past." The subtitle read, "As quickly as tombs are unearthed, looters sell contents to foreign dealers." No comment necessary.

The portrait of the U.S. art trader is not one of *Les Miserables'* Jean Valjean stealing a loaf of bread for his sister and her seven starving children, but one of far too many art possessors who have failed to control their appetite to strictly legal acquisitions. This problem, I hope, has been identified with fairness in reasonable terms. No matter how much those on the brink of illegality (or over it) wish to extol the misunderstood complexities of their business, strict adherence to government regulations is needed to solve it. The sleeping giant of public complacency has begun to awaken to this danger to civilization both within this country and outside it.

The question arises, "Who has the responsibility to be law-minded and law respecting in this matter?" My reply is, "Everyone." The burden rests on professional law enforcer and private citizen alike. Unfortunately the mere mention of "government control of art" may cause some art purchasers to stammer, blanch, turn argumentative, and undergo erratic changes in blood pressure and pulse. Fortunately, these word-induced emotional short circuits are not terminal and can be reactivated by compliance with the law. While law is but an imperfect tool used to obtain justice, it is the best one we have to date. When the art trade refuses self-control, outside authority must enter.

There are several U.S. government agencies which control domestic and international trade in artifacts (see Appendix I). These include the Bureau of Land Management, the National Park Service, the Fish and Wildlife Service, the Forest Service, the Federal Bureau of Investigation, the Bureau of Indian Affairs, the Army Corps of Engineers, and the Customs Service.

The primary law they enforce is the Archaeological Resources Protection Act, or ARPA (16 United States Code [USC] 470AA et seq.). ARPA prohibits excavation or sale of any archaeological resource located on public or Indian lands without a permit. Penalties for violation of this act include a fine of $10,000–20,000 and/or one year in jail. For a subsequent conviction, penalties increase dramatically to a $100,000 fine and/or five years in jail. (See Appendix I for a list of statutes and regulations related to cultural resources violations.)

The FBI enforces the National Stolen Property Act (18 USC 2314 and 2315) when a person knowingly receives or transports in interstate commerce stolen merchandise with a value over $5000. A conviction can bring a ten-year imprisonment and/or a $10,000 fine. State and local police agencies enforce robbery, burglary, and related art fraud that occurs intrastate or within their respective jurisdictions.

When stolen property enters the United States in foreign commerce, it first comes under the jurisdiction of U.S. Customs. That agency enforces various laws, acts, and statutes which prohibit smuggling, false declarations to U.S. Customs, and importation of certain categories of objects. In addition, the United States has special agreements with several countries, including Mexico, Peru, and Guatemala, whereby each country agrees to assist the other in recovering artifacts unlawfully excavated and exported in violation of their laws. In order to discourage the trafficking in certain Pre-Columbian (before AD 1500) artifacts, Congress enacted Public Law 92–587, and since 1972 it has been illegal to import Pre-Columbian monumental or architectural sculpture or murals into the United States from a majority of Latin American countries (see Appendix I).

Should a foreign country wish to assert a claim to an artifact not necessarily in violation of U.S. Customs regulations, an interpleader action can be utilized. In addition the INTERPOL network, which itself has no authority, can forward requests from the police of foreign governments to recover stolen art. U.S. Customs and the FBI investigate these referrals for possible seizure and arrest action.

When law enforcers are criticized for being overzealous in their work, they must be doing something right to receive such a backhanded compliment. The March 5, 1986 *New York Times* published a letter to the editor from Douglas Ewing, President of the American Association of Dealers in Ancient, Oriental and Primitive Art, entitled, "Customs Service Is Overzealous on Art Seizures." Mr. Ewing wrote in defense of a cultural property bill then under discussion in the Senate, "It is not this bill that would apply a special definition of the verb 'to steal.' That has been done by the U.S. Customs Service through a very loose interpretation of the 1979 case *United States vs. McClain.* . . . Customs has used the findings in *McClain* to prevent importation and effect seizure of Pre-Columbian and colonial objects from Central and South America."

AMERICA'S PRIVATE SECTOR FIGHT AGAINST ILLICIT ART SALES

It was private citizens who urged our country to join fifty-seven other countries in an international effort to reduce pillage of a nation's cultural patrimony. With the passage of the 1983 Convention on Cultural Property Implementation Act, the United States became the first major art importing country to implement the 1970 UNESCO Convention on the Means of Prohibiting and Preventing the Illicit Import, Export and Transfer of Ownership of Cultural Property. At the request of a signatory government, the United

States can improve import restrictions to protect endangered archaeological and ethnological materials. This act also prohibits entry of stolen cultural property documented as belonging to the inventory of a public monument, museum, or similar institution located in a member's country. The Cultural Property Advisory Committee consists of a cross section of the art market's private citizens. U.S. Customs is responsible for its enforcement. Both the American Association of Museums and the International Council of Museums have publicly urged museums to develop policies in acquisition that do not contribute to illegal export. New York's International Foundation for Art Research (IFAR), a nonprofit organization, is actively encouraging art market responsibility. More than voicing moral outrage, this group of three art historians has been responsible for art and artifact recoveries by law enforcement agents. These responsible women have received leads to the location of stolen sculpture and frescos from conscientious museum staff and art collectors seeking anonymity. Defying the 'don't get involved' mentality of many citizens, they notified this writer. I seized this art contraband to the joy of its true owners and those nameless art enforcers.

Professional archaeological associations, such as the Society for American Archaeology and the Association for Field Archaeology, have voiced their cry against plundering artifacts and for stronger laws against looting. On one occasion a New York University archaeology professor spotted a marble statue, which he had legally excavated for the Turkish government, but which was subsequently stolen, at a dealer's gallery. Investigation showed that it was innocently purchased in Germany before arriving in New York. It would never have been recovered for the Turkish people without such private sector cooperation. Another hero is archaeologist Oscar Muscarella of the Metropolitan Museum of Art, who deplores the removal of an object from its original context because it destroys its value as a historical clue. In the May 30, 1983 issue of *Newsweek* (McGuigan 1983: 86, 88), Muscarella stated, "Every object that surfaces on the art market is plundered," "End of discussion." Karl Meyer reported one Turkish official in a *New York Times* story as saying, "Either America does something tough to stop this racket, or a lot of your classical archaeologists are going to have to develop an interest in early Navajo culture" (1973: 70). Ironically, Norton Simon said it most succinctly in Hess' *Grand Acquisitors,* "The United States should not allow the import of art without clearance from the country of origin" (Hess 1974: 136).

If a group of drug dealers were, through their attorneys, to obtain the service of elected representatives on the local and national level to quietly have a bill introduced and passed into law that would cause their illegally obtained wealth to be protected by a very short statute of limitations from any prosecution, most of the honest, hard-working citizens of this country would

be demanding the law's repeal and a recall of said elected officials. Yet when influential art collectors, dealers and tax-subsidized museums have introduced similar bills to insulate their art acquisitions from legal recovery by their legal owners, a public passivity of silence at home results in the reality that citizens of poorer nations will be permanently deprived of their cultural history. Archaeological and ethnographic studies will be substantially aborted. But more importantly, the United States and especially New York City become the storehouse for stolen and illegally exported art (especially with the advent of NASA satellite-based technology made available to artifact grave robbers at a nominal cost).

I, for one, as a law enforcement official of this great country, am embarrassed to think that our national reverence for the Judeo-Christian Commands can be replaced by a codified immorality. My fellow law enforcers on the city, state, and federal level have worked on the principle that political might does not make right. I am angered when a small art lobby conspires to give themselves immunity from criminal and civil prosecution sought by the rightful owners of the world's artifacts. No law person I know ever wants a reduction of the statute of limitations on any criminal activity. If anything, we would like an extension of such protection for the past and future victims. Serving as a strategic deterrant is our country's U.S. Customs Service (whose origins go back to 1789) which is mandated to police contraband from entering this nation. If we believe that art smuggling is second only to narcotics in international crime, why shouldn't we insist that the means used to acquire art be as legitimate as the art itself? Why should the rich and cultured elite get away with things a common thief cannot? They are both criminals who declare by their actions that they are enemies of society and humankind. Let's stop the culture smugglers. Buy only what is legally exported. Protect the cultural heritage of all countries.

The term "Ugly American" has been hurled at our citizens by foreign adversaries of all political persuasions. As a nation, we can never please everyone in a time of propaganda wars and uneasy peace. But every step the United States takes in recovering a stolen artifact must set up a "thank you" in the mouth of an uncertain ally. They might even go as far as to say, "You're O.K., Yank." National difficulty can change to celebration of mutual admiration.

REFERENCES

Bator, Paul
1983 *The International Trade in Art.* Chicago: University of Chicago Press.

Burnham, Bonnie
 1978 *Art Theft, Its Scope, Its Impact and Its Control.* New York: Publishing Center
 for Cultural Resources.
Day, Bob
 1986 Forest Ranger Interview. *Salt Lake Tribune.* May 10.
Esterow, Milton
 1973 *The Art Stealers.* New York: MacMillan.
Ewing, Douglas
 1986 Customs Service Is Overzealous on Art Seizures. Letter to the Editor. *New
 York Times,* March 5.
Hess, John
 1974 *The Grand Acquisitors.* Boston: Houghton Mifflin.
Machlin, Milt
 1971 Antique Smuggling, New York. *Argosy Magazine.* September: 55–58.
McGuigan, Catherine with Elaine Shannon
 1983 The Booming Trade in Smuggled Art. *Newsweek.* May 30: 86, 88.
McLeave, Hugh
 1981 *Rogues In the Gallery, the Modern Plague of Art Thefts.* Boston: David R.
 Godine.
Meyer, Karl
 1973 *The Plundered Past.* New York: Antheneum.
Middlemas, Keith
 1975 *The Double Market, Art Theft and Art Thieves.* Westmead, England: Saxon
 House.
Watson, Peter
 1984 *The Caravaggio Conspiracy.* Garden City, N.Y.: Doubleday & Co. Inc.

CHAPTER 13

Cultural Property
and National Sovereignty

Let me start out by making three statements. The first one
is that cultural property is not, and cannot be claimed
to be the absolute property of a nation, any one nation. It
is the property of humankind as a whole since it repre-
sents the achievement of a part of all humankind that
cannot be set apart from other achievements, in other
geographical places. There can be no such thing as, for
example, American Cultural Property since American
cultural achievements are the product of worldwide inter-
action and are the heritage of future generations, world-
wide. The same holds for Mexico, Guatemala, the Cen-
tral African Republic, or any other country. No matter
what laws say.

National legislation is, by definition, self-serving. Gov-
ernments do not graciously give up their rights or their
power and this, in the case of antiquities, can hurt research
and knowledge. UNESCO Conventions notwithstanding,
countries consider their antiquities property, in the Ro-
man sense, for *usere et abutere.* Many national legisla-
tions are good examples of chauvinistic thought. They
look into cultural property solely as material that proves a
politically convenient ethnogenetical theory, or as assets,
whose monetary value can be added to a total in the na-
tional budget. They do not take into consideration that
cultural property is a highly perishable, nonrenewable re-
source for international research and scholarship. There
is no way, in this contemporary, interconnected world,

Jaime Litvak King

that we can recognize the absolute power, or the absolute sovereignty, of a state over its cultural patrimony.

My second statement is that the contribution of collectors to knowledge and to the safekeeping of pieces that are witnesses to the intellectual achievements of humankind is well known and well recognized. Gillett Griffin's article in *National Geographic* (1986) makes that point and, as far as the historic contribution is concerned, in the past, he is right. To his list of "good" collectors one can add many more.

We also have to recognize that official archaeology has never been able to reach an intelligent, sane adjustment with the activity of collecting. Legislations tend to either give collectors all the rights or deny them any. This is even truer in the Third World, where many of the pieces that interest collectors are found. There should indeed be a way to find means to constructively integrate amateurs to the work of digging out our past.

My third argument is about Griffin's remarks (Chapter 7) that archaeologists are not without blame regarding the loss of our cultural heritage. As he points out, there are good archaeologists and bad archaeologists; there are archaeologists who dig carefully and well and archaeologists who do a shoddy excavation; archaeologists who publish and archaeologists who hold on to the pieces that they excavated and neither publish them nor let anybody else do it. He is entirely right. There is no sense hiding that fact and our discipline should take steps to correct it.

I will even add another area of concern. Governments, mine and yours, do more damage to the cultural patrimony, through their programs of public works, than collectors and looters. This is the result of greed, shortsightedness, pseudo efficiency, ignorance, lack of culture, and plain stupidity. Something should also be done about that.

Those statements, though they might apparently weaken the case for national authority over objects of the cultural patrimony, do not reinforce the case for collecting. But, even if I am right, and there is no case for absolute and total state sovereignty, it still does not lead to a "finders keepers" situation. If some collectors, in times past—one notices that Griffin's examples are not very recent—were beneficial, it still does not mean that somebody's living room conversation piece contributes to anything but after-dinner boredom and snobbery. Nor does it mean that if some, or many, archaeologists are remiss in publishing their objects, then all collectors become saints, especially those who pay for looting and those who do not open their collections to the public.

In Chapter 7, Griffin comments that Third World countries especially have not been doing their job well when it comes to archaeology. He mentions two very sad and true cases: the theft of a piece in museum storage and

a snafu that resulted in a site not being protected. These, together with the well-known wholesale theft in the National Museum, are heavy charges. Up to this point, he is quite right. Security should be tightened and politics and bickering should not play a role in research. I do not think, however, that not taking good care of your house entitles everybody else to break in, take a piece of furniture, and call it rescue. This would only legalize and compound the felony.

State ownership of archaeological goods, the same as private property, does not hinge on whether we like it or not. Attorneys speak of jurisprudential traditions that differ in the definition of clear title, the element that decides the ownership of an object. It is basically an historically proven event. There has to be a continuous chain of legal right to the thing, from the original maker to the present possessor. The artist who made it sold it legally to somebody, he in turn gave his rights to somebody else and so forth up to now. If that is the case there is no doubt that the present owner indeed owns it.

Other situations not involving a direct chain of ownership from artist to present owner are covered by other laws, some of which originated in very ancient times. *Bobeh Mitzieh* is the talmudic term for such laws in Jewish religious legislation. English law refers to different situations and concepts that assign rights and authority over found objects. For example, debris found floating at sea—or flotsam and jetsam—might become the possession of those finding it, subject to the droits of admiralty, the courts having jurisdiction over maritime issues. While these laws are in general rather generous, one cannot use and own, for example, oil or coal just by virtue of having found it. One needs to get a concession and pay specific fees; even then the state limits the rights of ownership. Spanish royal law, from which Latin American jurisprudence for cultural property is based, was codified in the late fifteenth century, during a period of struggle between the king of Aragón and his feudal lords. Thus it assigned a large amount of power to the central government. Latin American independence movements translated it to Napoleonic terms and, in recent years, adorned it with much revolutionary gobbledygook. Mexico's basing its archaeological law on Article 27, the same one that deals with water rights, oil and coal, is a case in point. [See Lorenzo 1984:93 for a discussion of relevant articles in the Federal Law on Archaeological Monuments and Zones.]

Those traditions, and many more, govern found objects and their property and each country follows its own route. As anthropologists we recognize that different cultures view the matter of property in different ways. From different origins they evolve into present national laws and codes. They constitute the rules of the game and players abide by them. They are not easy to

follow since they are the product of centuries of history. They intermingle and make for lawyers being able to live well and in comfort. But they are the rules and each country has its own.

But I do not think that the important issue here is the fine points of law. Rather, it has to do with ethics. Discussions dealing with the good of collecting hide a few concepts and by this action become non sequitur. These concepts are precisely where the whole question of national sovereignty over cultural property really originates. These concepts are time and place and their consequences. As an archaeologist, one who digs pretty carefully and publishes, I have to see them as relevant parameters. As a Mexican national, conscious of the importance of cultural patrimony in aspects other than research, I have to claim that these are important, too. In those respects the examples put forth for the justification of unlimited collecting ignore the obvious. They tend to be from a time when countries did not think that antiquities and the cultural patrimony were of any use except the pleasure of eccentrics and had not, therefore, developed the legal, academic, administrative, and budgetary resources to do anything about them. This was the way of thinking in the United States after the Revolutionary War and in Mexico at the end of the Revolution. Today countries have developed, according to their own legal tradition, the necessary shields for their protection. They are not perfect. They are not even near being what they should be. The agencies they create and their methods should be made accountable, standards should be tightened, laws should be made more explicit. But those shields exist and there is nothing anybody can do about it. They are an important part of each nation's legal system and, in many cases, their only defense against being looted.

But, again, it is not really the laws that are most important. What really matters is that in every instance for either the defense or the damning of collecting, the concepts used are wholly inappropriate and irrelevant. True, in Thomas Jefferson's time, before systematic archaeology, it was all about objects, whole objects that were somehow believed to have intrinsic merit and whose artistic value was thought to be their only worthy trait. I would feel more certain of the collectors' sincerity if they talked about fragments too, but I don't know of any serious collector of potsherds over the age of eleven. The case for national protection of antiquities is precisely that the whole issue is not about objects at all, or artifacts, but about data.

In that light let us now look at collecting, as well as at how collectors have contributed to knowledge, to the safekeeping of the world's cultural heritage, and to the understanding of the past and of human achievements.

How do collectors obtain an object? Does it come from a well-controlled excavation, from a specific site, in its proper context, well registered and

Potsherds like this one from excavations at Becán, Campeche, Mexico have no value on the international art market and would be discarded by looters. However their discovery during controlled excavations allows archaeologists to record information about the vessel it came from and its ritual or utilitarian use. Photo by Lewis C. Messenger, Jr.

annotated? No. They buy it. It comes with no sure origin or provenance. It is not associated with other objects or fragments that can give to it the information needed to understand it. It is a single jewel. Its significance is not that of a witness to human achievement since the achievements do not really matter and are not collected or registered. It may, indeed, be the unique and valuable witness of an ancient ritual practice, as it is normally ballyhooed, or it may be just another chamberpot of the ancestors as it is seldom told to be. Who knows?

Let us suppose that the object comes from a tomb, as is many times the case. Who was buried with it? Was the individual buried there old or young, male or female, healthy or sick, well fed or undernourished? Who knows? Not only was the object not properly dug or registered but its associations and context, since they are neither valuable nor costly, nor contain that intrinsic aesthetic merit, are not kept. I have never seen in somebody's study, carefully guarded and displayed alongside a pot or a sculpture, the dust of a burial, bone fragments, or potsherds. What I see there is the subjective point of view of someone who had the money to pay for it. On its way to the mantelpiece the object has lost all trace of who made it and what it was used for. It also has lost the traces that physical anthropologists can use to tell us very important things about the human population that was relevant to it. The paleobotanist no longer has the pollen or the phytoliths that allow us to know more about the climate and the ecology of the culture that produced it. And it can no longer be dated any more. Humanistic culture and the collector, indeed.

Now let us look at provenance. We can imagine for a moment that archaeologists in the future, from the observation of the automobile culture, are going to come to the conclusion that, in late twentieth century America, although the elites were surely European, probably German or British, the middle classes were Japanese. That truth will be arrived at because we have objects with provenance. A Toyota in Osaka, for the student of material culture, means something very different from a Toyota in St. Paul. If every Toyota that we find, anywhere in the world, is said to have been found in Osaka some very strange things will happen to our knowledge about the Japanese economy, not to speak of the lack of a good explanation for the traffic situation that must have existed in that city.

Very important facts about culture, trade and exchange, focality and dependence, the extent of the domain of a culture and its relation with its neighbors, and the loci of development of ideas and inventions are direct derivatives of provenance. That vase on your table does not have provenance and is, therefore, of no use in teaching us about its creators. We have not saved witnesses to human achievement, we have destroyed them. By the way, provenance studies require an atomic reactor and pretty powerful computers. Your kitchen lab, lemon juice, and your IBM clone are not enough.

How did the ancient artifact get to the collector? It could have started on its way by being accidentally found by a poor peasant in a Third World country. He sold it for what seemed a lot of money to him. It was peanuts for the dealer who was the next link in the chain but it gave the peon the incentive to start looking for ancient objects, even dig around for them, therefore generating looting. It also could have begun its journey as a special order, and

was dug or cut away from its original site by specific instructions. It could have been stolen from a museum. In those cases the enterprise would necessitate the help of local officials. To looting add corruption.

The object has now reached a collection. Here is where we note that Griffin makes a point about archaeologists not letting anybody use the pieces. Do collectors allow access to their prizes? Can one really come into a collector's home, examine the things, photograph them, take a sample for lab analysis, bring in a couple of colleagues and discuss it?

The Classical Greeks believed that Hubris is followed by Nemesis. Do we really know whether the object is *really* Teotihuacán III? Or is it Jimmy Carter II? There are fakers, you know. Faking art has been good business for a long time. More than a few prized pieces in well-known collections have been exposed as forgeries. In Mexico, we have evidence for faking from at least the sixteenth century and it continues today. Brígido Lara, whose modern "interpretations" of Pre-Columbian clay figures have found their way to major museums and private collections, was arrested a few years ago in Mexico as a looter. He had to demonstrate his artistic skill and expose the efforts of his workshop, which had made a series of Classic Veracruz-style statues over a two-decade period, in order to gain his freedom (Crossley and Wagner 1987). But Lara is only the most famous of those who can make Pre-Columbian objects as well or better than the ancients themselves. There are three ways, and three ways only of authenticating an archaeological piece. The first one is to dig it out in properly controlled circumstances. The second one is to entrust it to a very complicated and very expensive laboratory, of which there are few, even in the United States. This process can often only tell you that the piece is not an obvious fake and it can never verify its authenticity beyond reasonable doubt. Thermoluminescence, the dating of pottery by the rate it recovers light emission properties, is not enough. It has not been sufficiently developed, its plus or minus range is too large to trust and it has consistently been fooled by fakes. We need to know more about specific ceramic materials before we believe it. The third way is to trust somebody who says he knows.

He knows in two ways. One is by style, which he knows very imperfectly because, among other causes, his use of collector's pieces has made it impossible to really know. Styles have constant subtle regional and temporal variations which cannot be well fixed without good provenance studies. Styles die out in one place and remain alive in another and they revive every so often. They start in one place and take time to reach another. When they do they are no longer the valid style in their point of origin. Anybody looking at dress fashions knows it. Style is a lousy way of dating and a stupid way of assigning provenance.

The other way is that your friendly evaluator is not an innocent dupe. Collectors specialize. If they are offered an object that fits their idea they will send it to the appraiser—and pay him for the work. If they are told that the piece is OK it will be bought. Quite a few appraisers get two fees, one from the collector to evaluate it and another from the seller for giving the green light to the sale. I have known authenticators who actually originate the sale even to the point of ordering the fake to be made in the first place. A discussion on the morals of collecting gets dangerously close to Nemesis.

Here is where the case rests. The past is not seen from objects alone. Cultures are not just things in a glass case. They come with context and association, with dates and with provenance, and those are destroyed by collecting, private or public. Whether you are an archaeologist or an art historian or a paleochemist or even a lawyer, if you are interested in the past, its art and its processes, whether you are a professional or an amateur, you have to recognize that the past does not belong to you and therefore you do not engage in activities that damage the few precious remains that can help us understand and appreciate it. Collecting, and its association with looting, does just that.

Let us go back to national sovereignty. Griffin, in his oft-quoted article in *National Geographic* (1986), gives an example. The Japanese government authorizes the sale of cultural objects it deems not unique enough to keep. Let's look at it. The decisions that are to be reached by the jury of experts that he cites are necessarily based on their knowledge, at present, of the archaeology of Japan, an imperfectly known field. Their mistakes will tell in the future. Also the Japanese government, from the article, must feel that the country has enough museums, and that no more of them have to be built and stocked, that the education of the population about their past and their culture is complete, and therefore that enough examples are now in stock. The pieces are therefore surplus and can be disposed of. With some profit if possible.

I come from a country that does not feel that way. We need more museums to educate our people and the edifices have to tell a story by the objects they show. Therefore they have to be stocked from our own reserves. Archaeological objects do not only serve to be looked at or admired, they are primarily to educate. Therefore we do not sell them and therefore national sovereignty over archaeological pieces is defined from national priorities. Other countries also think like that. I would advise the American government, or indeed the Japanese government, to look at their archaeological remains that way.

You have heard of *Nouveau Riche.* My country is *Nouveau Pauvre.* Our

biggest resource now is tourism and that means the sun on our beaches, the beauty of our mountains, the incomparable aroma of the Mexico City smog and, what else? The cultural patrimony. If you count how many tourists come to our cities to look at museums, churches, and archaeological sites you understand why we try to protect our cultural property. We make a fair living out of it. If we want to survive we have to preserve it.

All this does not mean that Mexico, or any other country, is all-knowing and cannot do wrong. On the contrary. Archaeological laws throughout the world have been conceived with an antiquarian, rather than an archaeological, point of view and that is why discussions about cultural property take place. They should be seen as the protection of a world cultural resource and as the defining of fields and subjects for important research. Professional supervision—as opposed to political vagaries—should be implemented. International agreements have been, can be, and should be made on the subject. National responsibility and therefore national use are complementary to national sovereignty.

Also a new way of dealing with collecting has to be developed. Collectors are not necessarily destructive, snobbish, tax-haven-seeking boors. Griffin is right in that. Many, perhaps the majority, are well-meaning, cultured, involved, caring individuals. Their function should be reexamined and a more constructive way of interacting with official archaeology, from governments and universities, must be found. I cannot believe that intelligent people limit themselves to hoarding because that is all they want. How many collectors would like to help in the work of the archaeologists, personally, institutionally, and monetarily? I would say quite a few. Many of their skills and knowledge would be of importance for our work. Many of them are damned good amateur archaeologists, better than some professionals. They should be given the opportunity of defining a whole new relation with the cultural patrimony. If what we are talking about is just whether they should be told that they can legally pay good money for unprovenanced, probably fake pieces, I feel it would be insulting to them.

So you see this discussion is not really about laws. Not even about ethics. It is really about common sense.

REFERENCES

Crossley, Mimi and E. Logan Wagner
1987 Ask Mexico's Masterly Brigído Lara: Is it a Fake? *Connoisseur,* June: 98–102.

Griffin, Gillett
 1986 In Defense of the Collector. *National Geographic.* Washington D.C.: National Geographic Society, 169 (4): 462–465.
Lorenzo, José Luis
 1984 Mexico. *Approaches to the Archaeological Heritage. A Comparative Study of World Cultural Resource Management Systems.* Edited by Henry Cleere. Cambridge: Cambridge University Press.

Part III

In important ways, the language people use reflects their conception of themselves and their world. If the language used is primarily the language of law, the conception of what counts as the relevant issues in a dispute will tend to be given in terms of what the law permits or requires. If the language used is primarily the language of morality, the relevant issues in a dispute will tend to be viewed as normative moral issues, that is, issues of right and wrong, moral rules and responsibilities, moral virtues and vices. And if the language used is primarily what some philosophers (e.g., the later Wittgenstein) refer to as "ordinary language," or as what others might refer to as "common sense," then the legal and ethical issues in a dispute will tend to be viewed as relevant to the extent that they do or do not get at what ordinary language or common sense dictates.

The language used by the four authors of section III, Leo J. Harris, Charles S. Koczka, Douglas C. Ewing, and Jaime Litvak King, to discuss their perceptions of cultural properties regulations differs in important respects. As a consequence, these four authors understand and frame the debate over cultural properties in different terms and from different perspectives.

In his essay, "From the Collector's Perspective: The Legality of Importing Pre-Columbian Art and Artifacts," Harris uses the language of law and the collector's perspective to discuss cultural properties issues. Harris discusses the actual legal restrictions and precedents in place in the United States as of 1987 in order to show that there is "little legal risk to concern the collector of

Karen J. Warren

Pre-Columbian art or artifacts, if he or she is willing to suffer port of entry indignities from the Customs Service," and if he or she collects items that are not stolen, not monumental artifacts or feathers, valued materially at less than $5000, and not from Mexico, Peru, or El Salvador. Furthermore, Harris assumes that his examination of the relevant legal issues can establish a lack of relevant discernible risk to the hypothetical casual collector of cultural art and artifacts without any position "being taken on the ethics or morality of collecting Pre-Columbian art and artifacts."

Although Koczka also uses the language of law and legality in his essay, "The Need for Enforcing Regulations on the International Art Trade," it is a very different conception of law and legality than Harris's. Appealing to Aquinas's view of law at the outset of his essay, Koczka makes it clear that his conception of law is laced with morality. Unlike Harris, who assumes that there is or can be a clear separation of *positive law*, or law as it is, from *moral* or *divine* law, or law as it ought to be, Koczka implicitly assumes either that no such distinction is in fact possible, or, if possible, that the only relevant issue is what good law, just and morally responsible law, permits or requires. In the spirit of Aquinas's famous natural law theory dictim that "an unjust law is no law at all," Koczka claims, "If laws are just, they are derived from eternal law such as the Commandment, 'Thou Shalt Not Steal.'"

Koczka's main argument is that law enforcement control of the U.S. art trade is necessary, desirable, and just: It is necessary in order to discourage or prevent the smuggling of stolen artifacts without legal penalties, to reduce the demand for these artifacts in a market monitored by supply and demand, and to prevent the continued depletion of cultural properties conceived as non-renewable cultural resources. It is desirable in order to discourage the irresponsible rationalizations and minimizations of art dealers, museum curators, collectors, and the like who claim "But, I bought it in good faith" or "What the hell! As long as U.S. laws are not broken, it's all right. They're brought here and given a home. Now cultured people can see them." (The latter, it should be noticed, is also suspect for its class, race/ethnicity, and national undertones.) And law enforcement control is just because "no entity is exempt, even if it be a tax-exempt foundation, from ethical behavior." For Koczka, everyone has the responsibility to be "law-minded and law-respective" and to adhere strictly to government regulations. The legally mandated and ethically justified role of the U.S. Customs Service is to police art contraband from entering the United States and to deter or criminally penalize "culture smugglers."

The Harris and Koczka pieces are an example of how theoretical issues characteristic of the *legal positivist-natural law* debate in jurisprudence emerge in discussions of cultural properties. The implications of that debate

for understanding some of the core issues underlying these two different approaches to cultural properties issues is significant: While Harris's discussion of legal regulations self-consciously brackets-off all ethical considerations, Koczka's discussion assumes that ethical considerations are inextricably connected to legal considerations in such a way that there can be no adequate discussion of the legality of collecting which is not also a discussion of the ethics of collecting. One can almost hear Koczka ask "But is it right?" when Harris claims that there is no legal risk to concern the collector of Pre-Columbian art or artifacts, as long as one observes certain restrictions on what items are collected. For Koczka, settling the question of legal risk would not settle the key issue of moral responsibility which attaches to "law-minded and law-respectful" conduct. Stated somewhat differently, settling the question of legal risk to the casual collector would still leave open the central question whether such collecting was justified—legally or morally.

Harris's and Koczka's use of the language of law and legality is different from that of Ewing. In his essay, "What Is Stolen? The *McClain* Case Revisited," Ewing appeals to a mixture of common sense and common law notions of "stolenness" to show some of what he takes to be the disastrous effects of *McClain,* as understood and enforced by the U.S. Customs Service. According to Ewing, use of *McClain* by Customs as justification for seizure of any Pre-Columbian objects entering the United States on the grounds that such objects, however obtained, are presumed to have been stolen, has resulted in an erosion of the legislative process, untold harms and injustices to bonafide purchasers of cultural artifacts, and a subterfuge of the really important questions concerning collecting. If Ewing is correct, U.S. Customs is a key culprit in the ineffectiveness of national legislation to resolve cultural property issues.

The Ewing essay shows why a debate over the meaning of "stolen" is no mere semantical dispute, of interest only to philosophical pedants: important legal and practical consequences flow from what is taken to be the legally relevant sense of "stolen." Can an object at any time become stolen, not by an act of theft, illegal export, or illegal import, but by a declaration, a claim of "stolenness"? Just what is the legally relevant distinction between "ownership" and "possession" of Pre-Columbian objects? In what sense (if at all) can someone meaningfully be said to legally possess an object which is, nonetheless, deemed to be stolen? Conceptual clarification of these issues has utmost urgency for collectors, art dealers, museum curators, and others affected by legislation and administration of cultural properties policies.

The attention to common sense and a non-legal sense of what is just in a given situation characterizes the Ewing essay as well as the Litvak King essay "Cultural Property and National Sovereignty." Like Ewing, Litvak King is in-

terested in unpacking what is at stake conceptually and in practice by how one understands the cultural properties debate. Yet the language, tone, and content of Litvak King's essay differs from that of Harris, as well as that of Koczka and Ewing, in three noteworthy respects.

First, unlike Harris, Koczka, and Ewing, Litvak King is not primarily concerned with the language of law or issues of national legislation and administration. This is because his focus is on showing that "cultural property is not, and cannot be claimed to be, the absolute property of a nation, any one nation. It is the property of humankind as a whole." According to Litvak King, where countries consider their antiquities their property, that is, a material political asset of monetary value in the national budget which is properly owned, transferred, regulated, divested, purchased, sold, or otherwise preserved or dispensed with in accordance with law and legal regulation, national legislation of cultural property is self-serving. Since, according to Litvak King, there can be no such thing as American Cultural Property or Mexican Cultural Property, attempts to frame the dispute over cultural properties in terms of national or international legal regulations concerning collecting (even if particular concerns are sometimes legal concerns) is simply misguided. Since Litvak King does not view cultural property in this way, he is not terribly interested in its legal regulation *qua property* in this sense. In this respect he differs from Harris, Kozcka, and Ewing.

As a second and related point, Litvak King has no desire to keep intact the familiar conception of cultural properties as *objects*. For Litvak King, "what really matters is that in every instance for either the defense or the damning of collecting, the concepts used are wholly inappropriate and irrelevant." This is because "the whole issue is not about objects at all, or artifacts, but about data." The central concepts are the concepts of provenance, "time and place and their consequences"—the stuff data is made of—not of property, rights, ownership, and law. For Litvak King, cultures come with context and association, with dates and provenance, and those are destroyed by collecting, whether private or public. Properly conceived, cultural property is "a highly perishable, nonrenewable resource for international research and scholarship." A construal of the debate over so-called "cultural properties" in terms of property (in the sense of object) misses this contextual interpretation of the nature, provenance, and significance—historical, cultural, scholarly, educational—of cultural properties.

Third, for Litvak King, although the past does not belong to a country, or a collector, or a museum, or an art dealer, nonetheless, for many countries (e.g., Mexico) their "cultural patrimony" is essential to their economic survival (e.g., as tourist centers). This means that cultural patrimony is both a

national economic resource and a world cultural resource requiring professional, as opposed to political, supervision. Whatever national sovereignty countries have over their cultural patrimony must be understood in this light.

It is for these three reasons that Litvak King concludes that the discussion of cultural property and national sovereignty "is not really about laws. Not even about ethics. It is really about common sense." Unlike Harris and Koczka, and to some extent like Ewing, it is the language of common sense that Litvak King uses to discuss the regulation of cultural property. Litvak King uses this language even though, since his starting assumptions are different that those of Ewing, Harris, and Koczka, he arrives at different conclusions about how one should construe the debate over cultural properties.

In summary, there are important differences in the language used by Harris, Koczka, Ewing, and Litvak King to discuss substantive issues around cultural properties. This is to be expected. The issue is complex and the multiple interests represented and perspectives taken often do conflict. The terms of the debate often do give rise to competing conceptions of what is important and how to resolve the debate.

Yet, perhaps surprisingly, there is also striking similarity among them. All four agree that some legal regulation at both national and international levels is important, indeed crucial, for protecting and preserving "cultural properties;" even what they disagree about is such issues as which laws are needed, who ought to be covered by the laws, and the extent to which legal solutions are adequate as solutions to the international trafficking of stolen or smuggled art and artifacts.

All four also agree that there are important scholarly, educational, and intellectual values of cultural properties that both professional archaeologists and responsible collectors preserve by their activities. Litvak King and Koczka explicitly refer to such cultural property as a nonrenewable resource, with Litvak King suggesting that the law treat it much the same way it treats "rare and endangered species" in environmental law. Nothing in the Harris or Ewing essays would rule out viewing cultural properties as endangered, nonrenewable resources.

All four agree that some cultural properties are legitimately owned and some are not. When they are legitimately owned, no legal intervention is warranted.

Lastly, all four agree on what are the key concepts in the debate over cultural properties: cultural property, stolen art, provenance, legal ownership. What they disagree about is what these concepts really mean, and the relative significance of these concepts in discussions and adjudications of cultural property issues. Indeed, it is one of the main points of the Ewing

The Classic Maya site of Palenque in Chiapas, Mexico, is a symbol of cultural patrimony and an important center of tourism. The Temple of the Inscriptions and the palace complex are widely recognized as symbols of Mexico's Pre-Columbian heritage and adorn tourism posters, t-shirts and a wide array of other products. Palenque also is the setting for a series of round table conferences on Maya hieroglyphics, art, and culture. *Photo by Phyllis Messenger.*

essay that prior to *McClain,* there was a presumption that everyone agreed on what constitutes "stolenness;" since *McClain,* there has been no clear conception of just what "stolen" means in the context of cultural properties.

Given this range of agreement and disagreement about the nature, significance, and regulation of cultural properties among such different parties to the dispute as Harris, Koczka, Ewing, and Litvak King, is there reason to be hopeful? I think so. If parties to the dispute would identify and put on the table at the outset of discussions both those things about which they agree and those things about which they do not agree, then conditions would be in place for policy-making on those issues where there *is* agreement, and for initiating compromise approaches to conflict resolution based on a consensual decision-making for those issues where there is not agreement. In the final analysis, such a two-pronged approach to resolution of cultural properties issues would be, I think, in everyone's interests.

Working Out Differences:
Round Table and Conclusion

Highlights of a Round Table Discussion and Some Recent Developments in the Cultural Heritage Arena

A round table discussion capped the conference on "the Ethics of Collecting Cultural Property: Whose Culture? Whose Property?" held May 23–24, 1986, in Minneapolis. In it speakers and moderators [1] answered questions from the audience which were put to them by Sheila McNally, professor of art history at the University of Minnesota. The ensuing dialogue allowed speakers to respond to one another's formal comments and address what they considered to be some of the most important points raised. They also were able to address what future steps should be taken.

ROUND TABLE ON THE ETHICS OF COLLECTING

The following section highlights comments made during the discussion. To begin, U.S. Customs Senior Special Agent Charles Koczka was invited to comment on issues discussed by attorney Leo J. Harris and art dealer Douglas Ewing. Koczka described the law and the Customs Service as a means to the end of stopping the illegal international art market. Referring to an analogy given earlier by archaeologist Ellen Herscher regarding the failure of Prohibition, he said, "I believe moral responsibility is going to be the main avenue to address plundering. . . .

Phyllis Mauch Messenger

I think we're all in agreement that [we are against stealing] from a museum, with all the violence that may accompany it, or from someone's home. But . . . when another country has a rich heritage in their art and it comes into this country in violation of U.S. law, I don't see the necessity to ponder for years whether we're going to be respectful of another entity's property. It belongs to them. Where do we get the nerve to doubt that they have the right to their own property? I am not naive enough to think that grave robbing, and that's what we're talking about, is going to end."[2]

He suggested areas for compromise, including long-term loans so that those outside a country of origin can share firsthand in the enjoyment and study of these various forms of cultural heritage, not just by looking at a photo. "But the bottom line is, in our ordinary experience, when we buy a car or a house we assume when we take the ordinary precautions that what we buy we have title to. A collector, a dealer, a museum curator should make that extra effort along with determining whether an item is correct and affordable, to see that it left with the approval of the country of origin and came into this country . . . legally as well."

In response Harris suggested that the Customs Service should consider the objections raised by Ewing's dealers' group and various lawyers, "perhaps looking to revising that customs regulation or at least give us a hearing."[3]

Herscher, who chaired the Committee on Professional Responsibilities for the Archaeological Institute of America, raised the possibility of increased import restrictions for property. "If the United States required export permits for objects coming into this country . . . this would simplify things for the Customs Service." She suggested that the procedures currently used by Customs probably are necessary in order to uncover illegal imports. "But if we had a simpler system in which export permits were required for entry into this country then that screening process would not need to be as heavy-handed as it is at this time."

McNally: "*United States versus McClain* may be flawed in the eyes of some legal experts, but those who see the urgency of the looting crisis, especially in Mexico and Central America, see it as a useful stopgap. How can we pass quickly to the next step—probably new laws?"

Herscher: "The new laws have been proposed, but unfortunately . . . I think they are trying to undo what's been accomplished to date. . . . Import restrictions that would honor the cultural property definitions of other countries would be a good way to go."

Thomas K. Seligman, deputy director of the Fine Arts Museums of San Francisco, reminded the panel and audience of the importance of knowing what definition of cultural property is being used. "What I used from the ICOM study has to be borne in mind throughout this. We should be talking

about significant, important objects, and we shouldn't be talking in a carte blanche way of any pot or any sherd or any little figurine or any wooden carving or anything else."

A questioner had anticipated that line of reasoning and offered a counter-argument. "If the law cannot care about trifles, archaeologists do. Is there any way we can educate people not to buy small figurines, et cetera, of no great intrinsic value but which probably came from looted sites and would be of great value in their context? Is that a lost cause?"

Alan Shestack, then director of the Minneapolis Institute of Arts: "I think that's impossible and I agree with the sentiment that has been expressed here so far—that the laws have to focus on objects of the greatest distinction." He used the example of environmental protection to illustrate levels and cate-gories of risk. "The endangered species laws specify the difference between endangered, threatened, and listed, and the severity of the punishment for importing goods in those different categories is different depending upon the importance or significance of the crime. Architectural elements and ste-lae and so on are the things we want to protect. But there's no way, given the profusion of material, that you're going to be able to control the sale or changing of hands of modest objects. I don't even think it's a desirable thing to do."

Jaime Litvak King, archaeologist and former director general of Aca-demic Programs at UNAM: "Let me be honest, I'm pretty scared at the defi-nition of things that are important and things that aren't important . . . be-cause I know that most data comes out of things that are not important, but get removed or discarded or broken, to get at the things that you people consider important. So, let me be a little scared in public.

"Also I find that although in general I agree that a law similar to the envi-ronmental protection law could work in a way, I see a very significant dif-ference. When you protect an endangered species, what you're telling the public is, 'Don't kill 'em until they can reproduce themselves back into an acceptable number.' I'm sorry, I do not see Teotihuacán figurines reproduc-ing themselves until they're back in abundance. That, I think, is a substantial difference. There has to be a better way."

Gillett Griffin, curator of Pre-Columbian Art at Princeton University's mu-seum, related the story of how he had tried to encourage a family in Teoti-huacán to manufacture really beautiful and creative figurines. He offered to make a logo for the fakes that could be exported to museum shops, "something that could be creative because the Mexican genius for creating is still there." Though the people who were producing those forgeries in Teo-tihuacán were extraordinarily talented, they never moved on Griffin's offer.

Litvak King countered with an anecdote of his own about Mexican arti-

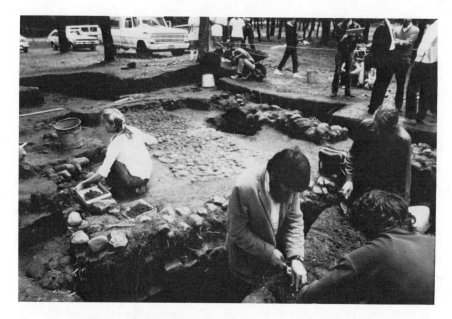

Careful archaeological excavation includes measuring, meticulous notetaking, and drawing of objects or portions of structures in situ. When a burial was discovered during an archaeological fieldschool at the site of Manzanilla, Puebla, Mexico, the excavation pace slowed considerably as preparations were made to open the chamber without disturbing the objects inside before they could be recorded. *Photo by Phyllis Messenger.*

sans and making fakes for tourism. "In the late 1960s and early 1970s the federal representative for tourism for the state of Morelos was an up-and-coming and very active architect named Felipe Giardel. He was very concerned about looting and about the way Mexico could use its patrimony to increase tourism." In northern Guerrero he found a village which specialized in making beautiful fakes. The local stone manufacturers were doing Olmec style axes and similar items.

They helped the artisans set up an exhibit of Olmec-style modern art in Cuernavaca, complete with catalog. After the exhibit closed, some pieces were sold, others went back to the owners. "A few years later I was in Europe and I saw a couple of my pieces in European museums. 'Place: Guerrero' or 'Place: Tabasco, date: 1200 BC—Olmec Ax'."

Karen Warren, professor of philosophy, Macalester College, picked up on Litvak King's remarks concerning how choices are made about what artifacts are significant, suggesting "that the notion of cultural patrimony was not gender neutral." She offered the term *cultural matrimony* to show that

what we count as a significant artifact can be viewed differently. "Just to think of *cultural matrimony*—how do mothers think about their objects—their houses, their quilts, their tapestries, their diaries, their letters, their journals—historically they haven't counted as philosophy. There hasn't been a great female philosopher for 2,500 years in the Western Tradition, partly because of what we think philosophy is and that women haven't produced it. There haven't been great women artists. Why? Because we haven't looked at what women produce in the home as art. . . . It does suggest that looking at it from an alternative perspective—what women in the home consider philosophy or art—may show us the ways in which our models are biased. It may show us that what we take as insignificant reflects a male bias or a white bias or a class bias or an ethnic bias."

Herscher discussed the 1977 Cultural Property Export and Import Act of Canada, which implements the UNESCO Convention in Canada, and its relevance to the question of import restrictions. While this "does prohibit the import into Canada of anything from another party to the UNESCO Convention that does not have an export permit from its country of origin, Canada does not enforce that law at the boundaries. . . . It's a very open border, particularly between Canada and the United States. They don't even really make an attempt to enforce that at the border. But they feel that one of the important assets of this law is that it facilitates the return of things once they've gotten into the country. Once something is discovered in Canada, this provides the legal mechanism for seizing and returning. So this method acts as kind of a screening process. The whole process will not be gone through for very minor objects, but only ones that are of importance to the country of origin." This is in contrast to the approach of making judgments for other countries about what should be restricted, whether monumental or small.[4]

McNally asked Litvak King to "describe what you would see as an appropriate new relationship between collectors and archaeologists or museums."

Litvak King pointed out that he speaks for himself only and not the Mexican government. "Let me start out by saying that I sincerely think the laws are stupid. I'm a born-again anarchist. I realize that every time I cross a border and somebody snoops into my bag and decides that chocolate or a computer chip endangers the national economy.

"Mexican archaeological law is particularly stupid. I know because I was one of the guys who made it." He agreed with Griffin that the Mexican government is often remiss, or even criminally negligent, in its protection of archaeological sites and artifacts. He emphasized, however, that weaknesses in the government don't make collectors any less culpable.

He described some of the characteristics and some of the idiosyncrasies of Mexico's 1972 federal law on monuments and archaeological zones (Ley

Federal sobre Monumentos y Zonas Arqueológicos, Artísticos e Históricos. Mexico. Diario Oficial de la Federación 26 de mayo de 1972.). "The law contained provisions for the formation of private units, private organizations, that could decide on their own to be the caretakers of their local, or a certain type of cultural, patrimony. In effect, it allowed for people to associate into civil societies and start a museum and do things like sponsor digs. That part of the law is still in the law, but it sort of disappeared when it got to the regulations that cleared the law. That, I think, was a very large mistake.

"The law for the first time in Mexican history had teeth in it and you can go to jail without bail for things like looting and selling together. However, it had a very interesting provision: if you are a poor peasant, all your penalties are reduced by half. Now, who loots? Who's the guy who's going to dig in a place? Of course, the peasant. So that in effect the law contradicts itself by being merciful. That is an old trouble with Mexican laws."

Litvak King offered suggestions of changes that could make the 1972 Mexican law more useful. He urged that there be some protection for colonial and nineteenth-century architecture, which is disappearing rapidly from Mexico City and is "being substituted by square boxes that are ugly, uncomfortable, and have only the virtue that they have fallen down in earthquakes." He had proposed without success a provision in the law that would give tax exemption to owners of these colonial homes if they took care of them.

As for reducing the looting of Pre-Columbian artifacts, "How would I do it? Well, very, very simple. I hold that most serious collectors spend enough money on their collection and care so much about it that they probably would be willing to spend an equivalent amount of money on sponsoring and participating in well-controlled, well-designed, and scientifically valid archaeological digs, if they get to keep and show and possess the pieces for an agreed number of years, subject to showing and lending them for research. Then after a reasonable number of years [the pieces would be] returned to the national patrimony. I would say that would probably get the agreement of ninety percent of the serious collectors anywhere in the world. It will not take care of the little bitty collector who steals a piece or . . . who goes to Teotihuacán and gets shown where he can dig up a piece and pays the 500 peso tip to the guy and is probably digging up a Lopez Mateos IV piece, not a Teotihuacán III. . . . As long as it is subject to professional supervision and to professional standards, it could be the way for a very interesting kind of procedure that would involve not only collectors but museums. And I would also hold that that sort of a thing should be complemented by a very active policy of mutual exchange and mutual loans between museums, not only between Mexico and the United States, but all over the world. If we have

that, we have better museums and better collections and a better relation and a better way of working."[5]

Orrin Shane, curator for archaeology of the Science Museum of Minnesota: "I want to second the suggestion that things like collection-sharing programs can be very useful in relieving the pressure on the market in illicit trade in artifacts."

Litvak King's suggestions for changing the nature of collecting generated several questions and comments about the mechanics and economics of such loan or sharing arrangements.

McNally: "How much collecting is done as financial investment? Obviously, if you have to give it back, that's a disincentive."

Shestack wondered how such activities would be policed and monitored. "Who would be in charge of the logistics and the administration of it? That's why I'm in favor of rather straightforward laws that neatly punish those who steal major objects and more or less wink at the minor things, even though I know that archaeologists don't like that, because it seems to me that for any law to work, or for any system to work, it has to be enforceable and simple and doable. It seems to me that what you've just suggested, although in the abstract a wonderful notion, isn't possible to accomplish."

Litvak King: "You may be right."

Seligman brought up adult education programs, such as Earthwatch and University Expeditions Research at the University of California, Berkeley, in which individuals pay to go with archaeologists, botanists, or other professionals for several weeks to help in a field project. They don't get any objects or a financial return, except a tax write-off. He emphasized that there is a public interest, as well as knowledge and energy to funnel into these projects.

Griffin described a project that was piloted in Mexico in the early 1970s to instill pride and nationalism in children who lived in small rural communities. He called it "a brilliant idea, the best I'd ever heard." Iker Larrauri and Mayan Cervantes proposed an idea that project organizers would approach the elders in the pueblos, get their approval, then go to the children and ask them to collect different sets of objects, bugs, bottlecaps, et cetera. They would then select two respected people in town, perhaps a teacher and a priest, to make a museum. "Some 600 were done with no expenditure of money. This means that a child who faced the future of just being another farmer might get interested in rocks, make a collection, realize that he could be a geologist, that there is an educational system that might take him through college. This is absolutely free and gives a feeling of national pride. . . . It is a most brilliant concept." Griffin said the program's success depends on giving children an interesting idea, then not meddling with them.

Litvak King responded by calling the project, which included 400 local temporary archaeological museums, "the most abundant piece of junk and a national catastrophe." The museums, which are now dismantled, were "placed in charge of some teacher, who either took care of them or not, or was shifted to another job in a couple of years. The director took them out of their case because he decided he needed the case to store books. Although there was a budding bureaucracy developing around this—it was never really checked. In the best of cases we produced forty-five kids who were damn good looters. And, boy, they dug because they wanted to have their collections better than the next town. There was a lot of damage. We are fortunately past that. And let us forget that sort of project for the next hundred years."

Herscher gave an example of cooperation reported by archaeologists who work in Honduras. Some local collectors there "are lured into archaeology classes with the promise that they'll learn more about their collections. But it's really more of a brainwashing effort," involving fieldwork and education about the cultures represented by their pieces. "It's been quite successful. There have been collectors who have given up collecting and donated their collections to the museum, and it has very positive effects along the lines we've been talking about."

She also discussed the question of collecting for investment. "I try to avoid knowing anything about that. There was an article in *Business Week* magazine in a January 1986 column called 'Personal Business.' It was advocating collecting Pre-Columbian artifacts and all sorts of antiquities." One of the things which struck her about the article was that *Business Week* was claiming that, "although there are restrictions, there is plenty of material out there to collect." This did not jibe with recent claims by art dealers and collectors that national laws of various countries and the Customs crackdown following the *McClain* decision had cut off their market. Herscher continued, "I wrote to the magazine, saying that this surprised me. They stood by the claim and said that the information came from collectors and dealers. That there was in fact a great deal of legitimate material to collect."

A questioner wanted to know if Shestack informed New Guinea about the mask his museum had considered buying. "Doesn't a museum have an obligation to inform the country of origin? Couldn't you have requested their permission to acquire it?"

Shestack: "We did none of those things; we did not want to get involved. We felt our nonpurchase was an adequate step. It's a problem which runs through my profession. Every time a museum director learns of the unethical behavior of another, it's considered correct etiquette to inform your colleague that you are aware of the indiscretion or crime, but one doesn't go on and report the activity to the police or the FBI or IRS."

He told an anecdote which occurred when he was director of another museum to illustrate the situation. "On one occasion, my museum was offered, after end-of-tax-year, a rather valuable picture only on the condition that I send a thank you letter and a receipt dated in the previous year because the donor needed a tax deduction in the previous year. . . . I turned it down and said I was very sorry, but could only accept it in the given year. It was considered to be tax fraud, a federal crime, to do what I was being asked to do. Three months later I saw this object that I had refused to accept in February on the cover of the accessions bulletin of another museum as their best acquisition of the previous year. So I was aware immediately of a colleague who had accepted the work of art that I had rejected. It struck me that because I had been law-abiding, my museum had suffered and the museum whose director had been willing to break the law benefited. So I phoned the other director and told him I was aware that he had committed tax fraud and I didn't know if he'd get two or five years. I was then chair of the ethics committee of the Museum Directors' Association and I told this gentleman that if I heard of his doing it again I would bring it to the floor of the association.

"Now I might react differently today. But the example of our New Guinea mask reveals that I still do not want to get involved to that degree. I want to protect my own institution from wrongdoing, but I am not sure I want to get deeply involved in international problems if I can avoid it. Maybe it's cowardly, maybe it's just appropriate caution."

Responding to a question about how a museum director should react to an offer to sell a collection of Pre-Columbian Peruvian pottery "guaranteed to be genuine," Shane said, "We have almost no acquisition funds [at the Science Museum of Minnesota]. I would tell him he shouldn't do it. I would not tell the Peruvian government. I would tell the individual that he should not have behaved that way."

Referring to the question of the New Guinea mask, Seligman said, "I happen to know Papua New Guinea has considerable latitude in their export permits. And one easy way to clear the slate is to send a photo with a letter to the head of antiquities in the country of origin and say, 'We have been offered this object for acquisition and would like to acquire it. May we?' If they say no, it's then back to the dealer or whomever it's coming from, and for Papua New Guinea and the dealer to fight it out. I don't think the museum has to be jeopardized in that process." He explained that directly contacting the appropriate government was the best way to assure legality of an acquisition. When the Fine Arts Museums of San Francisco requested and received permission in 1975 from the Nigerian government to purchase a stone object, "We could get nothing better. That would hold up in any court of law in this country."[6]

Shestack: "My own experience in trying to deal with Third World countries and sending letters to ministers in those countries is that you almost never get any response. I've written to many countries, including Italy and Mediterranean countries as well, where I have tried very hard to initiate dialogue, with no response from the other side. I'd like to take the answer one more step. If I had found that mask already in the collection, . . . then of course I would have tried to contact the country of origin. It never occurred to me. I didn't want it badly enough to get involved in what I expected to be a protracted series of negotiations with a government on the other side of the world. I try to avoid administrative complexities to as great an extent as possible."

McNally: "It can, however, work. The University [of Minnesota] Gallery was left a collection that they regarded as a hot potato because it had been collected by a minor diplomat and brought out in the 'diplomatic pouch.' He had done it for the best possible motive, to provide a teaching collection for his alma mater. They wrote to the government of Lebanon for permission and, to their surprise, given what the government of Lebanon must have on its mind right now, they got a quick response back, 'Yes, you may certainly keep this.' You never know who is going to answer your letters."

Koczka: "The idea of law enforcement shouldn't be limited to someone in law enforcement or a customs inspector. I think our citizens, even some collectors, are law-minded people." He pointed out the importance of citizens informing the authorities of wrongdoing, whether on the part of museums or individuals. He suggested writing an anonymous letter to an investigative agency, whether on the city, state, or federal level, being specific about the apparent violation. "You can have peace of mind that you tried to be part of the solution, not the problem. Because far too many people have not wanted to get involved, we are now on the verge of the greatest ripoff of history since the sixteenth century. So instead of saying, 'Let them do it,' we're all in it together. You're our eyes and ears to what's going on."

McNally asked, "What is the situation with things brought out of countries by diplomats?"

Koczka explained that diplomatic immunity is limited usually to the ambassador or consul general and immediate family; however, "the area of diplomatic pouches is a sacrosanct subject on both sides."

Harris expanded: "When I was in the government, one of my responsibilities was diplomatic immunity. I think there are two situations. An American abroad may or may not have diplomatic immunity, but if he does, it is only from the laws of the country which he is in. If that man should come back with a collection of things, he has no immunity from customs examinations and customs clearance. Unfortunately, customs authorities for many

years have had a tradition of letting American diplomatic and consular people go through with either no examination or a very cursory one. That is the root of the problem that's referred to here."

Herscher: "Under the Vienna accords, diplomats are supposed to voluntarily abide by the laws of the country in which they're accredited."

As a final question, McNally asked the panel what kind of practical follow-up could make their discussion significant for the future.

Litvak King suggested organizing other conferences that include representatives or officials of countries involved in cultural property issues. A series of conferences would encourage "people to talk to each other. . . . We should come out with a progressively better, more subtle, and more rounded approach to it. The fact that we are sitting here and talking to nominal enemies makes a hell of a difference."

Warren noted that an economist in the audience had asked her for references she had read as background for the discussion of cultural heritage issues. "He said he was interested in bringing it back to his own discipline. I would encourage you to include people like us, the philosopher and the economist, who have never thought about it before. . . . I will teach about it, read more about it, write about it, will get philosophers at association meetings to think about it. I will submit papers at philosophical meetings about it. None of which I would have done a month ago."[7]

Shestack: "A basic benefit of a conference is consciousness raising for everyone involved. There has been a greater understanding of various positions that the panelists here represent. . . . I will carry the . . . sense of discussion to the Museum Directors' Association's next meeting . . . and inform the ethics committee that this conference took place."

Harris reiterated Shestack's admonition that "laws should be simple. . . . For any law to be effective it must be consensual. The people involved in it must agree with the rationale behind it or the law will fail. So we need more education to pass new laws."[9]

Koczka: "If there are any collectors or future collectors who have a doubt as to the legality of that kind of hobby or enterprise, they would be strongly urged to contact U.S. Customs or the State Department and foreign consulates, so they don't walk into something with their eyes closed. I had no aspirations that there was going to be a mass hypnotism and everyone in this room was going to come away thinking that it's all illegal and we're not going to participate any more. But know what you're getting into, so you won't be embarrassed on either end of the border by officials, such as myself or Mexican officials, when you have a work of art that could have been plundered."

Seligman: "There is so little communication among museums about the kinds of situations that we have all been involved in in one way or another

regarding this issue. The model of Teotihuacán has received considerable national attention because we wanted it to. . . . We believe it says something positive. Others have done positive things as well, and it's very hard to find out about them. I'd like to encourage more publication or information circulating about these things. Let's take it out of the back room and put a little bit more on the table."[9]

Shane: "We have talked among ourselves about preparing some sort of publication of the results of the conference, and I think we are all encouraged to proceed with that."

Participants left the conference encouraged to think of concrete actions to take to learn more about the issues, to promote their viewpoint, or to work for changes in laws or policies affecting the international antiquities trade.

RECENT DEVELOPMENTS

Discussions of cultural property issues seem to have become more prominent recently in the media and in scholarly publications. An increasing number of newspaper stories and articles in popular and professional journals have reported on looting, efforts to retrieve or repatriate objects, and programs to save archaeological sites.

LINTEL RETURNED TO THAILAND

Perhaps one of the most highly publicized cases in the United States culminating in 1988 was that of a Khmer dynasty lintel called "The Birth of Brahma with Reclining Vishnu on a Makara," which was in the collection of the Art Institute of Chicago. The stone lintel had been on exhibit at the museum since 1967, first on loan from the Alsdorf Foundation, then as a gift from the Foundation since 1983. In 1976 the Thai Embassy had contacted the Foundation "concerning allegations that the piece may have been illegally removed from Thailand" (Art Institute of Chicago 1988a). The Foundation asked for additional information, but there was no further claim until 1988 when the Thai government requested the return of the lintel, the only missing piece in the newly restored Temple at Phanom Rung in northeastern Thailand.

Negotiations, which lasted throughout much of 1988, were complicated by several factors. Thailand was not a party to the 1970 UNESCO Convention. According to Prince Subhadradis Diskul, who had represented Thailand at the UNESCO negotiations, they felt that small poor nations such as Thailand would receive no justice from the plan which would require them to pay compensation and costs to recover their lost cultural treasures (personal communication April 1988). The Art Institute maintained the position that

some form of compensation was necessary before the lintel could be returned. The compensation could take the form of a donation or loan of "another object that is representative of the aesthetic and cultural richness of ancient Thailand" (Art Institute of Chicago 1988a). Although the lintel had been in the United States and on display long enough to be technically exempt from claims, the Art Institute wanted to comply with the government of Thailand and recognized the desirability of its return to complete the restoration of the national monument. The sticky point was the manner and form of compensation, since the Thai position was that the piece had originally been illegally removed and no compensation was necessary. "The feeling of the people of Thailand is that it is stolen," said Prince Diskul, "And they think that if it is stolen, we shouldn't have to send anything in return" (Associated Press 1988).

The stalemate came to an acceptable resolution in October 1988 when the Elizabeth F. Cheney Foundation of Chicago offered to obtain a comparable work for the Art Institute, thus clearing the way for the return of the lintel to Thailand. The sculpture was shipped to Thailand in November with the additional assistance of United Airlines (Art Institute of Chicago 1988b, 1988c). The lintel, which has been returned to its original setting in Phanom Rung, has become an important national symbol of Thailand's cultural heritage. The image appears on posters, T-shirts, and even plastic key chains.

CODES OF ETHICS DISCUSSED

In recent years, various professional organizations have adopted or revised ethical guidelines (see chapters 8, 16, and Appendix II). Museum codes stress their "role as preservers of humankind's culture and heritage, emphasizing an obligation to society that includes the importance of accuracy, honesty, and sensitivity" (Francell 1988: 35). In a 1988 round table discussion of museum ethics and professionalism (AAM 1988a), six members of the museum field agreed that museum standards of behavior are improving. Yet in the 1990s a series of exposés and revelations about ongoing secrecy in the art trade and legislative lobbying to block bills that would require greater scrutiny of provenience suggest that, for some curators, codes of ethics are not much more than lip service.

Discussion among professional archaeologists of these ethical issues has been widespread, prompted by ongoing looting, site destruction, and difficult issues related to the publishing and commercialization of looted archaeological materials. For example, an essay on archaeology and the ethics of collecting by Arlen Chase and Diane Chase of the University of Central Florida and Harriot Topsey, archaeological commissioner of Belize (now deceased), was prompted by the debate between collectors and archaeologists

published in *National Geographic* (see chapters 13 and 15). These archaeologists ask if the portrayal of a looted artifact on the cover of a national magazine, which may well raise its value on the illicit art market, is "offset by educating the public about the serious problem of a burgeoning black market in looted antiquities?" (Chase, Chase, and Topsey 1988: 56). They argue that "modern archaeologists have a series of commitments, contracts and responsibilities that they did not have in the past. Most often these ethics or rules of conduct are understood by working archaeologists, but the general public is largely unaware of them" (Chase, Chase, and Topsey 1988: 59). In 1991, the Society for American Archaeology (SAA) formed an Ethics in Archaeology Committee to review the Society's 1961 ethics principles in order to address ethical issues associated with the use of looted data in research and publication. Five years of study, debate, and widespread consultations led to a new statement of Eight Principles of Archaeological Ethics, approved by the SAA Executive Board in 1996 (see Lynott and Wylie 1995; Lynott 1997). The Principles, focusing on stewardship of the archaeological record as the key principle, are being used by SAA members as the framework for the practice of archaeology in the next century (see Appendix II).

CONTINUED SITE DESTRUCTION

Maya Stelae

Peabody Museum archaeologist Ian Graham knows the scale of the looting problem perhaps as well as anyone, having recorded hundreds of hieroglyphic inscriptions at remote Maya sites in the Guatemalan Peten. In many cases all he found when he arrived to survey a site was mangled and broken piles of carved stone discarded when looters hacked the fronts off stelae to pack them out of the jungle on muleback. He dismisses as "devoid of all merit" the claims sometimes made that "commercial 'salvage' has saved monuments lying abandoned in the forest, with the implication that the sculptural detail would have suffered greater damage from erosion in the unspecified future than any occurring in the course of its 'rescue'" (Graham 1988: 123). The archaeologist, the epigrapher, and the art historian are left with the regrettable task of trying to re-provenience the occasional piece on exhibit in a museum which can be matched to its discarded hieroglyphic blocks and hacked-up base discovered in an unrecorded site.

Slack Farm

Then there is the story of Slack Farm, a Late Mississippian site in Kentucky, which for years lay undisturbed, holding great promise of revealing much information about early contact with Europeans. Then, in late 1987, the farm changed hands and the new owner was persuaded to sell rights to

"excavate" the site (Fagan 1988: 15). The site was subsequently ravaged by tractor and shovel before local residents complained about the digging and the diggers were arrested. The incident prompted strengthening of laws to prohibit desecration of any grave site in Kentucky and raised some public awareness of the problem. Yet as archaeologist Brian Fagan discovered when he discussed the event with acquaintances, "I was horrified by some of the reactions. 'So what?' . . . 'It's a free country.' . . . 'It's up to landowners what they do with their property.'" He went on, "In my numbness, I had forgotten that many people see nothing wrong with private landowners ravaging the past for profit—as long as laws are not broken. We have a strange relationship with the prehistoric past in this country" (Fagan 1988: 16).

OTHER DISCUSSIONS OF LOOTING

Widespread publicity of situations such as the destruction of Slack Farm helps clarify the message that it is not acceptable to wantonly destroy evidence of the past. Thoughtful discussions of looting as a threat to our cultural heritage appear regularly in such popular magazines as *Archaeology* and *National Geographic* and in numerous scholarly books (for example, Weil 1983; Merryman and Elsen 1987; Ashmore and Sharer 1988; Layton 1988; Cleere 1984, 1989; Merryman 1988). And more than one recent bestseller has used these issues as a theme (Hillerman 1988, Koczka, chapter 12).

Even Indiana Jones is being educated to respect cultural heritage issues. The November 1988 *Bulletin* of SAA reported that Steven Spielberg and company at Lucasfilm Ltd. had been persuaded through the efforts of Native Americans, preservationists, and SAA officials to move the opening scene in *Indiana Jones and the Last Crusade* from a Mesa Verde kiva to a cave (SAA 1998b: 4). In a letter to archaeologists Jeremy Sabloff and Dena Dincauze, Spielberg's group said, "Please understand we take your letter very seriously. We had already planned to substitute the kiva for a cave. Additionally, we will make no reference to a kiva. There will continue to be the discovery of a gold crucifix, but please understand that this will not be represented as someone looting the cave. In fact, the crucifix is returned to a museum as a part of Spanish archaeological findings. We sincerely hope this addresses your concerns, and we continue to support the Society for American Archaeology" (Spielberg *et al.* 1988).

CONFERENCE ON PRESENTING THE PAST

A number of public and professional conferences held in recent years have included sessions or presentations on cultural heritage issues. These sessions not only report on promising programs that have been developed,

but also educate and encourage the dissemination of the positive aspects of these programs, as well as encourage further discussion.

One such conference, "Presenting the Past: Media, Marketing and the Public," was held in October 1988 at the University of Minnesota. It was organized by the University's Center for Ancient Studies and was sponsored by the National Park Service with the assistance of the Bureau of Land Management, the Tennessee Valley Authority, and the Soil Conservation Service. Speakers reported on a number of programs intended to engage and keep public interest in research on the past (see Wells 1991).

ARCHAEOLOGY AS COMMUNITY EFFORT

Arthur Spiess, an archaeologist with the Maine Historic Preservation Commission, discussed the transformation of Maine archaeology into a community effort over a ten-year period. An archaeological training program provides apprenticeship opportunities and professional supervision for individuals to do what they like to do in a constructive way. In some cases, it has transformed site looters into avocational archaeologists who understand context and preservation and who see from another perspective the problems generated by looting. Spiess commented that Maine does not have a rampant looting problem "because Maine folks have a respect for the environment" (Spiess 1988).

Marion Davison, anthropology curator at the Milwaukee Public Museum, suggested that the best deterrent against pothunting is peer pressure and loyalty to a group, such as a local archaeological society. The emphasis needs to be on the information gleaned from archaeological projects, rather than on beautiful objects. She urged museum and archaeological staffs to share their knowledge with volunteers and to carefully lay out their duties. The staff should set high expectations for volunteers, then trust their work in order to encourage them to continue with the program (Davison 1988).[10]

"DE-MARKETING" POTHUNTING

Harvey Shields, a research analyst with the U.S. Travel and Tourism Administration, discussed the possibility of adapting marketing strategies to help identify and reach individuals who engage in illegal pothunting in the United States, a sort of "de-marketing" program. He estimated that only a small portion of the population is involved in illegal pothunting, and most of them are ordinary people who need to be educated about the law and about preservation. In many cases, a slight change in the mission statements of museums and interpretive centers at archaeological sites will go a long way in

meeting educational objectives, such as changing from a mandate to "display objects" to one of "educating the public about the area" (Shields 1988).[11]

OPERATION SAVE

Another viewpoint was presented by Lynell Schalk, special agent-in-charge with the Bureau of Land Management (BLM) in Portland, Oregon. She insists that the population segment needing education about preservation laws includes anyone eligible to serve on a jury. In enforcing the Archaeological Resources Protection Act of 1979 (ARPA), she has seen defendants who had been caught in the act of looting on public land acquitted by juries who were not convinced that looting is a crime. Schalk sees the attitude of the public as the biggest problem, compounded by uninterested judges, lack of federal funding and coordination, and lack of archaeological expertise on the part of law enforcement officials. Laws that depend on judgments about monetary value and cultural importance of artifacts are difficult to enforce, she argues. Laws need to be enforceable by making the illegal excavation, export, or import of any object a misdemeanor.

In October 1986 to combat these problems in a meaningful way, Oregon officials in the BLM and the Park Service decided to mount an interdepartmental effort. Using the recently inaugurated U.S. Department of the Interior program *Take Pride in America* as a model, they began Operation SAVE (Save Archaeological Values for Everyone). A public awareness campaign of posters, news articles, and public service announcements urged everyone to "help save the past. . . . If you see someone removing artifacts or damaging archaeological sites on public lands, please note the location and report it immediately." Posters and stickers feature the face of Tsagaglalal, "She Who Watches," from Wishram Indian rock art. Beneath her watchful eyes is a toll free number ending in "SAVE."

The key to Operation SAVE is the interdepartmental cooperation of law enforcement, the state archaeologist, and public affairs personnel. The entire bureau is involved in public education, enforcement and prosecution of cases, and the offering of an archaeological theft protection course. The four-day course includes archaeological and law enforcement training, ending with a mock crime scene and arrest (with the media invited to watch).

Now, says Schalk, the program is becoming a grass-roots effort, as people in Oregon are beginning to report looting. Individuals who call the hot-line with questions or to ask for a free poster also receive a copy of the laws which protect archaeological sites. In addition, state police and deputies, who several years ago would not have been involved in enforcing ARPA, have had their consciousness raised (see Schalk 1986, 1988, 1991; Stanbro 1987).

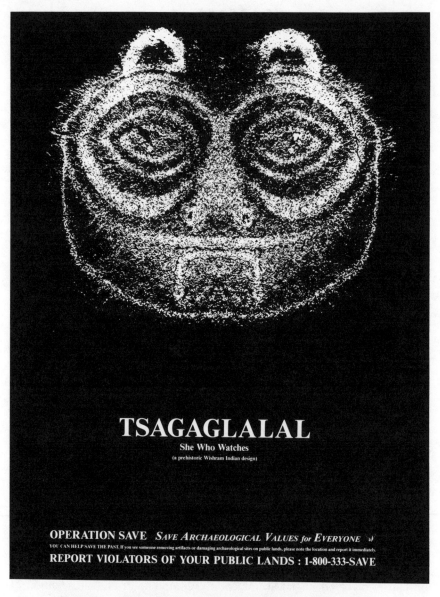

TSAGAGLALAL
She Who Watches
(a prehistoric Wishram Indian design)

OPERATION SAVE *SAVE ARCHAEOLOGICAL VALUES for EVERYONE* ▸

YOU CAN HELP SAVE THE PAST. If you see someone removing artifacts or damaging archaeological sites on public lands, please note the location and report it immediately.

REPORT VIOLATORS OF YOUR PUBLIC LANDS : 1-800-333-SAVE

Operation SAVE poster showing Tsagaglalal, "She Who Watches," from prehistoric Wishram Indian rock carvings. The poster is part of an Oregon program asking the public to help save the past by reporting looting of archaeological sites on public lands. According to Indian legend, Tsagaglalal was a mythical woman ruler who was changed into rock by Coyote and ordered to watch over her village along the banks of the Columbia River. The image is seen on rock art panels and bone carvings throughout the region. The image also has been adopted by the Society for American Archaeology for its Anti-looting Project. *Courtesy of the Bureau of Land Management, Portland, Oregon.*

THE BRITISH MONUMENTS PROTECTION PROGRAMME

British archaeologist Christopher Chippendale, author of *Stonehenge Complete* and editor of the journal *Antiquity,* discussed a realistic alternative to the notion that "if it's prehistory, it must be preserved." In 1986 in Great Britain, the Historic Buildings and Monuments Commission initiated the Monuments Protection Programme for England to establish a ranked schedule of sites, listing what exists, what is precious, what has disappeared, and making a rational proposal to conserve what remains (Chippendale 1988).

The idea of ranking the importance of sites and choosing which to save and which to let go if they are threatened may not be palatable to most archaeologists. But Chippendale argues that it is worse to have no game plan or point of view. Without preplanning, it is more difficult to control what happens to sites and artifacts when they are threatened. He suggested a variation on an old saying, "He who writes the agenda rules the world."

The initial phase of the British program has been to sort out its philosophy and procedures and to gather resources. The criteria for evaluating sites in the Monuments Protection Programme include relation to other sites, visual amenity, information potential, fragility, rarity, and diversity. Pilot studies were carried out in several counties, with scoring of sites resulting in similar rankings as those established by county archaeology officials. British officials hope these procedures will provide a framework for revision and review as new sites come to light. They are aware that, "It is one thing to convince fellow archaeologists of the arguments behind the selection process, we must also convince the general public of the validity of our judgements" (Darvill, Saunders, and Startin 1987: 403; see also Canham and Chippendale 1988).

SAA ANTI-LOOTING PROJECT

In 1988 SAA initiated an ambitious anti-looting project called "Save the Past for the Future." Goals of the project were to 1) "understand why archaeological looting occurs," 2) "determine ways to reduce looting," 3) "provide opportunities for public education," and 4) "better protect America's archaeological heritage." The program was developed to address the SAA's concern that federal laws, including ARPA and the National Historic Preservation Act, which were enacted to protect archaeological resources are "often ineffective, not only because of the greed of criminals, but also because of the attitude of many people who ignore or condone such activities" (SAA 1988a: 5).

The SAA "Save the Past for the Future" project was kicked off at a special session of the 1989 SAA Annual Meeting (see Reinburg 1991: 272) and a

week-long working conference in Taos, New Mexico, in May 1989 (see Judge 1991). In Taos, three working groups addressed the looting and vandalism problem from three perspectives—understanding, preventing, and combating the problem. Some fifty issues, resulting in 237 recommendations, were compiled in a final report *Action for the 90s,* which was released at the 1990 SAA annual meeting in Las Vegas (SAA 1990). Among the conclusions of participants in the session on preventing the problem was that public education was the most effective long-term solution to the problem of site looting and vandalism. An ad hoc working group developed an action plan which led to the establishment of the SAA Public Education Committee in 1990, which has been responsible for numerous programs and initiatives in archaeology education (see chapter 16).

These are just a few examples of current programs and publications that not only depict the serious problems of looting but consistently emphasize the importance of education. Can we hope that the grade school children of today are growing up, not only as environmentalists and recyclers, but also as respecters and preservers of our cultural heritage? The long-term educational process may be our best hope for salvaging our past. Professional archaeologists, art historians, and others who teach about our cultural heritage can help by emphasizing the cultural context of objects, as well as their stratigraphic context in archaeological terms. Objects are no more important than the story they tell. These individuals can multiply their efforts by helping other teachers create curricular units and by developing museum programs that emphasize education using objects as part of an environment rather than as objects of veneration. And once these programs, whether they be curricular units or volunteer archaeological programs, are established, they must be maintained, nurtured, and kept up-to-date.

Is it possible to develop a world where collectors join with governments to sponsor scientific excavations, in return for a long-term loan of artifacts? Can museum curators be on the cutting edge of seeking collection loan and sharing programs with institutions or governments in other countries while fulfilling the mandate of their jobs? Will foundations step in to fund the building of exhibition space for loaned exhibits in developing nations? Is it possible to return to thinking of artifacts in their original meaningful context rather than as commodities or objects with a price tag?

CONCLUSION

The essays in this book have no doubt raised more issues than they have settled. While they have introduced many points of view about ethics, they do not presume to have covered completely the issues discussed. It is our

The importance of context is shown by the La Venta Offering Number 4, a cluster of ritual Olmec celts. They were found during a controlled excavation, so their original configuration could be accurately reconstructed in the National Museum of Anthropology in Mexico City. If these had shown up on the market, we would never know what their original arrangement was, or even that they belonged together. Instead we have a hint of some Olmec ritual, some play being done before us, which we would not have known if those pieces had been out of context. It is one of the primary arguments for archaeological context, in which a photo, drawings, notes and measurements are made before the pieces are removed. *Photo by Lawrence G. Desmond.*

responsibility to understand the laws that govern the activities we pursue. Yet when it comes to the international art market and cultural property, nations' laws often disagree and interest groups work constantly to seek revision of those laws for one purpose or another. We are in a period of change and revision. Laws in effect today are likely to be revised next year or when the next president or prime minister takes office. Many individuals choose to take a position that not only abides by laws as they stand, but goes beyond legal requirements, serving to explain how they think laws should be revised and exemplifying how they might be implemented.

We must each work to keep ourselves informed, learn from other events and situations, and be willing to work together and seek compromises. We must always bear in mind that the uppermost shared goal is the preservation

of our cultural heritage in the best way possible to enrich not only our lives, but those of our children and grandchildren wherever they may live on this globe.

NOTES

1. Participants included Sheila McNally (moderator), Karen Warren, Thomas Seligman, Alan Shestack, Gillett Griffin, Ellen Herscher, Orrin Shane, Leo Harris, Jaime Litvak King, and George Stuart. New York art dealer Douglas Ewing addressed the conference but did not participate in the round table. Customs Agent Charles Koczka, a member of the audience, was invited to participate in the discussion.

2. For additional discussions of international law and the art market, see issues of the *International Journal of Cultural Property* and *Art, Antiquity and Law*. For discussion of the looting and site vandalism problems in the United States, see SAA (1990).

3. The Getty Conservation Institute has taken a leading role in developing a uniform international reporting form for customs agents to use in describing cultural objects (see www.getty.edu; see also "Playground for the Human Spirit," Ellen Herscher, *Archaeology* 51 [3]: 64–70; see also discussion of international protection in chapter 16).

4. See chapter 16 for a discussion of the 1997 United States-Canadian Bilateral Accord to Protect Archaeological and Ethnological Cultural Property.

5. INAH published a series of articles in *Arqueología Mexicana* summarizing the status of looting and destruction, artifact falsification, and the recovery of archaeological patrimony (IV [21, Sept.-Oct.] 1996). See chapter 16 for a discussion of United States-Mexican efforts to improve bilateral protection of cultural heritage along the borderlands.

6. The highly publicized case of the Government of Cyprus vs. Peg Goldberg, filed in May 1989 in Indianapolis to recover the Kanakariá mosaics, provides a complex example of the ramifications of not seeking permission of the appropriate government entity. Dan Hofstadter's *Goldberg's Angel* pieces together the intriguing tale (1994, New York: Farrar/Straus/Giroux). See also *Archaeology* 51 (4, July/Aug.) 1998 for further developments.

7. An exceptional example of educating professionals in related fields can be found in *Nonrenewable Resources,* journal of the International Association for Mathematical Geology. A special issue on "The Loss of Cultural Heritage—An International Perspective" provides rich background articles for scientists, land managers, and policy planners (6 [2, June] 1997).

8. For related discussion, see "The Politics of Archaeology and Historic Preservation: How Our Laws Really Are Made," by Loretta Neumann. In *Protecting the Past.* George S. Smith and John E. Ehrenhard, eds. Baton Rouge: CRC Press. 1991: 41–46. See also *Archaeology and Public Education,* Washington, D.C.: SAA, Fall 1995: 5 (4).

9. A thoughtful examination of this issue is provided by Clemency Coggins in "A

Licit International Traffic in Ancient Art: Let There Be Light!" delivered at the *Fifth Symposium on The Legal Aspects of the International Trade in Art, Licit Trade in Works of Art.* This and other papers from the conference are published in the *International Journal of Cultural Property,* New York: de Gruyter Berlin, 1995: 4 (1).

10. See also "Avocational Archaeology Groups: A Secret Weapon for Site Protection," by Hester A. Davis. In *Protecting the Past.* George S. Smith and John E. Ehrenhard, eds. Baton Rouge: CRC Press. 1991: 175–80.

11. See "Marketing Archaeological Resource Protection," Harvey M. Shields. In *Protecting the Past.* George S. Smith and John E. Ehrenhard, eds. Baton Rouge: CRC Press. 1991: 167–173.

REFERENCES

American Association of Museums (AAM)

1988a Ethics and Professionalism: Round Table Confident Standards are Rising. *Museum News* 67 (2): 37–41.

1988b Art Institute to Return Lintel to Thailand. *Aviso* 12, December: 4.

Art Institute of Chicago

1988a *Letter to the General Public Concerning Thai Lintel from the Desk of James N. Wood.*

1988b *Art Institute to Return Lintel to Thailand.* October 24 press release.

1988c *Art Institute of Chicago Ships Lintel to Thailand.* November 8 press release.

Ashmore, Wendy, and Robert J. Sharer

1988 *Discovering Our Past: A Brief Introduction to Archaeology.* Mountain View, Calif.: Mayfield Publishing Company.

Associated Press

1988 Deal to Return Artwork Angers Thailand. *San Francisco Chronicle.* Friday, July 22.

Canham, Roy, and Christopher Chippendale

1988 Managing for Effective Archaeological Conservation: The Example of Salisbury Plain Military Training Area, England. *Journal of Field Archaeology* 15 (1): 53–65.

Chase, Arlen F., Diane Z. Chase, and Harriot W. Topsey

1988 Archaeology and the Ethics of Collecting. *Archaeology* 41 (1): 56–60, 87.

Chippendale, Christopher

1988 The Ideas and the Realities in Monument Protection. Paper presented at the conference, *Presenting the Past: Media, Marketing, and the Public,* University of Minnesota, Minneapolis, October 12–14.

Cleere, Henry, ed.

1984 *Approaches to the Archaeological Heritage. A Comparative Study of World Cultural Resource Management Systems.* Cambridge: Cambridge University Press.

1989 *Archaeological Heritage Management in the Modern World.* Winchester, Mass.: Unwin Hyman.

Darvill, Timothy, Andrew Saunders, and Bill Startin
>1987 A Question of National Importance: Approaches to the Evaluation of Ancient Monuments for the Monuments Protection Programme in England. *Antiquity* 61 (233): 393–408.

Davison, Marion
>1988 Presenting the Past Through Public Programs. Paper presented at the conference, *Presenting the Past: Media, Marketing, and the Public,* University of Minnesota, Minneapolis, October 12–14.

Fagan, Brian
>1988 Black Day at Slack Farm. *Archaeology* 41 (4): 15–16, 73.

Francell, Mary
>1988 Ethics Codes: Past, Present, and Future. *Museum News* 67 (2): 35.

Graham, Ian
>1988 Homeless Hieroglyphics. *Antiquity* 62: 122–26.

Hillerman, Tony
>1988 *A Thief of Time.* New York: Harper and Row.

Judge, W. James
>1991 "Saving the Past for Ourselves: The Society for American Archaeology Taos Anti-Looting Conference." In *Protecting the Past.* George S. Smith and John E. Ehrenhard, eds. Boca Raton, Fla: CRC Press: 277–81.

Layton, Robert ed.
>1988 *Who Needs the Past? Indigenous Values and Archaeology.* Winchester, Mass.: Unwin Hyman.

Lynott, Mark J.
>1997 Ethical Principles and Archaeological Practice: Development of an Ethics Policy. *American Antiquity* 62 (4): 589–99.

Lynott, Mark J. and Alison Wylie, eds.
>1995 *Ethics in American Archaeology: Challenges for the 1990s.* Washington, D.C.: SAA.

Merryman, John Henry
>1988 The Retention of Cultural Property. *U.C. Davis Law Review* 21 (3): 477–513.

Merryman, John Henry and Albert E. Elsen
>1987 *Law, Ethics, and the Visual Arts.* 2d ed., 2 vols. Philadelphia: University of Pennsylvania Press.

Reinburg, Kathleen M.
>1991 "Save the Past for the Future: A Partnership to Protect Our Past" In *Protecting the Past.* George S. Smith and John E. Ehrenhard, eds. Boca Raton, Fla.: CRC Press: 271–76.

Schalk, Lynell
>1986 *Operation SAVE, Proposal to Increase Citizen Awareness and Enforcement of the Archaeological Resources Protection Act in the Pacific Northwest.* Portland: Law Enforcement Staff, Oregon State Office, Bureau of Land Management.
>1988 Looters of the Past: An Enforcement Problem in the Pacific Northwest. *CRM Bulletin* 11: 32–34.

1991 "Operation SAVE: An Integrated Approach to Protecting the Past." In *Protecting the Past*. George S. Smith and John E. Ehrenhard, eds. Boca Raton, Fla.: CRC Press: 209–14.

Shields, Harvey M.

1988 Marketing the Past: Identifying the Target Market. Paper presented at the conference, *Protecting the Past: Media, Marketing, and the Public*, University of Minnesota, Minneapolis, October 12–14.

Smith, George S. and John E. Ehrenhard, eds.

1991 *Protecting the Past*. Boca Raton, Fla.: CRC Press.

Society for American Archaeology (SAA)

1988a *Saving the Past for the Future*. Washington, D.C.: Office of Government Relations.

1988b SAA Plays Part in New Indiana Jones Film. *Bulletin* of the Society for American Archaeology 6 (6): 4.

1990 *Save the Past for the Future: Actions for the '90s*. Washington, D.C.: SAA, Office of Governmental Relations.

Spielberg, Steven, Frank Marshall, Kathleen Kennedy, and Robert Watts

1988 Letter to Jeremy Sabloff and Dena Dincauze (September 5). Reprinted in *Bulletin* of the Society for American Archaeology 6 (6): 4.

Spiess, Arthur

1988 The Use and Abuse of Volunteers in Archaeology. Paper presented at the conference, *Presenting the Past: Media, Marketing, and the Public*, University of Minnesota, Minneapolis, October 12–14.

Stanbro, Phil

1987 Program Set to Stop Archaeological Looting. *BLM News, Oregon and Washington*, June.

Weil, Stephen E.

1983 *Beauty and the Beasts. On Museums, Art, the Law, and the Market*. Washington, D.C.: Smithsonian Institution Press.

Wells, Peter S.

1991 "Presenting the Past: A Conference Series Aimed at Public Education." In *Protecting the Past*. George S. Smith and John E. Ehrenhard, eds. Boca Raton, Fla.: CRC Press: 181–85.

Conclusion: Working Together to Preserve Our Past

At the outset, it must be stated that this essay contains no hard answers to the questions posed by the preceding discussions. The reason for this is apparent in the widely varying viewpoints held by the numerous groups who are concerned with the tangible remains of the past. These mainly include archaeologists, collectors, museum curators, and Native Americans. Also involved in the problem are lawyers, law enforcement officers, and legislators. Representatives of virtually all of the above categories or viewpoints are represented in this volume.

The credentials that I bring to this discussion lie mainly in the nature of my present position as staff archaeologist of the National Geographic Society in Washington. More often than not, that position places me squarely in the middle of the crossfire from the conflicting viewpoints.

A good example lies in the reaction to the series of articles which appeared in the April 1986 issue of *National Geographic.* There were three—one on the archaeology of Rio Azul, Guatemala, by archaeologist Dr. Richard E. W. Adams; another by Ian Graham, who had observed the sad results of the extensive looting of Rio Azul during the years before Adams began his project; and a third by Gillett Griffin entitled "In Defense of the Collector." The cover of that issue bore a painting of a spectacular piece in a private collection—an unprovenanced stone mask that, by style and the appearance of a certain glyph on its reverse, could be at least tentatively

George E. Stuart

assigned to Rio Azul. The purpose of the entire package was not only to inform our membership of the archaeological conclusions regarding an important Classic Maya city, but also to make our members aware of the range of viewpoints involved in looking at the past.

Our hope that the articles would engender some productive discussions of the issues was far exceeded by the vehemence—and the volume—of the reaction. Some archaeologists deplored the publicity given an unprovenanced, privately owned artifact ("It will surely raise the price."); others chastised us for allowing the collector's view to be printed ("Are you going to print the case for drug dealers, too?"). Still others saw merit in our motives ("It's good to tell people how we all think."). Collectors ran a similar gamut of reaction, from positive ("The article on collecting said a lot of things that needed saying.") to partisan ("What makes archaeologists think that they are the only ones who have a right to dig up these things?"). And these were but a tiny sample. Other missives came from archaeological societies, from Native Americans, and from people who had absolutely no purpose other than to congratulate us on a continuing job of good archaeological coverage.

That torrent of reaction to our coverage indicated not only the importance of the issue we had raised—the conflict between anthropological archaeology (which focuses on past cultural systems and their dynamic relationships rather than on individual objects) and the world of the collectors and dealers in Pre-Columbian art—but its complexity as well. Certainly, my own reading of the various messages brought a fresher appreciation of, if not agreement with, many of the points raised. Since the degree of this understanding is a direct result of my particular background, it seems appropriate here to note that my path toward an archaeological career actually began with the collecting of artifacts—and the unsupervised digging of several archaeological sites near my hometown of Camden, South Carolina. In other words, I can speak with some expertise on both collecting and looting—at least as I knew them over three decades ago.

There were about half a dozen "serious" collectors in Camden then, and I was the youngest. Usually, our endeavors were confined to weekend surface collecting, mainly in plowed fields throughout Kershaw County. We had a vague knowledge that there was a serious science of archaeology, for we had some of the published works as references—among them the older reports of Squier and Davis (which treated briefly the sites in our area), the famed *Twelfth Annual Report of the Bureau of American Ethnology*, some reports by Warren K. Moorehead, and a smattering of then-recent works such as Joffre Coe's summary of the North Carolina Piedmont sites.

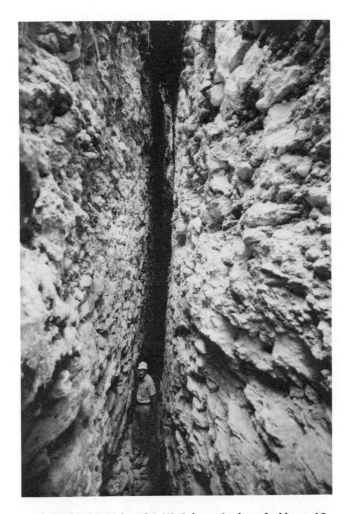

Archaeologist Richard E. W. Adams is dwarfed by a 60-foot deep looters' trench through Temple A II at Rio Azul, a remote site in the Department of Peten, Guatemala. Looters found several tombs as they trenched. Archaeologist Ian Graham took a snapshot of one of them when he visited there in 1978 as part of his long-term effort to record hieroglyphic writing at Maya sites. The looters were on break. Graham snuck by their camp and crawled down into the hole in Temple I, took the snapshot and crawled back out again. The floors had been covered with offerings; now there are just empty tombs. *Photo courtesy of the National Geographic Society.*

Our surface collecting gave way to actual excavation in 1951, with the transition provided by the discovery of complete burial urns and other grave goods at sites being eroded by the Wateree River. Soon we were digging in earnest at the mound sites, spending the evenings washing the day's "take," and carefully arranging the collections for display in our households.

In 1952, the first "real" archaeology came to Camden, when A. R. Kelley and Joe Caldwell of the University of Georgia—South Carolina had no professional archaeologist at the time—came to work at Mulberry, one of the best known of the Camden sites, and one at which I and other local collectors had worked intensively since the mid-1940s. That meticulous excavation of a small portion of the site that summer, on which I landed a job digging and drawing, was quite remarkable for the way in which it fostered cooperation between the archaeologists and the local collectors. I know we felt better when we realized that the archaeologists were not necessarily looking for whole, beautiful artifacts. The archaeologists, in turn, received from me and my colleagues a reasonably accurate archaeological survey of what to them had been an unknown area, coupled with our collective (and also reasonably accurate) memories of what had been found where. In a way, this made us proud of our work—and we resumed it enthusiastically after the Mulberry project ended.

My major point in the paragraphs above is that the motivation for the collecting—including the digging—that we did some forty years ago lay solely in the thrill of the accumulation of interesting objects whose assembly created, in effect, a highly informative collection of artifacts. And the material—unlike coins, stamps, and other targets of collectors—cost nothing except time. Never was there even a thought that the material we were finding and keeping had monetary value, nor did any of us ever buy or sell an artifact to another.

Although there are possibly many collectors out there who still operate much as we did, the general scene has changed dramatically. Now, every state has someone officially in charge of archaeology, and university anthropology faculties are larger and more numerous than before. Consequently, the message of what archaeologists do and why they do it is more available to the general public, although, as will be noted below, there remains a fundamental problem of communication between the two areas.

Money has now permeated the collecting scene to an unprecedented degree, as the fashion of possessing Pre-Columbian art has evolved to a status previously held exclusively by collectors of African and Oceanic art, or treasures of classical antiquity. Now as never before, artifacts from stone tools to painted vases not only command astronomical prices, but often serve as commodities in situations involving tax deductions, profit transactions, and

other financial manipulations. As a consequence, an age of innocence has passed. In most cases, collectors no longer find their objects; they buy from catalogues. And the market this creates, coupled with the limited available supply of ancient artifacts, at least indirectly contributes to the actual looting that begins the chain.

So far, then, what I have mentioned deals with two basic viewpoints, or "camps"—collectors and archaeologists. And within each group, attitudes and practices vary greatly between moderate and extreme, and these often change through time.

Archaeology, like everything else, has gone through a succession of intellectual changes. In the late nineteenth century as the science emerged from simple collecting and antiquarianism, it was the fashion to seek and find royal remains and, best of all, tombs, as exemplified in the works of Heinrich Schliemann, Sir Arthur Evans, and others in the eastern Mediterranean area. This trend, manifest in most New World archaeology for the first half of this century, gradually gave way to other kinds of archaeology. Beginning in the 1950s, a general swing began to take hold in the study of the remains of the lives of ordinary people. This change produced some interesting attitudes among collectors. Many got the notion that archaeologists simply were no longer interested in tombs and burials. A Mississippi collector I met said it best as he proudly showed me a sampling of the thousands of prehistoric painted water bottles and effigy vessels he had dug up at various sites in the lower Mississippi Valley:

"The archaeologists tell me I shouldn't be doing this, but they don't seem to want the pots. They're out there sifting and washing—I don't know what. They've got all these little pill bottles full of stuff. Anyway, they don't seem to want the graves. And I know where they are around the mound by the trees. I try to tell the archaeologists where to dig, but they don't, so I think it's all right if I get the whole pots."

The commercialization of the past takes place in many ways. At a roadside attraction on a prehistoric site in Arkansas, one can pay a small fee, dig in a designated square, and keep whatever comes out. And in Collinsville, Illinois, on the fringes of the great Cahokia site, I have seen real estate signs proclaiming, "Indian mound for sale." I should note here that if Cahokia happened to be located in Mexico, it would be, by definition, a federal monument qualifying for preservation and guardianship under the auspices of the National Institute of Anthropology and History.

Perhaps nowhere in the Americas is the problem of the conflict between the worlds of the archaeologist and the collector more visible than Mesoamerica. My own specialty, centered on the Maya area of southeastern Mexico, Guatemala, Belize, Honduras, and El Salvador, has given me a fairly de-

tailed view of the situation there—a true microcosm of what is happening all over the world in areas of ancient "high culture."

In Guatemala's Peten region, for example, highly organized bands of looters are going about in relatively desolate areas excavating tombs and sending the material forth into the illegal art market. I use the term "illegal" cautiously here, for the laws are not only ambiguous; they differ from one part of the Maya area to another, depending upon which country the material that shows up on the market came from. Legally proving which country any particular piece came from creates a corresponding morass of considerations. In one case, a highly "collectible" artifact was taken (probably) from the Guatemalan Highlands, and exported to the United States, where it appeared for sale at an art auction. It was purchased by a Mexican collector and taken to that country, where it presumably remains, registered as part of Mexico's national patrimony!

In the all-important matter of the use of nonprovenanced artifacts, the varied attitudes evident among professional Mayanists reflect differences in both personal attitudes and professional aims. As a general rule, most archaeologists feel that any artifact lacking archaeological context can neither be verified as authentic, nor be profitably studied.

In contrast, an art historian or an anthropologist interested in iconography and/or epigraphy, would with equal strength deplore a lack of context, but nonetheless believe that such a piece is useful for its style or for the images and texts upon it. As these experts would acknowledge, however, there are pitfalls in studying such material. One example that comes immediately to mind is the "restoration" of ancient polychrome vessels in which hieroglyphs or portions of painted scenes, damaged or destroyed by time, are renewed, sometimes creating a whole new set of data for the unwary scholar. Again, this results from economic considerations, for such restoration work is done to pieces in order to enhance their monetary value on the art market.

Matching the degree of difference in the opinions among archaeologists, art historians, epigraphers, and others who make a living by analyzing the remains of the past is the great variety of attitudes among collectors. Some cooperate readily with the world of scholarship, making their material available for study and publication. Others, for reasons that range from a desire for privacy to hesitancy to subject themselves to the hostility of some archaeologists (i.e., those who actively fight collecting), are less cooperative with those outside the world of the art collector.

In short, neither archaeologists nor collectors can be easily divided into categories of attitude. Indeed, it often appears to me that in some instances

two archaeologists may be farther apart on the issue of the appropriate use of nonprovenanced artifacts than are some archaeologists and collectors.

All, however, seem to be unanimous in deploring the looting of archaeological sites. However, both archaeologists and collectors must share in the blame for such practices—archaeologists for providing the knowledge that gives a piece more "meaning," and hence more value as a collectible; collectors for competing in the sales galleries or auction houses.

Another category of persons involved in the manipulation of antiquities is composed of those citizens of the countries where archaeological sites abound, who participate in their illicit excavation. In the cases involving the Maya area—and hence the nations of Mexico, Guatemala, Belize, Honduras, and El Salvador, the sacking of sites is at least partially fostered by local economic conditions that force rural subsistence farmers or others in the lowest economic stratum to simply seek money by which to live. There are few who would quarrel with the priorities in such cases.

Contributing to local expertise in the trenching of mounds and the high yield of royal tombs is the experience gained by local men who worked temporarily on legitimate archaeological projects, particularly those run by foreign investigators in the past several decades. It should also be noted that, to a farmer from Guatemala's Peten, there may well be no perceptible difference between being hired by archaeologists on a long-term legitimate endeavor, and being employed as laborer on a well-organized (and possibly long-term as well) looting effort. Thus, the matter of economics—in this case the practical economics of survival—again intrudes itself into the problem of the conservation of the past.

Still another set of considerations centers on the very act of digging up ancient burials and artifacts by anyone, whether archaeologists, collectors, or professional looters. The issue has come to public prominence in the past five years as various Native American groups have protested the desecration of what they consider the sacred sites of their ancestors, and in particular the removal and accumulation of human skeletal material for study or exhibition. Opponents of such practices point to what is estimated at some 300,000 American Indian skeletons in museum and laboratory storage—the results of decades of archaeological work—in the United States alone. This they contrast with the imbalance in many local laws which forbid the disinterment of the remains, no matter how old, of whites. This Native American movement seeks the reburial of all such study collections.

Perhaps the most tangible result of the protests so far is the increased awareness of other attitudes on the part of the archaeologists. And while even archaeologists disagree among themselves about just what to do about

excavated material, the approach to compromise and cooperation by both the scientists and the Native American cause, and the promise for the future is heartening.

So far, I have pointed out only a few of the factions who concern themselves with the past—archaeologists who study it, collectors who gather it (for many reasons), looters who dig it up, and the many Native Americans who simply want it left alone.

Also caught up in this turmoil are the museums—where most of the basic problems concerned with the "ownership" and stewardship of the past come to rest. Museum directors and curators, charged with the conservation of those materials that have already come from the ground, and with the dissemination of knowledge about these materials, are indeed the ones most often faced with the issues we are discussing, for the very acquisition of a piece can raise many issues ranging from the problem of falsification to the intricacies of international art law.

There is no easy answer to the questions being posed here. As long as the engine of economic gain propels most looting and at least some collecting; as long as the source sites for saleable artifacts remain isolated and unguarded; and as long as control over the artifacts is sought by such diverse interests, the problems will continue. In my opinion, the degree to which their solutions may someday become apparent depends on a variety of factors.

In general, archaeologists need to do a much better job of communicating with the public. As matters now stand, the public has very little idea what archaeologists do and why. And the public, as a rule, has virtually no notion of the results of archaeological investigation unless a sensational discovery is involved. And that further skews the public image of archaeology by making it seem like some sort of treasure hunt. If anthropological archaeology is to be taken seriously by the public, the profession should offer something to the public—an obligation underscored by the fact that, in this country and others, archaeology is often accomplished with public money. In keeping with this, archaeologists should make a conscious effort to appreciate the motives and attitudes of those collectors and amateur archaeologists who are sincerely interested in knowing about the past.

The United States needs a national, cabinet-level agency to deal with archaeological and historical matters. Unlike many other countries in the world community, we have no Ministry of Culture as in France; no National Institute of Anthropology and History as in Mexico, Guatemala, and other Latin American countries. This conspicuous lack is only partially alleviated by the role of our National Park Service (under the Department of the Inte-

rior), whose archaeological jurisdiction is limited to the federal properties it administers. The absence of a broader national archaeological agency complicates the ease with which the United States is able to deal, as a nation, with others in such things as national archaeological policy and the international traffic in art and artifacts.

Existing laws provide a basis for the prosecution and punishment of those who loot on public lands; others who dig up skeletal material; or still others who smuggle art and artifacts of great monetary value. In general, however, the success of such laws as deterrents to vandalism and archaeological looting varies wildly, depending on place, degree of inclination to enforce, and ability to enforce. Even if the laws were consistent, the official enforcement agencies are most often understaffed, overworked, and concerned with other priorities.

If national and state laws are complicated, international laws which pertain to the traffic in ancient, saleable objects are even more so, and again, appropriate enforcement is impossible.

No amount of legislation, however, can help in the long run without the essential foundation of a strong system of values that helps the people see the differences between, and the consequences of, "right" behavior and "wrong" behavior.

In the end much of the solution will depend upon education and learning. The public needs to know what archaeologists do and how that can help our world. Archaeologists need to realize that not all collectors are evil, and that some can actually help answer some of the questions. Collectors should know that most archaeologists are not really bad people either. Above all, each group must respect the attitudes of the other. The real problem, I submit, is the lack of time. If the arguments regarding the treatment of cultural property and its disposition continue while those remnants of the past that DO survive are being obliterated, then the questions that fostered this book will become meaningless. I hope with all my heart that such will not come to pass.

REFERENCES

Adams, Richard E. W.
 1986 Archaeologists Explore Guatemala's Lost City of the Maya, Rio Azul. *National Geographic*. Washington, D.C.: National Geographic Society 169 (4): 420–451.

Graham, Ian

 1986 Looters Rob Graves and History. *National Geographic.* Washington, D.C.:
 National Geographic Society 169 (4): 452–461.

Griffin, Gillett G.

 1986 In Defense of the Collector. *National Geographic.* Washington, D.C.: National Geographic Society 169 (4): 462–465.

Epilogue

INTRODUCTION

This chapter will discuss recent developments, particularly in the United States, that support the protection and stewardship of the world's cultural heritage. These include implementation of the Native American Graves Protection and Repatriation Act (NAGPRA), the establishment of public education programs to encourage stewardship of the past, the implementation of new and revised codes of ethics, and the signing of new bilateral agreements.

In the introduction to this volume, Warren suggests looking at issues related to cultural properties in a new framework, emphasizing an integrative principle of consultation and nonhierarchical win-win outcomes. To a large extent, this has been the framework for the areas where progress has been made—greater consultation among indigenous peoples, museums and archaeologists; increased communication among archaeologists, descendant communities, educators, and the public about the importance of saving the past for the future; and collaborative efforts between the United States and other governments.

The language used to describe cultural materials and their relevance to us is of great importance. Law professors Lyndel Prott and Patrick O'Keefe argue that it is time for law and lawyers to recognize that the term *cultural property* cannot "cover all that evidence of human life that we are trying to preserve . . . which are evidence of its intellectual and spiritual achievements (Prott and O'Keefe 1992: 307). They argue that *heritage* "embodies

Phyllis Mauch Messenger

the notion of inheritance and handing on" and the "concepts of duty to pre-
serve and protect." (1992: 307) In a review of eight recent publications dealing
with the debate over the proper disposition of objects of cultural significance,
Herscher discusses the highly charged debate over the moral and political
implications of the words *property, patrimony, heritage, resources,* and *treas-
ures,* noting that each has its problems (Herscher 1998b: 813). While the term
cultural heritage is objectionable to some because of "implicit moral claims,"
it may be the best term to use when discussing the "ethical context of studying,
owning, and preserving the past" (Messenger 1993: 311). It also acknowledges
that the class of materials under discussion should not serve as symbols of
cultural, political, or economic dominance (see also Ruppert 1997).

Herscher argues that most discussions regarding return and repatriation
fail to acknowledge the central importance of archaeological context and
the fact that the return of an object does not restore that context (Herscher
1998b: 813). Coggins discusses differing perspectives on context and mean-
ing (1995: 63–65) as well as the important difference between *provenance—*
an object's "history as cultural property" and *provenience—*"an object's
original context" (1995: 70).

The effort to place a higher value on the broader cultural context of ob-
jects seems to be having some effect on the media, law enforcement, and the
public at large. The situation relative to collectors, dealers, and some mu-
seums is less clear-cut at this time. The following discussion offers an intro-
duction to current issues and resources for further study.

DEFINING AND PROTECTING CULTURAL HERITAGE IN AMERICA

As Herscher (chapter 8) and others have discussed, "the United States is
virtually alone among nations in having no formal national cultural policy"
(McKean 1992: 5). Recent developments, however, have moved us toward
greater protection of cultural heritage resources and broader discussions
about who has the right and responsibility to decide how objects from the
past are treated.

The last two decades of the twentieth century have seen important addi-
tions to the set of U.S. laws designed to protect American cultural heritage
for the enjoyment and benefit of all, while acknowledging the special rela-
tionships of Native American and Native Hawaiian tribes to the objects and
places of their cultural heritage. It is hoped that the implementation of these
laws, in concert with strengthened state and local laws, as well as multifac-
eted public education programs, will enhance a stewardship ethic that val-
ues and preserves the nation's multi-ethnic past. See Appendix I for a sum-
mary of some U.S. and international laws.

Along with strengthened laws have come a number of well-publicized convictions for looting of archaeological sites on federal land. In 1997, for example, nine people received felony sentences under the Archaeological Resources Protection Act (ARPA) for looting a cave on U.S. Forest Service Land in Utah between 1989 and 1991 and removing hundreds of objects, including human remains dating as far back as 8,000 years ago. Three defendants were sentenced to two years in prison; the others were placed on probation or home confinement and all were ordered to pay restitution totaling $25,500, including the cost of repatriating the human remains to the appropriate tribe (NPS 1997: 10–11).

Federal legislation has slowly moved toward including more consultation with tribes (see Hutt 1997, Fred 1997). Since the early 1970s, tribes have been gaining political clout and seeking redress in various areas, including land issues, treaty infringements, and human rights (for perspectives on the historical context, see White Deer 1998, Fred 1997, and Bray 1995). As the issue of repatriating Native American remains and funerary objects gained momentum, many museum administrators feared that repatriation legislation would lead to the wholesale emptying of their collections, and many archaeologists feared the devastating loss of a database of skeletal material, or even the demise of archaeology. Some decried the idea of legislating at a national level the issues they felt were best worked out locally through consultation and state-by-state legislation. Newsletters of professional organizations, including the *SAA Bulletin* and the *Anthropology Newsletter* of the American Anthropological Association carried numerous articles on personal opinions and institutional policies.

With passage of the National Museum of the American Indian Act in 1989, Congress created a museum within the Smithsonian Institution dedicated to the preservation, study, and exhibition of the life, languages, literature, history, and arts of Native Americans. And it provided for the "inventory, identification and return of Indian human remains and Indian funerary objects in possession of the Smithsonian Institution" (USC 1989). Passage of the law was facilitated by public outcry over unequal treatment of excavated Euro-American and Indian skeletons (see Bray 1995), as well as the realization that the remains of thousands of Native Americans sat in boxes on museum shelves.

The purpose of NAGPRA, signed into law by President George Bush in November 1990, was to lay out a process and timetable for repatriating Native American and Native Hawaiian human remains and burial items, sacred property, and objects of cultural patrimony which were held by agencies receiving federal funds. With public sentiment on the side of equal and appropriate treatment of the dead, the bill, H.R. 5237, introduced on July 10, 1990,

by Representative Morris Udall, passed quickly through Congress after several arduous years of discussion and compromise among the various interested groups, including Native American tribes, museums, anthropologists and archaeologists, and attorneys.

With the passage of NAGPRA, the U.S. Department of the Interior was charged with developing NAGPRA regulations, including the definitions, procedures, and timelines that would guide implementation. After a process of review and commentary involving many organizations and advocacy groups, the final rule took effect on December 4, 1995, as 43 CFR 10, and a review committee was appointed.

NAGPRA has two main areas of concern, one being the inventory and potential repatriation of materials following a specific timetable, and the other providing ongoing protection of Native American and Native Hawaiian grave sites (see NPS 1995a, Pinkerton 1992). The first component of NAGPRA mandates that all agencies which receive federal funding after November 16, 1990, and possess or control collections of Native American remains and associated funerary objects shall complete an inventory and summary of the collections. An inventory is an item-by-item description of Indian human remains and associated funerary items with any identifiable cultural or geographic affiliation. This was to be completed within five years of the bill's signing and sent to any potentially affiliated tribe or Native Hawaiian group. A summary is a broader description of a collection containing unassociated funerary objects, sacred objects, and objects of cultural patrimony. Summaries were to be completed within three years of 1990 and circulated to potentially affiliated groups. The goal of developing the summaries and inventories was to facilitate the repatriation of human remains and associated objects to their rightful heirs through a consultative process as expeditiously as possible. The right of ownership was prioritized following specific criteria related to land ownership, cultural affiliation, or demonstrated relationships.

A NAGPRA advisory committee representing tribes, museums, archaeologists, and the public was appointed to interpret the act and to arbitrate competing claims for repatriation and determine which materials cannot be identified as associated with a particular culture. A program of consultation and training was established by the National Park Service Departmental Consulting Archeologist and Archeological Assistance Program. Beginning in 1994, funds were appropriated for grants to native groups and museums to inventory collections, consult among tribes, and travel to view collections. (For a summary of programs and multiple perspectives on NAGPRA implementation, see NPS 1995a.)

By most accounts, increased discussion and consultation have been beneficial outcomes to the process. As C. Timothy McKeown, NAGPRA pro-

gram leader for the National Park Service (NPS) Archeological Assistance Program, states, "Little did Rep. Morris Udall realize . . . when he introduced H.R. 5237, that a single word within that bill—'consultation'—would have such a profound effect on the relationship between the United States and Indian tribes. Midway between the traditional standards of notification and obtaining consent, consultation requires an ongoing dialogue" (McKeown 1997: 14). Hutt also emphasizes the importance of consultation. "NAGPRA has been referred to as human rights legislation because it affords Native people the respect for property rights that had been lacking in our society and the courts. . . . Under NAGPRA, consultation is true dialogue" (Hutt 1997: 29; see also McManamon 1995: 2).

Tessie Naranjo of the Santa Clara cultural preservation program, and a member of the NAGPRA review committee, described the differences in worldviews between traditional Native Americans and non-tribal people. "Traditional Native Americans see an essential relationship between humans and the objects they create. A pot is not just a pot. In our community, the pots we create are seen as vital, breathing entities that must be respected as all other living beings" (Naranjo 1995; in the same volume, see related essays by Edward Halealoha Ayau, Rosita Worl, and Carey Vicenti). For other perspectives on museum collections and NAGPRA, see also Jennings 1996 and Sonderman 1996. For further discussion of increased cooperation among Native Americans, museums, and archaeologists, see essays in *Native Americans and Archaeologists: Stepping Stones to Common Ground* (Swidler et al 1997).

By early 1998, according to McKeown, over one thousand NAGPRA summaries had been received from federal agencies and other institutions receiving federal funding. About 700 institutions had completed inventories, some 400 of which include human remains (personal communication). All major U.S. institutions with holdings are in the process of communicating with tribes with possible affiliations to cultural materials listed in the inventories and summaries, and some repatriations and reburials have taken place, following publication in the Federal Register and a prescribed waiting period. About 250 to 260 notices had appeared in the Register, accounting for about 9,000 human remains, about 300,000 funerary objects, 512 sacred objects, 176 objects of cultural patrimony, and 113 objects considered to be both sacred and objects of cultural patrimony. It is estimated that up to 200,000 individual remains will eventually be accounted for through the NAGPRA process. A significant portion of these, perhaps one quarter, cannot be traced to descendent communities. An important job of the review committee will be to determine how many of these remains cannot be connected to any tribal affiliation and what their disposition should be.

With 769 tribal entities eligible to make claims, McKeown notes that many

different approaches have developed, often following geographic and tribal relationships. Some involve making claims as a unit, for example, the Wabanaki Confederacy in Maine, confederacies of Lakota in the Midwest, and the Minnesota Indian Affairs Council (MIAC) representing Dakota and Ojibwe tribes in the state. In the Northwest, regional councils handle claims for Tlinget and Jaida villages. Native Hawaiians have actively pursued reburial and repatriation claims as a group, both nationally and internationally, with ancestral Hawaiians being returned from as far away as the University of Zurich (Ayau 1995: 26).

Civil penalties for failure to comply with NAGPRA are being developed as is a proposed rule establishing time limits for compliance in future cases in which institutions holding Native American remains receive federal funding for the first time, and thus are subject to NAGPRA compliance. In addition, new cases, such as that of Kennewick Man, discovered in 1996 along the Columbia River in Washington and thought to be one of the oldest skeletons found in North America, will continue to expand the range of scenarios to be considered under NAGPRA. At issue in the Kennewick Man case is who has the right to determine how and whether the remains should be studied or reburied (see Gerstenblith 1997; and ongoing discussions on the NPS website www.cr.nps.gov and in the *SAA Bulletin*). As Alaska Representative Don Young, chairman of the House Resources Committee, noted, "I did not envision a 10,000 year-old person," when he helped pass the Repatriation Act. Instead, he was thinking of remains from the past few hundred years (Hughes 1998). Discussion related to ownership of cultural knowledge and traditions has now extended to such issues as right of access to archives and written records (see Brown 1998).

By early 1998, five accusations of failure to comply with NAGPRA had been made. Three were reviewed and dismissed; two appear on the surface to be failures to comply. These and other cases will make news and be assessed in popular and scholarly journals as Americans continue to learn more and care more about remains from the past and their ongoing meaning for living cultures today.

Several authors have addressed return and restitution policies and cases in other countries. Paterson discusses domestic repatriations to First Nations and indigenous peoples in Canada, Australia, and New Zealand from museums, churches, and other institutions (1997: 269–70). Greenfield provides numerous examples, from "historically removed treasures" to Soviet spoils of war to contemporary art thefts (Greenfield 1996; see also Tubb 1995, Schmidt and McIntosh 1996). For a discussion of cases of mediation, negotiation, and international partnerships, see Messenger (1993). See also discussions of U.S. bilateral agreements and the 1995 UNIDROIT Convention, be-

low, and periodic articles in *Archaeology* and the *International Journal of Cultural Property.*

PUBLIC EDUCATION AND STEWARDSHIP OF THE PAST

Archaeology as a field has made dramatic changes in recent decades. The profession of archaeology in the United States has been transformed from a discipline practiced mainly in a university context to one that is primarily carried out in the context of cultural resource management, with increasing emphasis on responsibilities to the public. As early as 1972, McGimsey stated in his seminal *Public Archaeology,* "There is no such thing as 'private archeology'" (1972:5; see also, McGimsey and Davis 1977 for a discussion in the Airlie House Report of the need for public education). As McGimsey and Davis describe it today, it is not so much a matter of creating some new elements in archaeology, or a "public archaeology," but that "archeology has begun to recognize, utilize, and serve its various publics more effectively—publics which were there all along" (1998:1).

The 1988 amendments to ARPA not only strengthened penalties for violations of antiquities laws protecting archaeological resources on public and tribal lands, but also directed federal agencies to establish public education programs. "Each Federal land manager shall establish a program to increase public awareness of the significance of the archaeological resources located on public lands and Indian lands and the need to protect such resources" (Jameson 1991). The programs and initiatives set in motion by this amendment and ensuing directives by then-Secretary of the Interior Manuel Lujan may represent some of the most significant and promising trends in developing ethical perspectives in the treatment of cultural heritage resources. The NPS, Bureau of Land Management (BLM), Bureau of Reclamation (BOR), and other federal agencies within the Department of the Interior have developed and supported numerous initiatives. These agencies are making a concerted effort to include multiple perspectives in their interpretive programs at parks and heritage sites. NPS spells this out in its 1988 *Management Policies,* requiring that parks "actively consult" with tribes in planning, developing, and operating interpretive programs (Sucec 1997: 52–54). *Project Archaeology: Intrigue of the Past,* a middle school curriculum developed by BLM, seeks to use the excitement of archaeology to teach "young citizens about their cultural heritage so that they are equipped to make wise decisions concerning the use and protection of archaeological sites now and in the future" (Moe and Letts 1998: 26). BLM staff are working with networks of teachers and archaeologists in several states to implement and sustain the curriculum.

Professional archaeological societies, including the Archaeological Insti-

tute of America (AIA), the Society for American Archaeology (SAA), and the Society for Historical Archaeology (SHA) have been at the forefront of developing education programs that engage the public in the understanding and appreciation of the past through archaeology. For example, AIA has developed resources for educators including *Archaeology in the Classroom: A Resource Guide for Teachers and Parents.*

SAA's Public Education Committee was established in 1990 as a result of the 1989 "Save the Past for the Future" working conference in Taos, New Mexico (see chapter 14; see also SAA 1990, Judge 1991, Reinburg 1991). Its mission, as published in SAA's *Archaeology and Public Education* newsletter, is "to promote awareness about and concern for the study of past cultures, and to engage people in the preservation and protection of heritage resources" (see Messenger 1995b, Messenger and Smith 1995). The SAA Public Education Committee has initiated numerous programs and partnership efforts to promote this mission by outreach and collaboration with teachers and students, avocational societies, practicing archaeologists, and the general public through workshops, conference symposia, publications, consultation on media projects, and a traveling display of archaeology education resources. SAA has developed a network of coordinators representing most U.S. states and Canadian provinces to link SAA with local archaeologists and educators.

An initiative to look at how practicing archaeologists are trained in light of changing professional standards and increasing public involvement in archaeology was launched in 1998 with a working conference at Wakulla Springs, Fla. This led to the establishment of an SAA Task Force on Curriculum to encourage a dialogue across the discipline. For further discussion of SAA's public education initiatives, see Bender (1995), Smith (1995), Messenger (1995a), and SAA (1995; see also www.saa.org).

In addition to the work of professional societies, institutions such as Crow Canyon Archaeological Center and the Center for American Archaeology promote responsible public involvement in archaeology through their experiential learning programs. The Archaeological Conservancy, which protects archaeological sites through purchase, has launched a new publication, *American Archaeology,* aimed at a popular audience. Even the Boy Scouts of America have introduced an Archaeology Merit Badge. For discussion of these and other public education programs and opportunities in archaeology, see Friedman and Messenger (1996: 193–94), Messenger and Enloe (1991: 157–66), Jameson (1997), and NPS (1995b, 1998).

CODES OF PROFESSIONAL ETHICS

Since 1990, major societies of archaeology and museum professionals have carried out in-depth soul-searching work on ethical issues that affect

their professions. One of these issues involves the publication of descriptions of looted materials that might seem to condone looting or increase the value of looted objects on the art market. The *American Journal of Archaeology (AJA)* adopted a policy which does not allow the initial description of artifacts and archaeological materials from looted contexts (Kleiner 1990).

Soon after the AJA policy decision, SAA editors adopted a policy prohibiting publication of papers based on looted data, which led to a broader discussion of SAA's outdated ethical policy. In 1991 the SAA Executive Board empowered a Task Force on Ethics to review related policies. Several years of study and public symposia led to SAA's Eight Principles of Archaeological Ethics (Lynott and Wylie 1995; Lynott 1997). The overarching stewardship principle exhorts archaeologists to work for the long-term conservation and protection of the irreplaceable archaeological record by practicing and promoting stewardship. Another principle says that responsible archaeological research requires public accountability and active consultation with affected groups. A principle addressing commercialization states that archaeologists should discourage and avoid activities that enhance the commercial value of archaeological objects and contribute to site destruction. Regarding public education and outreach, archaeologists should participate in cooperative efforts with others to improve the preservation and interpretation of the record by enlisting public support and communicating interpretations of the past. The intellectual property principle says that the knowledge and documents created through the study of archaeological resources are part of the archaeological record and must be made available to others within a reasonable time. Following the principles on public reporting and publication, archaeologists must present knowledge gained from investigation of the archaeological record to interested publics in timely and accessible forms. A principle discussing records and preservation says that archaeologists should work actively for the preservation, responsible use, and accessibility of archaeological collections, records, and reports. The last principle, on training and resources, requires that archaeologists have adequate training, experience, facilities, and other support necessary to conduct research in accordance with the other principles. (See full text of principles in Appendix II.)

In 1997 a new organization, the Register of Professional Archaeologists (RPA), was formed by SAA and SHA as a transformation of the Society of Professional Archaeologists (SOPA) to develop and enforce an effective program of professional ethics and standards. The purpose of RPA is to encourage all who work as professionals in archaeology "whether in an academic or non-academic setting . . . to become publicly accountable for upholding an explicit set of research standards and ethical practices" (Lipe and Steponaitis 1998: 16). The RPA Code of Ethics includes support for and compliance with the 1970 UNESCO Convention among a long list of responsibilities to the

public, colleagues, employees, students, employers, and clients.

AIA's Code of Ethics, adopted in 1990 and revised in 1997, focuses on "protection and preservation of the world's archaeological resources" (text in Appendix II). The AIA Code of Professional Standards, adopted in 1994, lays out the responsibilities of professional archaeologists to the archaeological record, to the public, and to colleagues. For the American Anthropological Association (AAA) revised code of ethics, see www.ameranthassn.org. For a discussion of guidelines for art historians, see Kemp 1992.

With the surge of public education programs promoted by professional archaeologists and the revision of codes of ethics to include an emphasis on public accountability and communication, one criticism oft-repeated by collectors and dealers is losing any air of credibility it might have once enjoyed. The argument, that archaeologists do not share their findings with the public, cannot be used as an excuse to ignore concerns about the loss of contextual data. (see also Vitelli 1996.)

AMERICA'S ROLE IN THE INTERNATIONAL PROTECTION OF CULTURAL PROPERTY

As Americans become more aware of their potential role in protecting their own country's cultural heritage, so too what America does relative to the world's cultural heritage continues to be vitally important. With the United States continuing as the principal market for the antiquities trade, it can be argued that what the American government and its citizens do *does* make a difference.

The lead role the United States has played in implementing the 1970 UNESCO Convention (see chapter 9) entered a new phase in 1995 with the signing of a bilateral agreement between the United States and El Salvador. The request from El Salvador to restrict the importation of *any* Pre-Columbian material came as its eight years of emergency protection of material from the Cara Sucia region was about to expire. The comprehensive bilateral agreement was passed with great speed in April 1995, just in time to prevent a gap in protection. As Herscher notes, "Despite the importance—indeed, revolutionary, nature—of the 1995 agreement with El Salvador, it was little noticed at the time, probably because antiquities from El Salvador are not exactly highly visible hot items on the international market" (Herscher 1997). But it demonstrated the United States' willingness to conclude broad restrictive agreements; and before the year was over, agreements with Canada, Peru, Guatemala, and Mali had also been signed (Appendix I). These agreements can be renewed indefinitely in five-year increments.

The nature of these agreements points to a more comprehensive, long-term goal than the emergency protection of a narrow class of objects. As

The "Reclining Vishnu" lintel, returned to Thailand by the Art Institute of Chicago, has been returned to its rightful place at Phanom Rung in northeast Thailand. The mountaintop site is visited daily by thousands of pilgrims and tourists. Photo by Lewis C. "Skip" Messenger.

Public awareness and education is enhanced by a new program of signage at all major archaeological sites in Mexico. At each site introductory panels provide basic site information in Spanish, English, and a regional indigenous language. Each structure has an interpretive panel, such as this one for Structure 10 at Becán, Campeche. Photo by Phyllis Messenger.

Maria Papageorge Kouroupas, executive director of the Cultural Property Advisory Committee, describes it, U.S. protection under the 1983 Implementation Act is *prospective* and the primary aim of implementation "is not to curtail illicit trade but rather to protect the integrity of the object by finding ways to prevent its illicit and unscientific removal from its original context" (Papageorge Kouroupas 1995: 32). When the United States decides, after a lengthy process of review and decision-making, to enforce another state party's request for enforcement of its export restrictions, it "is significant, for it essentially removes a major art-consuming nation from the marketplace. This has the effect of legitimizing the export controls of the requesting country, since the United States does not otherwise enforce the export controls of another country" (Papageorge Kouroupas 1995: 33). These remarks were made in Mali at an ICOM Regional Workshop on the Illicit Traffic of Cultural Property to illustrate the U.S. experience within the 1970 UNESCO Convention framework. United States Information Agency's (USIA) description of the United States-Mali agreement further elucidates the intent of the bilateral agreements: "to reduce the incentive for pillage of Malian artifacts and extends the opportunity for Mali to further pursue certain regulatory, institu-

Important sites around the world have been designated as UNESCO World Heritage Sites, indicating that special care is being taken of them as part of the global cultural heritage. In Oaxaca City, Oaxaca, Mexico, at the Church of Santo Domingo, visitors see the UNESCO plaque as they cross the plaza in front of the church. The monastery of the church (left), which now houses a regional museum run by the National Institute of Anthropology and History (INAH), is being restored. Photo by Lewis C. "Skip" Messenger.

tional, and educational measures to help stabilize the situation there" (USIA 1997b: 1). Measures include implementing procedures for inventory and classification, improved export review, and education of local populations to safeguard sites.

The promotion of cultural values and the protection of cultural heritage also are among the action items agreed upon at the 1994 Summit of the Americas. Participants there agreed to "work with hemispheric governments to enhance appreciation of indigenous cultures and cultural artifacts through the implementation of cultural property protection agreements" (Papageorge Kouroupas 1995: 35). In particular, the agreement between the United States and Canada breaks new ground, according to Martin Sullivan, chair of the Cultural Property Advisory Committee and director of the Heard Museum in Phoenix. "For the first time this Agreement also addresses widespread concern in the U.S. for protecting against inappropriate international trade in sensitive Native American cultural artifacts" (USIA 1997a: 2). In 1996, the Cultural Property Advisory Committee met with ministers of culture and other officials from seven Central American countries at the Getty Conservation Institute in Los Angeles to explore long-term strategies for protecting cultural resources (USIA 1996; see also Hersches 1998a). In 1997, the United States and Mexico inaugurated regional bilateral meetings, with the first hosted by NPS in San Antonio, Texas, to discuss ways to better enforce existing laws to protect the objects of cultural heritage on both sides of the border (see Zander, Appendix I).

It is difficult to judge the effect that emergency bans on the import of certain materials may have had, due to the secretive nature of the antiquities trade. However by 1997, eighty-eight countries had become parties to the UNESCO Convention (Appendix I), including France, and Switzerland was giving it serious discussion. As Herscher notes, "Perhaps one way to measure the law's success is to monitor the reaction of the antiquities dealers. After many years of relative quiet, an article appeared in the November 1997 issue of *Art and Auction* magazine, in which a spokesman for the dealers' association denounces the Canadian and Peruvian agreements" (Herscher 1997). In general, however, media reports are coming down hard on looters, dealers, and museums that are suspected of overstepping the boundaries of ethical behavior (see a November 1997 series of articles in the *Boston Globe* on Mayan art in the Museum of Fine Arts, www.boston.com; see also Robinson 1998; Yemma 1998; Goodale 1996; Dobrzynski 1998). For additional discussion of some of the political issues in national and cultural identity related to objects of cultural heritage, see Karp, Kreamer, and Lavine (1992); Lowenthal (1985); Gathercole and Lowenthal (1990); Kohl and Fawcett (1995).

Another body which has addressed the international protection of cul-

tural property is the International Institute for the Unification of Private Law (UNIDROIT). Study began in 1987 and, encouraged by UNESCO, led to the 1995 UNIDROIT Convention on Stolen or Illegally Exported Cultural Objects. The agreement would require signatory countries to return stolen cultural objects and those cultural objects illegally exported from the territory of another country which is party to the Convention. Unlike the 1970 UNESCO Convention, UNIDROIT specifically equates illegal excavation with theft, allowing source countries to apply existing stolen property law to recover illegally excavated objects. During the writing stage, a group of museums and art dealers tried, unsuccessfully, to have this provision removed, but their opposition did help block the United States from signing the convention. As of mid-1998, China, Ecuador, Lithuania, Paraguay, and Romania had ratified the convention. For further discussion of the 1990 draft Convention and the final Convention, see Siehr (1992), Sidorsky (1996), Merryman (1996), and Gerstenblith (1998). The final text is available on the UNIDROIT Web site (see Appendix III) and in *The Spoils of War* (Simpson 1997).

CONCLUSION

In the years since *Ethics of Collecting* was first published, some might say things haven't changed much. Looting of sites around the world still continues at an alarming pace, collectors still pay astounding amounts for antiquities of unknown origin, and there are still no easy answers to the issues raised by parties to the debate.

On the other hand, there have been significant steps toward long-term solutions for protecting the world's cultural heritage. It may well be that the best chance of saving the past for the future is a combination of all the efforts described above: ethical behavior of involved professionals, national and international laws and agreements, and the public education that will support their being upheld. With these in place the use of mediation and negotiation to resolve conflicts *before* the need to apply law may well be "the best possible chance for making truces, for salvaging information, and for returning significant objects" (Coggins 1995: 75).

REFERENCES

Ayau, Edward Halealoha
 1995 Rooted in Native Soil. *Federal Archeology Special Report: The Native American Graves Protection and Repatriation Act.* Washington, D.C.: NPS Archeology and Ethnography Program (Fall/Winter): 24–27.

Bender, Susan

1995 Public Education and the Society for American Archaeology. Paper presented in a symposium on the SAA Public Education Committee at the 1995 Chacmool Conference, *Archaeology for the 21st Century: Public or Perish*. Conference volume in press, University of Calgary.

Bray, Tamary

1995 Repatriation: A Clash of World Views. *AnthroNotes, National Museum of Natural History Bulletin for Teachers* 17 (Winter/Spring).

Brown, Michael F.

1998 Cultural Records in Question: Information and Its Moral Dilemmas. *CRM*, Washington, D.C.: NPS Cultural Resources 21 (6): 18–20.

Coggins, Clemency Chase

1995 A Licit International Traffic in Ancient Art: Let There Be Light! *International Journal of Cultural Property* 4 (1): 61–79.

Dobrzynski, Judith H.

1998 To Save Mayan Artifacts From Looters, a Form of Protective Custody. *New York Times*. March 31.

Fred, Morris A.

1997 Law and Identity: Negotiating Meaning in the Native American Graves Protection and Repatriation Act. *International Journal of Cultural Property* 6 (2): 199–229.

Friedman, Edward and Phyllis Messenger

1996 Popular Education. In *The Oxford Companion to Archaeology*. Brian M. Fagan, ed. New York: Oxford University Press.

Gathercole, Peter and David Lowenthal

1990 *The Politics of the Past*. London: Unwin Hyman Ltd.

Gerstenblith, Patty

1997 Editorial. *International Journal of Cultural Property* 6 (2): 195–97.

1998 UNIDROIT Ratified. *Archaeology* 51 (4): 24.

Goodale, Gloria

1996 Protecting Indigenous Art: Central American Sleuths Target a Hot Black Market. *Christian Science Monitor*. October 23.

Greenfield, Jeanette

1996 *The Return of Cultural Treasures*. 2d ed. Cambridge: Cambridge University Press.

Herscher, Ellen

1997 The Convention on Cultural Property Implementation Act: An Assessment of the First 15 Years. Paper delivered as part of the Gold Medal Colloquium in Honor of Clemency Coggins: *Archaeology and the Antiquities Market, 99th Annual Meeting of the Archaeological Institute of America*, December 29, Chicago.

1998a Playground for the Human Spirit. *Archaeology* 51 (3, May/June): 64–70.

1998b Many Happy Returns? New Contributions to the Repatriation Debate. *American Journal of Archaeology* 102 (4/Oct.): 809–13.

Hughes, John
 1998 Kennewick Man's Skeleton Sparks Widespread Debate. *Associated Press,* June 22.
Hutt, Sherry
 1997 Sound Decisions, Respectful Results: The Native American Voice in Preservation Law. In *Common Ground, Archeology and Ethnography in the Public Interest. Speaking Nation to Nation: Fulfilling our Promise to Native Americans.* C. Timothy McKeown and Rosemary Sucec, eds. Washington, D.C.: NPS Archeology and Ethnography Program, 2 (3/4): 29.
Jameson, John H. Jr.
 1991 Public Interpretation Initiative. In *Federal Archeology Report.*
Jameson, John H. Jr., ed.
 1997 *Presenting Archaeology to the Public: Digging for Truths.* Walnut Creek, Calif.: Altamira Press.
Jennings, Paulla Dove
 1996 Objects of Life: An Interview with Paulla Dove Jennings. *Collections and Curation into the 21st Century. Common Ground: Archeology and Ethnography in the Public Interest.* Washington, D.C.: NPS Archeology and Ethnography Program, 1 (2/Summer): 38–45.
Judge, W. James
 1991 Saving the Past for Ourselves: The Society for American Archaeology Taos Anti-Looting Conference. In *Protecting the Past,* George S. Smith and John E. Ehrenhard, eds. Baton Rouge: CRC Press: 277–81.
Karp, Ivan, Christine Mullen Kreamer, and Steven D. Lavine
 1992 *Museums and Communities: The Politics of Public Culture.* Washington, D.C.: Smithsonian Institution Press.
Kemp, Martin
 1992 "The Guidelines for the Professional Practice of Art History" Issued by the Association of Art Historians in Great Britain. *International Journal of Cultural Property* 1: 239–51.
Kleiner, F. S.
 1990 On the Publication of Recent Acquisitions of Antiquities. *American Journal of Archaeology* 94: 525–27.
Kohl, Philip L. and Clare Fawcett, eds.
 1995 *Nationalism, Politics, and the Practice of Archaeology.* Cambridge: Cambridge University Press.
Lipe, William and Vincas Steponaitis
 1998 SAA to Promote Professional Standards through ROPA Sponsorship. *SAA Bulletin* 16 (2): 1, 16–17.
Lowenthal, David
 1985 *The Past is a Foreign Country.* Cambridge: Cambridge University Press.
Lynott, Mark J.
 1997 Ethical Principles and Archaeological Practice: Development of an Ethics Policy. *American Antiquity* 62 (4): 589–99.

Lynott, Mark and Alison Wylie, eds.

 1995 *Ethics in American Archaeology: Challenges for the 1990s.* Special Report. Washington, D.C.: Society for American Archaeology.

McGimsey, Charles R. III

 1972 *Public Archeology.* New York: Academic Press.

McGimsey, Charles R. III and Hester A. Davis, eds.

 1977 *The Management of Archeological Resources: The Airlie House Report.* Washington, D.C.: Special publication of the Society for American Archaeology.

McGimsey, Charles R. III and Hester A. Davis

 1998 The Old Order Changeth or Now that Archeology is in the Deep End of the Pool Let's Not Just Tread Water. Paper prepared for the SAA workshop on Enhancing Undergraduate and Graduate Education and Training in Public Archaeology and Cultural Resource Management, Wakulla Springs, Fla. Feb. 5–8.

McKean, David

 1992 *Communications and Culture: Should the United States Protect Cultural Resources?* Based on a conference on October 28, 1991, cosponsored by the National Endowment for the Arts and the Annenberg Washington Program. Washington, D.C.: The Annenberg Washington Program.

McKeown, C. Timothy

 1995 Confessions of a Bureaucrat. *Federal Archeology Special Report: The Native American Graves Protection and Repatriation Act.* Washington, D.C.: NPS Archeology and Ethnography Program, (Fall/Winter): 5–7.

 1997 Speaking Nation to Nation: Old Roads and New. *Common Ground: Archeology and Ethnography in the Public Interest. Speaking Nation to Nation: Fulfilling Our Promise to Native Americans.* Washington, D.C.: NPS Archeology and Ethnography Program, 2 (3/4): 14–15.

McManamon, Francis P.

 1995 The Reality of Repatriation: Reaching Out to Native Americans. *Federal Archeology Special Report: The Native American Graves Protection and Repatriation Act.* Washington, D.C.: NPS Archeology and Ethnography Program, (Fall/Winter): 2.

Merryman, John Henry

 1996 The UNIDROIT Convention: Three Significant Departures from the *Urtext. International Journal of Cultural Property* 5 (1): 11–18.

Messenger, Phyllis Mauch

 1993 Forging New Partnerships for the Study and Preservation of the Pre-Columbian Past. In *Collecting the Pre-Columbian Past.* Elizabeth Hill Boone, ed. Washington, D.C.: Dumbarton Oaks Research Library and Collection: 291–314.

 1995a Commentary: Public Education Initiatives. *Ethics in American Archaeology: Challenges for the 1990s.* Mark Lynott and Alison Wylie, eds. Special Report. Washington, D.C.: SAA.

 1995b *Archaeology and Public Education: A Communication Tool Across Disciplines.* Paper presented in a symposium on the SAA Public Education Commit-

tee at the 1995 Chacmool Conference, *Archaeology for the 21st Century: Public or Perish.* Conference volume in press, University of Calgary.

Messenger, Phyllis Mauch and Walter W. Enloe

 1991 The Archaeologist as Global Educator. In *Protecting the Past.* George S. Smith and John E. Ehrenhard, eds. Boca Raton, Fla.: CRC Press, 157–66.

Messenger, Phyllis and KC Smith

 1995 *Archaeology and Public Education.* Quarterly publication of the SAA, Washington, D.C.: 5 (4).

Moe, Jeanne M. and Kelly A. Letts

 1998 Education: Can It Make a Difference? *Common Ground: Archaeology and Ethnography in the Public Interest. Reaching the Public.* Washington, D.C.: NPS Archaeology and Ethnography Program, 3 (1): 24–29.

Naranjo, Tessie

 1995 Thoughts on Two Worldviews. *Federal Archeology Special Report: The Native American Graves Protection and Repatriation Act.* Washington, D.C.: NPS Archeology and Ethnography Program (Fall/Winter): 8.

National Park Service (NPS)

 1995a *Federal Archeology Special Report: The Native American Graves Protection and Repatriation Act.* Washington, D.C.: NPS Archeology and Ethnography Program (Fall/Winter).

 1995b *CRM: Archeology and the Public.* Washington, D.C.: NPS Cultural Resources 18 (3).

 1997 Cave Looters Brought to Justice. *Common Ground: Archeology and Ethnography in the Public Interest. Speaking Nation to Nation: Fulfilling our Promise to Native Americans.* Washington, D.C.: NPS Archeology and Ethnography Program 2 (3/4): 10–11.

 1998 *Common Ground: Reaching the Public.* Washington, D.C.: NPS Archeology and Ethnography Program 3 (1).

Papageorge Kouroupas, Maria

 1995 U.S. Efforts to Protect Cultural Property: Implementation of the 1970 UNESCO Convention. *African Arts* (Autumn): 32–37.

Paterson, Robert K.

 1997 The Protection of Cultural Property in Internal Law. *International Journal of Cultural Property* 6 (2): 267–77.

Pinkerton, Linda F.

 1992 The Native American Graves Protection and Repatriation Act: An Introduction. *International Journal of Cultural Property* 2: 297–305.

Prott, Lyndel V., and Patrick J. O'Keefe

 1992 "Cultural Heritage" or "Cultural Property"? *International Journal of Cultural Property* 2: 307–20.

Reinburg, Kathleen M.

 1991 Save the Past for the Future: A Partnership to Protect Our Past. In *Protecting the Past,* George S. Smith and John E. Ehrenhard, eds. Baton Rouge: CRC Press, 271–76.

Robinson, Walter V.
 1998 Museums' Stance on Nazi Loot Belies Their Role in a Key Case. *Boston Globe.* February 13: A1.
Ruppert, Dave
 1997 New Language for a New Partnership. *Common Ground: Archeology and Ethnography in the Public Interest. Speaking Nation to Nation: Fulfilling our Promise to Native Americans.* Washington, D.C.: NPS Archeology and Ethnography Program, 2 (3/4): 36–38.
Schmidt, Peter R. and Roderick J. McIntosh
 1996 *Plundering Africa's Past.* Bloomington: Indiana University Press.
Sidorsky, Emily
 1996 The 1995 UNIDROIT Convention on Stolen or Illegally Exported Cultural Objects: The Role of International Arbitration. *International Journal of Cultural Property* 5 (1): 19–72.
Siehr, Kurt
 1992 The UNIDROIT Draft Convention on the International Protection of Cultural Property. *International Journal of Cultural Property* 2: 321–30.
Simpson, Elizabeth, ed.
 1997 *The Spoils of War. World War II and Its Aftermath: The Loss, Reappearance, and Recovery of Cultural Property.* New York: Abrams.
Smith, KC
 1995 SAA Public Education Committee: Seeking Public Involvement on Many Fronts. *CRM: Archeology and the Public.* Washington, D.C.: NPS Archeology and Ethnography Program, 18 (3): 25–28.
Society for American Archeology
 1990 *Save the Past for the Future: Actions for the '90s.* Special Report on the working conference held May 1989, Taos, New Mexico. Washington, D.C.: SAA.
 1995 *Save the Past for the Future II: Report of the Working Conference.* Summary report of a conference held September 19–22, 1994, Breckenridge, Colorado. Washington, D.C.: SAA.
Sonderman, Robert C.
 1996 Primal Fear: Deaccessioning Collections. *Collections and Curation into the 21st Century. Common Ground: Archeology and Ethnography in the Public Interest.* Washington, D.C.: NPS Archeology and Ethnography Program, 1 (2/Summer): 26–29.
Sucec, Rosemary
 1997 Telling the Whole Story: Re-scripting Interpretations of American Indians. In *Common Ground, Archeology and Ethnography in the Public Interest. Speaking Nation to Nation: Fulfilling our Promise to Native Americans.* 2 (3/4): 52–56.
Swidler, Nina, Kurt E. Dongoske, Roger Anyon, and Alan S. Downer, eds.
 1997 *Native Americans and Archaeologists: Stepping Stones to Common Ground.* Walnut Creek, Cal.: Altamira Press.
Tubb, Kathryn W., ed.
 1995 *Antiquities, Trade or Betrayed: Legal, Ethical & Conservation Issues.* London: An Archetype publication in conjunction with UKIC Archaeology Section.

United States Code (USC)

1989 Title 9: National Museum of the American Indian Act. Section 80q.

United States Information Agency (USIA)

1996 United States Cultural Property Advisory Committee to Convene with Central American Cultural Ministers at Getty Center in Los Angeles (News Release). Washington, D.C.: USIA.

1997a Facts on U.S.-Canada Bilateral Accord to Protect Archaeological and Ethnological Cultural Property. Washington, D.C.: USIA.

1997b Facts on U.S. Action to Protect Archaeological Material from the Region of the Niger River Valley and the Bandiagara Escarpment, Mali. Washington, D.C.: USIA.

Vitelli, Karen D., ed.

1996 *Archeological Ethics.* Walnut Creek, Calif.: Altamira Press.

White Deer, Gary

1998 From Specimens to SAA Speakers: Evolution by Federal Mandate. *SAA Bulletin* 16 (3/May): 6–8.

Yemma, John

1998 Archaeological Digs Being Plundered by Looters. *Boston Globe.* January 1.

Some Domestic and International Laws and Regulations and Their Enforcers

I. Domestic cultural resources law enforcers
A. The Bureau of Land Management
B. National Park Service
C. U.S. Fish and Wildlife Service
D. U.S. Forest Service
E. Federal Bureau of Investigation
F. Bureau of Indian Affairs
G. U.S. Army Corps of Engineers

II. U.S. laws, codes, and regulations
A. Antiquities Act, 1906 (Public Law [PL] 59–209, 16 United States Code [USC] 431–433). First federal policy to preserve historic and prehistoric sites on federal lands, specifying punishments for violations. Authorizes president to declare areas of public lands as national monuments.
B. Historic Sites Act, 1935 (PL 74–292, 16 USC 461–467). Establishes national policy to preserve historic and prehistoric properties of national significance. Establishes National Historic Landmarks program.
C. National Historic Preservation Act (NHPA), 1966 (PL 89–665, 16 USC 470–470t), with subsequent amendments in 1980 (PL 95–515) and 1992. The cornerstone of U.S. historic preservation, NHPA established

Charles S. Koczka

Updated for the second edition
by Phyllis Messenger and Eric Poehler

the National Register of Historic Places, State Historic Preservation Offices (SHPOs), the Certified Local Government (CLG) program, and the President's Advisory Council on Historic Preservation. Section 106 (36 CFR Part 800) provides a five-step process designed to ensure that historic properties are considered during the planning and execution of federal projects. NHPA "establishes a Federal policy of cooperation with other nations, Tribes, States, and local governments to protect historic sites and values" (Carnett 1991: 2). 1992 amendments provide mechanisms, including training, that allow tribal groups to interact in partnerships with federal agencies with a kind of "mutual authority" (Ruppert 1997: 38).

D. Archeological and Historic Preservation Act (AHPA), 1974 (Reservoir Salvage Act, 1960 [PL 86–523], as amended by PL 93–291, 16 USC 469–469c). Sometimes called the Archeological Recovery Act, AHPA requires preservation of scientific, historical and archaeological data, including the objects and materials collected from archaeological sites, related to all federal construction projects.

E. American Indian Religious Freedom Act (AIRFA), 1978 (PL 95–341). Establishes as federal policy the protection and preservation of traditional Native American, Eskimo, Aleut, and Hawaiian spiritual beliefs and practices by allowing access to sites and possession of sacred objects.

F. Archaeological Resources Protection Act (ARPA), 1979 (PL 96–95, 16 USC 470aa–ll), with subsequent amendments in 1988 (PL 100–555, PL 100–588, 16 USC 470aa–mm). Supplements provisions of the Antiquities Act "by further defining the parameters for scientific research on public and tribal lands, clarifying the nature of illegal actions, strengthening penalties for violations of the law, and directing federal agencies to establish public education programs" (Smith 1995: 11).

 1. Prohibitions

 a. No person may attempt to excavate, remove, damage or otherwise alter or deface any archaeological resource located on public lands or Indian lands unless such activity is pursuant to a permit.

 b. No person may sell, purchase, exchange, transport, receive or offer to sell, purchase or exchange any archaeological resource if such resource was excavated or removed from public lands or Indian lands in violation of 1) the Prohibition contained in a. above or 2) any provision, rule, regulation, ordinance, or permit in effect under any other provision of federal law.

 c. No person may sell, purchase, exchange, transport, receive or offer to sell, purchase or exchange, in interstate or foreign commerce, any archaeological resource excavated, removed, sold, purchased, exchanged, transported, or received in violation of any provision, rule, regulation, ordinance, or permit in effect under state or local law.

2. Penalties

 a. *Criminal:* $10,000 and/or one year. If commercial value or restoration costs exceed $500 penalty is $20,000 and/or two years. Second or subsequent conviction is $250,000 and/or five years.

 b. *Civil:* Amount pursuant to regulation promulgated under the act taking into account the archaeological or commercial value of the resource and the cost of restoration and repair of the resource with provision for double penalties for second or subsequent violation. Forfeiture of all archaeological resources involved and all vehicles and equipment involved.

G. Abandoned Shipwreck Act, 1978 (PL 100–298, 43 USC 2101–2106). Transfers ownership of certain historic shipwrecks from the federal government to states and directs states to develop management and protection programs encompassing the needs of all user groups.

H. National Museum of the American Indian Act (NMAIA), 1989 (20 USC, Sec. 80q). Creates a museum within the Smithsonian Institution dedicated to the preservation, study, and exhibition of the life, languages, literature, history, and arts of Native Americans. It provides for the "inventory, identification and return of Indian human remains and Indian funerary objects in possession of the Smithsonian Institution" (20 USC 80q–9 Title).

I. Native American Graves Protection and Repatriation Act (NAGPRA), 1990 (PL 101–601, 25 USC 3001–3013). Establishes rules of ownership and control of Native American human remains and objects and establishes very limited bases for excavation or removal of objects from federal or tribal lands; criminalizes the knowing sale, purchase, use for profit, or transport without right of possession. Requires all museums and state or local agencies and all institutions of higher learning in the United States which receive federal funding to inventory and return the American Indian human remains, funerary objects, sacred objects, and objects of cultural patrimony for which the appropriate tribal relationships can be established. (See chapter 16 for additional discussion of NAGPRA.)

J. Other statutes and regulations covering cultural resources violations

1. 36 CFR 2.1. Preservation of natural, cultural, and archaeological resources.

2. 43 CFR Part 3. Preservation of American antiquities.
3. 18 USC 641, Embezzlement and theft. May be used with malicious mischief statute "in coordination with ARPA to establish liability of looters as well as their connected commercial agents or dealers in artifacts" (Carnett 1991: 4).
4. 18 USC 1361, Destruction of Government Property (Malicious Mischief). Provides penalties for damage or destruction exceeding $100.

K. National Stolen Property Act (18 USC 2314 and 2315). Enforced by the FBI when a person knowingly transports in interstate commerce or receives stolen merchandise with a value over $5000. A conviction can bring a ten-year imprisonment and/or $10,000 fine.

III. International cultural resources law enforcers within the United States
A. U.S. Customs
B. Federal Bureau of Investigations

IV. U.S. regulations covering international cultural resources
A. National Stolen Property Act (18 USC 2314 and 2315). When stolen property exceeding $5,000 in value comes into the U.S. in foreign commerce, act is enforced by U.S. Customs.
B. Smuggling Goods into the United States (18 USC 545). Prohibits smuggling of anything, including art, regardless of its value or legal ownership. Provides for a five-year sentence upon conviction.
C. Entry of Goods by Means of False Statements (18 USC 542). Merchandise, including artifacts, if falsely declared to U.S. Customs as to its value, description, ownership, et cetera, can be seized and the offender imprisoned for two years.
D. Transportation of Stolen Goods *et al.* (18 USC 2314). When an artifact is exported from Mexico, Peru, Ecuador, or Guatemala (all of which vest ownership of such art in the government), federal prosecution may be instituted in U.S. courts. The United States entered into a treaty with Mexico in 1971 and executive agreements with Peru in 1981, Ecuador in 1983, and Guatemala in 1984, whereby each country agreed to assist the other in recovering artifacts unlawfully excavated and exported in violation of their laws.
E. Sale or Receipt of Stolen Goods *et al.* (18 USC 2315). Companion regulation to 18 USC 2314 with same prosecution.
F. Pre-Columbian Monumental & Architectural Sculpture & Murals (Pub-

lic Law 92–587). Enacted by Congress in 1972 to prohibit the importation of Pre-Columbian monumental or architectural sculpture or murals into the United States from Bolivia, Belize, Colombia, Costa Rica, the Dominican Republic, Ecuador, El Salvador, Guatemala, Honduras, Mexico, Panama, Peru, or Venezuela. This law went into effect June 1, 1973 and is incorporated into U.S. Customs Regulations.

G. U.S. Convention on Cultural Property Implementation Act, Title III, PL 97–446, January 12, 1983. Grants to the President the authority to impose import restrictions in certain instances on designated types of archaeological and ethnological materials on a country-by-country basis, after considering the views of interested groups. This act set U.S. Customs as the enforcement agency (19 USC 2601). (See chapters 9 and 16 for discussion of this act and its implementation.)

V. United States bilateral agreements

The following summaries are drawn from facts sheets of the USIA Cultural Property Advisory Committee (see address in Appendix III).

A. United States Action to Protect Antique Textiles from Coroma, Bolivia (effective March 14, 1989–May 5, 1996). Restricted import of antique Aymara textiles without an export permit from Bolivia. Although the import restriction has expired, import of the textiles into the United States may be cause for enforcement of Section 308 (Articles of Stolen Cultural Property) of the 1983 Implementation Act, as the textiles are now on an inventory list with photo documentation.

B. United States-El Salvador Bilateral Cultural Property Agreement to Protect Pre-Hispanic Archaeological Objects (March 8, 1995, Federal Register notice March 10). Restricts importation into the United States of El Salvador's Pre-Columbian archaeological objects unless accompanied by an export permit issued by the government of El Salvador. Expands 1987 U.S. import restrictions to include all Pre-Hispanic archaeological objects in El Salvador. Can be renewed indefinitely in five-year increments.

C. United States-Canada Bilateral Cultural Property Agreement to Protect Archaeological and Ethnological Material (April 10, 1997, Federal Register notice April 22). Protects materials that represent the Aboriginal cultural groups of Canada, including Inuit (Eskimo), Subarctic Indian, Northwest Coast Indian, Plateau Indian, Plains Indian, and Woodlands Indians. Also covers historic shipwrecks and underwater sites. Contains a reciprocal provision in which Canada recognizes United States protection laws.

D. United States-Peru Memorandum of Understanding to Protect Ar-

chaeological and Ethnological Heritage (June 9, 1997, Federal Register notice June 11). Continues restrictions first imposed in 1990 on the importation of pre-Columbian and certain Colonial materials from Peru.

E. United States-Republic of Mali Cultural Property Agreement to Protect Archaeological Material from the Niger River Valley and the Bandiagara Escarpment (Sept. 19, 1997, Federal Register notice Sept. 23). Continues the restriction begun in 1993 of the importation into the United States of archaeological materials from the Niger River Valley region and the Tellem burial caves of Bandiagara.

VI. List of states party to the 1970 UNESCO Convention on Illicit Trade in Cultural Property

As of 1997, there were eighty-eight states party to the 1970 UNESCO Convention.

Africa: Angola, Burkina Faso, Cameroon, Central African Republic, Congo, Cote d'Ivoire, Guinea, Madagascar, Mali, Mauritius, Niger, Nigeria, Senegal, Tanzania, Zambia

The Americas: Argentina, Bahamas, Belize, Bolivia, Brazil, Canada, Colombia, Costa Rica, Cuba, Dominican Republic, Ecuador, El Salvador, Grenada, Guatemala, Honduras, Mexico, Nicaragua, Panama, Peru, United States, Uruguay

East Asia and the Pacific: Australia, Cambodia, Democratic People's Republic of Korea, Mongolia, People's Republic of China, Republic of Korea

Europe: Armenia, Belarus, Bosnia-Herzegovina, Bulgaria, Croatia, Cyprus, Czech Republic, Estonia, France, Georgia, Greece, Hungary, Italy, Kyrghyz Republic, Former Yugoslav Republic of Macedonia, Poland, Portugal, Romania, Russian Federation, Slovak Republic, Slovenia, Spain, Tadjikistan, Turkey, Ukraine, Uzbekistan, Yugoslavia

North Africa, Near East, South Asia: Algeria, Bangladesh, Egypt, India, Iran, Iraq, Jordan, Kuwait, Lebanon, Libya, Mauritania, Nepal, Oman, Pakistan, Qatar, Saudi Arabia, Sri Lanka, Syrian Arab Republic, Tunisia

REFERENCES

For additional discussion of laws relevant to archaeology, cultural heritage, and the international art market, see:

Carnett, Carol
 1991 *Legal Background of Archeological Resources Protection.* Washington, D.C.:

NPS Technical Brief No. 11. (Discusses legal background and case histories for archaeological protection in the United States. Includes a table of state statutes.)

Merryman, John Henry and Albert E. Elsen

1987 *Law, Ethics, and the Visual Arts,* 2d ed. 2 vols. Philadelphia: University of Pennsylvania Press.

Pinkerton, Linda F.

1992 The Native American Graves Protection and Repatriation Act: An Introduction. *International Journal of Cultural Property* 2 : 297–305. (Legal actions around the world are discussed regularly in this journal.)

Ruppert, Dave

1997 New Language for a New Partnership. *Common Ground, Archeology and Ethnography in the Public Interest. Speaking Nation to Nation: Fulfilling our Promise to Native Americans.* Washington, D.C.: NPS Archeology and Ethnography Program, 2 (3/4): 36–38. (This issue is devoted to NAGPRA and consultation issues; see, especially, "What the Law Requires: A Quick Reference," pp. 50–51.)

Simpson, Elizabeth, ed.

1997 *The Spoils of War. World War II and Its Aftermath: The Loss, Reappearance, and Recovery of Cultural Property.* New York: Abrams. (Appendices include texts of seventeen legal documents relating to the protection and repatriation of cultural property, including the 1954 Hague Convention, the 1970 UNESCO Convention, and the 1995 UNIDROIT Convention.)

Smith, George S., Francis P. McManamon, Ronald D. Anzalone, James W. Hand, and James C. Maxon

1988 Archaeology and the Federal Government. *CRM Bulletin* 11: 1, 3–8.

Smith, KC

1995 High Points in Historic Preservation. *Archaeology and Public Education.* Washington, D.C.: SAA, 5 (4): 10–11. (This issue of the SAA education newsletter is devoted to archaeology and law, including teaching strategies.)

Zander, Caroline

1997 Legal Authorities: Within the United States. *Bilateral Protection of Cultural Heritage Along the Borderlands: Mexico and the United States.* Proceedings of a conference held Oct. 23–25 in San Antonio, Tex. (For more information on the conference, contact Richard Waldbauer, Archeology and Ethnography Program, NPS, 1849 C Street NW, Mail Stop NC2275, Suite 210, Washington, D.C. 20240.)

Codes of Ethics

SOCIETY FOR AMERICAN ARCHAEOLOGY

Eight Principles of Archaeological Ethics

Adopted by the SAA Executive Board, April 1996

Principle No. 1: Stewardship

The archaeological record, that is, in situ archaeological material and sites, archaeological collections, records and reports, is irreplaceable. It is the responsibility of all archaeologists to work for the long-term conservation and protection of the archaeological record by practicing and promoting stewardship of the archaeological record. Stewards are both caretakers of and advocates for the archaeological record. In the interests of stewardship, archaeologists should use and advocate use of the archaeological record for the benefit of all people; as they investigate and interpret the record, they should use the specialized knowledge they gain to promote public understanding and support for its long-term preservation.

Principle No. 2: Accountability

Responsible archaeological research, including all levels of professional activity, requires an acknowledgment of public accountability and a commitment to make every reasonable effort, in good faith, to consult actively with affected group(s), with the goal of establishing a working relationship that can be beneficial to all parties involved.

Principle No. 3: Commercialization

The Society for American Archaeology has long recognized that the buying and selling of objects out of archaeological context is contributing to the destruction of the archaeological record on the American continents and around the world. The commercialization of archaeological objects—their use as commodities to be exploited for personal enjoyment or profit—results in the destruction of archaeological sites and of contextual

information that is essential to understanding the archaeological record. Archaeologists should therefore carefully weight the benefits to scholarship of a project against the costs of potentially enhancing the commercial value of archaeological objects. Wherever possible, they should discourage, and should themselves avoid, activities that enhance the commercial value of archaeological objects, especially objects that are not curated in public institutions, or readily available for scientific study, public interpretation, and display.

Principle No. 4: Public Education and Outreach

Archaeologists should reach out to, and participate in, cooperative efforts with others interested in the archaeological record with the aim of improving the preservation, protection, and interpretation of the record. In particular, archaeologists should undertake to: (1) enlist public support for the stewardship of the archaeological record; (2) explain and promote the use of archaeological methods and techniques in understanding human behavior and culture; and (3) communicate archaeological interpretations of the past. Many publics exist for archaeology including students and teachers; Native Americans and other ethnic, religious, and cultural groups who find in the archaeological record important aspects of their cultural heritage; lawmakers and government officials; reporters, journalists, and others involved in the media; and the general public. Archaeologists who are unable to undertake public education and outreach directly should encourage and support the efforts of others in these activities.

Principle No. 5: Intellectual Property

Intellectual property, as contained in the knowledge and documents created through the study of archaeological resources, is part of the archaeological record. As such it should be treated in accord with the principles of stewardship rather than as a matter of personal possession. If there is a compelling reason, and no legal restrictions or strong countervailing interests, a researcher may have primary access to original materials and documents for a limited and reasonable time, after which these materials and documents must be made available to others.

Principle No. 6: Public Reporting and Publication

Within a reasonable time, the knowledge archaeologists gain from investigation of the archaeological record must be presented in accessible form (through publication or other means) to as wide a range of interested publics as possible. The documents and materials on which publication and other forms of public reporting are based should be deposited in a suitable place for permanent safekeeping. An interest in preserving and protecting in situ archaeological sites must be taken into account when publishing and distributing information about their nature and location.

Principle No. 7: Records and Preservation

Archaeologists should work actively for the preservation of, and long-term access to, archaeological collections, records, and reports. To this end, they should encourage colleagues, students, and others to make responsible use of collections, records, and reports in their research as one means of preserving the in situ archaeological record, and of increasing the care and attention given to that portion of the archaeological record which has been removed and incorporated into archaeological collections, records, and reports.

Principle No. 8: Training and Resources

Given the destructive nature of most archaeological investigations, archaeologists must ensure that they have adequate training, experience, facilities, and other support necessary to conduct any program of research they initiate in a manner consistent with the foregoing principles and contemporary standards of professional practice.

Reprinted from American Antiquity *(Lynott 1997: 592–93) with permission of SAA. See chapter 16 and Lynott and Wylie (1995) for additional discussion.*

ARCHAEOLOGICAL INSTITUTE OF AMERICA

Code of Ethics

Approved by the AIA Executive Council at its December 29, 1990, meeting and amended at its December 29, 1997, meeting.

The Archaeological Institute of America is dedicated to the greater understanding of archaeology, to the protection and preservation of the world's archaeological resources and the information they contain, and to the encouragement and support of archaeological research and publication.

In accordance with these principles, members of the AIA should:

1. Seek to ensure that the exploration of archaeological sites be conducted according to the highest standards under the direct supervision of qualified personnel, and that the results of such research be made public;

2. Refuse to participate in the trade in undocumented antiquities and refrain from activities that enhance the commercial value of such objects. Undocumented antiquities are those which are not documented as belonging to a public or private collection before December 30, 1970, when the AIA Council endorsed the UNESCO Convention on Cultural Property, or which have not been excavated and exported from the country of origin in accordance with the laws of that country;

3. Inform appropriate authorities of threats to, or plunder of archaeological sites, and illegal import or export of archaeological material.

Reprinted with permission of AIA.

A Code of Professional Standards was approved by the AIA Executive Council at its December 29, 1994, meeting. Full text of the Code is available from AIA (Appendix III).

REFERENCES

For additional discussions of ethics, see:
Fluehr-Lobban, Carolyn, ed.
1991 *Ethics and the Profession of Anthropology: Dialogue for a New Era.* Philadelphia: University of Pennsylvania Press.
Kemp, Martin
1992 "The Guidelines for the Professional Practice of Art History" Issued by the Association of Art Historians in Great Britain. *International Journal of Cultural Property* 1: 239–51.
Lynott, Mark J.
1997 Ethical Principles and Archaeological Practice; Development of an Ethics Policy. *American Antiquity* 62 (4): 589–99.
Lynott, Mark and Alison Wylie, eds.
1995 *Ethics in American Archaeology: Challenges for the 1990s.* Special Report. Washington, D.C.: SAA.
Vitelli, Karen D., ed.
1996 *Archaeological Ethics.* Walnut Creek, Cal.: Altamira Press.

Some Organizations and Resources Related to Archaeology and Cultural Heritage Issues

American Anthropological Association (AAA)

4350 North Fairfax Drive, Suite 640, Arlington, VA 22302-1620

Phone: (703) 528-1902, **Fax:** (703) 528-3546

Internet: www.ameranthassn.org, **Email:** Bdavis@ ameranthassn.org

Publications: *American Anthropologist, Ethnos, Anthropology Newsletter, Anthropology and Education Quarterly, Museum Anthropology*

Description: AAA is the largest organization of individuals interested in anthropology in the world. It was formed to "promote the science of anthropology, to stimulate and coordinate the efforts of American anthropologists, . . . and encourage the publication of matter pertaining to anthropology" ("A brief history of the AAA").

American Association of Museums (AAM)

1575 Eye Street NW, Suite 400, Washington, D.C. 20005

Phone: (202) 289-1818, **Fax:** (202) 289-6578

Internet: www.aam-us.org/

Publications: *Museum News, Aviso*

Description: Promotes excellence within the museum community. Enhances the ability of museums to serve the public interest (AAM Homepage).

Archaeological Institute of America (AIA)

656 Beacon Street, Boston, MA 02215-2010

Phone: (617) 353-9361; **Fax:** (617) 353-6550

Internet: AIA: http://archaeological.org/, **Email:** aia @bu.edu; AJA: http://classics.lsa.umich.edu/AJA.html

Compiled by Eric Poehler

Archaeology Magazine: http://www.archaeology.org

Publications: *Archaeology, The American Journal of Archaeology (AJA)*

Description: AIA is "dedicated to the encouragement and support of archaeological research and publication and to the protection of the world's cultural heritage" (AIA Homepage/"Who We Are").

Archaeological Conservancy

5301 Central Avenue NE, Suite 1218, Albuquerque, NM 87108-1517

Phone: (505) 266-1540

Internet: www.gorp.com/archcons/, **Email:** archons@nm.net

Publication: *American Archaeology*

Description: The Archaeological Conservancy is "a national non-profit organization formed in 1980 to identify, acquire, and permanently preserve the most significant archaeological sites in the United States" (Archaeological Conservancy Homepage).

ArchNet—Archaeology's Virtual Library

Internet: http://www.lib.uconn.edu/ArchNet

Description: The World Wide Web's Virtual Library in Archaeology, ArchNet provides access to archaeological resources available on the internet. Reviewed resources are categorized by geographic region and subject.

Federal Register Online

Internet: wais.access.gpo.gov.

Description: Provides online access to U.S. government notifications related to NAGPRA, federal regulations, et cetera., via GPO Access.

Getty Conservation Institute

The Getty Center, 1200 Getty Center Drive, Los Angeles, CA 90049

Phone: (310) 440-7300

Internet: www.getty.edu

Description: The Getty Conservation Institute works internationally to further the appreciation and preservation of the world's cultural heritage for the enrichment and use of present and future generations.

International Council of Museums (ICOM)

Internet: www.icom.org/

Description: "ICOM is devoted to the promotion and development of museums and the museum profession at an international level" (ICOM Homepage).

International Council on Monuments and Sites (ICOMOS)

49-51 rue de la Federation, 75015 Paris, France

Phone: 33 1 45 67 67 70, **Fax:** 33 1 45 66 06 22

Internet: www.icomos.org/, **Email:** secretariat@icomos.org

Publications: 25,000 documents, 10,000 slides, periodicals from around the world.

Description: "ICOMOS is an international non-governmental organiza-

tion of professionals dedicated to the conservation of the world's historic monuments and sites. ICOMOS provides a forum for professional dialogue and a vehicle for the collection, evaluation, and dissemination of information on conservation principles, techniques, and policies" (ICOMOS Homepage).

International Cultural Property Society

Th. H. Weyland, Kerkstraat 313, NL-1017 GZ Amsterdam, The Netherlands

Fax: (20) 624 59 65

Internet: www.law.depaul.edu /snolley/cultprop.htm, **Email:** pgersten@ condor.depaul.edu

Publications: *The International Journal of Cultural Property (IJCP)*

Description: Founded in 1990, the Society publishes the *Journal*, "a unique multidisciplinary periodical which addresses the concerns of people in all fields of learning and professional activity that touch upon cultural property" (IJCP Homepage).

International Foundation for Art Recovery (IFAR)

46 East 70th Street, New York, NY 10021

Phone: (212) 879-1708

International Institute for the Unification of Private Law (UNIDROIT)

28 Via Panisperna, 00184 Rome, Italy

Phone: 39 6 699 41372, **Fax:** 39 6 699 41394

Internet: www.agora.stm.it /unidroit /welcome.htms, Email: unidroit. rome@agora.stm.it

Publications: *Uniform Law Review*

Description: "UNIDROIT is an independent intergovernmental organization [with its purpose] to examine ways of harmonizing and coordinating the private law of States and groups of States, and to prepare for an adoption by the various States of uniform rules of private law" (UNIDROIT Homepage).

Interpol

Quai Charles de Gaulle, 69006 Lyon, France

Phone: 33 4 72 44 70 00, **Fax:** 33 4 72 44 71 63

Internet: www.kenpubs.co.uk/interpol-pr/ (UK), www.rcmp-grc.gc.ca/ html/interp-f.hm (Canada)

Publications: *International Criminal Police Review*

Description: Interpol aims to "promote and enhance international police cooperation with a view to creating a safer environment around the world" (Raymond E. Kendall QPMMA, Secretary-General, Interpol).

Journal of Field Archaeology (JFA)

"The Antiquities Market"

Internet: http://jfa-www.bu.edu /

Boston University Scholarly Publications

985 Commonwealth Avenue, Boston, MA 02215

Phone: (617) 353-4106

Description: JFA is an international, refereed quarterly serving the interests of archaelolgists, anthropologists, historians, scientists, and others concerned with the recovery and interpretation of archaeological data.

The Museum Security Network

Internet: http:/museum-security.org

Description: This organization publishes reports of cultural property incidents, such as art theft, looting of art in wartime, fire, forgery, etc. (securma Homepage).

National Park Service (NPS)

Archeology and Ethnography Program, 1849 C Street NW, Washington, D.C. 20240

Phone: (202) 343-4101, **Fax:** (202) 523-1547

Internet: Links to the Past www.cr.nps.gov/

Publications: *Reading in Archaeological Resource Protection Series, CRM Magazine*

Description: Web site includes links to laws, regulations, standards, and conventions.

Pre-Columbian Archaeology Related Links

Internet: http://copan.bioz.unibas.ch/mesolinks.html, **Email:** burglin@ ubaclu.unibas.ch

Description: An exhaustive list of links related to Mesoamerican archaeological sites, research, travel.

Register of Professional Archaeologists (RPA)

Description: RPA is a voluntary registry of professional archaeologists dedicated to establishing, promoting, and enforcing high ethical and professional standards for the conduct of archaeology. Formed under joint sponsorship by SAA and SHA, RPA evolved out of the Society of Professional Archaeologists (SOPA) (see *SAA Bulletin*, March 1998).

Society for American Archaeology (SAA)

900 Second Street NE #12, Washington, D.C. 20002-3557

Phone: (202) 789-8200, **Fax:** (202) 789-0284

Internet: www.saa.org, **Email:** Headquarters@saa.org

Publications: *American Antiquity, Latin American Antiquity, Archaeology and Public Education, Bulletin of the Society for American Archaeology.*

Description: "SAA is an international organization dedicated to research, interpretation, and protection of the archaeological heritage of the Americas" (SAA Homepage).

Society for Historical Archaeology (SHA)

Internet: www.sha.org/sha_back.htm, **Email:** sriarc@aol.com

Publications: *Historic Archaeology, SHA Newsletter*

Description: "The society supports the conservation, preservation, and

research of archaeological resources, including both land and underwater remains" (Article VII of SHA Bylaws).

Society to Prevent Trade in Stolen Art (STOP)

918 16th Street NW, Suite 400, Washington, D.C. 20006

Phone: (202) 835-9843, **Fax:** (202) 293-3187

Internet: www.stop.org/, **Email:** director@stop.org

Description: STOP is dedicated to stopping the international trade in illicit antiquities through such activities as linking theft victims with art detectives, continuing the debate for a uniform international art law code, and providing an on-line database for pre-1987 auction records (STOP Homepage).

Sources of Information on Antiquities Theft

Internet: http://amelia.db.erau.edu/robbinsl/Theft/Theft.html

Email: robbinsl@db.erau.edu

Description: A listing of bibliographies and references from the perspective of a librarian interested in topics of archaeology and antiquities theft.

UNIDROIT

See: International Institute for the Unification of Private Law

United Nations Educational, Scientific, and Cultural Organization (UNESCO)

7 place de Fontenoy, 75352 Paris, 07 SP France

Phone: 33 1 45 68 10 00, **Fax:** 33 1 45 67 16 90

Internet: www.unesco.org

Publications: UNESCO publishes 160 titles each year in eighty languages, including books, periodicals, CD-Rom, and scientific maps.

Description: UNESCO promotes "collaboration among nations through education, science, culture, and communication in order to further universal respect for justice, for the rule of law, and for the human rights and fundamental freedoms which are affirmed for the people of the world without distinction of race, sex, language, or religion, by the Charter of the United Nations" (UNESCO homepage).

United States Information Agency (USIA)

Cultural Property, 301 4th Street SW, Room 247, Washington, D.C. 20547

Phone: (202) 619-6612, **Fax:** (202) 619-5177

Internet: www.usia.gov, **Email:** culprop@usia.gov

Description: "An independent foreign affairs agency which supports U.S. foreign policy and national interests abroad, USIA conducts international educational and cultural exchanges, broadcasting, and information programs" (USIA homepage). Within the United States, the Cultural Property Advisory Committee was established by the Convention on Cultural Property Implementation Act of 1983 to review state party requests submitted to the United States under Article 9 of the 1970 Convention.

INDEX